Visual Translation

MEDIEVAL
INSTITUTE
UNIVERSITY OF NOTRE DAME

THE CONWAY LECTURES IN MEDIEVAL STUDIES 2013

The Medieval Institute gratefully acknowledges the generosity of Robert M. Conway and his support for the lecture series and the publications resulting from it.

Previous titles published in this series:

Paul Strohm
Politique: Languages of Statecraft between Chaucer and Shakespeare (2005)

Ulrich Horst, O.P.
The Dominicans and the Pope: Papal Teaching Authority in the Medieval and Early Modern Thomist Tradition (2006)

Rosamond McKitterick
Perceptions of the Past in the Early Middle Ages (2006)

Jonathan Riley-Smith
Templars and Hospitallers as Professed Religious in the Holy Land (2010)

A. C. Spearing
Medieval Autographies: The "I" of the Text (2012)

Barbara Newman
Medieval Crossover: Reading the Secular against the Sacred (2013)

John Marenbon
Abelard in Four Dimensions: A Twelfth-Century Philosopher in His Context and Ours (2013)

Sylvia Huot
Outsiders: The Humanity and Inhumanity of Giants in Medieval French Prose Romance (2016)

William J. Courtenay
Rituals for the Dead: Religion and Community in the Medieval University of Paris (2019)

Alice-Mary Talbot
Varieties of Monastic Experince in Byzantium, 800–1453 (2019)

VISUAL TRANSLATION

Illuminated Manuscripts and the First French Humanists

ANNE D. HEDEMAN

University of Notre Dame Press

Notre Dame, Indiana

University of Notre Dame Press
Notre Dame, Indiana 46556
undpress.nd.edu

Copyright © 2022 by the University of Notre Dame Press

Published in the United States of America

Library of Congress Control Number: 2021948732

ISBN: 978-0-268-20227-9 (Hardback)
ISBN: 978-0-268-20229-3 (WebPDF)
ISBN: 978-0-268-20226-2 (Epub)

To Carla Bozzolo and the memory of Nicole Pons

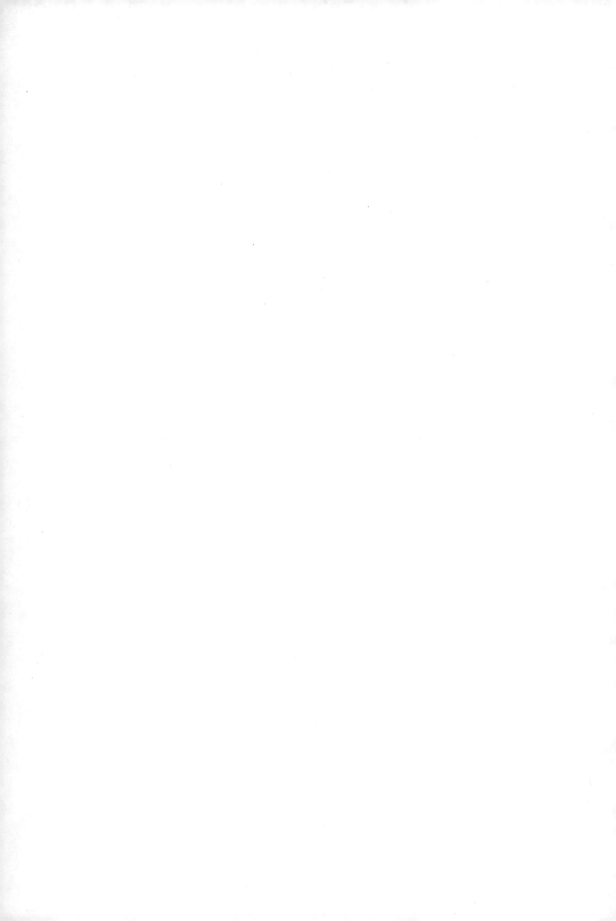

CONTENTS

PART 3
THE CYCLES ESCAPE

CHAPTER 5
Normalization 207

FIGURES

PREFACE

Through a consideration of artistic collaboration, *Visual Translation: Illuminated Manuscripts and the First French Humanists* seeks to expand the established areas of study referenced in its title: the intertwined fields of study about French humanism, the reception of the classical tradition in the first half of the fifteenth century, and textual translation. In the past thirty years scholars in these fields have shifted from the intellectual model of center and periphery with Italy as the center. For instance, scholars of humanism suggest that fifteenth-century humanism is not a philosophical position, but a literary product manifesting, as Stephen Milner eloquently put it, "a knowledge and interest in classical languages, a philological approach towards textual criticism, an interest in the imitation of classical literary style, and a sense of participating in a revival of learning with a moral purpose."[1] They saw humanism taking many forms because of its different reception contexts. It was international from the outset; it manifested continuity with, rather than rupture from, classical study in the medieval past; and it spread through contact and exchange.

Many scholars of the impact of the classics on the postclassical tradition have begun to consider readers as active participants in the classical tradition who are involved in a "chain of reception" at specific times and places. They use reception theory as a valuable tool to offer insight into active, even if unintentional, transformations of classical Greek and Latin texts; for them reception shifts the temporal notion of center and periphery, so that the classical past is not the center that radiates out to passive later recipients. Instead, reception involves "the *active* participation of readers (including readers who are themselves creative artists) in a two-way process backwards as well as forwards, in which the present and the past are in dialogue with each other."[2] These active and diverse readings of classical texts over time in different geographic locations actively construct meaningful understandings of that past that offer insight into changing "present" moments.[3]

Scholars of translation speak of the vast program of translations in the French Middle Ages as evidence of the continuity between antiquity and the Middle Ages. Most translations during this period were from Latin, which, Michel Zink observes, was neither a maternal language nor monolithic because medieval Latin varied considerably from place to place and classical Latin differed significantly from it.[4] Perhaps as a result, Claudio Galderisi describes medieval translation as "polyphonic" and the vast enterprise of translation as offering a bridge between antiquity and modernity.[5] Furthermore, as Frédéric Duval suggests, both the medieval French and the Romans thought of history as exempla, as moral guides to behavior; until the sixteenth century "the human experiences of the ancients served as powerful models in the Middle Ages in France not so much to explain the present as to offer models that would allow those present to amend their comportment for salvation" [Les experiences humaines des Anciens doivent servir aux modernes, non pas tant à expliquer le present qu'à amender leur comportement en vue du salut].[6]

As will become clear, visual translation, the subject of this book, coexists with textual translation as a way to make the classical and medieval pasts present and to enhance reception of the moral examples in these texts that were seen as particularly relevant to medieval readers. Readers and viewers alike use the "fruitful alterity" of past stories to offer insight into their present and, hopefully, to shape their futures.

ACKNOWLEDGMENTS

I have many to thank for their help and support as I worked on *Visual Translation: Illuminated Manuscripts and the First French Humanists*. This book was begun during a sabbatical awarded by the University of Illinois and finished during a sabbatical granted by the University of Kansas. I completed research and writing in Europe and the United States with the help of subventions from the Centre national de la recherche scientifique (CNRS), and a John Simon Guggenheim Memorial Foundation Fellowship. My research and writing benefited as well from appointments as a university scholar at the University of Illinois, as a museum guest scholar at the J. Paul Getty Museum, as a distinguished professor at the University of Kansas, and most recently as a *chercheur invitée* at the Institut national d'histoire de l'art (INHA). I was honored to present the Conway Lectures at the Medieval Institute, University of Notre Dame, in 2013, which gave shape to this book, and I am grateful to the University of Kansas Endowment Association for a subvention toward its publication.

Over the years I benefited from responses to my work at conferences and seminars at the Universities of Leeds, Liverpool, and Manchester in the United Kingdom; the Université Sorbonne Nouvelle, the Laboratoire de médiévistique occidentale de Paris (LaMOP), and the Institiut de recherche et d'histoire des textes (IRHT) in Paris; Le Studium, Loire Valley Institute for Advanced Studies, Orléans; the J. Paul Getty Museum; Harvard University; University of Notre Dame; Princeton University; the State University of New York, Binghamton; the University of Kansas; and the University of Pennsylvania.

I would like to thank Getty Publications, the Presses Sorbonne Nouvelle, Publications de la Sorbonne, Peeters, Taylor & Francis, the Pontifical Institute of Mediaeval Studies, *Mediaevalia*, and *Viator* for permission to incorporate revised and expanded versions of material previously published.

I would like to offer particular thanks for insights and stimulating discussion to: Peter Ainsworth, Guyda Armstrong, François Avril, Carla Bozzolo, Rosalind Brown-Grant, Brigitte Buettner, Olivia Remie Constable, Godfried Croenen, Catherine Croizy-Naquet, Rhiannon Daniels, Lisa Fagin Davis, Olivier Delsaux, Marilyn Desmond, Anne-Marie Eze, Patrick Gautier-Dalché, Claude Gauvard,

Marie-Thèrese Gousset, Jeffrey Hamburger, Jackie Hedeman, Sandrine Hériché-Pradeau, Olivia Holmes, Danielle Joyner, Thomas Kren, Mélisande Krypiec, Isabelle Marchesin, Scot McKendrick, Hélène Millet, Stephen Milner, Elizabeth Morrison, Nancy Netzer, Patricia Osmond, Robert Ousterhout, Gilbert Ouy, Marianne Pade, Margherita Palumbo, Maud Pérez-Simon, Nicole Pons, Bernard Ribémont, Elizabeth Sears, Dana Stewart, Patricia Stirnemann, William P. Stonemann, Michelle Szkilnik, Marie-Hélène Tesnière, Robert Ulery, Anne van Buren, Inès Villela-Petit, and Tara Welch.

Carla Bozzolo and Nicole Pons in particular offered models of careful and thoughtful scholarship on Laurent de Premierfait and Jean Lebègue. Over the years I benefited equally from their scholarly support and their friendship, and I dedicate this book to Carla and the memory of Nicole as a token of my gratitude.

EDITORIAL PRINCIPLES
AND ABBREVIATIONS

When Latin and Middle French texts are cited directly from manuscripts, modernized spelling and punctuation and minimal diacritics have been added. When citations are taken from critical editions, quotations are transcribed exactly. The names of historical figures are anglicized except where anglicization would be confusing: for instance, Louis of Orléans and John of Berry, but Christine de Pizan. Finally, I have used the following abbreviations when referring to manuscripts.

Arsenal	Paris, Bibliothèque de l'Arsenal
Ass. Nat.	Paris, Assemblée nationale
BAV	Vatican City, Biblioteca Apostolica Vaticana
BL	London, British Library
BML	Florence, Biblioteca Medicea Laurenziana
BnF	Paris, Bibliothèque nationale de France
Bodl.	Oxford, Bodleian Library
Bordeaux, BM	Bordeaux, Bibliothèque municipale
Chantilly	Chantilly, Musée Condé
Geneva	Geneva, Bibliothèque de Genève
Houghton	Cambridge, MA, Harvard University, Harvard College Library, Houghton Library
JPGM	Los Angeles, J. Paul Getty Museum
KB	The Hague, Koninklijke Bibliotheek
KBR	Brussels, Bibliothèque royale de Belgique

Morgan	New York, Pierpont Morgan Library
ÖNB	Vienna, Österreichische Nationalbibliothek
Pal. Arts	Lyon, Palais des Arts
Philadelphia	Philadelphia Museum of Art, Department of Prints, Drawings, and Photographs
Ste-Gen	Paris, Bibliothèque Sainte-Geneviève
Trivulzano	Milan, Archivio Storico Civico e Biblioteca Trivulziana, Trivulziano Trivulzano
UCB	Berkeley, University of California, Bancroft Library
Yale	New Haven, Yale University Library

CHAPTER 1

Noble Leisure and French Humanism

Beginning in the fourteenth century during the reigns of the Valois kings, French humanism and translation were associated, and they flourished with the active support of King Charles V, who reigned from 1364 to 1380.[1] At its inception, French humanism was enriched by contacts made by its practitioners in Avignon with Petrarch and the papal chancellery.[2] The connections that scholars made in Italy and deepened through personal correspondence and participation in diplomatic missions continued to influence the graduates and students of the Collège de Navarre in Paris who filled the royal chancellery during the early fifteenth century. Scholars such as Gilbert Ouy, Ezio Ornato, and Carla Bozzolo describe French humanists of the early fifteenth century as motivated by a desire to rival contemporary Italian authors in written expression (which they suggested often manifested a kind of French nationalism) and to collect and study manuscripts of the classics, thus contributing to a French revival of the antique past that often presented it in the image of the French present.[3]

The network of humanists in Paris was a close-knit community that included graduates of the Collège de Navarre, such as Jean de Montreuil, Nicolas de Clamanges, Jean Gerson, and Jean Courtecuisse, as well as notaries and secretaries with different backgrounds such as Gontier Col, Laurent de Premierfait, and Jean Lebègue. They had diverse relations to each other and to members of the nobility. For instance, Jean de Montreuil, Col, Laurent de Premierfait, and Lebègue were royal and ducal notaries. Jean de Montreuil and Gontier Col were also members of the Cour amoureuse, a literary society, founded in 1401 by Dukes Louis of Bourbon and Philip the Bold of Burgundy and headed by King Charles VI, that brought together a cross section of nobility, clerics, and bourgeoisie.[4] They participated actively, along with Pierre Col, Jean Gerson, and Christine de Pizan, in the literary

debate surrounding the *Roman de la Rose,* known in part through dossiers given to Queen Isabeau of Bavaria and Duke John of Berry, among others.[5] Manuscripts annotated by Gontier Col and Jean Lebègue attest that they were avid fans of Laurent de Premierfait. The surviving manuscripts of Jean de Montreuil's letter collection, also annotated by Lebègue, reveal Jean's classical knowledge.[6] He peppers his letters with classical references to such authors as Cicero, Virgil, Sallust, Terence, Valerius Maximus, Seneca, Horace, and others. Even more important, Jean de Montreuil's letters offer insight into the relationships between Col, Laurent de Premierfait, Jean de Montreuil, and other humanists.

Ornato's analysis of the letter collections shows how Jean de Montreuil was part of a community that read and discussed classical texts.[7] His letters describe how he obtained books from contacts in Italy and shared them and other manuscripts with colleagues. For instance, in his correspondence with Gontier Col (letter 38), Jean de Montreuil describes a dream in which Terence appeared and told Jean to study his comedies, as Col and Pierre Mahac were doing. Jean also writes Col (letter 120) in 1400 or 1401 to tell him that he had read the *Roman de la Rose* at Col's suggestion and loved it. He writes an unknown correspondent (letter 90), to ask to borrow a Latin copy of Augustine's *City of God.*

Sometime between 1401 and 1403 Jean de Montreuil wrote a particularly rich series of letters involving rare texts procured from Italy. The first (letter 125) was a letter of introduction sent with Guillaume de Tigonville to a scholarly Italian friend, Jacopo, in which Jean asked what Jacopo had accomplished in the monastery of Cluny and reminded him to transcribe a manuscript of Plautus and to procure a manuscript of Cicero in Bologna. Shortly thereafter (letter 126) Jean thanked Jacopo for sending him the copy of Plautus. In a third letter (letter 157) Jean observed that one of his unknown correspondent's copyists had just transcribed a manuscript of Livy owned by Jean. Further, he informed that person that he had received rare works from Italy that were unavailable in France, even in a college; these included Cato's *Censorinus,* Varro's *De Agricultura,* Vitruvius's *De Architectura,* and Plautus. Jean offered to make them available to copy. Because Jean ended his letter by asking the addressee to help speed payment of two hundred francs reserved for him by the Duke of Berry, Ornato speculated that this letter may have gone to Martin Gouge, who had classical interests and was the duke's treasurer and counselor.[8]

François Avril suggested that two Latin manuscripts painted by Virgil Master illuminators around 1405 may be copies made after those mentioned in Jean de Montreuil's correspondence because they contain several of the rare texts that Jean procured. One combines Vitruvius's *De Architectura,* Cato's *De Rustica,* and Varro's *Res Rustica* (BML Plut. 30.10) and the second contains Plautus's *Comedies* (BnF Ms. lat. 7890).[9] Marie-Hélène Tesnière speculated that Jean de Montreuil could equally well have addressed this offer of access to Jacques Courau, treasurer and maître

d'hotel to Duke John of Berry, rather than to Martin Gouge.[10] Courau had given a French translation of Valerius Maximus painted by Virgil Master illuminators (BnF Ms. fr. 282) to John of Berry in January 1402. He also owned a Latin manuscript of Virgil's works transcribed by Pierre de l'Ormel in 1403 (BML Med. Palat. 69) that also was painted by Virgil Master illuminators. Since the same scribe and artists that produced Courau's Virgil manuscript wrote and decorated Plautus's *Comedies* (BnF Ms. lat. 7890), Tesnière suggests that Courau may have been the scholar whom Jean de Montreuil addressed.

While we will never know with certainty the identity of Jean de Montreuil's noble French reader with interest in classical texts, the precious survival of his letters gives insight into the moment in the early fifteenth century when early French humanists began to promote the classical heritage more broadly to the nobility and the powerful, perhaps in order to counter their ignorance or apathy. In the same letter that had offered the noble Frenchman access to rare classical texts, Jean de Montreuil expressed a wish that other nobles had been as interested as his correspondent in Livy and the other historiographers and authors because then a great portion of Livy and the works of other learned and venerable writers would not be lost. He wrote that talented literate men leaned toward pursuing active and earthly things in such a way that they scorn and reject contemplative things, which Virgil calls "noble leisure," with the result that modern men had no passion to pursue books from antiquity.[11] Jean referred at the end of the letter to his correspondent's shared pleasure in reading works that were among the oldest in Latin literature.

Two among the group of humanists in early fifteenth-century Paris—Laurent de Premierfait and Jean Lebègue—were deeply involved in the production of illuminated manuscripts designed to expand the nobility's cultural exposure to both Latin classics and contemporary Italian literature, thereby combating the phenomenon that Jean de Montreuil described. They are ideal candidates for exploring the complex relationship between the culture of humanist members of the French chancellery and manuscript illumination at the moment when classical texts were being transcribed and painted with an eye toward capturing the attention of new readers.

The elite audiences for books produced by Laurent and Lebègue differed from the clerics and scholars in Avignon and Paris who were the first French humanists. When Laurent and Lebègue broadened the circle of humanist readers to include Dukes John of Berry, Louis of Bourbon, John the Fearless of Burgundy, Louis of Orléans, Louis's sons Charles of Orléans and John of Angoulême, and possibly Dauphin Louis of Guyenne, they had to take into account the differing levels of Latin literacy of the princes of the blood. An anecdote from the memoirs of Bonaccorso Pitti offers some insight into the state of the French elite's grasp of Latin at the turn of the fifteenth century.[12] Pitti was sent on an embassy to Paris in 1397, during

which he met with King Charles VI and his council in the presence of the chancellor Arnaud de Corbie and other prelates. One of the Italians who accompanied Pitti gave an eloquent speech in Latin asking Charles VI to support the Florentines in their struggle against Milan. Pitti was astonished that the plea seemed to fall on deaf ears, even though the members of the council and other lords had asked for written copies of the discourse. After receiving nothing but vague responses for two months, he concluded that the chancellor and prelates in attendance understood the Latin speech but had not translated it fully for the others. He wrote that neither the king nor his dukes understood Latin, and that although the king's brother, Louis, Duke of Orléans, did, he probably did not help because it would have aided the Florentine cause and Louis was a partisan of the Duke of Milan. Having come to this realization, Pitti gave a French speech at a subsequent meeting with the king and his council in which he reiterated their request and reminded Charles VI of his prior promises for support. According to Pitti, once the Italians left the room, Charles reprimanded his chancellor and the others who had not fully translated the Latin speech. When the Italians returned, the French chancellor acknowledged that the king would live up to his promise to support the Florentines.

If Pitti's memoir is accurate, King Charles VI and the adult princes of the blood (with the exception of Louis of Orléans) did not comprehend complex Latin rhetoric, even in writing. It may be, however, that they were more literate than he thought if, like Louis of Orléans, they did not wish to support Florence against Milan. For instance, Laurent's description of Duke Louis of Bourbon's court in the prologue to his translation of Cicero's *De amicitia* suggests that Louis's court, like his brother-in-law Charles V's, was a bilingual or even trilingual environment: "And because your court and presence . . . for necessary and honest reasons attract many men of diverse social positions and from foreign countries, some of whom read and understand the French language and others Latin . . ." [Et pour ce que a vostre court et presence . . . accourent et surviennent tant pour necessaires et pour honnestes causes plusieurs hommes de divers estas et d'estranges pais, dont les aucuns lisent et entendent le langaige François et les autres le latin . . .].[13] Marie-Pierre Laffitte categorized the Latin books of law and of classical authors described in an inventory of 1474 as having belonged to Louis of Bourbon as "astonishing in an otherwise traditional aristocratic library" [détonnent dans une bibliothèque aristocratique par ailleurs traditionalle].[14] At the very least, princes of the blood must have had the sort of passive Latin literacy that would allow them to recite by rote the content of prayer books or function at the mass. However, even if they understood or could read medieval Latin, most would probably have needed help when faced with the Latin employed in classical texts, even those that were commonly used in the schools.[15]

This situation began to change in the younger generation, which included Louis's sons, Charles of Orléans and John of Angoulême, and possibly Louis of

Guyenne. In their youth, they had been given numerous books in Latin by their tutor and others.[16] A cluster of educational books used in the first decade of the fifteenth century by Nicolas Garbet, the tutor for the three sons of Louis of Orléans and Valentina Visconti, suggests how important facility in Latin was becoming in the education of young nobles. Three manuscripts are associated with Louis and Valentine's sons and with Garbet: Sallust's *Conspiracy of Catiline* (BnF Ms. lat. 9684) decorated with a frontispiece (fig. 1.1) representing Sallust was given to Louis of Orléans by Lebègue and subsequently used for study by his sons Charles of Orléans and John of Angoulême and annotated by them and their tutor; Sallust's *Jugurthine War* (BnF Ms. lat. 5747) was transcribed and annotated by Garbet and decorated with a frontispiece (fig. 1.2) that has been identified as the brothers Charles of Orléans, John of Angoulême, and Philip, Count of Vertus, speaking with a king, but more likely represents Sallust's King Micipsa interacting with his sons Adherbal and Hiempsal and nephew Jugurtha; and a copy of Terence's *Comedies* (BnF Ms. lat. 7917), transcribed and annotated by Garbet, belonged to Charles of Orléans.[17] Although this copy of the *Comedies* was never illustrated, it contained blank spaces for pictures at the beginning of each of Terence's six plays.

One of the striking features of these three textbooks is their visual difference from the densely illuminated, largely unannotated copies of Statius's *Thebaid* and *Achilleid* and Terence's *Comedies* supervised by Laurent de Premierfait, or the longer visual cycles that Lebègue developed after he finished cooperating on the Sallust for Louis of Orléans that later belonged to the Orléans princes. The textbooks belonging to the Orléans brothers resemble most closely contemporary scholarly books with single illustrations, such as the copies of Vitruvius's *De Architectura*, Cato's *De Rustica*, and Varro's *Res Rustica* (BML Plut. 30.10) and of Plautus's *Comedies* (BnF Ms. lat. 7890) that may have been copied after books sent to Jean de Montreuil (figs. 1.3–1.4), or a Latin copy of Valerius Maximus (BnF Ms. lat. 6147) belonging to Jean Courtecuisse (fig. 1.5) that was written by Monfaut, the same scribe who worked with Lebègue.[18]

Unlike Italian and French humanist manuscripts or schoolbooks like those given to the Orléans brothers, the elite illustrated subset of manuscripts made with the collaboration of humanists for French courtly patrons or audiences in the early fifteenth century are densely illuminated. Classical Latin texts, French translations of ancient Latin texts, and translations of contemporary Italian classics, such as Giovanni Boccaccio's *De casibus* and *Decameron* or Leonardo Bruni's completion of Livy, were given elaborate visual cycles. While the prominence and quality of illustrations in these French manuscripts have attracted attention, their pictures have rarely been studied systematically as components of humanist translation. This is surprising because Paris was a center not only for the translation but also the production and consumption of artistic products in the early fifteenth century.[19]

FIGURE 1.1. Sallust in his study. Gaius Sallustius Crispus, *Bellum Catilinarium*. BnF Ms. lat. 9684, fol. 1r. Photo: BnF.

FIGURE 1.2. King Micipsa speaks with Adherbal, Hiempsal, and Jugurtha. Gaius Sallustius Crispus, *Jugurthine War*, BnF Ms. lat. 5747, fol. 3r. Photo: BnF.

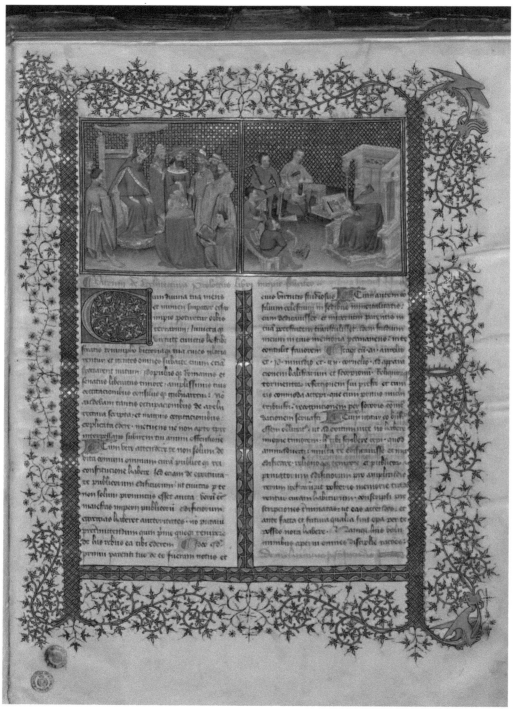

FIGURE 1.3. Vitruvius presents his book to the emperor; Vitruvius surrounded by artisans. Vitruvius, *De Architectura*; Cato, *De Rustica*; and Varro, *Res Rustica*, BML Plut. 30.10, fol. 1r. Reproduced with permission of MiBACT. Further reproduction by any means is prohibited.

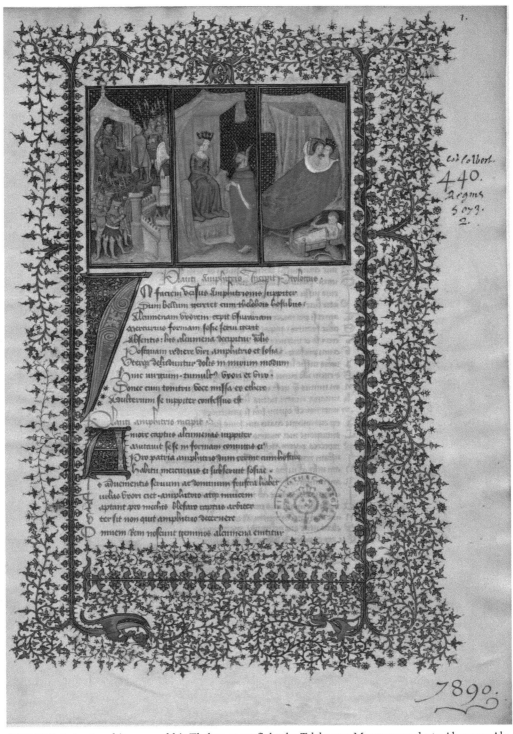

FIGURE 1.4. Amphitryon and his Theban army fight the Teleboans; Mercury speaks to Alcmena; Alcmena sleeps with Jupiter disguised as Amphitryon and the infant Hercules strangles snakes. Plautus, *Comedies*, BnF Ms. lat. 7890, fol. 1r. Photo: BnF.

I seek to fill this gap by studying the humanist book production closely super-vised by Laurent de Premierfait and Jean Lebègue for courtly audiences in the early fifteenth century. When these two men decided to collaborate with *libraires* in pro-ducing this elite illustrated subset of humanist manuscripts, they began to learn how powerful visual imagery could be in glossing and facilitating understanding of Latin texts. Indeed, in manuscripts overseen by these humanists for courtly patrons or even, in the case of Lebègue, for personal use, we can begin to identify the role of visual translation. A term first coined by Claire Sherman, visual translation resem-bles rhetorical amplification, the development of a simple phrase or description by the addition of details or images, a process frequently used by medieval translators.[20] Visual translation uses images to leap over cultural and chronological gaps, to en-rich the texts they accompany, and occasionally to introduce ideas and associations that are not in the text.

Laurent and Lebègue were ideal collaborators in the effort to bridge the gap between the humanist textual tradition and the expectations of noble readers be-cause both were directly involved in both the humanist milieu and in book produc-tion. Laurent de Premierfait is famous as a Latin poet, as translator of Cicero, Livy, Aristotle, and Boccaccio, and as a commentator on Statius and Terence. He was also an occasional clerk and secretary or *familier* (household member) to Amadeus of Saluces at Avignon; Jean Chanteprime, a counselor to the French king; Dukes Louis of Bourbon and John of Berry, both uncles to King Charles VI; Louis of Guyenne, heir to the French throne; and Bureau de Dammartin, a wealthy merchant who became treasurer of France. Laurent's intellectual gifts, political connections, and interest in book production distinguish him among the group of humanists and translators that flourished around the court and chancellery in Paris during the reign of the mad king Charles VI.[21]

Laurent was not well known for his interactions with book producers in Paris until Olivier Delsaux examined Laurent's interventions in manuscripts containing his authored texts and translations of Cicero and Boccaccio. His codicological and paleographical analysis revealed that Laurent worked with two scribes circa 1400 to 1418; they produced all the earliest surviving manuscripts of texts authored or translated by him.[22] Many of these are the earliest, or the only, densely illuminated examples of these texts to be made in northern Europe. While we do not yet know whether Laurent worked as his own *libraire* in producing any of these manuscripts or, as is probably more likely, collaborated with an established *libraire* in Paris, it is clear that the earliest copies of books associated with him share a sophisticated ap-proach to the layout of text and images that must be due in part to Laurent's role in their production.[23]

Jean Lebègue was an active collector and maker of books, working with Parisian authors, artists, and *libraires* during his long life.[24] Lebègue had a successful sixty-

FIGURE 1.5. Valerius Maximus presents his book to Emperor Tiberius. Valerius Maximus, *Factorum ac dictorum memorabilium libri IX*. BnF Ms. lat. 6147, fol. 2r. Photo: BnF.

year career in government, first as a notary and secretary in the royal chancellery and then from 1407 also as *greffier* (clerk) in the Chambre des comptes in the royal palace, a post that he held into the 1440s. As a copyist himself, Lebègue had a strong interest in book production and significant interest in both Parisian artists and those who arrived in Paris from Flanders and Italy. For example, in 1431 he copied a compilation of pigments from Flemish and Italian artists visiting Paris made by Giovanni Alcherio, and he oversaw the production of several illuminated manuscripts for his own collection and for the collections of others. As *greffier* of the Parliament of Paris, he was charged with verifying and completing inventories of the royal libraries in 1411 and 1413, which allowed him to review the rich illuminated holdings of the royal collection. He was involved from 1395 until the 1440s as a book collector and as an author of letters and of a translation into French of Bruni's account of the Punic Wars, which was thought to replace the lost decade of Livy.[25]

Lebègue was a reader and bibliophile who collected not only manuscripts of the classics, but also writings by contemporary humanists, such as Laurent de Premierfait.[26] He heavily annotated his own manuscripts in response to their texts, often with additional observations. For instance, in an autograph copy of Jean de Montreuil's letters, Lebègue annotated a mention of Laurent with a note recording his death in 1418 and his burial in the Cemetery of the Innocents in Paris (BnF Ms. lat. 13062, fol. 20r).[27] He also collected older, secondhand illuminated manuscripts, such as an early fourteenth-century *Faits des Romains* (BnF Ms. fr. 23083) that subsequently entered Charles of Anjou's collection in 1439, an early thirteenth-century southern French anthology of classical texts (BnF Ms. lat. 7936), or a copy of John of Salisbury's *Polycraticus* of circa 1380 to which he added an introductory illuminated quire (BnF Ms. lat. 6416).[28] While we know less about Lebègue's commissions than we do Laurent's, he did supervise a Latin copy of Sallust's *Conspiracy of Catiline* in the early fifteenth century, and from 1410 to 1435 he drafted descriptions of a fuller visual cycle for illustrating Sallust that were both derived from and employed to illustrate the *Conspiracy of Catiline* and the *Jugurthine War* in another manuscript (Geneva Ms. lat. 54).

This book examines how visual translation works in a series of unusually densely illuminated manuscripts associated with Laurent and Lebègue circa 1404 to 1430: Latin texts, such as Statius's *Thebaid* and *Achilleid*, Terence's *Comedies*, Sallust's *Conspiracy of Catiline* and *Jugurthine War*; and French translations of Cicero's *De senectute*, Boccaccio's *De casibus virorum illustrium* and *Decameron*, and Bruni's *De bello Punico primo*. Illuminations constitute a significant part of these manuscripts' interpretive apparatus, shaping access to and understanding of their texts by a French audience. Consideration of them as a group reveals Laurent's and Lebègue's growing understanding of visual rhetoric and its ability to visually translate texts originating in a culture removed in time or geography for medieval readers

who sought to understand them. It also offers insight into both shared and individual approaches to visualizing humanist texts.

In part one, chapters 2 and 3 analyze visual translation in the Latin manuscripts produced with Laurent de Premierfait and Jean Lebègue's participation. They track the pair's growing commitment to exploiting the visual arts as an active component of a humanistic visual translation in manuscripts of such Latin texts as Statius's *Thebaid* and *Achilleid*, Terence's *Comedies*, and Sallust's *Conspiracy of Catiline* and *Jugurthine War*. In part two, chapter 4 examines visual translation in texts translated by Laurent de Premierfait: first a bilingual edition of Cicero's *De senectute* and then translations of Boccaccio's *De casibus virorum illustrium* and *Decameron*. These manuscripts embody textual and visual translations that work together, complicating the process of translation. Finally, in part three, chapter 5 considers what happens when the visual cycles so carefully devised by Laurent and Lebègue, in collaboration with *libraires* and artists, escape their control in a process of normalization.

PART 1

Illustrating the Past in Latin Texts

Laurent de Premierfait's Involvement with Statius's *Thebaid* and *Achilleid* and Terence's *Comedies*

Statius's *Thebaid* and *Achilleid* were popular school texts by the end of the twelfth century, and by the thirteenth century Statius was recognized as one of four standard antique school poets.[1] Despite their importance in education and appeal to humanists, the Latin *Thebaid* and *Achilleid* do not appear in any surviving French royal or ducal inventories from the late fourteenth and early fifteenth centuries.[2] Instead, for stories of Thebes, the hero Achilles, or Troy, most French nobility consulted the French *Romans d'antiquités* or later texts such as the *Histoire ancienne jusqu'à César*, which were in their libraries.[3]

For instance, Duke John of Berry, the brother of the French king Charles V, was an avid collector of ancient history in French. His inventory records that he reimbursed Bureau de Dammartin in April 1402 for a manuscript of *Troye le grant* (BnF Ms. fr. 301) which Bureau had copied for him from a model borrowed from the royal library, where it was described as a *Histoire de Troye, d'Alixander et des Romains* (BL Ms. Royal 20 D I).[4] In July 1403 Martin Gouge, who later presented a Latin copy of Terence's *Comedies* to the duke, gave John a French *Istoire de Thebes et de Troye* that seems to have been another copy of the text in BnF Ms. fr. 301 under a different title.[5]

Terence's *Comedies* were equally popular as a school text, but illuminated copies were also lacking from royal and ducal French inventories until Gouge presented an illuminated manuscript of the text to John of Berry in 1408.[6] Nicolas Garbet, tutor

to Duke Louis of Orléans's sons, had transcribed and annotated a copy for them (BnF Ms. lat. 7917) in the first decade of the fifteenth century with blanks for miniatures at the beginning of each play, but they were never painted.[7]

The copies of Statius's *Achilleid* and *Thebaid* (BL Burney 257), made circa 1405 for an unknown patron, and of Terence's *Comedies* (BnF Ms. lat. 7907A), made circa 1407 and presented by Gouge to John of Berry in January 1408, were among the first densely illuminated Latin classical texts made expressly for fifteenth-century French courtly audiences. Both were supervised by a team that included Laurent de Premierfait, and both contained carefully arranged Latin texts, each with an apparatus designed to enhance its use by an audience that did not have as good a grasp of Latin as Laurent and other humanist scholars had. They were transcribed by the same scribe (Delsaux's Hand T) who worked for Laurent consistently in the early fifteenth century.[8] These manuscripts of Statius and Terence, produced with Laurent's cooperation, were daring attempts to broaden noble taste and introduce noble audiences to classical texts that dealt with the same stories they were reading in French medieval adaptations. Rather than appealing to university students or humanists, these new manuscripts were designed for readers accustomed to consuming luxurious manuscripts with rich illustrative cycles.

In both new manuscripts, the Latin texts are distinctly separate from their framing paratexts. BL Burney 257 is a particularly clean copy of Statius because it lacks both marginal and interlinear commentary. In this manuscript an original compendium by Laurent (an introduction to Statius's text on fols. 2r–4v) and capital periochae (prose summaries of chapters on fols. 210v–22v) by Laurent introduce and conclude the text of the *Thebaid*, which includes all but one of its *argumenta antiqua* (twelve-line poetic summaries).[9] An original accessus (discussion of the artist's life as it relates to the work on fol. 225r) and compendium (introduction to the text on fols. 225r–26r) by Laurent precede Statius's *Achilleid*.[10]

The accessus and compendia written by Laurent had limited circulation. The accessus and compendium to the *Thebaid* survive only in a handful of manuscripts; Jean Lebègue copied them in fifteenth-century additions to two earlier manuscripts that he owned, and they were also transcribed in a later fifteenth-century manuscript whose text was based on one of Lebègue's.[11] Only one manuscript belonging to Lebègue copied the compendium of the *Achilleid*, and its textual features suggested to Colette Jeudy and Yves-François Riou that Lebègue had copied it directly from BL Burney 257.[12]

In the slightly later manuscript of Terence's *Comedies*, framing materials include an elaborate frontispiece (fol. 2v) and a commentary by Laurent (fols. 143r–43v). Summaries of each individual scene from the six plays follow Laurent's commentary (fols. 143v–159r), so, as had happened in the manuscript of Statius, Terence's text is cleanly separated from the supplemental materials. Even the physical

structure of the quires in the manuscript of Terence isolates the plays from the frontispiece that appears without text in a quire of two folios at the beginning of the manuscript and from Laurent's commentary and the summaries that fill the last quire of the manuscript. Like his additions to Statius, Laurent's commentary on Terence did not circulate widely.[13]

Dense visual cycles of illumination are the major supplemental elements within these manuscripts of Statius and Terence. These embedded images are a distinctive part of the paratext that interacted with the added textual compendia and summaries to make the classical stories come alive for their new Parisian audiences. The illuminations mark chapters within Statius and scenes within Terence, enabling them to work with the summaries that follow the texts of Statius's *Thebaid* and Terence's plays in these manuscripts. The illuminations help readers find their way through the Latin text, working with the summaries that guide understanding of the text itself to bridge the gap between late antiquity and fifteenth-century France.

LAURENT DE PREMIERFAIT AND STATIUS'S *THEBAID* AND *ACHILLEID*

With 129 original illuminations, BL Burney 257 is the mostly densely illuminated copy of Statius to survive.[14] Its pictures, painted circa 1405 by artists working in the styles of the Bedford Trend, the Master of the *Ovide moralisé*, the Virgil Master, the *Cité des Dames* Master, and others, illustrate all but one of 118 chapters in the twelve books of the *Thebaid* and the five books of the *Achilleid* with great care.[15]

The *Thebaid* concentrates on the story of Odysseus's sons, Eteocles and Polynices, who were cursed when their father appealed to the gods to punish them. The gods listened and stirred up a civil war between the brothers and their allies. Battles between the Argive and Theban forces, fueled by divine intervention, fill the rest of the book, which ends with the brothers killing each other in single combat.

Illuminations in the *Thebaid* bear a complex relationship to their textual apparatus. Laurent's compendium, which precedes the text, offers a clear explanation of Oedipus's backstory from his youth until he was banished from Thebes by Creon, the brother of Jocasta. It provides the background to Oedipus's opening speech, which is illustrated by the first narrative illumination of the manuscript (fig. 2.1).[16] Laurent's other contribution to the textual apparatus is the chapter summaries for the *Thebaid* (on fols. 210v–22v) that follow the transcription of Statius's illuminated text.[17] Clearly labeled by book and chapter number, these outline the major actions of the chapters in one to three sentences of clear Latin prose that incorporate incipits to Statius's text, thereby encouraging readers to key these simple summaries to both the more complex chapters and their illuminations. These would enable a

FIGURE 2.1. Oedipus curses his sons Polynices and Eteocles. Publius Papinius Statius, *Thebais*, with the argumenta antiqua; *Achilleid*. BL Burney 257, fol. 6r. © The British Library Board.

reader who was less skilled in Latin than Laurent to both read the summary and study an illumination related to it before beginning to read Statius's Latin. In this the summaries act like rubrics, which are lacking in this manuscript.

The illuminations embedded in the text resemble Laurent's chapter summaries in their incorporation of textual details drawn from different sections of the chapter that make stories vivid; these provide a visual summary of important events described in the text. For instance, the illustration to *Thebaid* 9.570 (fig. 2.2) not only emphasizes the same two related events as the summary of the chapter on folio 218v, but also integrates details only available in the text itself.[18] Whereas the summary states that Atlanta had a horrible premonitory dream about her son and went to Diana to pray for his safety, the picture creates a strong visual memory for Statius's story by representing concrete details of the setting and of the content of the dream derived directly from Statius's text. This chapter describes Queen Atlanta's dream, in

FIGURE 2.2. Queen Atlanta's Dream; Queen Atlanta gives thanks to Diana. Publius Papinius Statius, *Thebais*, with the argumenta antiqua; *Achilleid*. BL Burney 257, fol. 150r. © The British Library Board.

which she approached an old oak tree in a grove near Diana's shrine in order to add a boar's head to the display of her trophies from battles and the hunt. As she neared the tree, she realized that it was dying; its leaves were falling and dripping blood. When Atlanta awakened from her dream, she hastened to the grove near "armed Diana's" shrine and rejoiced to see that the tree holding her trophies was still standing. She prayed to Diana to protect her son. The illuminator carefully represented details from both Atlanta's dream and her prayer at the shrine. At the left Atlanta holds a bow and arrows as she watches her handmaiden place a boar's head in a carefully rendered oak tree filled with pieces of armor. A few small branches with blood-covered leaves lie on the ground to either side of the tree, evoking the more frightening part of her dream. At right the queen kneels with her hands joined in prayer before Diana's shrine, and Diana, represented as a female statue atop a column, bends her head and raises her hand in response to the prayer. A reader who

had difficulty with Statius's Latin could read the summary and look at the vivid picture; together they would provide a structure through which to approach the text.

Because few illuminators read Latin, artists must have received directions, possibly from Laurent, about the subjects they should paint. In constructing these pictures, they adapted common workshop models that they had accumulated, which gave the antique stories a contemporary resonance. For instance, one of the two miniatures painted by the Virgil Master (fig. 2.3) employs models also used in a contemporary manuscript given to John of Berry circa 1405, Jean Creton's *Livre de la prinse et mort du roy Richart d'Angleterre* [*Book of the Capture and Death of King Richard II*] (BL Harley Ms. 1319).[19] A comparison of the positioning, scale, and rendering of horse and rider in scenes from these manuscripts or of the treatment of architecture within them (compare fig. 2.3 to figs. 2.4 and 2.5) reveals the use of shared models, but also differing levels of complexity of space and treatment of landscape. The Virgil Master illuminator may have simplified his treatment of space in the illuminations of the *Thebaid* to harmonize with images painted by other artists in the manuscript.

While individual artists drew on their stock of models to realize scenes, someone such as Laurent, who wrote the summaries and knew Roman culture and the Latin text of Statius well, must have suggested the subjects and iconography of

FIGURE 2.3. Polynices in exile. Publius Papinius Statius, *Thebais*, with the argumenta antiqua; *Achilleid*. BL Burney 257, fol. 11v. © The British Library Board.

FIGURE 2.4. Dukes of Exeter and Salisbury. Jean Creton, *La prise et mort du roi Richart*. BL Harley 1319, fol. 25r. © The British Library Board.

FIGURE 2.5. Richard II meets the Duke of Northumberland. Jean Creton, *La prise et mort du roi Richart*. BL Harley 1319, fol. 37v. © The British Library Board.

individual illuminations, which the artists then interpreted and visualized by drawing on fifteenth-century artistic conventions, as happened in the Virgil Master illuminators' representation of Mercury in the illustrations for both Plautus and Statius.

Sometimes artists drew on traditions of visual representation that were distinct from Statius to illustrate this manuscript. Both the Virgil Master illuminator and an artist working in the style of the Master of the *Ovide moralisé* (fols. 104r–105r) gave the god Mercury special emphasis that went beyond the details of his appearance that Statius provided when describing Mercury's reaction when Jupiter admonished him to take a message to Laius (*Thebaid* 1.303–308): "Atlas' grandson obeys his sire's words and hastily thereupon binds the winged sandals unto his ankles and with his wide hat covers his locks and tempers the stars. Then he thrust the wand into his right hand. . . ."[20] The artists' visual representations differ. In one of two illuminations contributed to the manuscript, the Virgil Master illuminator painted a scene (fig. 2.6) showing Juno kneeling before Jupiter at the council of the gods to mark the beginning of the speech in which she begged Jupiter to change his mind about stirring up war between Argos and Thebes (*Thebaid* 1.248). Juno and Jupiter

FIGURE 2.6. Juno kneels before Jupiter at the Council of the Gods. Publius Papinius Statius, *Thebais*, with the argumenta antiqua; *Achilleid*. BL Burney 257, fol. 10v. © The British Library Board.

appear as a king and queen, and the other gods, with the exception of Mercury, wear exotic eastern dress and turbans. Mercury alone is distinctive among these lesser gods, probably because Juno, Jupiter, Pluto, and he were the only ones mentioned, but not described, in Laurent's summary.[21] In the illumination Mercury has an animalistic face, green wings sprouting by his ears, human hands, and scale-like fur on his legs, feet, and head, and he holds a staff. This formulation recalls that used by the Virgil Master illuminator to illustrate Mercury in the central scene of the contemporary frontispiece to Plautus's *Comedies* (fig. 1.4), in which Mercury also has fur resembling scales on his hands and wings sprouting above his floppy canine ears.[22]

Mercury looks different in a sequential pair of miniatures (figs. 2.7–2.8) painted by the Master of the *Ovide moralisé* and placed between the *argumentum antiquuum* of book 7 and the beginning of its first chapter. This pair echoes the two moments emphasized in Laurent's summary as much as Statius's text.[23] The first shows Jupiter enthroned as a king holding a scepter topped by a black bird. He sends Mercury,

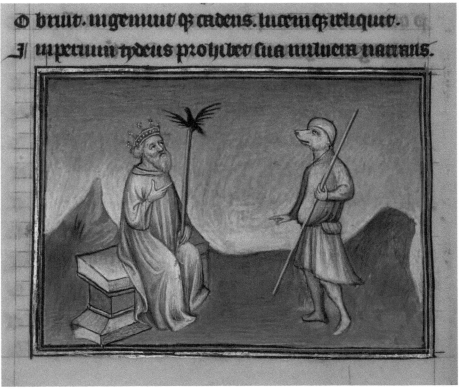

FIGURE 2.7. Jupiter sends Mercury to Mars. Publius Papinius Statius, *Thebais*, with the argumenta antiqua; *Achilleid*. BL Burney 257, fol. 104v. © The British Library Board.

FIGURE 2.8. Mercury delivers Jupiter's message to Mars. Publius Papinius Statius, *Thebais*, with the argumenta antiqua; *Achilleid*. BL Burney 257, fol. 105r. © The British Library Board.

who stands before him with a dog's head covered by a cap and holding a staff, to Mars. In the second illumination Mercury delivers Jupiter's message to Mars, who is shown as a heavily armed soldier leaning out the window of the temple of Mars, which resembles a residence or tavern. Statius mentions Mercury's staff, but not Jupiter's bird-topped scepter or Mercury's distinctive canine head. Instead, they may come from a source such as Pierre Bersuire's *Ovidius Moralizatus*, the fifteenth book of his *Reductorium Morale*.[24] There, Bersuire describes Jupiter as a king enthroned, and he includes eagles, along with the other attributes that distinguish him.

Among Mercury's many attributes, Bersuire describes his staff, the wings on his feet and head, a cap, and sometimes a dog's head: "His figure was according to Fulgentius and Rabanus (in his book on the nature of things) that of a man who had wings on his head and heels. In his hand he had a staff that had the power to put men to sleep. . . . Others as Rabanus says painted him with the head of a dog."[25] When faced with the problem of illustrating Jupiter and Mercury, the Virgil Master and the Master of the *Ovide moralisé* drew on models derived from different visual traditions.

Artistic conventions occasionally clash with the interest in clear narrative detail manifested by the illustrations of the *Thebaid*. For instance, a series of four images illustrates competitions in running, discus, boxing, and wrestling that King Adrastus of Thebes staged to prepare his forces for combat. Details in the first (fig. 2.9 [placed at *Thebaid* 6.550]) represent the four top finishers in a footrace and the prizes that King Adrastus awarded to them: the horse, shield, and quivers described at the end of the chapter (*Thebaid* 6. 644–45). The third miniature represents a moment in the

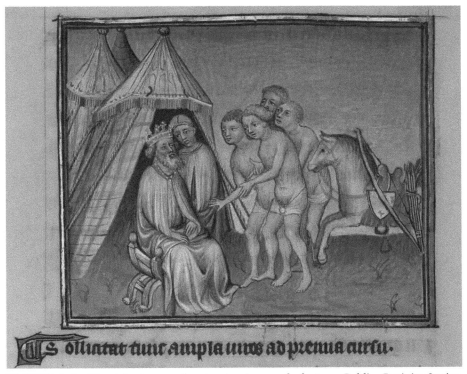

FIGURE 2.9. King Adrastus awards prizes to winners of a footrace. Publius Papinius Statius, *Thebais,* with the argumenta antiqua; *Achilleid*. BL Burney 257, fol. 96v. © The British Library Board.

boxing match between Capaneus and Alcidamas (fig. 2.10 [placed at *Thebaid* 6.729]) when Alcidamas wounds Capaneus's forehead and draws blood, an event described later in the text (*Thebaid* 6.780). When it becomes necessary to identify characters within an image via costume, artists often contradict the text in order to convey the protagonist's identity. Thus, the artist illuminating the wrestling competition between Tydeus, Adrastus's son-in-law, and Agylleus in the fourth miniature (fig. 2.11 [placed at *Thebaid* 6.834]) ignores the text's description of the competitors as naked; Tydeus's elongated sleeves and dagged hood affiliate him with the noble spectator behind him and distinguish him from his opponent, who, though a "son of Hercules," was defeated by Tydeus. The second image in the competition series (fig. 2.12 [placed at *Thebaid* 6.646]) shows how iconographic tradition can overwhelm textual specifics. The text describes a series of discus throwers, but the illuminator based the representation of the sport on medieval scenes of stoning, common in painted and sculpted representations of martyrdom, as for instance the Stoning of Saint Stephen from the south facade of the cathedral of Notre Dame in Paris (fig. 2.13).

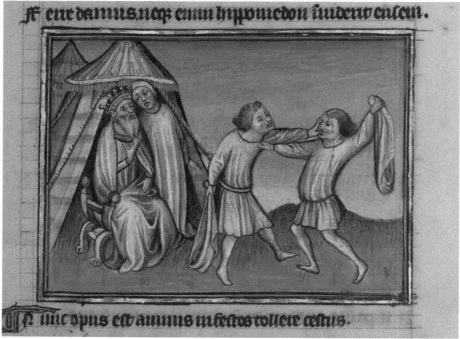

FIGURE 2.10. Alcidamas wounds Capaneus during a boxing match. Publius Papinius Statius, *Thebais*, with the argumenta antiqua; *Achilleid*. BL Burney 257, fol. 100r. © The British Library Board.

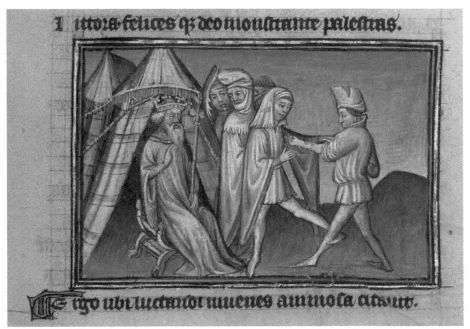

FIGURE 2.11. Wrestling competition between Tydeus, King Adrastus's son-in-law, and Agylleus. Publius Papinius Statius, *Thebais*, with the argumenta antiqua; *Achilleid*. BL Burney 257, fol. 102r. © The British Library Board.

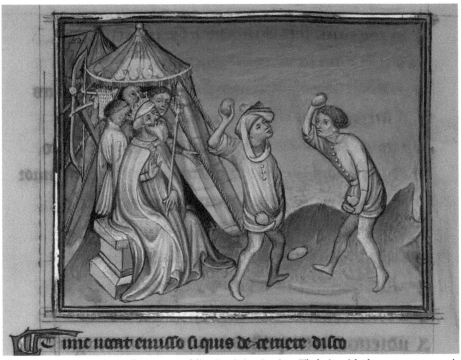

FIGURE. 2.12. Discus throwers. Publius Papinius Statius, *Thebais*, with the argumenta antiqua; *Achilleid*. BL Burney 257, fol. 98v. © The British Library Board.

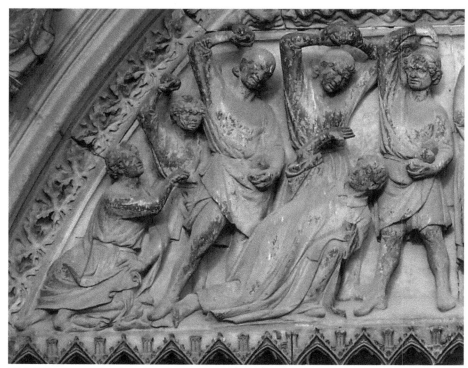

FIGURE 2.13. Stoning of Saint Stephen. Detail of south tympanum, Notre Dame, Paris. Photo: author.

In addition to contemporizing stories so that readers would better understand what a chapter addressed, illuminations eased the transition between chapters in order to enhance narrative flow. For instance, the picture placed at the beginning of *Thebaid* 11.193 (fig. 2.14) shows King Polynices outside the city wall, speaking to his kneeling wife, whose hands are clasped in prayer. Inside the city King Adrastus makes an offering at an altar whose flames flare to knock the crown from his head. Polynices' farewell is probably a reference to a statement he made towards the end of the previous chapter when he left to fight his brother Eteocles: "Farewell my wife and farewell dear Mycenae" (*Thebaid* 11.187), whereas the incident with Adrastus's crown is the result of the action taken by the Fury Tisiphone at the end of the chapter this image introduces. She diverted Adrastus's prayer for Polynices' safety so that it did not reach Jupiter, but instead went to the god of the underworld, who forced the flames to knock the crown from Adrastus's head (Thebaid 11.225).

Occasionally the book's designer called for double images that seem planned to draw special attention to important chapters. The first such important chapter (*Thebaid* 3.648–721) begins and ends with images that foreshadow the dire out-

FIGURE 2.14. King Polynices' farewell to his wife; King Adrastus makes an offering. Publius Papinius Statius, *Thebais*, with the argumenta antiqua; *Achilleid*. BL Burney 257, fol. 181r. © The British Library Board.

come of the Theban war. The first image (fig. 2.15) illustrates the first half of Laurent's summary of the chapter.[26] It draws attention to the folly of Capaneus, who urged Adrastus to wage war despite the warning that the seer Amphiaraus gave him after a reading of bad auspices. The second (fig. 2.16) illustrates the second half of Laurent's summary and represents Adrastus's daughter Argia, who also urged him to go to war. She showed her infant son to her father as part of her argument for him to send the Argive forces, led by her husband, Polynices, to wage war for Thebes. The second doubled image (see discussion above of figs. 2.7 and 2.8) illustrates *Thebaid* 7.1, in which Jupiter accomplishes what Capaneus and Argia could not. Outraged by the delay to the start of the war, he sends Mercury to Mars to have him incite the Argives to attack.

The image that opens the manuscript (fig. 2.17) functions differently than those that illustrate the narrative of the Theban war. Showing Statius presenting the book

FIGURE 2.15. Capaneus urges King Adrastus to wage war. Publius Papinius Statius, *Thebais*, with the argumenta antiqua; *Achilleid*. BL Burney 257, fol. 50v. © The British Library Board.

FIGURE 2.16. King Adrastus's daughter Argia urges him to go to war. Publius Papinius Statius, *Thebais*, with the argumenta antiqua; *Achilleid*. BL Burney 257, fol. 52r. © The British Library Board.

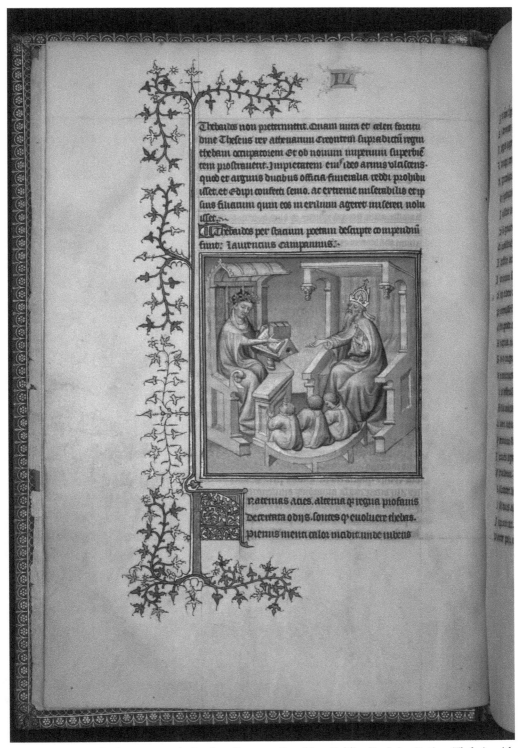

FIGURE 2.17. Statius presents the book to Emperor Domitian. Publius Papinius Statius, *Thebais*, with the argumenta antiqua; *Achilleid*. BL Burney 257, fol. 4v. © The British Library Board.

to Emperor Domitian in the presence of three young boys, the frontispiece serves as an overarching introduction to the manuscript as a whole.[27] Statius sits at left at a desk, a book open before him, as he extends a closed book with a bright red binding decorated with a delicate gold pattern toward the emperor. Domitian reaches to receive it. Statius, carefully represented as both a scholar and a poet, wears academic robes and a black calotte on his head, as was typical of scholars, and he looks down towards three youths, who may be students. However, the addition of a laurel wreath over Statius's calotte emphasizes that he is also a poet.

Domitian also wears layered headgear to express his Roman identity clearly through late medieval visual language. He wears a bishop's miter with dangling lappets under an imperial crown that is very like that used in representations of contemporary emperors or such medieval heroes as Charlemagne.[28] Inclusion of the bishop's miter shows a deeper knowledge of Roman practice as it was interpreted in the early fifteenth century. Beginning with Augustus and lasting until the late fourth century, Roman emperors held the title *pontifex maximus* to signal their religious function in addition to their secular one.[29] In contemporary translations, such as that of Valerius Maximus completed for John of Berry in 1402, *pontifex maximus* is translated as a very great bishop [un très grant evesque], which may explain why Domitian wears a combination of imperial crown and bishop's miter.[30]

Laurent's summary for the first chapter of the *Thebaid* describes the two goals the chapter outlines, the second of which suggests that the poet Statius gave Domitian the book to win his favor in hopes that the emperor would accept it and protect Statius from the envious.[31] This evocation of Statius's motivation probably explains why the initial scene in the *Thebaid* was a variation on a presentation scene that carefully blended medieval and classical references to the status of poet and emperor and that also referenced education, which was, of course, the context in which medieval manuscripts of Statius were experienced before this manuscript was made.

The images illustrating the five books of the *Achilleid* are less complex than those illustrating the *Thebaid*, which they followed, perhaps because they were designed to draw attention to some of the themes already raised by Laurent in his compendium.[32] The compendium's opening lines interlace the *Achilleid* with the *Thebaid*, reminding readers that Statius, author of the *Thebaid*, was rewarded with laurels and that Emperor Domitian, known as a persecutor of Christians, was also a lover of poetry under whom poetry flourished in Rome, as well as the patron to whom Statius gave the *Achilleid*. After this, Laurent's compendium includes a genealogical sketch that tracks Achilles' descent from Jupiter and mentions his son Pyrrhus, who captures Troy and kills Priam. Only then does it turn to a description of the text of the *Achilleid*. The compendium's short description of the poem mentions Queen Thetis's fears, after Paris ravished Helen, that the prophecy that her son would die at Troy would come true; Thetis's decision to disguise Achilles as a girl

and hide him among the female members of King Lycomedes' court; Achilles' exposure as a male to those at court once his love for Lycomedes' daughter Deimeda results in her pregnancy, the birth of Pyrrhus, and Achilles' marriage to Deimeda; Achilles' unmasking by Ulysses and Diomedes, who had been sent to look for him by King Agamemnon; and Achilles' departure with them to join the Greek forces at Troy. The compendium continues with descriptions of the deaths of Hector and Achilles, events that were not part of Statius's poem but that interlinked the *Achilleid* with popular narratives of the fall of Troy.

The illuminations for the *Achilleid* work with the compendium to unify the manuscript. For instance, its opening descriptions of the laureate Statius and the poetry-loving Domitian in Laurent's compendium are unillustrated, probably because this description emphasizes the visual characterizations of Statius and Domitian already developed in the image that opened the manuscript. The absence of an image at the beginning of the *Achilleid* allows the presentation on folio 4v to serve as an introduction to the whole. The seven subsequent images embedded in the *Achilleid* focus on the events that Laurent mentioned in his summary, and they begin and end with illuminations of Thetis contemplating ships at sea. In the first (fig. 2.18),

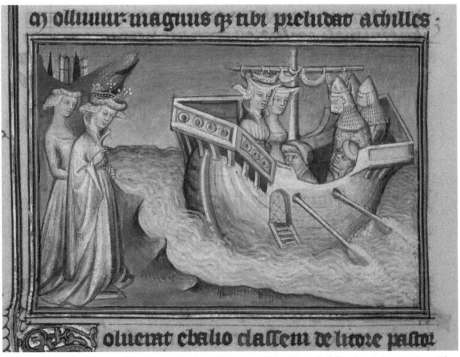

FIGURE 2.18. Queen Thetis sees Paris and Helen sail for Troy. Publius Papinius Statius, *Thebais*, with the argumenta antiqua; *Achilleid*. BL Burney 257, fol. 226v. © The British Library Board.

FIGURE 2.19. Queen Thetis sees Achilles sail with Ulysses and Diomedes to Troy. Publius Papinius Statius, *Thebais*, with the argumenta antiqua; *Achilleid*. BL Burney 257, fol. 245v. © The British Library Board.

she sees Paris and Helen sailing for Troy, the event that set her failed attempt to defy fate in motion, and in the last (fig. 2.19), she watches her son sail away with Ulysses and Diomedes to Troy. The images between show her efforts to hide Achilles and the Greeks' actions to find Achilles and take him away: Achilles is disguised as a girl and presented to Lycomedes (fols. 230r and 232r); and Agamemnon sends Ulysses and Diomedes, who then attempt to unmask Achilles (fols. 234, 239v, and 241r).

The manuscript of Statius integrated paratextual elements, such as chapter summaries and Laurent's compendia, designed to frame the Latin text of Statius's *Thebaid* and *Achilleid* in BL Burney 257 and guide the understanding of readers with a rudimentary grasp of Latin. At the same time, and in an even more radical departure, the manuscript embedded a dense cycle of illumination in Statius's Latin text designed to make the chapter summaries and chapters accessible to a fifteenth-century noble reader by visualizing past events within fifteenth-century frames of reference. This approach must have been deemed a success, for Laurent continued to hone his approach to visual translation a few years later when he worked in col-

laboration with the scribe Hand T and Master of Flavius Josephus and Orosius Master illuminators on illustrating the *Comedies* of Terence.

LAURENT DE PREMIERFAIT AND TERENCE'S *COMEDIES*

The illuminated Latin copy of the *Comedies* of Terence (BnF Ms. lat. 7907A) made in 1407 resembles BL Burney 257 in its distinct separation of the illuminated versified text of Terence from both Laurent's compendium and the summaries of each scene within the plays. Unlike the manuscript of Statius, we know the circumstances of production for this manuscript of Terence's comedies and how it entered the collection of Duke John of Berry, the bibliophile uncle of King Charles VI. The *Comedies* were presented to John of Berry as an *étrennes*—a New Year's gift—on January 1, 1408, by Martin Gouge, who had served the Duke of Berry from 1402, when he was named the duke's *trésorier général*.[33] Gouge continued as treasurer and counselor until John of Berry's death in 1416 while also moving in royal circles, where he worked in finance starting in 1403, acting as receiver of taxes in Poitiers, as one of four *généraux sur les finance des aides* from about 1404 until 1409, and, subsequently, serving in the governments of Charles VI and Charles VII, for whom he became chancellor of France in 1422.

Laurent de Premierfait and Martin Gouge were probably associated both through their service to John of Berry and through shared humanist interests, which included Terence. They were certainly well known to each other when Gouge presented the Terence on which Laurent collaborated to the duke in 1408, and their relationship continued at least through 1409 or 1410, when Laurent completed his translation of Boccaccio's *De casibus virorum illustrium*, the *Des cas des nobles hommes et femmes*, for John of Berry. Gouge presented the first manuscript of the *De cas* to John at *étrennes* in 1411.[34]

Terence was popular in the circle of Parisian humanists in which Gouge and Laurent moved. Bozzolo cites letters written sometime before 1407 by Jean de Montreuil that offer evidence for Terence's reception in Parisian humanist circles.[35] One letter (letter 147) accompanied a manuscript of Terence that Jean de Montreuil sent to an unnamed correspondent who had attended a public reading and discussion of the author; Jean suggested that reading Terence along with Virgil would contribute to his correspondent's understanding of rhetoric. In a second letter (letter 165) addressed to a friend of Gontier Col, Jean asked that he read Terence and other antique authors in order to research and compile rudiments of rhetoric for Jean that would go beyond both generalities and reliance on Cicero. This level of interest in Terence

was probably the reason why Gouge, who himself owned a copy of the text (the unillustrated eleventh- to thirteenth-century manuscript BnF Ms. lat. 7902), set Laurent to work to produce the first surviving illuminated manuscript of Terence to be made since the twelfth century.

In preparing this volume of plays, Laurent radically rethought the traditional mise-en-page of Terence, which he could have known from a Carolingian copy like that kept in the library of the Abbey of Saint-Denis outside Paris from at least the thirteenth to the fifteenth centuries (BnF Ms. lat. 7899).[36] He also worked with Flavius Josephus and Orosius Master illuminators, doubtless through the mediation of a *libraire*, to translate images from the earlier tradition into a fifteenth-century visual idiom. The relationships and differences between text and image of the fifteenth-century manuscript and its likely Carolingian model are telling because they reveal aspects of Laurent's perceptions of the need for cultural translation and his desire to use visual images to further it.

This Latin manuscript of Terence's *Comedies* was produced in the same spirit as Statius's *Thebaid* and *Achilleid*. The *Comedies* incorporates textual and purely visual features that I believe Laurent devised, which recall those that he experimented with in his translation of Cicero from Latin into French circa 1405, to be discussed in chapter 3. As in that and his illuminated Statius, his additions to Terence accomplish a cultural translation between Terence's Rome and John of Berry's France through mise-en-page and illustration. The design for John of Berry's Terence established a distinction between the framing materials, which include the full-page frontispiece at the manuscript's beginning and summaries of the plays at its end, and the text of Terence's plays, which are carefully written in verse. Like the earlier manuscript of Statius produced with Laurent's cooperation, the text of Terence was adorned by very few of the scholia (interlinear commentaries) or marginal glosses that characterize other medieval copies of the text.[37] In place of these traditional textual annotations, this manuscript incorporates a frontispiece and 142 illuminations placed at the beginning of scenes within the comedies. These represent the characters who speak in each scene within a simplified setting of one or two schematic houses.

It seems that Laurent sought to present the text freshly to John of Berry. He recognized the distinct differences between past text (Terence) and present fifteenth-century readers as he had done previously in the text and image of Statius's *Thebaid* and *Achilleid*. Laurent added distinct visual and textual supplements to frame the sections of the book that contain Terence's *Comedies* proper. Seventeen of the twenty-one quires that formed the units of this manuscript were quaternions of eight folios that contained the text of Terence's *Comedies*. This pattern is broken only at the very beginning and the very end of this collection. A small quire of two folios at the beginning contains no text and an unusual and new prefatory image.

The last play ends in quire nineteen, a short quire of four folios, in order to allow the final two quires to contain Laurent's commentary and traditional Latin summaries of individual scenes from the plays. This practice of separating Laurent's additions from the original Latin text was already a feature of the manuscript of Statius made circa 1405, and the physical separation of texts within quires in the Terence also happened in Laurent's translation of Cicero's *De senectute,* presented to Duke Louis of Bourbon in 1405.[38] What is new in this manuscript of Terence is the way that the isolation of the frontispiece without text in its own quire in the book's structure suggests that this particular illumination was thought of as a visual commentary, the equivalent to the commentaries and summaries that fill the quires which end the manuscript.

Laurent's visual and textual frames contextualize Terence. His original textual contribution, the commentary on folios 143r–43v, does three things.[39] First, it provides a short biographical note on Terence and emphasizes his superiority over other playwrights. Second, it specifies that the contents of the six comedies are summarized in *argumenta* and prologues that begin each play, and it gives the first play, *The Woman of Andros*, as an example, quoting the opening words of its *argumentum* and prologue. Then Laurent explains that Terence wrote his plays and had their prologues read aloud by Calliopius "according to the laws of comedy" in which an author always had another speak. Finally, Laurent emphasizes that individual scenes are connected to each other, as the chapter headings and titles announce and the colophons reiterate. The rest of the manuscript (fols. 144r–59r) is filled with Latin summaries of the prologues and of each scene in all six plays, which are cross-referenced to the scenes themselves by citations of the scenes' incipits.

Laurent's commentary relates to the images that illustrate the manuscript, most notably to the frontispiece painted by a Flavius Josephus Master illuminator, which reflects both Laurent's historical recreation of the setting of Roman theater and his preoccupation with clarifying exactly who Calliopius was.[40] Calliopius's identity is not addressed in other medieval manuscripts of the Calliopian recension of Terence, including the Carolingian manuscript at Saint-Denis. In these manuscripts, the evidence for Calliopius's existence is contained in three notes: "Feliciter calliopio" [Successfully Calliopius] is on their title pages; "calliopus recensuit" [Calliopius reviewed] appears at the end of each play; and "feliciter Calliopio bono scholastico" [Successfully Calliopius, good scholar] is written after the final colophon.[41] On the basis of these notes, David Wright suggested that Calliopius was a late antique scribe who used insertions like these to advertise his skills, and that medieval scribes copied the inscriptions to signal the quality of their text.

After puzzling through the evidence, Laurent came to a different conclusion and transformed Calliopius into a public reader.[42] While most of the plays in

Terence's section of the manuscript end with the traditional "calliopus recensuit," the plot summaries in Laurent's final section describe him in different terms.[43] In the summary of the prologue to the first play, as mentioned above, Laurent described Calliopius as reading Terence's prologues aloud or publicly.[44] The summary of each subsequent prologue reiterates that Terence wrote the plays and that Calliopus then read the prologue aloud. One even mentions that he read aloud in the *scena*.[45]

The unusual frontispiece (fig. 2.20) to John of Berry's manuscript of Terence reinvents the late antique and Carolingian visual traditions and clarifies Calliopius's role. Laurent worked with a Flavius Josephus Master illuminator to translate the Carolingian images into a fifteenth-century visual vocabulary. Laurent served as a mediator because the artists did not have access to the Carolingian model. The similarities and differences between the text and illustration of the fifteenth-century manuscript and its Carolingian model are revealing, for they show Laurent's growing understanding of the necessity of cultural translation and his desire to collaborate with artists to develop it. There is a strong distinction between the content of the isolated frontispiece and the illustrations embedded in the plays. Whereas the frontispiece seems to be the result of literary research by Laurent, the illustrations of the plays offer insight into the visual rhetoric of fashion practiced by artists.[46]

In place of three distinct images of the author, a display of masks, and a masked speaker of the prologue (figs. 2.21 to 2.23) characteristic of late antique and Carolingian illuminated manuscripts of Terence, the frontispiece to John of Berry's Terence substitutes an image that introduces the author and reader while establishing a historical context for the duke.[47] This new frontispiece represents Laurent's understanding of a Roman theater's appearance and identifies the scribe Calliopius as Terence's reader. Unfolding from bottom to top, the frontispiece shows the author Terence seated on a faldstool, wearing a hooded robe and the scholarly black calotte on his head as he presents his book to a bearded, bareheaded man in blue who stands before Terence alongside a richly dressed man. Terence's identity is clear from the label *terencius*, and the location of Rome is specified by the inscription *civitas Romana* on the city wall at the bottom of the miniature. While the identity of the richly dressed man remains a mystery, careful examination of the upper half of the miniature reveals that there, the anonymous man in blue appears again, but this time he is labeled *calliopius*. He reads within the white-curtained *scena* placed at the center of the circular theater labeled *teatrum*. A masked actor emerges from the *scena*, and three others, labeled *gesticulatores*, cavort in the foreground before the *scena* to the music of two medieval instruments: a trumpet and shawm.[48] The actors are represented with such care that the ties holding their colorful masks on their heads are visible. Mature male Romans filling the theater are categorized as *populus Romanus*

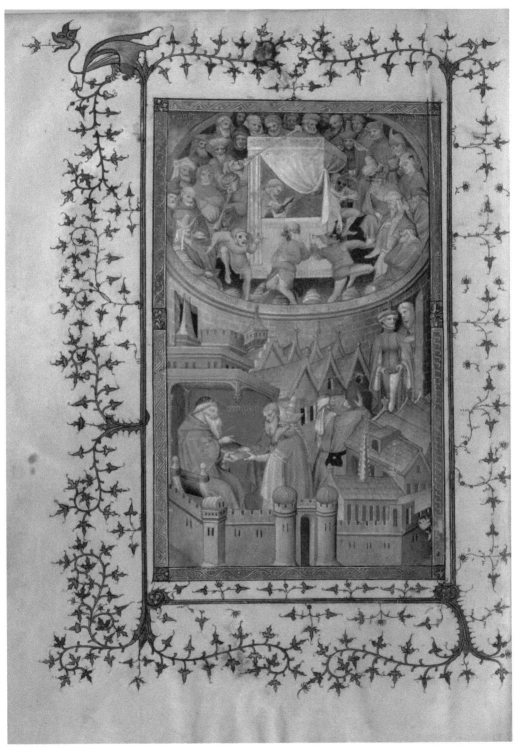

FIGURE 2.20. Frontispiece. Publius Terentius Afer, *Comediae*. BnF Ms. lat. 7907A, fol. 2v. Photo: BnF.

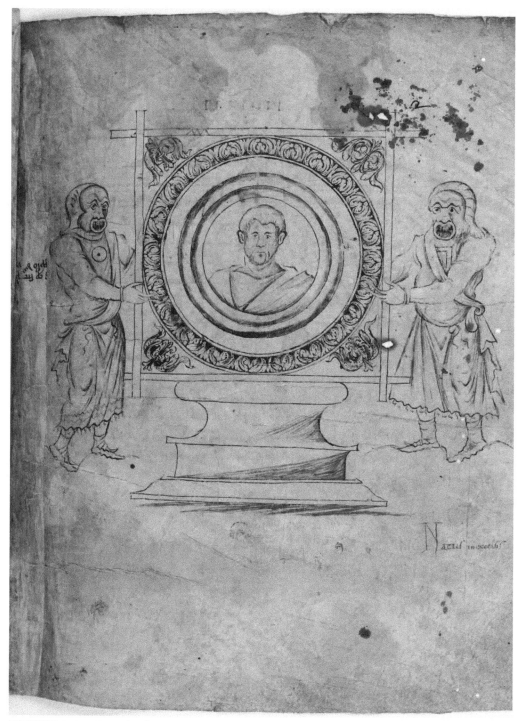

FIGURE 2.21. Portrait of Terence. Publius Terentius Afer, *Comedies*. BnF Ms. lat. 7899, fol. 2r. Photo: BnF.

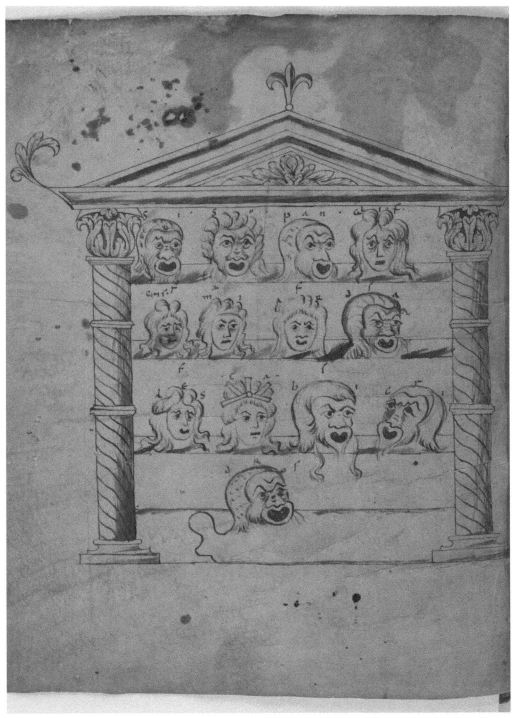

FIGURE 2.22. Masks for *Woman of Andros*. Publius Terentius Afer, *Comedies*. BnF Ms. lat. 7899, fol. 2v. Photo: BnF.

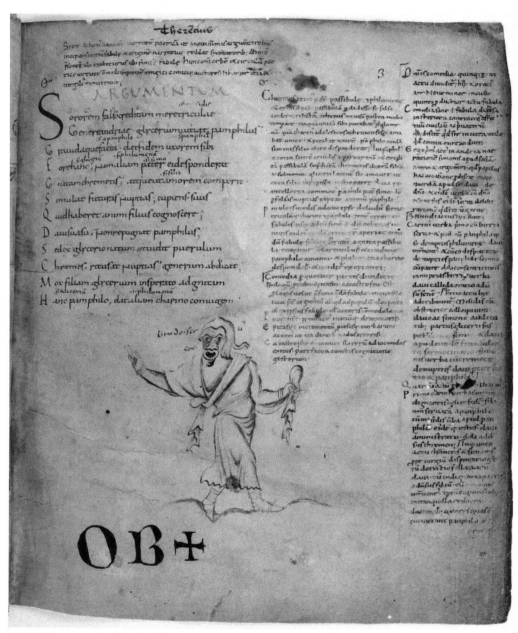

FIGURE 2.23. Declaiming the Argumentum. Publius Terentius Afer, *Comedies*. BnF Ms. lat. 7899, fol. 3r. Photo: BnF.

and *Romani* by labels on the top of the theater and in the sky above it. Romans moving along the road that connects the site of presentation to the theater hail an unidentified dandy who stands in the street outside the theater.

Classical texts and medieval commentaries that Laurent knew well, such as Valerius Maximus, Livy, Isidore of Seville, or Raoul de Presles's translation of Augustine's *City of God,* offered contradictory evidence about the shape and appearance of Roman theaters, and Millard Meiss suggested that the visualization of the theater's appearance in this Terence manuscript could easily have come from one of these antique authors.[49] Laurent worked with his artist, doubtless through the intermediary of a *libraire*, and the artist used as a starting point a composition employed by the Orosius Master to illustrate Raoul de Presles's extensive glosses to his translation of Augustine's *City of God* (Philadelphia 1945-65-1), a manuscript purchased for John of Berry's collection in 1405 or 1406 and painted by some of the same artists who worked on the Terence.[50] Meiss drew parallels between the Terence frontispiece

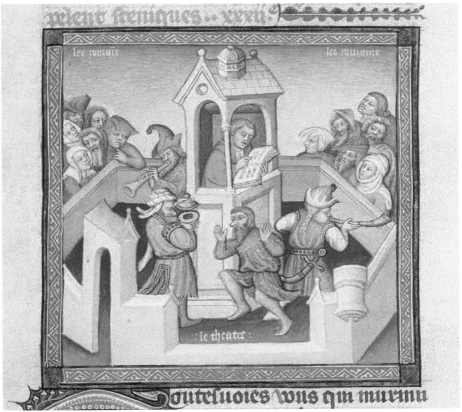

FIGURE 2.24. The Roman theater. Augustine, *Cité de Dieu*, translation by Raoul de Presles. Philadelphia 1945-65-1, fol. 26r. ©2019 Philadelphia Museum of Art.

and the visualization of a theater (fig. 2.24) in this *Cité de Dieu* that illustrated Raoul's added exposition of Valerius's book 1, chapter 31, placed just above the image. The exposition concerned the Roman argument that the elimination of rivalry with Carthage and the influence of Greek theater would contribute to a decline in morals among the Romans. In his exposition Raoul quotes from the *Etymologiae* of Isidore of Seville, from Orosius, from Livy, and from Valerius Maximus, and many of his sources describe features of the theater that were represented in both John de Berry's *Cité de Dieu* in 1405 or 1406 and in his Terence in 1407 or 1408, most notably, the centrality of the *scena*. The differences in the Terence manuscript—the pure roundness of its theater, the identification of Calliopius as the reader in the *scena*, and the *scena* itself, with its softly draped curtains—show input from someone, likely Laurent himself, who did additional textual research to find further information about Roman theater, and who carefully prescribed the labels that are the only text accompanying the frontispiece in its quire.

While Laurent may have consulted the *Cité de Dieu* in John of Berry's collection, he also seems to have gone back to Raoul's cited sources to complete research on the appearance of the theater. At the very least he consulted Isidore of Seville's description, and he seems to have studied the newly completed French translation of Valerius Maximus, which had been presented to John of Berry at *étrennes* in 1402.[51] In Isidore's *Etymologies* Laurent would have found a passage that Raoul did not incorporate into his gloss on Augustine. Isidore wrote that a theater's "shape was originally round like an amphitheater, but afterwards, from half an amphitheater, it became a theater."[52] Bozzolo was the first to show that Laurent believed that Roman theaters were round; she noted that he describes them in this way in an amplification to his translation of Cicero's *De amicitia*, begun for Louis of Bourbon around 1405 or 1406 and completed for John of Berry circa 1416. Laurent described a play about Orestes recounted in the middle of a circular theater with Roman people seated around it.[53]

The curtains surrounding Calliopius as he reads in the *scena* may reflect further research. It seems likely that Laurent consulted the commentary tradition on Terence, so ably studied by Mary Marshall and Marianne Pade, who find numerous authors who describe the curtain as providing shade and sheltering the person who recites the play, and still others who describe musicians and mimes who act out the actions.[54] One of the most pertinent authors for understanding the visual formulation of the theater in the frontispiece to Terence is Nicolas Trevet, whose early fourteenth-century commentaries on Livy and on Seneca describe the *scena*. Trevet's commentary on Livy, which Laurent would mine just a few years later in his revision of Bersuire's translation of Livy, described the *scena* as "a little house in the midst of the theater in which tragic and comic actors sang, and actors and mimes danced," and his commentary on Seneca's plays describes it "as a little shelter in the

midst of the semicircular theater, with a pulpit upon which the poet pronounced the words, while the mimes in the space outside mutely illustrated the verses by appropriate physical actions."[55] Laurent resolved what he thought the *scena* was and had it incorporated into the frontispiece miniature before he integrated it into the later, expanded version of his commentary on Terence that is preserved in BnF Ms. lat. 7907. There, he added a description: "And one can thus call *scena* a covered space closed with a curtain from which emerge the characters who 'speak' by mimicking the voice of the reciter."[56] It is striking how close Laurent's later description is to the innovative *scena* first visualized in the frontispiece for John of Berry's Terence.

Laurent, or his collaborating artists, also mined everyday experience to heighten the immediacy of the frontispiece and used costume to emphasize the pastness of the Romans. For instance, the musicians in the Terence illumination play the fifteenth-century instruments (shawm and trumpet) typically used to play *alta musica* (loud music), the kind of outdoor music that fifteenth-century towns and courts required for processions or ceremonies.[57] Similarly, the dancing done by the masked figures involves the kinds of high kicks, bodily distortions, and grotesque whirling motions that were characteristic of the period, employed for instance in the dance known as the *moresca*, seen in later sculptures (figs. 2.25 and 2.26) carved by

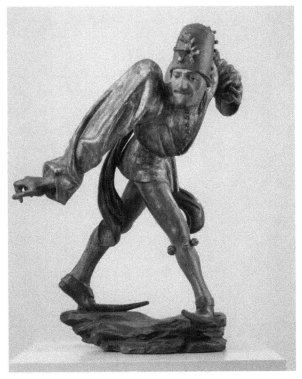

FIGURE 2.25.
Erasmus Grasser, moresca dancer: Burgunder. Munich, Stadtmuseum. Photo: Münchner Stadtmuseum, Sammlung Angewandte Kunst.

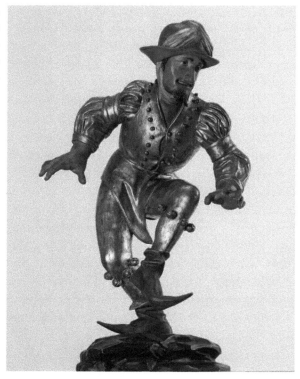

Erasmus Grasser for the Renaissance town hall in Munich.[58] The combination of loud music, reading, and lewd pantomime (the foremost dancer in pink almost exposes himself) in the frontispiece elicits an uneasy response from the mature, exclusively male, Roman audience. They watch with crossed hands, crossed arms, or a hand thoughtfully placed on the chin. Even the sponsor, the man with the gold-and-white hat to the right of the *scena*, puts his arm around the shoulder of a companion, who points at the players who burst upon him.

While Laurent may have devised the prefatory miniature's iconographic innovation for his collaborators in the book trade by drawing on new research in texts, he also seems to have learned from them how to exploit contemporary artists' understanding of the rhetoric of costume. The youth outside the theater is a striking case of this. Unlabeled, he is the only figure in the frontispiece folio to be dressed fashionably in late fourteenth- or early fifteenth-century attire, a short, belted tunic with elaborately full sleeves, a belt riding low on his hips, bicolor hose, and a cap with a feather. His clothing is distinctly different from the longer, less form-fitting dress of the mature male *populus Romanus* who fill the theater, and who often are rendered in exotic clothes—full, loose robes occasionally marked at the shoulders by horizontal bands, decidedly eastern hats, and even an occasional pigtail.[59] Diverse

artists in early fifteenth-century Paris employed this kind of exotic dress and orientalizing headgear, which they had observed in embassies from Constantinople to Paris and other contacts with the East. However, they used it selectively, not so much to indicate someone from the eastern Mediterranean as to indicate people removed in time, in this case, the Romans.[60]

The youth's dress does not draw on this orientalizing tradition. Its connotation remains mysterious until later in the manuscript, where (as we will see shortly) figures devised by artists to represent lowlifes, parasites, or soldiers wear comparably extravagant fifteenth-century dress. Who is he? What's happening to him? Is he being turned away at the theater door? Given the age of the Romans inside the theater, might he be too young and susceptible to be exposed to theater? The image does not provide answers, but the juxtaposition of this young man out in the street with the lewd figures, excessive gesture, and loud music onstage and the ambiguous reactions of an exclusively masculine audience sets a tone of wariness about Terence's plays that might have been designed to encourage John of Berry to ask questions of Gouge or of Laurent himself.

It may be that the clothes of this dandy outside the theater allude to the moral corruption that Livy and Augustine, and their French translators feared would result from the establishment of theater in Rome. Illustrators of early printed copies of Terence referenced this association more explicitly by representing men consorting with prostitutes outside the theater, in response to the sentiment voiced by Isidore, among others, "But indeed a theater is the same as a brothel (*prostibulum*), because when the plays are finished prostitutes 'stretch themselves out' (*prostrari*) there."[61]

After this exotic frontispiece, with its carefully researched image recreating a Roman theater, the visual rhetoric shifts to dissolve the difference between past and present and to make the plays come alive for fifteenth-century viewers. Laurent, with his collaborating *libraire* and artists, transformed the label, mask, gesture, and costume that identified characters in late antique Terence manuscripts and their Carolingian copies into a fifteenth-century visual rhetoric centered on dress that its Flavius Josephus and Orosius Master illuminators then brought to life.[62] These images present a view of Terence that Laurent wrote about circa 1414 in his translation of Boccaccio's *Decameron*, describing Terence's universality and the plays as "a fiction that offered common people fables that represent the true mirror and form of all human life" [fables representans le vray miroer et la forme de toute vie humaine].[63]

As in the manuscript of Statius, the summaries of the individual scenes of Terence's plays, placed on folios 143v through 159r after Laurent's commentary, complement the images that illustrate the scenes by referring to the context or content of the words that pass between the characters who are represented. In this they reinforce Laurent's assertion in his compendium that individual scenes are connected

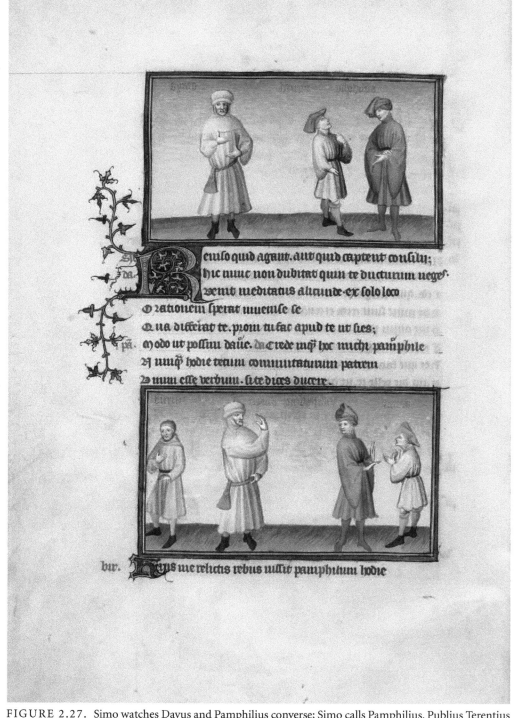

FIGURE 2.27. Simo watches Davus and Pamphilius converse; Simo calls Pamphilius. Publius Terentius Afer, *Comedies.* BnF Ms. lat. 7907A, fol. 11v. Photo: BnF.

to each other. For instance, the miniature for the very short act 2, scene 4 of *The Woman of Andros* (fig. 2.27) shows Simo standing at the left, looking out of the illumination and gesturing toward his slave Davus and son Pamphilius, who converse.[64] In the very short eight-line scene below this picture Simo says to himself that he is there to determine what the two men are planning, Davus warns Pamphilius that Simo has come to convince him to marry and tells him to keep his wits about him, Pamphilius says that he hopes he can, and Davus reassures him that if he agrees to marry, he will surprise his father, who will have nothing to say in response. The summary complements these thoughts and external conversations by reminding the reader that Davus, who scurried about in previous scenes, is a central figure. After reporting that Davus spots Simo, it turns to what Simo is thinking; Simo knows that Davus reports to his son and will encourage Pamphilius not to marry the woman Simo wants him to wed.[65] This summary, and others like it, reminds readers to integrate this scene with the scenes that precede and follow it, in which Davus gradually decides to get involved in order to help Pamphilius marry the woman he loves. These summaries differ from those in the manuscript of Statius, which had helped to guide readers' attention to key moments of a complex narrative. The narrative of Terence is not as complex because it consists exclusively of dialogue.

The artists who painted the "true mirror and form of all human life" in the illustration of the scenes in this manuscript did not see the Carolingian model that doubtless inspired Laurent. They worked instead from written directions that now are visible through the paint under ultraviolet light in one quire of the manuscript; those that still are legible dictate what should be represented by a single word describing the profession or social role of the figure or identifying a building type: *la mere, le frere, l'advocat, le paisant, valet, chambrière, maison* [mother, brother, lawyer, peasant, valet, maid, house].[66] Dress is the primary means by which artists characterized the figures. The costumes that artists painted in response to these French directions are carefully keyed to social role and completely fifteenth century. For example, all matrons (fig. 2.28) wear simple robes with relatively high (even covered) necklines, sleeves with simple extensions, if any, and the tailed, open-fronted hoods of nonaristocratic women, whereas prostitutes (fig. 2.29) wear dresses with necklines that plunge further, open-fronted hoods that have wider brims, longer and even more elaborate sleeves, or brightly colored red dresses.[67]

This consistency of characterization by dress is broken only in a few cases. For instance, Meiss observes that such Latin labels as *senex* (old man) or *adulescens* (youth) recorded in the red rubrics are not always duplicated by the French directions that survive.[68] He offers the example of Micio and Demea in *The Brothers*. These brothers are both old men, and are labeled as such by the scattered Latin

FIGURE 2.28. Representations of matrons. Publius Terentius Afer, *Comedies*. BnF Ms. lat. 7907A. Top row, left to right: a. fol. 63v (Sostrata), b. fol. 72r (Sostrata), c. fol. 72v (Sostrata); middle row, left to right: d. fol. 81r (Sostrata), e. fol. 81v (Sostrata), f. fol. 102r (Sostrata), g. fol. 111v (Sostrata); bottom row, left to right: h. fol. 104v (Myrrina), i. fol. 109v (Myrrina), j. fol. 135v (Nausistrata), k. fol. 140r (Nausistrata). Photo: BnF.

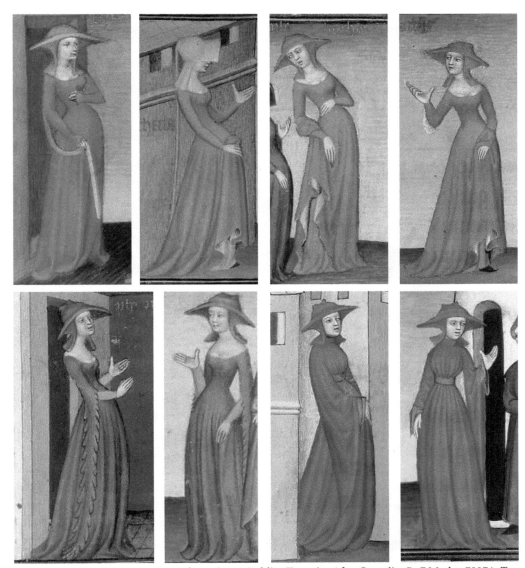

FIGURE 2.29. Representations of prostitutes. Publius Terentius Afer, *Comedies*. BnF Ms. lat. 7907A. Top row, left to right: a. fol. 27v (Thais), b. fol. 42v (Thais), c. fol. 58v (Bacchis), d. fol. 66r (Bacchis); Bottom row, left to right: e. fol. 99v (Philotis), f. fol. 100v (Philotis), g. fol. 114r (Bacchis), h. fol. 115r (Bacchis). Photo: BnF.

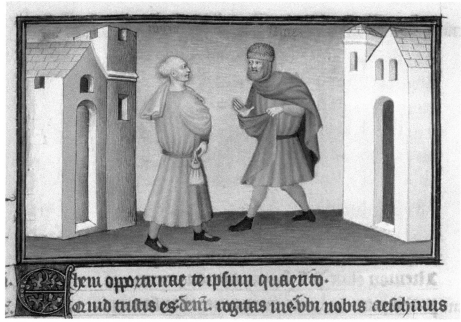

FIGURE 2.30. Micio and Demea meet. Publius Terentius Afer, *Comedies*. BnF Ms. lat. 7907A, fol. 76r. Photo: BnF.

rubrics to the play, as for example by the rubric "demea micio fraters et senes" [Demea, Micio brothers and old men] that appears at the bottom of fol. 75v, just before the miniature at the top of the next folio in which the brothers first appear together (fig. 2.30). Though both old men are described as such in the Latin rubrics, they are dressed differently from one another because French directions instructed the artist to represent Micio as *ladvocat* (the lawyer) and Demea as *le paisant* (the peasant). Meiss rightly suggests that the goal of this shift was to express something about the origins of the brothers because one lived in the city and the other in the country; Terence has Micio make the country/city distinction explicitly when he characterizes his brother and himself in the scene before they appear together: "I've pursued an easy going life of leisure in the city, and I've never had a wife, which they reckon is a blessing; he's lived in the country, choosing a life of thrift and hardship. He married and had two sons."[69] By following the French directions to artists and, possibly, occasionally more extensive verbal or written directions that do not survive, artists effectively translated the plays into French by communicating and nuancing social position and character through costume. They employed what might constitute a rhetoric of dress that is amazingly consistent and legible across the images of the manuscript, even when painted by different artists.

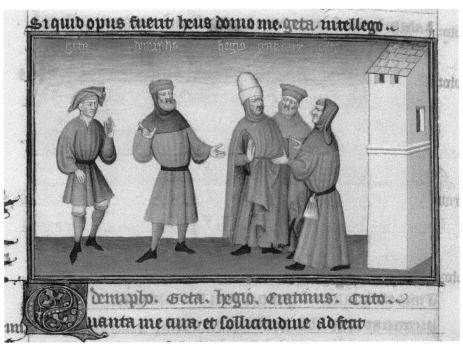

Siquid opus fuerit heus domo me geta intellego..

demipho. Geta. hegio. Cratinus. Crito

FIGURE 2.31. Geta, Demipho, Hegio, Caratinus, and Crito in conversation. Publius Terentius Afer, *Comedies*. BnF Ms. lat. 7907A, fol. 127v. Photo: BnF.

Dress makes all the plays come alive as late medieval slices of life. When Micio and Demea appear together, dressed differently despite their shared characterization in the Latin rubric as old men, readers would anticipate that the play will clarify the distinction and they might be more attentive to it. Micio's long robe with wide sleeves closed at the wrist, money purse, and hood duplicates the dress of the lawyer Crito (fig. 2.31), one of three lawyers to appear later in *Phormio*.

The variety of dress represented in figures 2.30 and 2.31 and in a scene from *The Woman of Andros* (fig. 2.32) conveys the nature of the generic types used by the artists to represent male characters in Terence's plays and the permissible variations within them. Recognizable types in these three images alone include old men (fig. 2.30 has Demea, fig. 2.31 Demphio, and fig. 2.32 Crito, Cresmes, and Simo), servants (fig. 2.31 shows Geta), a youth (fig. 2.32 has Pamphilius), and lawyers (fig. 2.31 has Hegio, Cratinus, and Crito). Servants such as Geta are shorter than other men, and they wear robes (in this case a shorter tunic possibly of a length and color that was out of fashion), hose often rolled down as they are here, and differently colored shoes. Old men almost always are shown with facial hair. They wear three-quarter-length robes belted low on the waist with sleeves closed around the wrists, often with

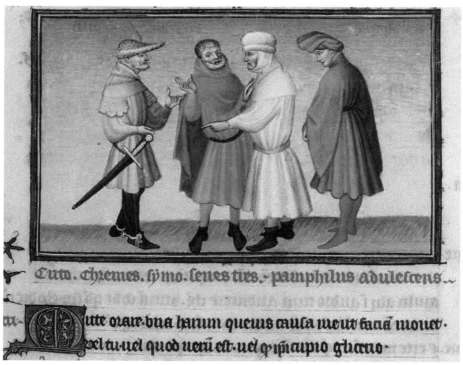

FIGURE 2.32. Crito, Cremes, Simo, and Pamphilius in conversation. Publius Terentius Afer, *Comedies*. BnF Ms. lat. 7907A, fol. 23r. Photo: BnF.

a mantle or hood covering or fragmenting the upper part of their torso. Sometimes they have props, such as purses, swords, hats, or hoods, which serve to distinguish them from each other. When old men's clothing is embellished with dagging, as in the scallops on Crito's grey robe in figure 2.32, it is restrained. Similarly, their hoods are either draped over one shoulder, worn covering head and ears, or left hanging down the back. In contrast, youths such as Pamphilius wear current high fashion: robes belted high and sweeping below the knee (midway in length between old men and the servants), usually with elaborate full and flowing sleeves unrestrained at the wrist that occasionally cover their hands. In all but two cases, their hose have soles so that the color extends to cover their feet as well, elongating their legs and streamlining their silhouettes.[70] They usually wear elaborately twisted and draped hoods as hats, arranged so that the ends of the hood flounce above their faces. Lawyers wear robes to the floor but are distinguished one from another by distinctive hats (*pilei* or *mortiers*) or purses hung at the belt.[71]

Artists and viewers alike were aware of nuances of dress and fashion and would have been able to understand its role in characterization and plot development in this manuscript. They would notice such subtle details as Crito's shorter robe, leg-

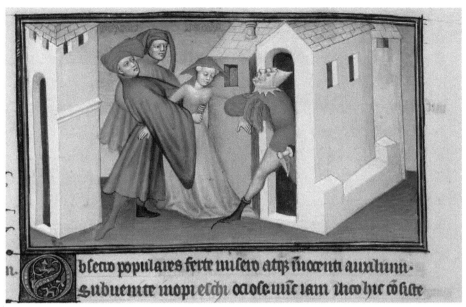

b sciro populares ferre unsero atq̃ ĩcerĩti auxlium·
subuenire mopi efc̃hi oaofe unĩc iam thco hic c̃ofiste

FIGURE 2.33. The abduction of Calida. Publius Terentius Afer, *Comedies*. BnF Ms. lat. 7907A, fol. 77v. Photo: BnF.

gings, and spurs in figure 2.32, which establish that he has ridden from afar in a rush. They would also understand the excessiveness of fashions (fig. 2.33) worn by the pimp Sannio, who emerges from a building in this scene from *The Brothers*. The pimp dresses extravagantly in a tight-fitting scalloped hood, a very short tunic with elaborate contrasting green dagging at the sleeves, shoes with incredibly long, extended toes, and bicolored hose of red and white. Characters identified as soldiers and parasites/hangers-on wear similarly extravagant dress. For example, see the soldier Thraso dressed in pink (fig. 2.34) and the parasite/trickster Phormio in a short green robe and bicolor hose (fig. 2.35).

However, the makers of the book also understood the limitations of this rhetoric of costume and manipulated it to guarantee that the visual message would be clear. This manipulation must have been done by someone who knew the Latin play—either a *libraire* or Laurent himself. Thus, the lawyerly dress given to Micio in *The Brothers* (see fig. 2.30) associates aspects of his personality with those of the three lawyers who fuss, equivocate, and offer useless and conflicting advice in a single scene (see fig. 2.31) in *Phormio*.[72] Despite the direction to the illuminator suggesting that Micio's brother Demea be represented as a peasant, the *libraire* or artist gave Demea dress typical of an old man. For the costume glossing to work in characterization, it was essential to vary only one figure, in order to maintain one figure as a foil who calls attention to the other, nontraditional figure.

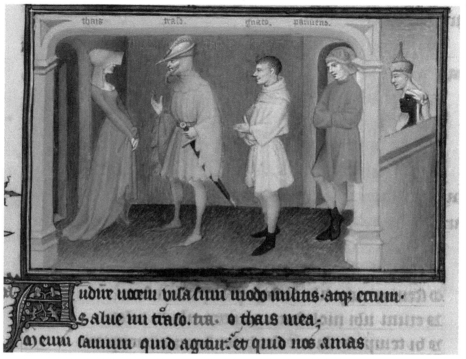

FIGURE 2.34. Thais in conversation with Thraso as Gnatho, Parmeno, and the eunuch listen. Publius Terentius Afer, *Comedies*. BnF Ms. lat. 7907A, fol. 35r. Photo: BnF.

In a similar vein, because the dress of pimps, soldiers, and parasites was so similar, some dress would be muted when more than one of these lower types appeared in a play, particularly if they appeared in the same scene, in order to highlight visually the most significant character. For example, the parasite Gnatho in *The Eunuch* (see fig. 2.34) is dressed more conservatively than other parasites in the manuscript because the soldier Thraso, who appears in this scene with Gnatho, plays a more important role. Thraso, not Gnatho, is represented with visual extravagance, wearing a high-collared and dagged pink *houppelande* with sweeping sleeves, pink hose that extend into long pointed toes, and a cap with a feather. Gnatho is dressed in light yellow, more like the servant behind him. In contrast, *Phormio* features a titular character who is a parasite or trickster and another character, Dorio, who is a pimp. Because parasite and pimp never appear in a scene together, they both are flamboyantly dressed. Phormio (see fig. 2.35) wears a very short tunic with full sleeves and a dagged chaperon, bicolor hose, and short boots with excessively long pointed toes, and Dorio (fig. 2.36) dresses like the pimp Sannio from *The Brothers*, with cusped hood, short tunic, and hose, though his hose are rolled down.

FIGURE 2.35. Phormio and Geta in conversation. Publius Terentius Afer, *Comedies*. BnF Ms. lat. 7907A, fol. 125r. Photo: BnF.

Analyses of these examples of visual rhetoric offer insight into the nature of the collaboration of humanists such as Laurent with *libraires* and artists. The *libraire* and artists who worked on the Duke of Berry's copy of Terence's *Comedies* were almost certainly given detailed directions about how to draw the new frontispiece and its attempted reconstruction of a Roman theater. Laurent may also have devised the written directions dictating the types to be painted as illustrations within the plays, but these directions seem to have been mediated, possibly by a *libraire*. This mediator thought about the strengths and limitations of visual rhetoric and deviated from the original plan in order to clearly draw attention to the characterization of specific protagonists including the old man Micio and the soldier Thraso.

Following directions like these, artists collaborating with Laurent communicated and nuanced social position and characterization through a rhetoric of clothing that is amazingly consistent and legible across the manuscript, even in pictures painted by different artists. Artists and viewers would notice subtle differences from the norm and read Terence carefully to understand why they were there. The pictures would be an invaluable aid to John of Berry as he read or discussed the Latin text.

Analysis of these examples of visual rhetoric offers insight into the ways Laurent and Gouge hoped John of Berry would read the book. The visual rhetoric creates both historical distance in the frontispiece and experiential immersion in the

FIGURE 2.36. Phedria speaks to Dorio at left and Geta to Antipho at right. Publius Terentius Afer, *Comedies*. BnF Ms. lat. 7907A, fol. 128v. Photo: BnF.

plays themselves. It was part of a language understood by artists, by authors of visual programs, and by readers of the luxurious manuscripts produced in early fifteenth-century Paris. It was deployed with particular care to construct a visual translation in Latin books for noble readers, such as John of Berry, who were more comfortable negotiating books written in the vernacular.

The visual rhetoric so clearly employed in the Duke of Berry's manuscript of Terence was deployed particularly carefully in Latin books supervised by humanists such as Laurent and his friend Lebègue. Lebègue's description of illustrations for Sallust, discussed in chapter 3, reveal a similarly self-conscious manipulation of visual rhetoric. This visual vocabulary was stock-in-trade for artists, who were, however, less systematic in its usage when left to their own devices.[73]

The illuminations of John of Berry's Terence seem to be less a response to humanist interests in Terence as a model of rhetoric and more an illustration of Laurent's later characterization of Terence's fiction in his translators prologue to *Des cent nouvelles* as "fables representing the true mirror and form of all human life." The mise-en-page and illustration of this manuscript gave life to the plays principally by visually amplifying the Latin text with 143 images that clarify the distinct social roles of the protagonists. Unlike the frontispiece, so carefully amplified by Laurent's research in commentaries on Terence that may have needed explanation, the illustrations of scenes in the plays contained a simpler visual amplification that would have been totally accessible to fifteenth-century viewers.

CHAPTER 3

Jean Lebègue and Sallust's *Conspiracy of Catiline* and *Jugurthine War*

As a royal notary and secretary from the 1390s and a *greffier* of the Chambre des comptes from 1407, Jean Lebègue shared an interest in locating and reading works of antiquity with a circle of humanists that included Jean de Montreuil and Laurent de Premierfait. Lebègue was not as directly involved as Laurent had been either in writing or translating texts or in being part of a team that produced densely illuminated ducal manuscripts in the early fifteenth century. However, he was someone who, as Inès Villela-Petit suggested, moved from an interest in texts, to an interest in illustration in the first quarter of the fifteenth century, to an interest in artists, manifested in both his directions to artists on how to illustrate Sallust and his treatise on painting technique, the *Liber colorum* (BnF Ms. lat. 6741), which he transcribed in 1431 after having its model translated from Italian to Latin.[1] His relation to illuminated texts thus offers another avenue for understanding the relationship between French humanism and visual translation in the first half of the fifteenth century. Lebègue's copying of images and affiliation with artists develops equally in two illuminated copies of Sallust's *Conspiracy of Catiline* and *Jugurthine War*. In each iteration of the illuminated text, he worked with *libraires* who produced luxurious copies for princes of the blood, and he seemed to be making a move to break into the scholarly circle surrounding the Orléans family and to craft illuminated works for the education of a new generation of princes who were skilled in Latin. While he may not be as active an agent as previously thought in the development of the visual cycles of Sallust, he was active in their diffusion.

During the Middle Ages and Renaissance Sallust was renowned as a moralist and historian and served as a model of Latin style in university arts courses.[2] Because princely members of the French court were educated differently, they

experienced Sallust secondhand through such texts as the summary of the *Conspiracy of Catiline* in the *Faits des Romains*, the medieval French compilation of circa 1213–1214 that became particularly popular among royal, princely, and Parisian audiences starting in the 1370s.[3] In the early fifteenth century it continued to be more common that French kings and princes learned about Rome from vernacular texts, reading the *Faits des Romains* or French translations of Livy or Valerius Maximus.[4] For instance, in 1404 Christine de Pizan wrote in her biography of King Charles V, who had died in 1380, that Charles often listened between vespers and supper in winter to readings of "diverse beautiful stories from Holy Scripture or from the *Faits des Romains*, or the *Moralités des philosophes*, and other knowledgeable works" [En yver, par especial se occupoit souvent à ouir lire de diverses belles hystoires de la Sainte Escripture, ou des *Faits des Romains*, ou *Moralités de philosophes* et d'autres sciences jusques à heure de soupper].[5] The popularity of the *Faits des Romains* continued into the early fifteenth century, when the biography (1406–1409) of the military hero Jean II le Meingre, known as Boucicaut, described him as having the *Faits des Romains* publicly read, along with "fair books about God and the saints" or "histories of old valiant heroes, of the Romans, or others" [Moult lui plait lire beaulx livres de Dieu et des sains, des Faits des Rommains et histoires authentiques. . . . Aux jours des dimanches et des festes, il occupe le temps a aler en pelerinages tout à pie, ou a ouyr lire d'aucuns beaulx livres de la vie des sains, ou des histoires des vaillans trespassez, des Roumains ou d'autres].[6]

With their accounts of treachery, corruption, heroic action, and ultimate triumph of good, Sallust's *Conspiracy of Catiline* and *Jugurthine War* had obvious potential to appeal to both humanists and broader fifteenth-century noble audiences with a taste for Roman history.[7] The *Conspiracy of Catiline* of 63 BCE pitted the Roman noble Catiline against the consul Cicero and the Senate. Eliminated from contention in the annual consular election, Catiline and other disaffected nobles attempted to assassinate the consuls Cicero and Antonius and overthrow the government of Rome. Catiline was called before the Senate and denounced by Cicero. He left Rome but continued to foment rebellion. When an intercepted letter finally confirmed his guilt, the Senate debated and, after impassioned speeches by Julius Caesar, who pled for banishment of Catiline and his coconspirators, and Cato, who argued they should be executed, the Senate voted to put the conspirators to death. The conspirators arrested in Rome were executed, and subsequently Catiline and his forces were defeated at a battle in which Catiline died.

The *Jugurthine War* is a tale of unfettered ambition, military prowess, and political corruption in the story of the indefatigable quest for power by Jugurtha, a Numidian leader who was ultimately defeated by the Romans. Following the death of his father, Jugurtha was adopted by his uncle, King Micipsa of Numidia. Micipsa, observing the charisma and prowess of his nephew and adopted son,

feared his ambition but hoped that Jugurtha would be willing to share power with his own sons, Hiempsal and Adherbal. Unfortunately, during the years that followed Micipsa's death, Jugurtha eliminated the two princes and exasperated the Romans by exercising his skilled diplomacy, covert maneuvers, and audacious strategies to keep Numidia free. After a long series of battles pitting a succession of consuls against Jugurtha, the consul Marius and Sulla, Marius's quaestor, finally arranged for Jugurtha's ally, King Bocchus of Mauritania, to turn Jugurtha over to Sulla.

Despite their evident dramatic appeal, Sallust's Latin *Conspiracy of Catiline* and *Jugurthine War* were better known in French monastic and university circles than in courtly ones until the early fifteenth century. Surviving inventories suggest that neither Kings Charles V and Charles VI nor the royal princes Dukes Louis of Bourbon, John of Berry, Philip the Bold of Burgundy, or John the Fearless of Burgundy owned a Latin Sallust.[8] The exception to this practice is an uninventoried book (BnF Ms. lat. 9684), to be discussed shortly, given to the king's brother, Duke Louis of Orléans, between 1404 and 1407.[9] It was only in 1423 that an inventory of King Charles VI's collection, made after his death, refers to what might be a French translation of the *Conspiracy of Catiline*, but that copy does not survive.[10]

The earliest surviving evidence for French princely educational reading of Sallust outside the Orléans family appears in an undated *Tractatus [de considerationibus quas debet habere principes]* that Jean Gerson, the chancellor of the University of Paris, addressed to the preceptor of an unnamed dauphin in either 1410 or 1417.[11] Gerson recommended Sallust in a list that intermingled seven vernacular and fifteen Latin texts on religious, moralizing, historical, and scientific topics that Gerson thought a prince should read. These included French texts: Laurent d'Orléans's mirror of princes, the *Somme le roy*; selected sermons and writings by Gerson himself, including his sermons *Vivat rex* and *Fiat pax*;[12] Nicole Oresme's translations of the *Economics, Ethics*, and *Politics* of Aristotle;[13] a translation of Vegetius's *De re militari*, a treatise on Roman warfare; translations of works by Cato, Theodolus, and Aesop "cum similibus" (probably a reference to works serving ethical and grammatical ends grouped in the popular school text known as the *Liber catonianus*);[14] John of Holywood's *De sphaera*, included "for some knowledge of the physics of this world";[15] the *Grandes chroniques de France*, the history of the French kings; and Raoul de Presles's translation of and commentary on Saint Augustine's *City of God*.[16] Latin recommendations included biblical commentaries by Peter Comestor and Nicolas of Lyra; a tract on the virtues and vices, possibly by Guillaume Péraud; a tract on the four cardinal virtues by Martin of Braga; a Carthusian martyrology; legends of the saints and lives of the fathers; Vincent of Beauvais's *Speculum historiale*, a history of the world to 1250; meditations and prayers by various saints; Giles of Rome's *De regimine principum*, a

mirror of princes; Valerius Maximus's *Facta et dicta memorabilia*, a thematically arranged collection of memorable deeds and sayings from the antique world; Sextus Julius Frontinus's *De stratagematibus bellicis*, a collection of anecdotes on strategy for war drawn from Greek and Roman sources; Sallust (probably his *Conspiracy of Catiline* and *Jugurthine War*); Boethius's *Consolation of Philosophy*; Seneca's *De clemencia ad Neronem*, a letter on clemency addressed to Nero by Seneca, who was thought to be his tutor; Livy's *History of Rome*; and Suetonius's *History of the Twelve Caesars*. Jacques Verger analyzed the list and suggested that Gerson developed an unusual educational program that differed from those current in grammar school or the *faculté des arts* at Paris. He believed that Gerson deliberately selected this particular blend of Latin and French sources to advance the prince's religious, moral, and political education.[17]

Did Gerson's recommendations and the surviving manuscripts used to educate Louis of Orléans's sons resonate with illuminated Parisian manuscripts of Sallust in the early fifteenth century? I would like to examine this question through the example of a series of uninventoried illuminated Sallust manuscripts associated with Lebègue that were prepared for humanist collections and, possibly, for princely education in the first quarter of the fifteenth century, when the younger generation of princes of the blood, including Louis of Orléans's sons Charles and John, and possibly Charles VI's sons, were increasingly literate in Latin.

Lebègue was involved in the production of several illuminated copies of Sallust, including a set of manuscript twins: one copy of the *Conspiracy of Catiline* made for his own collection and a second made for Louis of Orléans and actively used by his young sons (BnF Mss. lat. 5762 and 9684).[18] Besides participating in the production of this pair, Lebègue also recorded a unique set of French directions on how to illustrate Sallust, *Les histoires sur les deux livres de Salluste*, that are preserved in a manuscript in Oxford (Bodl. D'Orville 141) and reflect an extended cycle that survives in part in two distinct manuscripts: one which belonged to Lebègue (Geneva Ms. lat. 54) and a second now in a private collection. As a group, these copies of Sallust associated with Lebègue or his writings offer an opportunity to document one French humanist's evolving understanding of the utility of visual images in shaping reception or comprehension of the Roman past within dual frameworks of humanist reading and of the education of a prince.

In a seminal article, Donal Byrne tracked the relationship between Lebègue and Sallust from the earliest evidence provided by Lebègue's quotation from Sallust in the 1390s in a letter sent to Louis of Orléans's chancellor; to his supervision between 1404 and 1407 of production of twin Sallust manuscripts for himself and Louis of Orléans; to his transcription in 1417 of a Latin commentary on Sallust

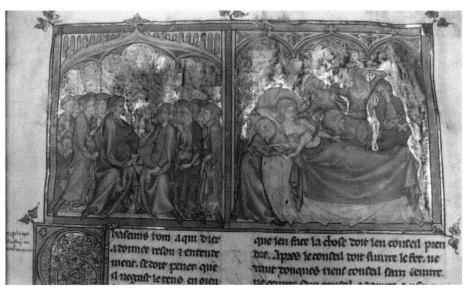

FIGURE 3.1. Marginal note by Jean Lebègue; Roman senators; Birth of Caesar. *Les Faits des romains.* BnF Ms. fr. 23083, fol. 1r. Photo: BnF.

that is preserved with *Les histoires sur les deux livres de Salluste*, his French directions to artists; and his supervision of an illuminated copy of Sallust's *Conspiracy of Catiline* and *Jugurthine War* now in Geneva.[19] Byrne concentrated on the relationships between textual themes present in the Latin commentary on Sallust and the recurring humanistic themes present in the new illuminations of the three manuscripts associated with Lebègue. He complemented his analysis of humanist themes and images with a careful consideration of what the visual relationships between Lebègue's directions in Bodl. D'Orville 141 and the images in the Sallust in Geneva reveal about Lebègue's interaction with artists and knowledge of artistic practice. His work continues to be a valued addition to our understanding of the role of a patron in the production of fifteenth-century books and to the reception of Sallust in late medieval France. My analysis revisits fundamental research by Gilbert Ouy and Byrne on Lebègue's manuscripts of Sallust to consider the ways in which new scholarship enriches Byrne's findings.

How did Lebègue's visual engagement with Sallust begin, and how did it grow? His fascination with ancient history led him to value books that gave him access to it, as annotations in a thirteenth-century copy of the *Faits des Romains* (BnF Ms. fr. 23083) that Lebègue owned make clear. Lebègue's marginal additions delineate contributions from classical sources.[20] Most reference passages in Lucan, Caesar's *Gallic Wars*, and Suetonius, but two annotations cite Sallust: Lebègue annotated folio 1r in the left margin (fig. 3.1) to suggest it derived from the prologue

of Sallust's *Conspiracy of Catiline* and folio 5r to indicate material describing Catiline's conspiracy. The *Faits des Romains* was one of the older books in Lebègue's personal collection; he deaccessioned it sometime before 1439, when it was purchased by Duke Charles of Anjou.[21] Consideration of manuscripts produced for Lebègue suggest that his interest centered on the *Conspiracy of Catiline* in the first decade of the fifteenth century and then extended to the *Jugurthine War* in the 1430s.

THE CONSPIRACY OF CATILINE

Around 1404 to 1407 Lebègue was involved in the production of twin manuscripts containing Sallust's *Conspiracy of Catiline*, one likely made for himself (BnF Ms. lat. 5762) and the other originally made for Duke Louis of Orléans and quickly adopted for use in the education of his young sons (BnF Ms. lat. 9684). Lebègue's personal copy (fig. 3.2) originally contained his arms (de gueules a trois croix ancrées d'or, à la bordure engrêlée de sable) in the opening initial O. These are now partially visible beneath the overpainted French royal arms. The manuscript (see fig. 1.1) that contains the arms of Duke Louis of Orléans in the initial O includes two ex libris of Louis's son, the poet Charles of Orléans: one written before Louis's assassination in 1407 and one written after.[22] These annotations by Charles and later additions by his younger brother John of Angoulême and their schoolmaster Nicolas Garbet make clear that this Sallust manuscript was put to active use as a schoolbook by the young princes.

Lebègue's and the princes' manuscripts of the *Conspiracy of Catiline* were twins when first made. Not only do they have the same justification, number of lines, and ruling patterns; they were both written by the same scribe, whom Ouy identified as a man named Monfaut, and they both contained a single miniature painted in the same artistic style.[23] They also had identical textual divisions, each decorated by flourished initials drawn by the same artist. Both manuscripts contain annotations written by Lebègue, some of which are identical: for example, *Notate Domini mei* (BnF Mss. lat. 5762, fol. 27r and lat. 9684, fol. 25r) or *Nota de amicitia* (compare figs. 3.3 and 3.4) accompanied by unusual six-fingered pointing hands. However, the majority of Lebègue's annotations in the two manuscripts differ in content. Ouy categorized the annotations written in the manuscript that Lebègue kept for himself as being more numerous and of a philological and lexicographical character; he described the annotations in the manuscript made for the young princes as pedagogical above all.[24]

This first pair of manuscripts associated with Lebègue had one illustration: a portrait of Sallust painted by the workshop of the Bedford Master (compare

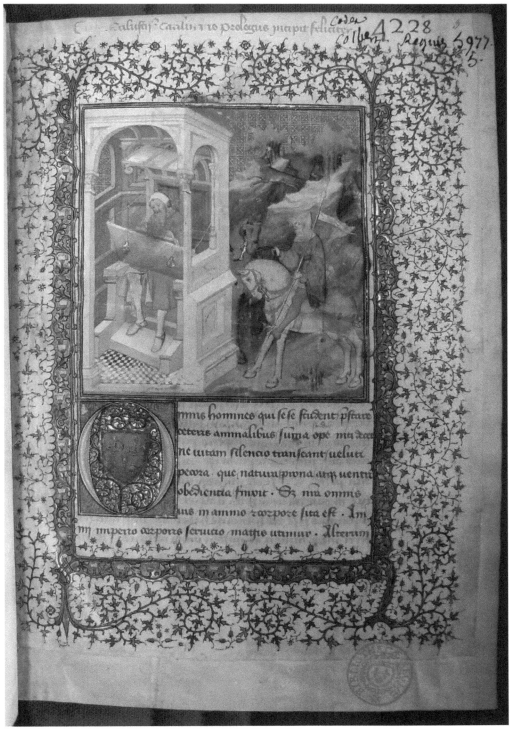

FIGURE 3.2. Sallust in his study. Gaius Sallustius Crispus, *Bellum Catilinarium* and *Bellum Jugurthinum*. BnF Ms. lat. 5762, fol. 3r. Photo: BnF.

FIGURE 3.3. Marginal note "De amicitia." Gaius Sallustius Crispus, *Bellum Catilinarium* and *Bellum Jugurthinum*. BnF Ms. lat. 5762, fol. 11v. Photo: BnF.

arbitris procul amotis orationem huiuscemodi ha
buit · Ni virtus fidesque vestra spectata mihi foret ·
nequicquam opportuna res cecidisset · spes magna do
minatio in manibus frustra fuissent · neque ego per
ignaviam aut vana ingenia incerta pro certis cap
tarem · Sed quia multis et magnis tempestatibus
vos cognovi fortes fidosque mihi · eo magis animus
ausus est maximum atque pulcherrimum facinus incipere ·
simul quia vobis eadem que mihi bona malaque in
tellexi · nam idem velle · atque idem nolle · ea demum
firma amicitia est · sed ego que mente agitavi omnes
iam antea diversi audistis · Ceterum mihi in dies
animus magis accenditur cum considero que condicio
vite futura sit · nisi nosmet ipsos vindicamus in
libertatem · Nam postquam res publica in paucorum
potentium ius atque dicionem concessit · semper illis
reges tetrarche vectigales esse · populi nationes
stipendia pendere · Ceteri omnes strenui boni nobi
les atque ignobiles vulgus fuimus sine gratia
sine auctoritate · his obnoxii quibus si res publica
valeret formidini essemus · Itaque omnis gratia poten
tia honos divitie apud illos sunt aut ubi illi vo

FIGURE 3.4. Marginal note "De amicitia." Gaius Sallustius Crispus, *Bellum Catilinarium*. BnF Ms. lat. 9684, fol. 10r. Photo: BnF.

figs. 3.2 and 1.1). Byrne was the first to observe that Lebègue explained their ico-
nography in French directions for illuminators that he wrote to describe a later
version of this composition. Lebègue wrote,

> One could devise the first *histoire* [illumination] in this way. First *histoire*. Let
> there be made and portrayed a man with a great forked beard who will have
> a white coif on his head like they used to wear. And he will be seated in a chair
> which will be well built. And before him will be a small table on which he
> will seem to write and [he will have] all that pertains to a scribe/writer when
> he is in his chair to write. And the said scribe/writer will be dressed in a tunic
> of vermillion or another color, with a low collar and divided in the front in
> such a way that one can see his coat of mail above and below. And he will wear
> his leg armor and gilded spurs. And outside the masonry surrounding his
> chair will be his squire or valet mounted on a grey horse with a gilded harness,
> a lance with a pennon in his left hand, and with his other hand the said squire
> holds his master's horse with a gilded harness [and] one will only see the front
> half of the horse, because the other half will be covered or hidden by the said
> chair, signifying that the said writing man left knighthood for study. And the
> said valet will be in a beautiful plain where there will be plants and trees of
> various sorts and above will be the background of the illumination grace-
> fully made.

> [On peut deviser la première histoire en ceste forme. Première histoire. Soyt
> fait et pourtrait ung homme à grant barbe fourschue qui aura en sa teste
> une coiffe blanche comme l'en souloit porter. Et sera assis en une chayère qui
> sera bien edifiée et devant soy aura la tablecte sur laquelle il fera semblant de
> escripre et tout ce que il appartient à ung escripvain quant il est en sa chaière
> pour escripre. Et sera ledit escripvain vestu d'une cocte vermeille ou d'aultre
> couleur, à baz colet et fandue par devant en celle manière que l'en puisse veoir
> par hault et baz sa cocte de maille, et si aura son harnois de jambes et esperons
> dorés chaussiez. Et au dehors de la maçonnerie de sa chaie aura son escuyer
> ou varlet arqué monté sur ung cheval grison à harnoiz doré, une archegaye à
> un pennon en sa main senestre et de l'aultre main tenra ledit escuier le cheval
> de son maistre à harnoiz doré, duquel cheval en ne verra que la moitié de de-
> vant pour ce que l'autre moitié sera couverte ou mussée de ladite chaière, en
> signifient que ledit homme escripvant sera descendu de chevalerie à l'esstude
> et sera ledit varlet cum dit est en une belle plaine où aura herbe et arbres de
> diverses façons et au seurplus sera la champaigne de l'histoire par en hault
> faicte graceusement.][25]

Lebègue's distinctive direction helps clarify details of the meaning of these frontispieces that are not as evident to modern viewers as they may have been to a late medieval French audience. The directions make clear that for Lebègue, the scribe or writer wearing armor and the view of only half of his horse "signifies that the writing man will have left knighthood for study."[26] As Byrne was the first to suggest, the artists of these miniatures constructed them by merging distinct visual traditions they knew well: the scholar surrounded by books and writing implements, the knight in armor, and the authority and wisdom of age conveyed by a fluffy beard, as was common in portraits of God the Father or prophets. Byrne categorized the new frontispiece to the *Conspiracy of Catiline* as one of the first humanist images to represent the choice between the scholarly and knightly lives and suggested that it was a visual parallel to Sallust's prologue to the *Conspiracy of Catiline,* whose two main themes are "the superiority of mind over body, of intellect over pleasure, fortune, and beauty" and the "the corruption of public life and the contrasted praise of history as a noble, disinterested pursuit."[27] This humanist image has analogies to the presentation image of Statius (see fig. 2.17) in the manuscript supervised by Laurent de Premierfait around 1405. Like Lebègue, Laurent constructed a humanist image that emphasized distinctive qualities of the author. Both contrast with the prefatory image decorating the *Jugurthine War* transcribed by the Orléans brothers' tutor, Garbet (see fig. 1.2).

Byrne concentrated his discussion of the two early manuscripts on their shared frontispiece and its relationship to that of Geneva Ms. lat. 54. As a result, he did not mention that the early Orléans schoolbook and Lebègue's early copy of Sallust—its so-called twin—were really only twins in the beginning, when they each only contained the *Conspiracy of Catiline* illustrated by the famous frontispiece portraits of Sallust. Ouy showed in his study of Ambrogio Migli, a humanist secretary to Louis of Orléans, that the books quickly diverged.[28] The Orléans boys and their tutor used their manuscript as a schoolbook. They wrote further comments in the margins, added lists of kings and emperors on blank leaves at the beginning (fig. 3.5) and had poems by Ambrogio Migli (fig. 3.6) and a poem written by Charles of Orléans when he was ten years old (fig. 3.7) transcribed at the end of the manuscript.[29] Because of their content, these additions help establish the date for the production of these manuscript "twins" as after 1404 and before 1407. However, they also start to personalize the Orléans boys' manuscript and differentiate it even more from Lebègue's.

Lebègue's second manuscript of Sallust (Geneva Ms. lat. 54) is exceptional among his personal collection; it shows both his developing interest in visualizing Roman history and a shift from his practice of collecting un- or sparsely illustrated texts. It is also unusual because there was no tradition of densely illuminated Sallust

FIGURE 3.5. Lists of kings and emperors. Gaius Sallustius Crispus, *Bellum Catilinarium*. BnF Ms. lat. 9684, fol. Br. Photo: BnF.

cognatum reperiebant. fuere item qui inimicos suos
cognoscerent. ita uarie per omnem exercitum le-
ticia. meror. luctus atque gaudia agitabantur. ~

Salustij crispi de Catelinario bello liber explicit

Hic infra Sibilla uates alloquitur illustres dñi duces :
aurelian gentos moneiq pro cor̄ p egregios mores exaltatos .

Indole cesarei fratres soliiq nepotes
Liliferi solij Ludouici parte parentis .
Regificam stirpem frigio qui ducitis Anglo
Sanguine materno liguru serpentis auite
Formosi nimium pueri ceu sidera trina .
Illa ego que saluum duxi secura portum
Vipereæ sobolis genitorem urbiuoq quirine
Magnanimu eneadum uobis deuota Sibilla

FIGURE 3.6. Poem by Ambrogio Migli. Gaius Sallustius Crispus, *Bellum Catilinarium*. BnF Ms. lat. 9684, fol. 35r. Photo: BnF.

Qui veult a grant honneur venir
Il doit lamour dieu acquerir
Car sans icelle moiennement
Nul ne peut faire bonnement
Aucune morale euure
Se la grace de dieu my euure
Pour ce pri la trinite
Et la dame humilite
Quils me vueillet tel sens donez
Quun liure puisse composer
Qui soit dautrui vtilite
Proufitat a humanite
En honneur de dieu et prouffit
De celui qui ce liure fit
Le quel liure est appelle
Le liure contre tout peche

Du peche dorgueil
Est qui se vieult enorgueillir
Il peut bon exemple querir
Du mauuais ange lucifer
Qui fut depuis deable penser
Le quel par oultrecuidance

FIGURE 3.7. Poem by Charles of Orléans. Gaius Sallustius Crispus, *Bellum Catilinarium*. BnF Ms. lat. 9684, fol. 37v. Photo: BnF.

FIGURE 3.8.
The beginning of *Histoires sur les deux livres de Salluste*. Jean Lebègue, *Histoires sur les deux livres de Salluste*. Bodl. D'Orville 141, fol. 42r. Permission Bodleian Libraries, University of Oxford.

manuscripts before the early fifteenth century. Prior French manuscripts of Sallust were illuminated with at most two pictures: a world map placed shortly after the beginning of the *Jugurthine War* [at Iug. 17.3] and, less frequently, an author portrait.[30] But like Laurent, Lebègue had learned that the nobility and princes expected illuminations. The presence of visual cycles would not only signal "history" to readers but might also serve as an aid to Latin, offering a supplementary apparatus for reading and engaging with Sallust as they had in the manuscripts of Statius and Terence that Laurent de Premierfait supervised.[31] As an essential component of Christine de Pizan's "praiseworthy teachings" for princes, illuminations were an important vehicle for encouraging readers to compare Sallust's Rome with the reader's France through visual translation.

The literature on Lebègue's densely illuminated manuscript of Sallust has been shaped by Byrne's fundamental study of the relationship between Geneva Ms. lat. 54 and Lebègue's French directions to illuminators, *Histoires sur les deux livres de Salluste* (fig. 3.8), the second text transcribed in a manuscript in Oxford

(Bodl. D'Orville 141, fols. 42r–55v). Byrne studied the commentary, *Glose supra Catilinarium et Iugurtinum Salustij*, that fills folios 1r–41r of Bodl. D'Orville 141, and he published the colophon on folio 41r, which establishes that Lebègue completed his original transcription of the commentary on October 26, 1417.[32] Byrne assumed that 1417 was also the date for *Les histoires sur les deux livres de Salluste*, which was transcribed after the commentary and its colophon; as a result, he believed that 1417 was also the *terminus post quem* for Lebègue's illuminated manuscript, Geneva Ms. lat. 54.

REVISITING BODL. D'ORVILLE 141

Recent discoveries complicate Byrne's model of production and dating for the written directions in Bodl. D'Orville 141. I am a member of a research group that has been given rare access to an early fifteenth-century French illuminated Sallust n a private collection that shares thirty-one of the sixty-six images in Geneva Ms. lat. 54.[33] Preliminary research on this luxury manuscript, combined with Anne van Buren's and my reexamination of *Les histoires sur les deux livres de Salluste* in Bodl. D'Orville 141 and of the images in Geneva Ms. lat. 54, reveals that the date of 1417 traditionally ascribed to the directions and to the manuscript in Geneva is questionable. Instead, the expanded body of evidence suggests that Geneva Ms. lat. 54 and the luxury manuscript were complementary products of the Parisian book trade. They were probably produced independently by a *libraire* for Lebègue and another unknown patron, and they both share distinct relationships to the artists' directions transcribed in Bodl. D'Orville 141. Further, Bodl. D'Orville 141 is not an original autograph manuscript written by Lebègue, but a later copy of some of his work.

Van Buren was the first to question Byrne's dating of Bodl. D'Orville 141. Following Albina de la Mare's unpublished observation that the closest watermark comparison for the paper used throughout the manuscript appears in books dated around 1468 (comparable to Briquet no. 1834), van Buren questioned Byrne's suggestion that the watermarks could have been in use as early as 1417. She concluded that the manuscript in Oxford could not have been written by Lebègue himself.[34] Like Jean Porcher, van Buren also noted errors in transcription; several of the marginal notes correcting illuminations in Geneva Ms. lat. 54 were transcribed next to the wrong miniature's description in Bodl. D'Orville 141, then crossed out and inserted in their proper position. This sort of error would probably not happen in an author's autograph manuscript.[35] If, as its watermarks suggest,

the manuscript in Oxford was transcribed in the 1460s after Lebègue's death in 1457, then it copies a now-lost original manuscript (or manuscripts) by Lebègue. This means that it is possible that the Latin commentary on Sallust that Lebègue copied in 1417 and the French directions on how to illustrate Sallust may not have circulated together before the 1460s. Their juxtaposition in a single manuscript may have been part of a mid-fifteenth-century scholar's independent collection of Lebègue's complete works on Sallust.

Van Buren's analysis of the transcription of the directions preserved in Bodl. D'Orville 141 by Porcher suggested to her that the portion of the written directions for the frontispiece and illustrations for the *Conspiracy of Catiline* and for the first ten miniatures of the *Jugurthine War* was of a different character than those that followed them.[36] She observed that the directions in the first part of *Les histoires sur les deux livres de Sallust* seemed to be descriptive. Because they had no marginal corrections like those that appear in the second portion of the text, she suggested that these directions could have been written down after the illuminations through the first part of the *Jugurthine War* had already been completed in Geneva Ms. lat. 54. She hypothesized that they might even copy directions that had been used elsewhere by a *libraire*, as for instance seems to have been the case for the frontispieces for the early twin *Catiline Conspiracy* manuscripts from 1404 to 1407.[37] In contrast, she believed that the descriptions of illustrations after the tenth picture in the *Jugurthine War* were prescriptive, designed to tell artists what to paint as they completed Geneva Ms. lat. 54. These descriptions contain extensive marginal corrections that often cite specific folios in Geneva Ms. lat. 54 or refer to errors that had to be fixed, as Byrne also had noted. Finally, she observed that the style of the illuminations and the dress of the figures change in this later section of Geneva Ms. lat. 54. These changes correspond with the point where the descriptions shift from being descriptive to prescriptive in Bodl. D'Orville 141. Van Buren suggests that these later illuminations may have been devised, and were certainly painted, in the 1430s, well after the rest of the manuscript was transcribed and painted.[38]

My codicological analyses of Bodl. D'Orville 141 and of Geneva Ms. lat. 54 supports van Buren's hypothesis. The first portion of the French *histoires sur les deux livres de Salluste* is written within a ruled text block in which the directions are usually separated from those following them by no more than two blank lines (fig. 3.9). Directions are numbered sequentially within marginal notes, which often also provide French chapter summaries that read almost like rubrics and were never used in Geneva Ms. lat. 54, for example on folio 45r: "17th picture. There. How after Caesar offered his opinion, Cato stood up and offered his opinion that the conspirators should all die" [xvij^e histoire. Illec comment après ce que

FIGURE 3.9. Directions on illustrating the *Conspiracy of Catiline*. Jean Lebègue, *Histoires sur les deux livres de Salluste*. Bodl. D'Orville 141, fols. 44v–45r. Permission Bodleian Libraries, University of Oxford.

Cesar ot dit son opinion Caton se leva et dit en son opinion que les conjurez devoient tous mourir].

This practice of numbering illuminations and including summaries ends on Bodl. D'Orville 141, folio 47r, right after the description of the tenth miniature for the *Jugurthine War* (fig. 3.10) and above nine lines left blank. Instead, marginal notes detailing specific corrections to be made in Geneva Ms. lat. 54 begin to appear, written in the same ink and hand as the directions. The inescapable conclusion is that both the marginal corrections and the space "copied" in the manuscript were present in in the textual model for Bodl. D'Orville 141. The space likely marked a disjuncture in Lebègue's now-lost original copy of his directions.

These codicological observations about Bodl. D'Orville 141 and Geneva Ms. lat. 54 reinforce van Buren's claim that the illuminations in Geneva Ms. lat. 54 were left unfinished and completed later. The unexplained gap between the French directions to artists that I observed on folio 47r in Bodl. D'Orville 141 coincides exactly with the place where van Buren noted a major shift of artistic style in Geneva Ms. lat. 54. In addition, the first two miniatures painted in Geneva Ms.

FIGURE 3.10. Directions on illustrating the *Jugurthine War*. Jean Lebègue, *Histoires sur les deux livres de Salluste*. Bodl. D'Orville 141, fols. 46v–47r. Permission Bodleian Libraries, University of Oxford.

lat. 54 as illustrations to the directions to artists that began directly after the gap in Bodl. D'Orville 141 (figs. 3.11 and 3.12) have the initials *A* and *B* written in the margins adjacent to them, suggesting that they were the first two in a new artistic campaign. This raises the possibility that there may even have been an intermediate set of directions, planned for a *libraire* by Lebègue, that were annotated with letters of the alphabet to show artists where to draw and then paint this final set of images.[39] Finally, while the manuscript in a private collection has thirty-one illuminations with iconography identical to that in the Geneva manuscript, the overlap in iconography ceases precisely at the point (Geneva Ms. lat. 54, fol. 38v) where the unexplained gap in the French directions to artists occurs in Bodl. D'Orville 141. The visual cycles of the manuscripts in Geneva and in the private collection diverge from this point onward.[40] For reasons that remain unexplained, Lebègue suspended work on the miniatures in Geneva Ms. lat. 54 shortly after artists illuminated the spaces that were left blank for images through the beginning of the *Jugurthine War*. The remaining spaces were left unfinished in Geneva lat. 54 until much later.

It seems that Lebègue planned Geneva Ms. lat. 54 circa 1410 to 1415, probably with a *libraire* who oversaw the transcription of the manuscript and ensured that

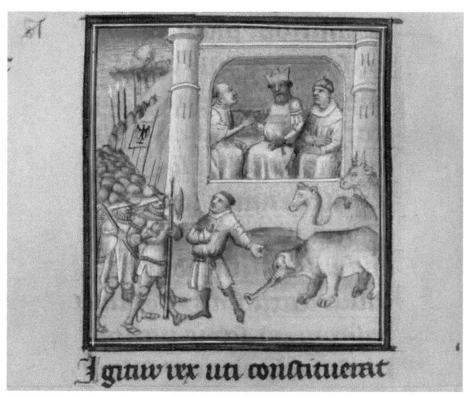

FIGURE 3.11. Jugurtha meets with Bestia and Scaurus in Vaga and the quaestor Sextius receives gifts, including elephants, as part of the terms of the surrender to Rome. Gaius Sallustius Crispus, *Bellum Catilinarium* and *Bellum Jugurthinum*. Geneva Ms. lat. 54, fol. 39v. (www.e -codices.ch).

blank spaces were left for the placement of miniatures at predetermined locations that had been selected in consultation with Lebègue in both *Conspiracy of Catiline* and *Jugurthine War*. The Orosius Master, who also collaborated on the Sallust manuscript in a private collection, painted all the highly unusual pink, green, and blue acanthus initials that appear throughout Lebègue's manuscript. Bedford Master illuminators and Orosius Master illuminators, following directions also used for the manuscript now in a private collection, painted miniatures up through folio 38v.[41] Then, for some unknown reason, Lebègue put his manuscript aside until the 1430s, when he had artists related to the Dunois Master complete the manuscript. Sometime between the end of the first stage of illustration of Lebègue's manuscript in Geneva between 1410 and 1415 and its completion in the 1430s, Lebègue wrote the descriptions preserved in D'Orville Ms. 141; these both commemorated what had already been painted in Geneva Ms. lat. 54 and mapped out

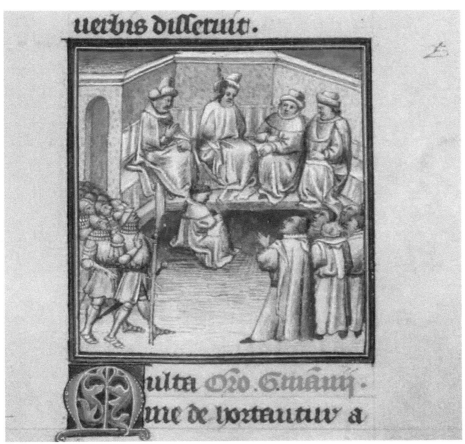

FIGURE 3.12. The speech of Gaius Memmius to the people after Bestia's return. Gaius Sallustius Crispus, *Bellum Catilinarium* and *Bellum Jugurthinum*. Geneva Ms. lat. 54, fol. 40r. (www.e-codices.ch).

descriptions for the illuminations that remained to be painted in that manuscript's blank spaces.

THE *CONSPIRACY OF CATILINE* AND JEAN LEBÈGUE'S DESCRIBED IMAGES IN BODL. D'ORVILLE 141

Comparison of Lebègue's densely illuminated manuscript of Sallust's *Conspiracy of Catiline* and *Jugurthine War*, with his French directions to illuminators, suggests that he worked with a *libraire* to map out the placement, subject matter, and scale

of Geneva Ms. lat. 54. It is clear that Lebègue had some contact with both the artists and the *libraire*. He showed them the frontispiece of his *Catiline Conspiracy* manuscript, made 1404 to 1407, as Byrne observed. The frontispieces of Geneva Ms. lat. 54 and BnF Ms. lat. 5762 are identical not only in iconography but also in their palette (compare figs. 3.2 and 3.13). Lebègue's descriptions of the thirty-one illuminations in Geneva Ms. lat. 54, which are related iconographically to those in the luxury manuscript in the private collection, show Lebègue's direct interaction with artists or a *libraire* because those illuminations that Lebègue described are just different enough from each other to make it clear that neither Geneva Ms. lat. 54 nor the luxury manuscript copies the other. The illuminations of Geneva Ms. lat. 54 are often of different scale and have slightly different placement within their text than those in the luxury manuscript. Further, each manuscript contains occasional illuminations that do not appear in the other.

Lebègue's descriptions may have been written in order to plan a twinned manuscript for a member of the nobility, as had happened when his manuscript (BnF Ms. lat. 5762) was twinned with Louis of Orléans's (BnF Ms. lat. 9684). There is evidence that such a plan never came to fruition; in one of Lebègue's directions for illuminating the *Jugurthine War* (fig. 3.14), the scribe of Bodl. D'Orville Ms. 141 copied Lebègue's inscription *aultre histoire* [other picture] in the margin next to the direction prescribing the subject of the illustration for Iug. 76.6:

> *Hii postquam murum* How Metellus had the said castle assailed and approached the walls with assault engines with armed men on the towers, and those in [the castle] defended themselves. And let it be made [in the illumination] how those in it, when they saw that they could not resist, carried all their goods, gold, and silver, and everything that they had into the grand hall of the royal palace. There they sat down to drink and eat, and when they had eaten and drunk well, they made a great fire in the hall and they pushed all their goods into the fire and then also themselves and burnt themselves with their goods. And Metellus entered the castle and found nothing because everything was burnt.

> [*Hii postquam murum* Comment Metellus fist asailir ledit chastel et approcher des murs les engins et gens d'armes sur ces tours, et ceulx de dedens se defendirent fort. Et si sera fait comment ceulx dedens quant ilz virent qu'ilz ne pouraient resister portèrent tous leurs biens, or et argent et tout ce qu'il avoient dedens la sale du palais royal. Illec se assirent à boire et manger et quant il eurent bien beu et mangé ilz firent grans feux en la sale et il boutèrent tous leurs biens es feux et puis aussi eulx mesmez et se ardirent avec leurs biens. Et Metellus entra ou chastel et ne trouva riens car tout estoit ars.][42]

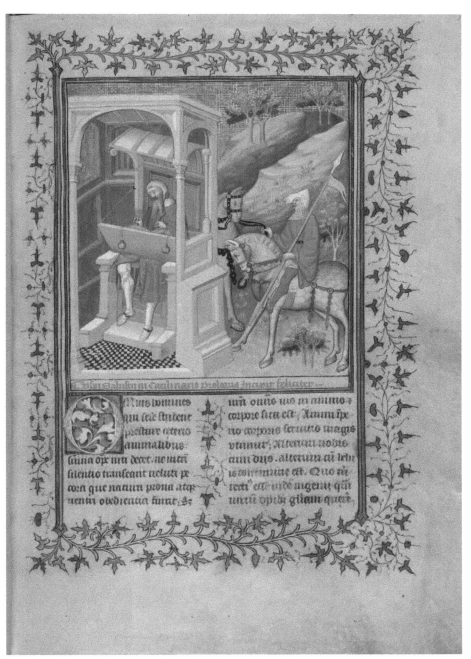

FIGURE 3.13. Sallust in his study. Gaius Sallustius Crispus, *Bellum Catilinarium* and *Bellum Jugurthinum*. Geneva Ms. lat. 54, fol. 1r. (www.e-codices.ch).

FIGURE 3.14. Marginal inscription "aultre histoire." Jean Lebègue, *Histoires sur les deux livres de Salluste*. Bodl. D'Orville 141, fol. 51v. Permission Bodleian Libraries, University of Oxford.

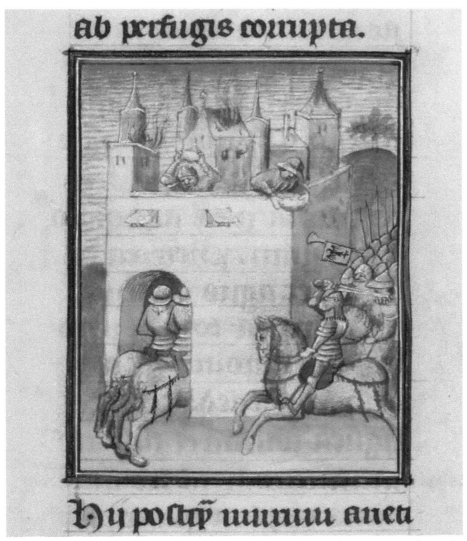

FIGURE 3.15. Romans take the city of Vaga; residents, fearing the Romans, set fire to the palace. Gaius Sallustius Crispus, *Bellum Catilinarium* and *Bellum Jugurthinum.* Geneva Ms. lat. 54, fol. 59v. (www.e-codices.ch).

The illumination (fig. 3.15) in Geneva Ms. lat. 54 that his annotation proposed changing in a subsequent cycle did not do justice to his direction or to the text of Sallust that the direction paraphrases; it shows Metellus assailing the castle without his siege engines as scattered small flames emerge from the roof.

In marginal annotations directly within Geneva Ms. lat. 54, Lebègue responded to another mistake that he had made in his prescriptive directions to artists. Lebègue

had drafted two distinct descriptions for images in Bodl. D'Orville 141 to be placed at Iug. 89.4 and Iug. 91.6. They were not executed because he erroneously gave both directions the same incipit, *Ceterum oppidum* [Iug. 91.6], and he seems to have run the directions together.

> *Ceterum oppidum* Item, let there be made a great castle on a rock named Capsa and the surrounding countryside all sandy, full of serpents, without water or springs. For this the consul Marius who had a great desire to go conquer it had all the skins of beasts that they had killed filled at a river where his army was and put them on horses and went towards the castle, and when they were near, he had all their baggage removed except for the water. And let there be made his men who ascend behind a mountain and go just to the door [of the castle]. But outside the door will be made the good people of the city who had gone [outside] to their work. And for this reason, they enclosed the Romans outside, because the Romans were between the castle door and the laborers. And after, let there be made how the men from the castle surrender and give the keys of the castle.
>
> *Ceterum oppidum* Item let there be made the said castle where the Romans and Consul Marius [are], and they will kill all the men who are old enough to carry arms and will take all the other men, women and children prisoners and will sell them as slaves. And they set fire to the castle.

> [*Ceterum oppidum* Item illec soit fait un grant chastel sur une roche nommée <u>Capsa</u> et le païs d'environ tout sablonneux plain de serpens sans eaus ne fontaines. Pour ce le consul Marius qui avoit grant desir de le aler conquerir fist amplir à une rivière où il estoyt tous les cuers des bestes que l'en tuet en son ost et les charga sur chevaulx et s'en ala vers le chastel et quant il fu près il fit descendre tout son bagage excepté l'eaue et seront fais ses gens qui par derrière une montaigne monteront et iront jusque devant la porte, mais au dehors de la porte seront faiz les bonnes gens de la ville qui estoient alez à leurs labours. Et pour ce les encloront les Roumains dehors, car les Roumains seront entre la porte du chastel et les laboureurs. Et après sera fait comment les gens du chastel de rendront et balleront les clefs du chastel.
>
> *Ceterum oppidum* Item illec soit fait ledit chastel ouquel les Roumains et le consul Marius et tueront tous les hommes qui estoient d'âge de porter armes et tous les aultres hommes, femmes et enfans firent prisonniers et les vendirent comme esclaves. Et si boutent le feu au chastel.][43]

The scribe who transcribed Geneva Ms. lat. 54 sometime between 1410 and 1415 did not leave a place for an image to illustrate the first of these directions,

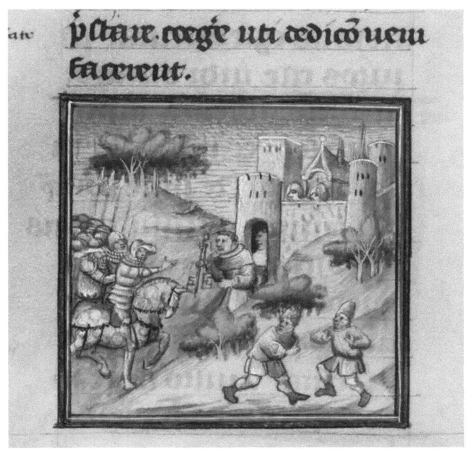

FIGURE 3.16. Surrender of Capsa to Marius and his forces. Gaius Sallustius Crispus, *Bellum Catilinarium* and *Bellum Jugurthinum*. Geneva Ms. lat. 54, fol. 67v. (www.e-codices.ch).

which should illustrate Iug. 89.4 (*Erat inter ingentes solitudines oppidum magnum*). Instead, he left a space for an image at the incipit *Ceterum oppidum* when it appeared at Iug. 91.6. He probably never realized the error, but Lebègue did, and, in response, he may have suggested modifications to the artist for the image in Geneva Ms. lat. 54. The illumination actually painted at the incipit *Ceterum oppidum incensum* (fig. 3.16) was a compromise; it represents men surrendering the keys of a castle to a group of knights while two laborers react with astonishment in the foreground. Rather than illustrating either of the directions that Lebègue drafted for *Ceterum oppidum*, the illumination in figure 3.16 is an illustration of the Latin line directly above it, which Lebègue may have translated for the artist: "When the townspeople perceived what was going on, their disorder, their great panic, their unexpected plight, and the fact that a part of their fellow citizens

FIGURE 3.17. Annotations for placement of an illumination in the future. Gaius Sallustius Crispus, *Bellum Catilinarium* and *Bellum Jugurthinum*. Geneva Ms. lat. 54, fol. 66v. (www.e -codices.ch).

were outside the walls and in the power of the enemy, compelled them to sur-render."[44] In planning for a future copy of Sallust that was never made, Lebègue fixed his manuscript (fig. 3.17) by inserting in Geneva Ms. lat. 54 the word *histoire* [picture], a paragraph sign, and a pair of parallel lines in the margin beside the unillustrated incipit for Iug. 89.4. He also placed a caret mark in the body of the text at the incipit to mark the correct spot in the text for the skipped image to ap-pear. This annotation would only make sense if Lebègue were ensuring that he would be ready to supervise another copy of Sallust with the help of both Geneva Ms. lat. 54 and his written directions for illuminators.

Lebègue's descriptions in *Les histoires sur les deux livres de Salluste*, taken in combination with analyses of the subdivision of the text itself in Geneva Ms. lat. 54 and with the relationship of image to text in that manuscript, offer insight into one humanist's reception of Sallust in the second decade of the fifteenth century. Appendix 1 outlines how flourished initials subdivide the text into unnumbered chapters and structure the *Conspiracy of Catiline* in all three manuscripts associated with Lebègue, and appendix 2 does the same for the *Jugurthine War* in the two manuscripts that Lebègue owned that contain it. The early twin manuscripts (BnF Mss. Lat. 5762 and 9684) belonging to Lebègue and the sons of Louis of Orléans were transcribed by the same scribe and had identical layout and decoration (seventeen chapters and one illumination) for their core text, the *Conspiracy of Catiline*. Lebègue's manuscript now in Geneva subdivides the text of the *Jugurthine War* differently, perhaps in an attempt to balance the structures that he gave the *Conspiracy of Catiline* (twenty-three chapters) with its twenty-two chapters. The result is that textual divisions into chapters of the *Conspiracy of Catiline* are relatively stable in the three manuscripts associated with Jean Lebègue, but those of the *Jugurthine War* differ dramatically in length. For instance, the shortest chapter of the *Jugurthine War* in Geneva Ms. lat. 54 is unillustrated and fills one folio, while the longest chapter is illustrated with fifteen illuminations and fills sixteen and a half folios. Clearly the structure of the text in Geneva Ms. lat. 54 was carefully planned from the beginning to interrelate the *Conspiracy of Catiline* and the *Jugurthine War* and to guide readings of each of them.

One result of the textual division into chapters in Geneva Ms. lat. 54 is an emphasis on letters and exemplary speeches. In the *Conspiracy of Catiline*, six new chapters set apart Catiline's speech to his men (Cat. 20.2), Gaius Manlius's letter to Cicero (Cat. 33.1), the coconspirator Lentulus's letter to Catiline (Cat. 44.5), Julius Caesar's speech (cat. 51.1), Cato's speech countering Caesar (52.2), and finally Catiline's speech to his army (Cat. 58.1). A new chapter in the *Jugurthine War* isolates Scipio's letter to Micipsa, Jugurtha's uncle, praising Jugurtha (Iug. 9.2), and the manuscript echoes BnF Ms. lat. 5762 in giving chapters to Micipsa's discourse on his deathbed (Iug. 10.1); the allocution of Adherbal that warned the Roman Senate of his cousin Jugurtha's ambitions (Iug. 14.1); the letter of appeal sent by Adherbal to the Roman Senate when besieged by Jugurtha's forces (Iug. 24.2); the tribune of the people Gaius Memmius's condemnation of the Senate for being corrupted by Jugurtha (Iug. 31.1); Marius's speech at Rome when he was elected consul to Numidia and formed the army that would defeat Jugurtha (Iug. 85.1); and Sulla's speech before King Bocchus (Iug. 102.5). The speeches by Adherbal, Gaius Memmius, and Marius at Rome receive further emphasis in Geneva Ms. lat. 54 because they are the only chapters to be singled out by red rubrics. It is not

surprising that these examples of Roman rhetoric would be of particular appeal to a humanist such as Lebègue.

The illustrations were also carefully constructed to offer a visual translation of the text. Byrne was the first to discuss the cycle of Geneva Ms. lat. 54 from the standpoint of the artists' visual language; he offered sensitive readings of images considered individually, and occasionally in pairs, in relation to their texts, and Brigitte Buettner extended his analysis.[45] I build on their work by considering how density of images, scale, and anachronism worked rhetorically to structure the visual cycle and, through it, the text of Sallust. My approach differs from theirs in that I consider the two texts separately because the illuminations of the *Conspiracy of Catiline* and *Jugurthine War* were completed at two distinct moments, even though the placement of the illuminations was planned when the text was initially transcribed. As a result, they pose different interpretive challenges.

Because the illustration of only the *Conspiracy of Catiline* and the beginning of the *Jugurthine War* shares iconography with the luxury manuscript in the private collection, we cannot be certain that Lebègue alone devised their iconography. He or a *libraire* with whom he worked may have been inspired by artists' models, by the luxury manuscript, or by other manuscripts that now are lost. Nonetheless, Lebègue's descriptions of the thirty-one images that his book shares with the luxury Sallust show that he had the ability to "read" the kinds of moral commentary that artists deployed via details of fifteenth-century dress such as those used in the illuminations of both Sallust manuscripts. For instance, he describes Catiline (fig. 3.18) "in the guise of a bawdy companion [at arms] dressed in a short *pourpoint*, a hat with a feather on his head, his sword at his side, and a Bohemian belt low on his hip" [Et sera pourtrait Catilina en guise d'ung compaignon gaillart vestu d'ung coint pourpoint ung chapel à une plume en sa teste, l'espée au costé à une sainture de Behaigne sur le cul].[46] In the illumination, Catiline wears contemporary fifteenth-century dress that fits the categorization "bawdy companion-at-arms," thereby establishing his moral character as resembling those of the lowlifes and military men wearing similar dress in Terence's *Comedies* (compare fig. 3.18 to figs. 2.20 and 2.34). The comment in the next description, "Catiline and his companions dressed as above" [Catiline et ses compaignons habillez cum dessuz], suggests that Lebègue intended the artists to read his full set of directions and be able to refer back or to remember previous categorizations when they illustrated another manuscript of Sallust.

We can be reasonably certain that the decision to include two images that are not in the manuscript of Sallust in a private collection and the selection of differing scales of images for the illuminations in the *Conspiracy of Catiline* were choices made by Lebègue to guide interpretation of Sallust in Geneva Ms. lat. 54. The first

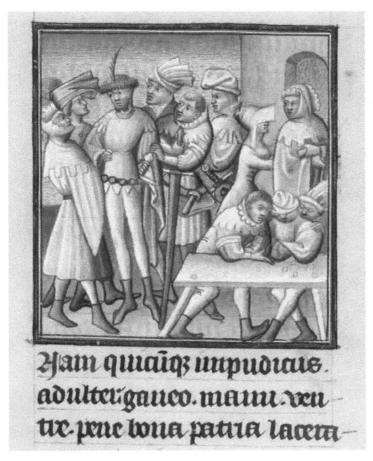

FIGURE 3.18.
Catiline and his companions. Gaius Sallustius Crispus, *Bellum Catilinarium* and *Bellum Jugurthinum*. Geneva Ms. lat. 54, fol. 5r. (www.e-codices.ch).

unusual image is a copy of the frontispiece from BnF Ms. lat. 5762 (see figs. 3.2 and 3.13). It is the largest image in Geneva Ms. lat. 54 and the only one painted in full color.[47] Clearly Lebègue valued this humanist portrait of Sallust in his earlier manuscript and chose to have it repeated. The second unusual image, a picture of Catiline's female companion Sempronia, is less obvious as a choice for inclusion because her function only emerges when she is considered within the fabric of the visual cycle in which she forms part of a visual amplification.

Appendix 1 shows that the pictures are distributed fairly evenly within the chapters of the *Conspiracy of Catiline* in Geneva Ms. lat. 54. There are six unillustrated chapters, thirteen chapters illustrated with a single image, three chapters illustrated with two images, and one, the final chapter, illustrated with three. When chapters contain two or three, the images serve to amplify the text by creating image pairs or sequences that draw special attention to ideas present in the text and entice viewers to pause over them and consider them particularly important.

This is a practice that Laurent de Premierfait also employed in his translations of Boccaccio into French, as chapter 4 will show.

For instance, the two illustrations in chapter 8 of the *Conspiracy of Catiline* terminate and visually amplify the section that establishes Catiline's immoral character. In the first image from the chapter (fig. 3.19), Catiline's coconspirators swear a blood oath to take part in the conspiracy by drinking wine mixed with Catiline's blood, which had been bled earlier in a scene visible in the middle ground of the illumination. The scene in the background takes place later, when Quintus Curius, who had sworn the oath, tells Fulvia, a "woman of quality," about the conspiracy. Lebègue's description establishes the sequence of actions and, as Byrne observed, emphasizes that the conspirators are drinking blood-laced wine by showing Catiline's blood pouring into a contemporary fifteenth-century drinking vessel. It also establishes Fulvia's identity.

> Item. At *Sed in ea conjuratione* let there be made Catiline seated in a chair, the valet before him supporting his bare arm from which the blood runs into a small elongated pot that Catiline holds in his right hand, and at the bottom will be a servant who will hold a pot filled with wine and blood and will give it to Catiline's companions (of whom there will be three or four) to drink. And in another quarter, there will be made a man and an elegant woman speaking together about the conspiracy.

> [Item illec *Sed in ea conjuratione* sera faict Catiline assis en une chaière le varlet devant lui tenant son bras nu dont le sang decoulera en ung petit pot longuet que Catiline tanra à sa main dextre et embas sera ung serviteur qui tanra ung pot et le boute plain de vin et de sang et donnera à boire aux compaignons [fol. 43v] de Catiline dont illec en aura trois ou quatre. Et en ung aultre quartier de la p[l]ace sera fait ung homme et une femme de vie bien gaie parlans ensemble de ladite conjuroison.][48]

The inclusion of a second, unique image to subdivide chapter 8 (fig. 3.20) expands the characterization of Catiline in Lebègue's Sallust by using the representation of women and their dress to amplify Catiline's characterization as a man with lax morals. It introduces Sempronia, who is discussed in the text directly above her picture and serves as an attribute of Catiline in the illuminations of Lebègue's manuscript. Sallust identifies Sempronia as one of Catiline's female conspirators. He describes her as "having many other accomplishments which minister to voluptuousness. But there was nothing which she held so cheap as modesty and chastity; you could not easily say whether she was less sparing of her money or her honor; her desires were so ardent that she sought men more often than she

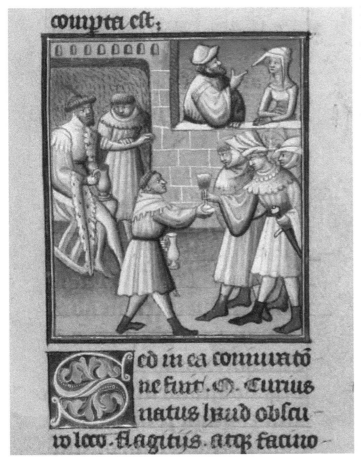

FIGURE 3.19.
Catiline's men take a blood oath; Quintus Curius tells Fulvia about their conspiracy. Gaius Sallustius Crispus, *Bellum Catilinarium* and *Bellum Jugurthinum*. Geneva Ms. lat. 54, fol. 8r. (www.e-codices.ch).

was sought by them. Even before the time of the conspiracy she had often broken her word, repudiated her debts, been privy to murder; poverty and extravagance combined had driven her headlong."[49]

The visual representation of Sempronia uses dress to enhance Sallust's characterization of her as a loose woman and of Catiline as a lowlife. Lebègue understood the visual references to Sempronia's bawdy character when he described the illumination:

> At *Verum ingenium ejus* let there be made Catiline sitting in a chair dressed in a short robe or pourpoint with long dagged sleeves. And before him a bawdy woman [wearing] a hood with its tail turned towards the front, [and] a tight-fitting robe with dagged sleeves reaching to the floor. Catiline will hold that

FIGURE 3.20.
Semphronia and Catil-
ine. Gaius Sallustius
Crispus, *Bellum Catili-
narium* and *Bellum
Jugurthinum*. Geneva
Ms. lat. 54, fol. 9r.
(www.e-codices.ch).

woman by the hand and behind Catiline will be three or four men of his
soldiers.

[Illec Verum ingenium ejus soit fait Catiline assiz en une chaière vestu
d'ung pourpoint court ou robe courte à longues manches decouspées. Et
devant lui une gaillarde femme ung chapperon la pate devant une robe juste
ou corps a manches descoupees jusques à terre. Laquelle femme Catiline
tendra par la main et derrière Catiline seront troys ou quatre hommes de ses
souldars.]⁵⁰

The artist adapted an appropriate contemporary visual model for Sempronia
that was also used for the Orosius illuminator's design for the prostitute Phi-

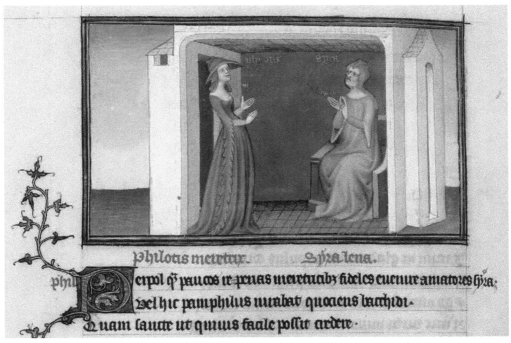

FIGURE 3.21. Philotis speaks to Syra. Publius Terentius Afer, *Comedies*. BnF Ms. lat. 7907A fol. 99v. Photo: BnF.

lotis (fig. 3.21), who appeared in John of Berry's copy of Terence's *Comedies* (discussed in chapter 2). The artists and Lebègue alike understood the power of this visual language of costume as an established and highly legible sign of moral character.[51]

But the illuminations of Catiline, Fulvia, and Sempronia from chapter 8 also interact with the illumination for chapter 9 (fig. 3.22), which introduces the Roman hero of Sallust's history, Cicero. These images interlace their chapters, and their opposing characterizations of women through dress are an additional, purely visual means of reinforcing the moral opposition between Catiline and Cicero that plays out from this point forward in the text of the *Conspiracy of Catiline*. The contrast between Catiline's and Cicero's representations and interaction with women immediately establishes the moral probity of one and degeneracy of the other. In chapter 8 (see fig. 3.20) Catiline and Sempronia appear as equals placed face-to-face, each raising one hand in speech and extending another on the verge of touching each other. They are depicted close to each other, and Catiline's foot nudges her dress. Both wear luxurious clothes with extravagantly cut or dagged sleeves. The image of Cicero on folio 9v offers a deliberate contrast that Lebègue's

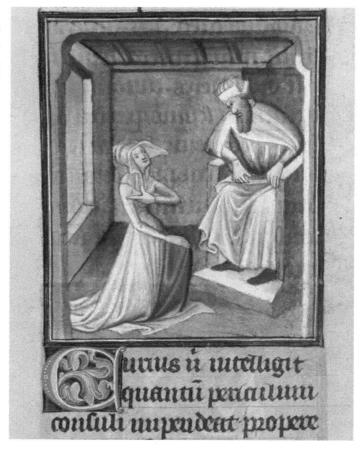

retrospective description recognizes through the distinctions established by the clothes and physical position of Cicero and Fulvia:

> At *Curius ubi intelligit* let there be portrayed a member of council sitting in a chair with a big beard dressed in a mantle and a furred hood [*amice/barret*] on his head with a band of fur below. And before him there will be a kneeling woman dressed simply in a chaperon and a snugly-fitting robe [who] will seem to speak to the man, who, in lowering his head, will seem to listen intently to what she is saying.

> [Illec *Curius ubi intelligit* soit pourtrait un homme de conseil assiz en une chaiere ayans grant barbe vestu d'un mantel et une aulmuce fourée en sa teste// a ung baston de pelles pardessus. Et devant lui soyt à genous une femme vestue d'ung chaperon simplement à une cocte hardie juste laquelle

fera semblant de parler audit homme de conseil qui en baissant la teste fera grant semblant de bien entendre a ce qu'elle dira.][52]

The artist emphasized the social position and importance of Cicero in the illumination. Fulvia kneels respectfully before Cicero's elevated seat, and Cicero is dressed as an administrator. They do not touch. But the artist paid equal attention to the representation of Fulvia; he highlights her modesty by showing her with her hair and décolletage completely covered. Indeed, here, as in the first illumination of chapter 8, the artist exceeded the bounds of modesty employed in contemporary workshop models, as a comparison of Fulvia with the Orosius Master's types for matrons (see above fig. 2.28) from the manuscript of Terence *Comedies* of 1407 makes clear.

Fulvia's gesture (pointing to the left as she speaks with Cicero) also works with the book's physical structure to enhance the association of the two illuminations and polarize the opposition of Cicero and Catiline via Fulvia and Sempronia. Fulvia's gesture of pointing in the illumination on the left side of the opening (fol. 9v–10r) could be seen as referring readers back to the preceding opening in the book (fol. 8v–9r), where the image of Sempronia and Catiline appears on the right-hand page. The opposition between Sempronia and Fulvia created in the text and reinforced in images and the book's physical structure underlines the moral distinction between Catiline and Cicero. Byrne noted this, but he did not explore how this visual amplification becomes part of a larger visual rhetorical structure in the manuscript that associates a suite of images through compositional repetition, changes of scale, and the integration of extratextual details that gloss and expand potential meanings within the text.

A second example from the *Conspiracy of Catiline* exploits the rhetorical power of the change of scale within this system of visual glosses to emphasize Cicero's last appearance in the manuscript in one of only two two-column-wide miniatures to appear within the narrative. This large miniature illustrating chapter 19 (fig. 3.23) shows the meeting of the Roman Senate at which Cato delivered his speech demanding that the conspirators be condemned to death. The Senate's representation in this image differs from five prior scenes of the Senate (on fols. 10r, 10v, 12r, 16r, and 17v), which defined its space vaguely by means of Cicero's chair and low benches and were described accordingly by Lebègue.[53] In contrast, the large illumination and its description by Lebègue evoke fifteenth-century reality by representing the Senate in the guise of the Parlement of Paris. In the foreground, an officer with a baton guards the entry to the large enclosed space within a hall and a sergeant-at-arms holding a mace guards the door to the palace. Lebègue in his description of the image makes a direct comparison to the

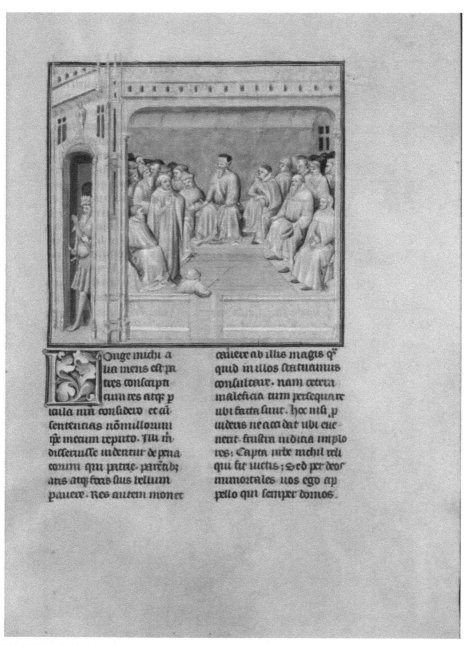

FIGURE 3.23. Cato's speech to the Senate. Gaius Sallustius Crispus, *Bellum Catilinarium* and *Bellum Jugurthinum*. Geneva Ms. lat. 54, fol. 20r. (www.e-codices.ch).

Parlement of Paris, describing a space that he knew well because it was adjacent to the Chambre des comptes in the royal palace where he worked:

> *Longe michi alia* Let there be made a large illumination or Senate in this manner. That is to say a great hall in the palace and at the entry to the hall will be a sergeant-at-arms with his mace guarding the door outside. And in the hall will be a great enclosed space like that of Parlement and guarding at the entry to the enclosed space will be a doorkeeper with his baton, a furred hat with a pearl button on his head. Item, in the enclosed space will be benches like in Parlement. And the Consul Cicero will be seated in the middle dressed as above [that is, earlier in the direction for another illumination] seated a bit higher and the others assembled all around. And among them will be one directly in front, bald headed, his hood lowered who will appear to speak and say his opinion.

> _____

> [*Longe michi alia* Soit fait une grande histoire ou Senat en cette maniere. C'est assavoir une grant sale en my le palaiz et a l'entre de la sale sera ung sergant d'armes a tout sa mace gardant l'uis par dehors. Et dedens la sale sera ung grant parc comme celui de parlement et à l'entrée du parc sera gardens ung huissier à tout sa verge le bonnet fouré à ung bouton de perles en sa teste. Item dedens ledit parquet seront faiz bans comme en parlement. Et sera le consul Ciceron ou milieu vestu comme dessus un pou plus hault assiz que les autres bans tout autour. Et entre eulx sera ung tout droit son chaperon avalé à teste pelée vestu d'un long mantel qui fera semblant de parler et dire son opinion.][54]

Lebègue's assimilation of the Roman past with French present continues in the scene illustrating chapter 20, which shows the consequences—now totally independent of Sallust's text—of Cato's eloquent plea for the death penalty. In a scene related to one in the Sallust in a private collection, it represents (fig. 3.24) the execution of the conspirator Lentulus, leader of the plot in Rome, once his co-conspirator Catiline fled the capital. Rather than a death by strangulation in a dank cellar, as Sallust described, Lentulus is hanged in his chemise in a courtyard before two witnesses and under the watchful gaze of an officer with a mace, who is described and painted exactly like the officer guarding the door of the Parlement in the large illumination immediately preceding: "*Et in carcere locus* Let there be made a prison in which there will be an empty space where there will be a gibbet, the executioner on a ladder who hangs a man, and at the foot of the ladder there will be a sergeant-at-arms with his mace and on the other side there will be two men clasping their hands." [*Et in carcere locus* Soit faite une prison dedans laquelle

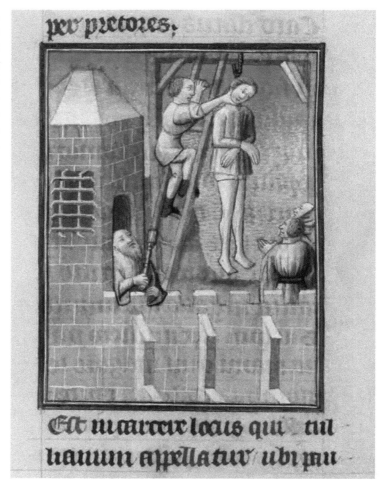

aura une place vuide ou sera ung gibet, le boureau en l'eschièle qui pendra ung homme et au pié de l'eschièle sera ung sergent d'armes à tout sa mace et de l'autre costé seront deux hommes joignans les mains.][55] Lentulus's death conforms to fifteenth-century Parisian practice, when hanging was the capital punishment employed for those who committed murder, theft, and political crimes.[56] Emphatically fifteenth-century in their iconography, anchored by the first image's scale and interwoven by the shared figure of the sergeant-at-arms, this pair illustrates a crime and its punishment that could be read simultaneously as ancient Roman and fifteenth-century French.

Visual amplification and thematic linkage continue in the image that ends the *Conspiracy of Catiline* (fig. 3.25). Though separated from Cato's speech to the Senate on folio 20r, the scene of Catiline found dead among his troops invites as-

puis pugnātes cadūt. post
q̄ catilina fusas copias se
q̄ cū paucis relictū uidet
memor generis atq̄ p̄stine
sue dignitatis ī cōfertissimō
hostes inaurit. Ibiq̄ pugnās
cōfoditur. Sʒ confecto p̄lio
tū vero cerneres q̄ta auda
cia q̄ta animi vis fuissʒ
exercitus catiline. nam fe
re quē quisq̄ uiuus pugnā
do locū ceperat cū amissa
anima corpore tegebat.

Pauca autem quos medios
cohors pretoria disiecerat
paulo diuersius sed omnes
aduersis uulneribʒ conci
derant. Catilina vero lō
ge a suis inter hostium
cadauera repertus est pau
lulum etiam spiritus fe
rotatemq̄ animi quam
habuerat uiuus in uul
tu retinens. Postremo
ex omni copia neq̄ in
prelio neq̄ in fuga q̄sq̄

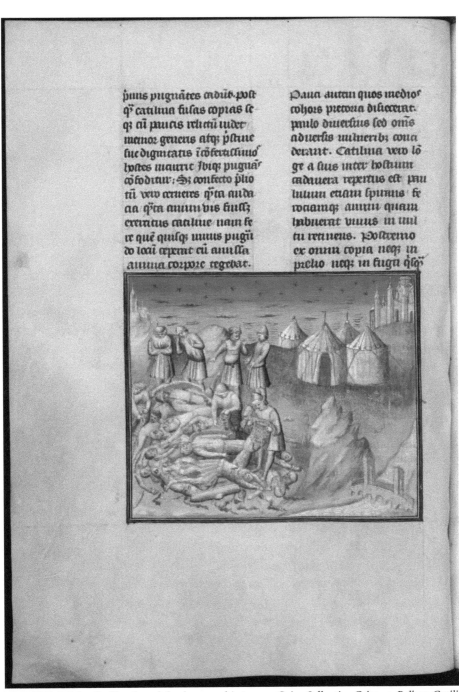

FIGURE 3.25. Catiline found dead among his troops. Gaius Sallustius Crispus, *Bellum Catilinarium* and *Bellum Jugurthinum*. Geneva Ms. lat. 54, fol. 25v. (www.e-codices.ch).

sociation with the speech because of its large scale and violent subject matter. They share a relationship of cause and effect because the Senate's decision resulted not only in the execution of Lentulus and his coconspirators in Rome but also in the military pursuit of and triumph over the forces that had rallied around Catiline outside the capital city.

THE *JUGURTHINE WAR* AND JEAN LEBÈGUE'S PRESCRIBED IMAGES IN BODL. D'ORVILLE 141

When Lebègue's manuscript in Geneva was first planned and transcribed, spaces were left for sixty-five illuminations (a sixty-sixth was placed at the end of the manuscript in an unplanned space). However, the last thirty-four were neither drawn nor executed in Geneva Ms. lat. 54 at the time that its *Conspiracy of Catiline* and the beginning of the *Jugurthine War* were painted up through folio 38v. Although the spaces planned for images in Geneva Ms. lat. 54 were left blank when the manuscript was written and its initials illuminated, the full iconography of Lebègue's cycle of the *Jugurthine War* was neither executed nor completed until the 1430s, when Lebègue collaborated closely with Dunois illuminators to plan thirty-five illuminations in response to directions that he wrote and annotated in preparation for the manuscript's completion. Annotations to Lebègue's prescriptive directions preserved in the margins of D'Orville 141 make clear that he used his original manuscript of directions in the 1430s in supervising diverse artists from the circle of the Dunois Master who both completed Geneva Ms. lat. 54 and added an illustration to the *Jugurthine War* in BnF Ms. lat. 5762.[57]

We will never know why the first campaign of illustration in Geneva Ms. lat. 54 stopped where it did on folio 38v. That campaign ended at an opportune moment with the illustration of Jugurtha consolidating power by killing his remaining cousin, Adherbal, and massacring Adherbal's troops at Cirta, the capital of Numidia [Iug. 28.3]. Though not ideal, it was a comfortable breaking point in the tale of Jugurtha's rise and fall.

This cessation of work on his manuscript may have been caused by a political disruption outside Lebègue's control. Lebègue's gloss at the end of the Latin commentary on Sallust transcribed in Bodl. D'Orville 141 alludes to circumstances that led him in 1417 to flee Paris and take refuge in Bois Trousseau, a chateau in Armagnac Berry, where he found the Latin commentary.[58] If he had to leave Paris when the Burgundians were in the ascendency, he might have fled at other moments as well, for instance when Louis of Orléans was assassinated by Burgundian order in 1407. While Lebègue's motivation for putting the manuscript aside for at

least fifteen years remains uncertain, it seems clear that he lost contact with his collaborators—either the *libraire* who had coordinated production or the artists who had decorated the early portion of Geneva Ms. lat. 54 with images very like those in the Sallust in a private collection. Original illustrations designed by the Orosius Master continue in the privately owned manuscript, often appearing in roughly the same spots in the text as the blanks left after folio 38v in Geneva Ms. lat. 54. However, their visual content is distinctly different from that which finishes Lebègue's book. Clearly Lebègue did not have access to the continuation of the iconographical models that his artists had followed for the first portion of his manuscript completed between 1410 and 1415, and therefore he designed his own to take their place. He then worked closely with the Dunois artists, who made underdrawings for the illuminations and then painted them after reviewing Lebègue's suggested changes.

Appendix 2 outlines the textual structure that initials established in Lebègue's two manuscripts of the *Jugurthine War*, one of which had twenty-two chapters and the other twenty-four. While the *Jugurthine War* added to BnF Ms. lat. 5962 in the 1430s had a single image, to be discussed below, Lebègue planned for a series of thirty-four single-column pictures for the twenty-two chapters of the *Jugurthine War* in Geneva Ms. lat. 54. These were unevenly placed in the chapters subdivided by illuminated initials. They emphasize the sequence of Roman leaders who fought Jugurtha, and they give pride of place to images of Metellus and Marius, the most victorious consuls in the war. For instance, the most densely illustrated chapter (fols. 46r–62v) has sixteen images that document events that took place during Metellus's consulate in Numidia, when he served as head of the forces fighting Jugurtha.[59] The next illustration (fol. 62v), for chapter 18, shows Metellus's successor Marius being appointed consul to Numidia by the Roman Senate. Chapters 19, 20, and 22 emphasize Marius's ultimately successful efforts to defeat Jugurtha. Chapter 19's four images show Marius's Roman forces attacking a series of towns; the three images in chapter 20 show the short-lived alliance of King Bocchus of Mauritania with Jugurtha; and chapter 22 illustrates Bocchus's negotiations in Rome and with Marius's general Sulla that led Bocchus to betray Jugurtha, Jugurtha's defeat by Sulla, and Marius's triumphal entry into Rome.[60]

Lebègue's prescriptive directions to artists on how to illustrate these new scenes in *Les histoires sur les deux livres de Salluste* are much messier than were his descriptions of the images that had already been painted in his manuscript. They are extensive and too full to be effectively represented in the one-column-wide blank spaces left for the artists. As a result, the artists read the directions and visualized some, but not all, that Lebègue described. When Lebègue reviewed the

resulting underdrawings, he accepted some of their omissions but reacted strongly to others, specifying in his marginal comments the essential changes that the artists should make as they completed the illumination. The mid-fifteenth-century copyist of Bodl. D'Orville 141 transcribed Lebègue's marginal directives correcting artists at the same time that he copied Lebègue's original directions.

Consideration of the directions and annotations together reveals, again, how well attuned Lebègue was to artists' spatial conception and their practice of contemporizing dress in order to make Roman identities understandable for a fifteenth-century audience. For instance, in the scene of Jugurtha appearing before the commons in the Senate in Rome (fig. 3.26), Lebègue's direction emphasizes the simple dress of Jugurtha and the office of Gaius Baebius, a tribune of the people, whom he compares to a *prevost des marchans*. He also interjects a figure that he knew well, a *greffier* (a clerk of the register like Lebègue himself), who sits on a low bench taking notes.

> *Igitur Jugurta contra.* Let there be made again the senators seated in their seats and the *greffier* and the less important officers below and let there be shown King Jugurtha, not in royal dress, but poorly dressed and the judge of military affairs, who presents him to the senators, like a male prisoner who had surrendered to them. Item. Let there be made the Consul Memmius, who lists the evils that he [Jugurtha] has done and by whose counsel, and, in the other part near the said king, let there be made Baebius, tribune of the people, like a *prevost des marchans*, who will speak for him and calm the people.

> [*Igitur Jugurta contra* Soient derechief faiz les senateurs assiz en leurs sièges et le greffier et les menus officiers (fol. 48r) en bas et soit fait ledit Jugurta roy non mie en habit royal mais povrement vestu et le preteur Cassius qui le presentera aux senateurs comme homme prisonnier qui s'estoit rendu à eulx. Item soit fait le consul Memmius qui recitera les maulx qu'i[l] a fait, et par quel conseil. Et d'aultre part emprès ledit roy soit fait <u>Bebius</u> tribun du peuple, comme prevost des marchans, qui parlera pour lui et rapaisera le peuple.][61]

In their final product, the artists made careful distinctions. It seems they read *menu* in the French direction as meaning "little" rather than "less important" so they drew everyone in the foreground smaller than the senators seated on the bench. King Jugurtha is crowned, and he wears a simple untrimmed robe that is neither as long nor as fur-trimmed as the robes worn by the consuls Memmius and Baebius in the left foreground. Baebius's categorization, "like a *prevost des*

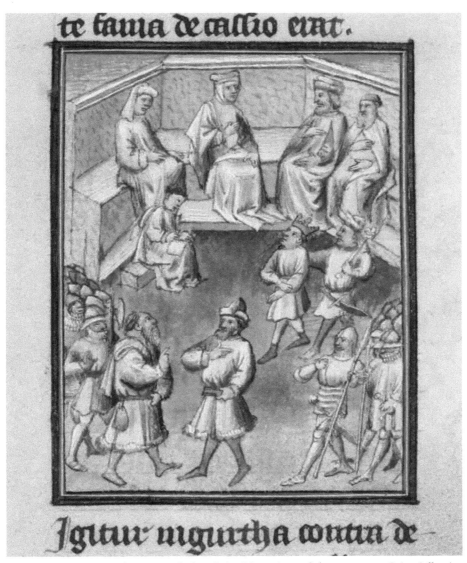

FIGURE 3.26. Jugurtha appears before Gaius Memmius and the commons. Gaius Sallustius Crispus, *Bellum Catilinarium* and *Bellum Jugurthinum*. Geneva Ms. lat. 54, fol. 42r. (www.e -codices.ch).

marchans," clarified for the artists that he came from the financial arm of the government, which may explain why he alone wears a purse dangling from his belt of his fur-trimmed robe. It is tempting to speculate that the purse could have been suggested by Lebègue in conversation with the artists, since Baebius spoke in defense of Jugurtha because he had been bribed to do so [Iug. 33.2].

The artists were less concerned than Lebègue that the Roman consul be immediately apparent. For example, the marginal annotations to Lebègue's directions to the illuminator in Bodl. D'Orville 141 (fig. 3.27) indicate that corrections needed to be made on Geneva Ms. lat. folios 51r and 52r and outline the type of omission that should be corrected: "Here the Consul Metellus and his army are necessary" [Cy fault le consul Metellus et son ost] and "Here the Roman consul and the Roman banner are necessary" [Cy fault le consul Romain et la baniere roumaine]. The artist responded by inserting on Geneva Ms. lat. 54, folios 51r and 52r, a version of the imperial eagle (a sable eagle on a field of gold) and a mass of heads to indicate the army (see, for example, fig. 3.28).

When studied in the aggregate, Lebègue's prescriptive notes show two things. First, there are revelatory moments in which the experience and visual frame of reference of the artists led them to misunderstand Lebègue's historical allusions. For instance, Lebègue's direction for the illustration on folio 47r gave rise to an artistic mistake:

> *Igitur legatos ad consulem* Let there be made the army of Metellus and his companion together and the said two consuls or captains seated in an open tent on which there will be the imperial eagle, before whom will be the legates or messengers of King Jugurtha who ask for peace saying that the king will put himself, and his realm, his goods, and his children in the hands of the Romans and will ask nothing except that they leave him and his children alive.

> [*Igitur legatos ad consulem* Soit fait l'ost de Metellus et de son compaignon tout ensemble et lesdits deux consuls ou capitaines en une tente sur laquelle sera la bannière imperial ouverte assiz, devant les quelz seront les legaz ou messages du roy Jugurta qui les requerront de paix disant que le roy metoyt soy et son reaume, ses biens et ses enfans en la main des Roumains et ne demandoit fors que l'en lui laissast la vie et à ses enfans.][62]

The artist, seeing the word *legaz*, probably represented the characters as religious figures, thinking of a possible fifteenth-century definition: "representative of the pope, ambassador of the Holy See."[63] The image was corrected (fig. 3.29) to show lay legates in response to Lebègue's marginal correction to his directions: "On folio 47 let the legates be corrected and made in the guise of laymen" [Ou fueillet xlvij soient corrigé les legaz et fais en guise de gens lays].

Lebègue's correction to the artist's directions for the illustration of Marius attacking a fortress near the Muluccha River (fig. 3.30) illustrates how different the

FIGURE 3.27. Marginal annotations indicating corrections for folios 51 and 52 in Geneva Ms. lat. 54. Jean Lebègue, *Histoires sur les deux livres de Salluste*. Bodl. D'Orville 141, fol. 49v. Permission Bodleian Libraries, University of Oxford.

FIGURE 3.28. Metellus and his men burn and pillage fertile lands in Numidia. Gaius Sallustius Crispus, *Bellum Catilinarium* and *Bellum Jugurthinum*. Geneva Ms. lat. 54, fol. 51r. (www .e-codices.ch).

frames of reference of a humanist and an artist could be, and how misunderstanding can produce strange results. Lebègue wrote,

> Item, there *Et forte in eo loco* let there be made a large rock on which will be another castle close to a river, to which one mounts by a narrow path in front. And in front of this castle Marius and his army will be made and for mounting by this narrow road there will be made *vignes* below which the men-at-arms will go. These *vignes* are a sort of long and large engine covered with leather under which men-at-arms can be made to go up to the wall of the said

facere conatus est.

Igitur legatos ad consulē cum supplicijs mittit; qui

FIGURE 3.29. Jugurtha's envoys come before the Consul Metullus. Gaius Sallustius Crispus, *Bellum Catilinarium* and *Bellum Jugurthinum*. Geneva Ms. lat. 54, fol. 47r. (www.e-codices.ch).

castle. There will be those in the castle who throw large stones and fire which destroy the *vignes*.

[Item illec *Et forte in eo loco* soit faite une haulte roche sur laquelle sera assis un aultre chastel assez près d'une rivière, ouquel chastel on montoit par une estroite voye par devant. Et devant se chastel sera fait Marius et son ost et pour monter par celui estroit chemin seront faites vignes par dessoubz lesquelles

FIGURE 3.30. Marius attacks a fortress on a craggy hill near the Muluccha River. Gaius Sallustius Crispus, *Bellum Catilinarium* and *Bellum Jugurthinum*. Geneva Ms. lat. 54, fol. 68v. (www .e-codices.ch).

iront gens d'armes. <u>Ces vignes sont une manière d'angines longs et larges couvers de cuir où se peuvent mectre par dessoubz gens d'armes pour aler jusques au mur dudit chastel.</u> Or seront ceulx du chastel qui getteront grosses pierres et feu qui corrompront les vignes.] (underlining in original)[64]

Lebègue's description of the siege engine was very similar to that given by Pierre Bersuire in his translation of Livy in the 1350s, a text that Lebègue knew well.[65] The artist must have taken only a cursory look at the direction, however, because

he ignored Lebègue's definition and took the word *vignes* at face value. As a result, he painted large grape leaves right outside the door of the castle. Perhaps in frustration, Lebègue underlined the words in his directions as a way of defining *vigne,* but he did not repeat the definition in a marginal note to correct the image. Because Lebègue's corrections were almost always in the margins, this correction escaped the artist's notice and the siege engine was never substituted for the vines when the illumination was painted in Geneva Ms. lat. 54.

Consideration of Lebègue's prescriptive notes also shows that he assumed he would only have to give concrete directions once, and that artists would refer back to or remember them when illustrating the images. While this worked for areas of visual expression in which artists were practiced, such as dress, it did not work for all. For instance, Lebègue expected the artists to remember the Roman banner as described at the first appearance of the Roman army in the *Conspiracy of Catiline* on Bodl. D'Orville fol. 45v: "those of Rome who will have for a banner a sable eagle on a field of gold" [ceulx de Romme qui auront pour bannière un aigle de sable et le champ d'or].[66] But the artists did not look back very often; they followed the written direction for the miniature that they were painting and nothing more. As a result, Lebègue had to suggest that they add the arms of Rome to nine miniatures in Geneva Ms. lat. 54.[67]

Lebègue also seemed more interested than his artists in using race as a visual indicator to differentiate the Romans from the Numidians and Mauritanians. The direction for the first of his newly prescribed images (see fig. 3.11) uses race and dress; it specifies that contemporary dress be used to distinguish the Romans from the Numidians, who should be dressed as "Saracens." To enhance clarity, Lebègue called for racial distinctions as well:

Igitur rex Let a great castle be made where the king Jugurtha will be seated on a bench or a chair and on either side of him there will be two Roman legates, all armed. And the said king will swear peace and loyalty to one of the legates who will be on his right side. And outside the said castle there will be elephants and other beasts which the said king will give to a Roman magistrate or captain accompanied by several men-at-arms. And be warned that in all the *histoires* [pictures] the Romans should be made more in the manner of Italy and typical faces but the king and his people from the countries of Africa will be less white and in the dress of Saracens.

[*Igitur rex Soit* fait ung grant chastel où que soit assiz un ung banc ou une chaière le roy Jugurta et aux costés de lui seront deux legas de Romme tous en armes. Et ledit roy baillera la foy à l'ung desdits legas qui sera au costé dextre

en manière de paix et de abandonnement. Et au dehors dudit chastel seront elefans et al aultre bestail que ledit roy pour paix faisant fera bailer à un questeur ou capitaine roumain acompaigné de plusieurs gens d'armes. Et soit adverti que en toutes histoires l'en face les Romains plus selon la manière d'Italie et visages communs, mais le roy et ses gens du pays d'Auffrique seront moins blans et en habiz de Sarazins.][68]

The diverse artists who painted the manuscript ignored Lebègue's suggestion that Africans be painted as "less white" throughout the *Jugurthine War*. Jugurtha was represented with a dark face only in the miniature following this direction. Because Lebègue did not correct them in his marginal notes, Jugurtha, his soldiers, and his envoys were represented as white men on all subsequent folios. However, once King Bocchus of Mauritania appears [Iug. 80.3], Lebègue became more insistent. His directions for the first representation of Bocchus (fig. 3.31) categorize Bocchus and his men as "blacks from Mauritania":

Preteres regis Bocci Let there be made in the first part, King Jugurtha and King Bocchus of Mauritania speaking together and making an alliance by faith and oath one to another. And let the said King Bocchus be made all black and also all his men like blacks from Mauritania. And in the other part of the place let the castle of Cirtha be made and the said two kings together with their entire host ready and willing to besiege the castle, but they [the kings] had not yet come down. And in another part will be the Consul Metellus waiting to learn if the new King Bocchus and his Moors would fight, and [he] had his troops close ditches all around.

[*Preteres regis Bocci* Soient fais en la première partie le roy Jugurte et le roy Boccus de Morienne parlans ensemble et faisant aliance par foy et serment l'un à l'autre. Et soyt fait ledit roy Boccus tout noir et aussi tous ses gens comme noirs de Morienne. Et en l'aultre partie de la place soyt fait le chastel Cirtha et lesdits deux roys ensemble à tout leurs ost prest de vouloir aler asseger asseger [*sic* repeated twice] ledit chastel mais ne seront point encores descendus. Et d'aultre part sera l'ensul [*sic* for le consul] Metellus attendant de savoir comment se nouvel roy Boccus et ses Maures se contendront et fist son ost fermer de fossez tout autour.][69]

In addition to his marginal correction insisting that artists add a Roman banner, Lebègue made a second marginal note reiterating the racial identity of the Mauritanians for his artists: "Let it be known that from here on the king Bocchus of Mauritania and all his men will be figures all black, like Moors" [Soit cy adverti

FIGURE 3.31. King Boccus becomes an ally of King Jugurtha; they approach Cirta as Metellus and his men wait nearby. Gaius Sallustius Crispus, *Bellum Catilinarium* and *Bellum Jugurthinum*. Geneva Ms. lat. 54, fol. 61r. (www.e-codices.ch).

que doresenavant le roy Boccus de Morianne et tous ses gens soient figurés tous noirs comme Mors].[70] Bocchus is shown as black in all subsequent representations of him, probably because Lebègue continued to specify in his directions that Bocchus was "all black" [tous noir].[71] In contrast, other black Mauritanians were shown only three times, and in each case their blackness was described in the directions. This happens when Marius and Sulla rout Bocchus and Jugurtha's forces, which included Bocchus's sons; when Bocchus, accompanied by his two sons,

receives a Roman embassy; and when envoys of Bocchus appear before the Roman Senate.[72] In each of these cases Lebègue seems to have realized what Laurent de Premierfait had learned when planning illustrations for Terence's *Comedies*: if a visual clue is designed to establish difference, it is essential that it be used carefully. This practice was used in Terence's *Comedies* when artists distinguished the brothers Micio and Demea, both old men, by dressing only one in atypical clothing (see fig. 2.30). Similarly, in Lebègue's *Jugurthine War* Jugurtha is black when he is first introduced, to differentiate him from the Romans, but subsequently he is white. Bocchus, his sons, and his envoys are shown as black to distinguish them from both the Romans and Jugurtha.

The final image of the *Jugurthine War,* showing Marius's triumph as Jugurtha is brought prisoner to Rome (fig. 3.32), differs from the other prescriptive images because it may have been planned as an addition. It was not painted in a void left by the scribe who transcribed Geneva Ms. lat. 54, but appears at the bottom of the column after the explicit, where it overflows from the left column into the intercolumnar space. Because of its size and placement, it is the most significant visual amplification in the *Jugurthine War.*

Lebègue's humanist interest informed the content and visual form of the Triumph of Marius. This scene illustrates the last lines of the *Jugurthine War,* "but when it was announced that the war in Numidia was ended and that Jugurtha was being brought a captive to Rome, Marius was made consul in his absence and Gaul was assigned to him as his province. On the Kalends of January, he entered upon his office and celebrated a triumph of great magnificence. At that time the hopes and welfare of our country were in his hands."[73] Lebègue's planned illumination of the triumph makes it more vivid by including details that derive from research in other histories of Rome, such as those by Valerius Maximus and Livy, or even in commentary by Isidore of Seville (see appendix 3). Lebègue's surviving directions for the Sallust in Geneva offer rare insight into what he sought to achieve in the image:

> Item. At the end let there be made the consul Marius crowned with laurel in a *char* [cart] with four white horses. And before the *char*, Jugurtha and his two children will be on foot, bound with iron chains like prisoners, their hands behind their backs. Behind the *char* will be soldiers from Marius's army mounted and on foot. And before the *char* there will also be numerous trumpets and the banner of Rome. Item let the city of Rome be made before them from which all manner of people will issue to come before the consul in great joy.

> [Item en la fin soyt fait le consul Marius couronné de laurier en un char à quatre chevaux blanc. Et devant le char seront à pié le roy Jugurte et ses deux

nostram memoriam sic
romani habuere alia
omnia uirtus sue pro
na esse cum gallis pro
salute non pro gloria
certare. Sz postq̄ in in
uidia bellium confecti
et iugurtham uinctum
adduca rome nunciati
est. marius consul ab
sens factus est et ei decr̄
ta prouincia gallia est.
Is q̄. kl. Januarij ma
gna gloria consul trim
phauit. Er ea tempesta
te spes atq̄ opes ciuita
tis in illo sit siue.

Expliat.

FIGURE 3.32. Marius's triumph as Jugurtha is brought prisoner to Rome. Gaius Sallustius Crispus, *Bellum Catilinarium* and *Bellum Jugurthinum*. Geneva Ms. lat. 54, fol. 78r. (www.e-codices.ch).

FIGURE 3.33. Marius's triumph as Jugurtha is brought prisoner to Rome, detail of image. Gaius Sallustius Crispus, *Bellum Catilinarium* and *Bellum Jugurthinum*. Geneva Ms. lat. 54, fol. 78r. (www.e-codices.ch).

enfans liez de chaennes de fer comme prisonniers les mains derrière le dos. Derrière le char seront les gens d'armes à pié et cheval de l'ost Marius. Et devant le char aussi seront plusieurs trompettes et la bannière de Romme. Item soit fait faitte devant eulx la cité de Romme de laquelle toute manière de gens istront pour venir au devant du consul faisant grant joie.][74]

Lebègue's concern for the clarity of the image in the Geneva book led him to critique its original design, which is still partly visible in pentimenti that show through the thin surface of paint (fig. 3.33). The artist was stymied by the amount of detail that Lebègue had provided and chose to focus on Marius's *char* and horses in the underdrawn design. The drawn remnants of horses' legs visible in the bottom right of the illumination clarify that the artist had originally omitted the prisoners to focus his composition on Marius's *char*, pulled by horses moving parallel to the picture plane. Lebègue annotated his original directions with a marginal note of correction: "Let King Jugurtha and his children be made on foot tied up like prisoners like the thing devises it" [Soit fait le roy Jugurte et ses enffans à

pié liez comme prisonniers comme la chose le divise].[75] In response to this critique, the artist of the Geneva Sallust adjusted the horses pulling the *char* so that they turned into the landscape at a ninety-degree angle in order to leave room for the king and his sons. The arms of Jugurtha and his sons are bound, as the marginal correction demanded, but not behind their backs, as Lebègue's original direction had specified. Apparently Lebègue cared less about the crowds he had described emerging from Rome to greet the triumphant consul; he did not mention in his correction that they had been omitted, even though he had described them in the original direction to the artist.

This added image works in interesting ways with the full cycle of the *Conspiracy of Catiline* and *Jugurthine War*. By including an elaborate picture of triumph after the text's end, Lebègue responded to a common medieval disquiet with the vagueness of the end of Sallust's tale of Jugurtha. The ending gave no indication of Jugurtha's ultimate fate, so frustrated readers often rounded out Jugurtha's life by transcribing a couplet found in many medieval manuscripts of Sallust explaining that he died at the base of the Tarpeian Rock.[76] The final miniature that Lebègue prescribed ended the *Jugurthine War* with Marius's triumph after he was named consul, with Gaul as his province. In many ways this picture, which is larger than a column in width, terminates the pair of large-scale exemplary pictures from the *Catiline Conspiracy* in the manuscript in which, first, Cicero decides to punish the coconspirators in response to Cato's speech, and second, the punishment is completed when the Romans defeat Catiline and he is found dead among his troops (see figs. 3.23 and 3.25). This celebration of Marius's designation as governor of Gaul, which was often equated with France, would give French readers another avenue for understanding Sallust's history as pertinent to them. It is almost as though the good government of Rome were to be translated to Gaul. Lebègue had pointed out the easy equivocation between Gaul and France in a marginal comment to his copy of *Les faits des romains* (BnF Ms. fr. 23083, fol. 20v) where he responded to the rubric, "How Julius Caesar conquered France" [Comment Iulius Cesar conquest France] with a long note that included his observation that the country was called Gaul at the time of Julius Caesar and that the French came later.[77]

THE ADDITION OF THE *JUGURTHINE WAR* TO JEAN LEBÈGUE'S EARLY *CONSPIRACY OF CATILINE*

Perhaps because Byrne concentrated on the *Conspiracy of Catiline* in his analysis of Lebègue's earlier manuscript of Sallust (BnF Ms. lat. 5762), he did not notice

that Lebègue revised this personal copy even more dramatically in the 1430s, when he more than doubled it by adding the *Jugurthine War,* beginning with a second narrative frontispiece decorated by artists from the circle of the Dunois Master.[78] It is striking that this happened at roughly the same time that Lebègue finished the visual cycle of Geneva Ms. lat. 54. The different scribe who added the *Jugurthine War* placed rubrics in the upper margins of folios 3r and 38v to distinguish Sallust's two texts from each other (compare figs. 3.2 and 3.34), and Lebègue (perhaps) erased his signature, which had appeared on folio 36v at the end of the *Conspiracy of Catiline,* where his manuscript formerly ended. The frontispiece beginning the *Jugurthine War* is particularly inventive in the way that it reinforces the unity of the newly expanded volume. It begins not with a second author portrait of Sallust, but rather with a multicompartment illumination, which Lebègue carefully annotated with French captions on the bare parchment when the images had been drawn but not yet painted.[79] The words and images in this frontispiece draw attention to key events of the *Jugurthine War* and shape its reception as both the account of an internecine feud that was resolved by Rome and an example of the rise and fall of Jugurtha at the hands of fortune.

The frontispiece's four distinct scenes are arranged in three registers, each with its own French caption. The first register's caption, "How Jugurtha, in order to reign alone, had Hiempsal killed and drove Adherbal out of the country" [Comment Jugurta pour regner seul fist tuer Hiemsal et hors du pays chassa Atherbal], links the two scenes of Jugurtha's attacks on his cousins, which contain additional single-word captions written on the bare parchment ground to identify Jugurtha and his cousins Hiempsal and Adherbal. In the first scene at left, Jugurtha stands crowned, wearing armor, and surrounded by foot soldiers outside a building in which a soldier assassinates King Hiempsal. In the second scene, at right, King Jugurtha leads his mounted knights, who rout King Adherbal and his army. Though individually framed within the register, these scenes are unified artistically. Jugurtha moves relentlessly from left to right, actively ordering or taking part in the sequential aggressive actions that the miniatures show.

In contrast, the two lower registers emphasize Jugurtha's punishment at the hands of the Roman consul Marius. The middle register's caption, "How the Consul Marius defeats the two kings Jugurtha and Bocchus" [Comment le consul Marius desconfist les deux rois Jugurta et Bocchus], sits below a scene set in a sweeping landscape. At left, Marius sits astride a white horse, accompanied by his forces, and looks down over the battlefield littered with bodies; he spots the fleeing figures of King Jugurtha, his ally King Bocchus, and their smaller army. The final register is a scene of Marius's triumph in Rome, which illustrates the caption that begins above and ends below the image: "Rome. How Marius the Consul in triumph

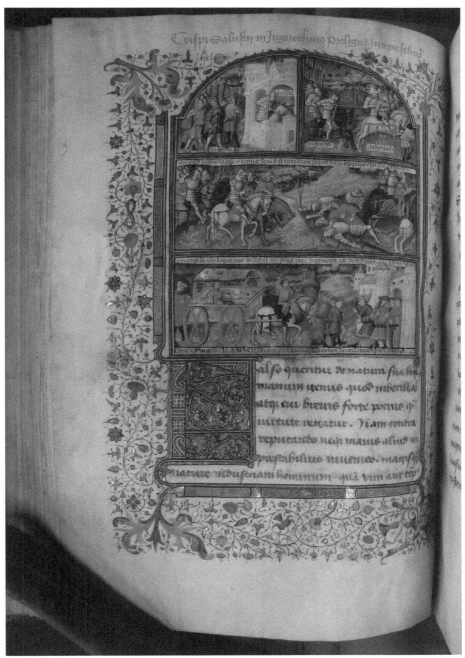

FIGURE 3.34. Hiempsal is murdered at night and Adherbal is routed; Marius defeats Kings Jugurtha and Bocchus; Marius's triumphal entry into Rome. Gaius Sallustius Crispus, *Bellum Catilinarium* and *Bellum Jugurthinum*. BnF Ms. lat. 5762, fol. 38v. Photo: BnF.

leads Jugurtha and his children before him" [Roma. Comment Marius le consul en triumphe menoit devant Jugurta et es enfants]. Like the others, this narrative scene moves from left to right. Marius wears a red robe and golden crown and sits enthroned under a golden canopy in a four-wheeled golden cart pulled by two horses, one of whom turns abruptly back into the landscape to save space. Marius's horse handler cracks his whip over the heads of a red-robed king with his hands bound behind his back, who, with his sons, walks toward Rome. At right, burghers and citizens pour out of the gates of the city to greet Marius.

Perhaps because the four scenes are drawn from widely separate sections of the text, their visual material often amplifies or recasts the story, effecting a double visual translation: first, the Latin text is condensed and translated into French captions, and second, the French captions are visualized in the pictorial representation in the frontispiece. For example, Jugurtha lurks outside the building in the first scene in which Hiempsal is murdered at night. This clarifies visually his responsibility for the murder, perhaps illustrating Jugurtha's promise "to be at hand at the proper time with a strong force" [Iug. 12.4]. The second scene in the top register could illustrate any number of texts concerning Adherbal. It resonates with Adherbal's speech in the Roman Senate in which he says, "Jugurtha, wickedest of all men on the face of the earth, in despite of your power robbed me, the grandson of Masinissa and hereditary friend and ally of the Roman people, of my throne and all my fortunes" [Iug. 14.2]. Because of the starry sky, however, it is closer to the events Sallust described happening near the city of Cirta just before daybreak, when Jugurtha's men attacked Adherbal's camp and routed him and a handful of his followers, who fled into the city [Iug 21.2]. Neither of these texts concerning Adherbal is a perfect fit for the caption.

The second register's scene of Marius defeating Jugurtha and Bocchus resonates with Sallust's description of a daybreak attack that initiated the pursuit of the two kings [Iug. 99.2] and with the bloody battle outside Cirta that ended the kings' alliance, leading to Bocchus's betrayal of Jugurtha to the Romans [Iug. 101.11]. In the final register Lebègue honed the final scene of Marius's triumph in Geneva Ms. lat. 54 (compare figs. 3.33 and 3.34). Perhaps following Lebègue's written directions and the model of Geneva Ms. lat. 54, the painter of the frontispiece preserved the awkward turn of the horses pulling the *char* that was apparent in Geneva Ms. lat. 54 and included the citizens pouring out of the city of Rome that Lebègue had described in his written direction preserved in Bodl. D'Orville 141. His sole divergence from Lebègue's original directions was to give the consul a golden crown instead of a laurel wreath. This distinctive addition in BnF Ms. lat. 5762 reflects the kinds of research on Lebègue's part that lay behind the formulation of the triumph that ends Geneva Ms. lat. 54. The closest description to this

visual formulation among the early fifteenth-century textual descriptions of triumphs to which Lebègue had access (outlined in appendix 3) is the gloss of a translation of Valerius Maximus begun for Charles V circa 1374 and completed for John of Berry in 1401. Because the Romans were familiar with triumphs, Valerius Maximus did not describe their appearance. However, fifteenth-century audiences were ignorant of the ritual, and so the translator of Valerius Maximus amplified the passage on triumph with a paraphrase from Isidore of Seville's *Etymologies*. This amplification explains that the person being celebrated sits in a chariot (*char*) pulled by four horses. If he has defeated his enemy in combat, as Marius had in the *Jugurthine War*, he wears a spiky gold palm crown. If he had not been involved in direct combat, he wears a laurel crown. People pour from the gates of Rome in celebration to greet the triumphant warrior, prisoners precede him with their hands tied behind their backs, and soldiers follow, praising their "prince." Images in Lebègue's Sallust manuscripts are closer to the description of a triumph given in the French translation of Valerius Maximus than are the illustrations from manuscripts of that translation itself, as for instance in John of Berry's copy of 1402 (fig. 3.35). The substitution of a gold crown in the *Jugurthine War* frontispiece for the laurel described in the directions and represented in Lebègue's densely illuminated manuscript suggests that between production of these two manuscripts Lebègue realized that Marius should wear the gold palm crown rather than a laurel wreath because Jugurtha had been defeated in combat.

The visual version of Jugurtha's tale offered in the four scenes of Lebègue's frontispiece signals the end of Jugurtha's public life. It presents the succession from treacherous government to good government as a theme of the *Jugurthine War*. The scenes gathered in the frontispiece and anchored by their French captions visually translate and amplify select moments in the text to establish an overall reading of the *Jugurthine War* as a tale of political crime within a family and of the just punishment of the perpetrator. The Latin accessus (discussion of the artist's life as it relates to the work) on folios 37r to 38r, which precedes the frontispiece and introduces the *Jugurthine War*, reinforces this interpretation. It discusses the prologue that begins the *Jugurthine War*, orients the reader to Sallust, identifies major themes discussed by him, and praises the pursuit of literary studies. In this respect, as Byrne first suggested, the accessus certainly alludes back to the prologue to the *Conspiracy of Catiline* and to the picture (see fig. 3.2) that preceded it.[80] This Latin accessus, however, resonates even better with Lebègue's second frontispiece (see fig. 3.34). Before turning to its discussion of Sallust's prologue, which follows the second frontispiece, the commentary mentions Sallust's goal in producing the text—a goal that the sequence of four images in the frontispiece embodies. "His aim is to warn men not to strive for position by treachery, lest they

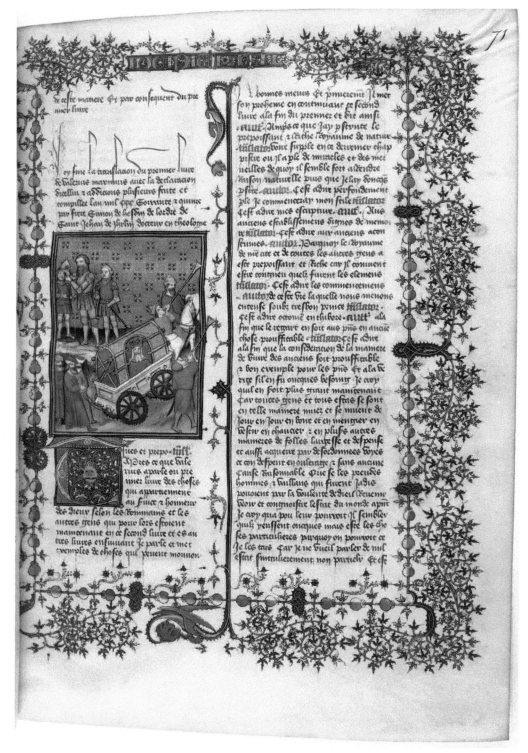

FIGURE 3.35. Roman triumph. Valerius Maximus, *Faits et dits mémorables*, translated by Simon de Hesdin and Nicolas de Gonesse. BnF Ms. fr. 282, fol. 71r. Photo: BnF.

come to a bad end, as in the case of Jugurtha, who acquired a kingdom by treachery and so came to grief."[81]

The condemnation of treachery expressed in the Latin commentary added with the *Jugurthine War* to Lebègue's manuscript in the 1430s resonates particularly well with both the visual frontispiece that follows it and the historical events of the early fifteenth century. Like Sallust's North Africa, Lebègue's France was in political turmoil. The debilitating madness of King Charles VI left an opening for political factions, which in the early fifteenth century were led by Duke Louis of Orléans, the brother of the king, and John the Fearless, Duke of Burgundy, who was the cousin of the king and of Louis of Orléans. Throughout the early years of the fifteenth century, the dukes jockeyed for influence. Their struggle reached a crisis in 1407, when John the Fearless arranged the assassination of Louis of Orléans, the father of the boys for whom Lebègue had made the manuscript twin to his copy of the *Conspiracy of Catiline*. The added frontispiece and text of the *Jugurthine War* may have been an allusion made by Lebègue either to this event, in which cousin murdered cousin, to the civil war that ensued, or to the retaliatory assassination in 1419 of John the Fearless by supporters of Dauphin Charles (later King Charles VII). If Byrne is right, the civil war forced Lebègue to leave Paris for a time in 1417 to take refuge in Armagnac Berry, where he took advantage of his location to copy an old commentary on Sallust that he found—the commentary preserved in Bodl. D'Orville 141—whose colophon provides this information. The familial strife continued to be present in public memory in the 1430s, when Lebègue had the missing thirty-five illuminations of the *Jugurthine War* completed and the text of the *Jugurthine War* and its frontispiece added to his earlier manuscript of the *Conspiracy of Catiline*. Fratricide like that recorded in the *Jugurthine War* was a topic at the Treaty of Arras in 1435, when several conditions negotiated by the Burgundians required Charles VII to atone for the death of his cousin John the Fearless in 1419.[82]

Lebègue was not alone in finding in the past echoes of contemporary concerns. Numerous French authors, confronted with the horrors of civil war and the plight of the French monarchy, turned to biblical and ancient history for parallels to contemporary suffering, often described as family strife.[83] The Burgundians even wrote an allegorical account of the events leading up to the Treaty of Troyes as part of a justification for breaking that treaty in order to seal the Treaty of Arras. This allegory, which was followed by a text in which "all the points of law were posed and resolved," presented Charles VI as Darius, King of Persia, the dauphin as Darius's son, the Duke of Galilee, and Henry VI as Pharaoh, the king of Egypt.[84]

Lebègue's visual meditation on crimes and their punishment in the frontispiece to the *Jugurthine War* resonated with these contemporary public events and

texts. Its visualization of a just resolution celebrated in a classical triumph is more hopeful than the passages echoing the familial strife and civil war in France that Lebègue himself marked in the margins of this book. As just one example, but a typical one, Lebègue placed a *trefle* on folio 58r in the margin by a passage in Gaius Memmius's speech condemning Jugurtha's assassinations and urging the Romans to action: "But who are they who have seized upon our country? Men stained with crime, with gory hands, of monstrous greed, guilty, yet at the same time full of pride, who have made honor, reputation, loyalty—in short everything honorable and dishonorable—a source of gain."[85] Perhaps because the content of the frontispiece embodies four moments excerpted from the text and presented with captions by Lebègue, it displays an optimism that even his marginal annotations of Sallust lack. Lebègue's visual expansion in the frontispiece celebrated the order and just government that followed Jugurtha's revolt. Such visualizations must have offered comfort to Lebègue and others in the troubled early fifteenth century.

Lebègue's interest in Sallust extended over several decades during which he, like Laurent before him, came to terms with and embraced densely illuminated manuscripts. What is striking about the examples associated with Lebègue is the way in which his own collection was enriched by the manuscripts that he had made for himself at the same time that other copies were produced for a more noble audience. Lebègue's directions to illuminators, preserved in Bodl. D'Orville 141, reveal that he worked assiduously to create his own visual cycle, and his frontispiece added in the 1430s to the *Jugurthine War* in BnF Ms. lat. 5762 shows that he had devised a new way to invigorate the text by introducing a frontispiece for a Latin text that simultaneously offered both visual and French-language epitomes of the tale of Jugurtha.

PART 2

Illumination in French Translations

Illumination in French Translations by Laurent de Premierfait

How does visual translation work in manuscripts that are themselves translations from Latin or Italian to French? Unlike the classical texts whose production Laurent de Premierfait and Jean Lebègue supervised and whose illustration established a cultural translation, illuminated manuscripts containing translations into French involve a minimum of two layers of translation: translation of text and visual translation. A consideration of Laurent's prologues for a series of translations from Latin or Italian to French between 1400 and 1414 gives insight into both his awareness of the difficulties posed by translation of books from another time or different culture and the steps he took to be successful at it. As Laurent gained experience, linguistic and visual translation became more and more intertwined.

Laurent explains his use of rhetorical amplification, the development of a simple phrase or description by the addition of supplemental details, in a series of prologues accompanying his translations. In 1409, in the prologue to his revised translation of Giovanni Boccaccio's *De casibus virorum illustrium*, Laurent explained that he had tried to do a literal translation in his first attempt to translate Boccaccio in 1400, but the complexity of the text had been such that an average reader found it difficult to understand:

> I Laurent translated from Latin into French the least badly as I could a very noble and exquisite book of Giovanni Boccaccio, *Des cas des nobles hommes et femmes*, at the encouragement and request of someone. In this I followed precisely and exactly the sentences taken from the author's manner of expression which is very subtle and artificial. . . . And it is true that even some of those who

consider themselves clerics or literary men suffer from ignorance which came about because they lacked the three sciences that teach how to correctly, truly, and beautifully speak, that is to say, grammar, logic and rhetoric. That is why it happens that Latin books composed and written by philosophers, poets, and historians who are well taught in all human sciences are distant and removed from the understanding that Lady Nature commonly gives to men. Therefore to overcome this great default, it seems appropriate that Latin books in their translation should be changed and converted into such language so that readers and listeners would understand the effect of the sentence without too great or too long efforts at understanding.

[(J)e Laurens a l'enhortement et requeste d'aulcuns eusse translate de latin en françois le moins mal que je peu un tres notable et exquis livre de Jehan Boccace des cas des nobles hommes et femmes, en la translation duquel je ensuivi precisement et au juste les sentences prinses du proper langaige de l'auteur qui est moult subtil et artificial. . . . Et il soit vray que neiz aulcuns de ceulz qui se dient clercs et hommes letrez souffrent en eulx tres grant dommaige d'ignorance qui leur advient par default des trois sciences qui enseignent droitement, vraiement et bellement parler, c'est assavoir grammaire, logique et rethorique, par quoy il advient que les livres latins dictex et escriptez par les philosophes, poetes et historiens bien enseignez en toutes sciences humainnes, sont moult loing et desseuvrez de l'entendement que Dame Nature donne communement aux hommes. Pour doncques secourir a ce tres grant default, il convient ce me semble que les livres latins en leur translation soient muex et convertiz en tel langaige que les liseurs et escouteurs d'iceulx puissent comprendre l'effect de la sentence senz trop grant ou trop long traveil d'entendement.][1]

In 1405, when Laurent translated Cicero's *De senectute* for Duke Louis of Bourbon, he observed that he had to change his approach to rhetoric so that the translation would be comprehensible to its readers and listeners:

I tried to take it on my weak shoulders, while keeping in mind two things: one, because the art of rhetoric cannot be entirely preserved in the vernacular, I will use words and sentences easily and promptly understandable and clear to readers and listeners of this book, without leaving out anything essential. The other thing is that I will expand, explaining in words and sentences that which seemed too short or obscure.

[Je me suis essaié a le porter sur mes floibles espaules, en guardant deux choses: l'une pour ce que en langaige vulgar ne puest estre pleinement gardee art rheto-

rique, je userai de paroles et de sentences tantost et promptement entendibles et cleres aux liseurs et escouteurs de ce livre, sanz riens laisser qui soit de son essence, l'autre chose iert que ce qui semble trop brief ou trop obscur, je le allongirai en exposend par mots et par sentences.][2]

Between 1409 and 1410, in the prologue to his revision of the translation of *De casibus virorum illustrium*, Laurent explained that it was necessary to amplify the translated text while staying faithful to the meaning Boccaccio intended, and he affirmed that he would do so without deviating too much from Boccaccio's original:

It seems to me that Latin books should be transformed and converted in their translation into such language that their readers and listeners could understand the effect of the sentences without too large or long an effort at understanding. . . . And thus this very small book, brief in words, is the amplest and longest among all other books to explain correctly by sentences drawn from histories. Thus, in undertaking this long and expansive task and gathering from diverse historians by means of divine grace, I want principally to base myself on two things, that is to say, to put in clear language the sentences of the book and the histories that are so briefly touched on by the author that he does not leave much beyond the names. I will complete them by means of the truth of old historians who wrote about them at length.

And this is not to say that Giovanni Boccaccio, author of this book, who in his time was a very great and famous historian, abandoned the said histories by ignorance, not knowing them, or by pride, not deigning to write them down, because he had them so close at hand and so fixed in memory that he thought them shared and known to others as [they were] to himself. Therefore, in order that the book has all its parts and will be complete in itself, I will include them briefly without straying too far from the text of the author.

[Il convient ce me samble que les livres latins en leur translation soient muez et convertiz en tel langiage que les liseurs et escouteurs d'iceulx puissant comprendre l'effect de la sentence senz trop grant ou trop long traveil d'entendement. . . . Et par ainsi ce livre moult estroit et brief en paroles est entre tous aultres livres le plus ample et le plus long a le droit expliquer par sentences ramenables aux histoires. En faisant doncques ceste besoingne longue et espendue et recueillie de divers historiens par le moien de la grace divine, je vueil principalement moy ficher en deux choses, c'est assavoir mettre en cler langaige les sentences du livre et les histoires qui par l'auteur sont si briément touchees que il n'en met fors seulement les noms. Je les assomeray selon la verité des vieilz historians qui au long les escrivirent.

Et si ne vueil pas dire que Jean Boccace acteur de ce livre, qui en son temps fut tres grant et renommé hystorian, ait delessié les dictes histoires par ignorance de les non avoir sceues ou par orgueil de les non daigner escrire, car il les avoit si promptes a la main et si fichees en memoire il les reputa communes et cogneues aux aultres comme a soy. Afin doncques que le livre ait toutes ses parties et soit complet en soy, je les mettray briément senz delessier que tres pou le texte de l'auteur.]³

Finally, Laurent's prologue to the translation of Boccaccio's *Decameron* from Italian to Latin to French, produced from 1411 to 1414, emphasizes the same point:

And because I am French by birth and language, I do not know fully the Florentine language, which is the most precise and excellent that is in Italy. I was brought together with a Franciscan friar named Master Antonio d'Arezzo, a man well versed in the Florentine vernacular and the Latin language. This friar Antonio, well taught in two languages, maternal and Latin, for a merited and just salary first translated the said *Livre des cent nouvelles* from Florentine into Latin, and I Laurent, assisted by him, secondly converted into French the Latin language received from the said Brother Antonio as best I could while keeping the truth of words and sentences, even according to the two languages, except that I extended the too short into longer and the obscure into clearer language, so as to easily understand the contents of the book. And thus, through two long and heavy labors, I have before me the *Livre des cent nouvelles* in Latin and French."

[Et pour ce que je suis Françcoiz par naissance et conversacion, je ne scay plainement langaige florentin, qui est le plus precizet plus esleu qui soit en Italie, je ay convenu avec ung frère de l'ordre des cordeliers nommé maistre Anthoine de Aresche, home tresbien saichant vulgar florentin et langaige latin. Cestui frère Anthoine bien instruit en deux langaiges, maternel et latin, pour condigne et juste salaire translate premierement ledit *Livre des cent nouvelles* de florentin en langaige latin et je Laurens, assistant avec luy, ay secondement converty en françcoiz le langage latin recue dudit frère Anthoine, ou au moins mal que j'ay peu ou en gardant la verité des paroles et sentences, mesmement selon les deux langages, forsque j'ay estendu le trop bref en plus long et le obscure en plus cler langaige, afin de legierement entendre les matieres du livre. Et ainsi a deux longs et griefz labours je ay par devers moy le *Livre des cent nouvelles* en latin et en françcoiz.]⁴

Laurent grew in confidence during this series of translations in shaping visual cycles and—even more important—in learning to give the *libraires* and artists with

whom he collaborated more freedom, trusting them to contribute their skills to producing the complex illustrations for his final product. Consideration of three of Laurent's translations, Cicero's *De senectute* (1405), Boccaccio's *De casibus* (1409/10), and Boccaccio's *Decameron* (1416), demonstrates how Laurent and his artists became increasingly sensitive to and experienced at manipulating illumination and other elements of the mise-en-page in the service of translation.

A BILINGUAL SOLUTION: MARCUS TULLIUS CICERO'S *DE SENECTUTE* AND LAURENT DE PREMIERFAIT'S *LE LIVRE DE VIEILLESSE*

Around 1405, at the same time that Laurent de Premierfait collaborated on the densely illuminated manuscript of Statius's *Achilleid* and *Thebaid* (BL Burney 257), he also worked on an experimental illuminated bilingual manuscript (BnF Ms. lat. 7789) that embodies a different approach to visual translation of Latin texts. This manuscript contains Marcus Tullius Cicero's *Oratio pro Marcello* and *De senectute* and Laurent's *Le livre de vieillesse*, his translation of the *De senectute*, which was one of the first translations of Cicero into French.[5] It is almost certainly the presentation manuscript given to the uncle of King Charles VI and brother-in-law of Duke John of Berry, Duke Louis of Bourbon, to whom the translation was dedicated.[6]

All but the first quire in this bilingual manuscript of Cicero were transcribed by Hand S, one of the two scribes Olivier Delsaux identified as collaborating on the earliest manuscripts of Laurent's writings.[7] It was decorated by artists whom François Avril identified as members of the Bedford Trend working in Paris. Avril grouped BnF Ms. lat. 7789 with manuscripts of the *Roman de la Rose* (JPGM Ms. Ludwig XV 7), *Tristan de Léonois* (BnF Mss. fr. 100–101) and Valerius Maximus's *Faits et dits mémorables* (BnF Ms. fr. 290) dating circa 1405 to 1410.[8]

Louis of Bourbon's manuscript shares the concern with textual clarity that was manifest in Statius's *Thebaid* and *Achilleid* (BL Burney 257), but it goes even further because it contains Cicero's Latin in a carefully orchestrated juxtaposition with Laurent's French translation. In this manuscript Laurent and his collaborators experimented with mise-en-page and iconographic innovation to associate and distinguish the French and Latin texts. This distinction is visible in the textual contents, but the manuscript's codicology and illuminations also encourage readers to think about the difference between authorship and readership of a classical original and its vernacular translation and to recognize the opportunity that a linguistic shift offered to establish connections between the classical period and their own current experiences in fifteenth-century Paris.

This manuscript of Cicero's *De senectute* (BnF Ms. lat. 7789) offers the medieval equivalent of a modern bilingual edition. Laurent's edition gives the Latin text pride of place; it presents the texts sequentially and incorporates cross-referencing points to facilitate comparison between the Latin original and the French translation that follows it. The three texts in the manuscript appear on distinct quires (see appendix 4), showing a codicological approach to distinguishing texts similar to that employed in the manuscript of Terence given to John of Berry (BnF Ms. lat. 7907A). The first quire, written by a different but contemporary scribe, contains Cicero's *Oratio pro Marcello*, whose opening words are decorated by an initial. Cicero's *De senectute* fills quires 2 to 5, and quire 5 is shortened in order to allow it to contain the end of the Latin text. Within this section a miniature and initial decorate the beginning of Cicero's Latin prologue to *De senectute* on folio 8r, and five painted initials subdivide the rest of the Latin text. In contrast, Laurent's French *Livre de vieillesse* occupies quires 6 to 14 and is decorated with seven illuminations, each accompanied by a painted initial. The first of these marks Laurent's unique translator's prologue, which has no Latin equivalent (fig. 4.1), and the six illuminations that follow carefully coordinate the French texts with the Latin texts that had been distinguished by initials. To further encourage comparison between the Latin text and its French equivalent, the rubrics in Laurent's French translation provided Latin incipits to the texts that are translated (compare figs. 4.2 and 4.3), as for instance when the French rubric on folio 39r cites the Latin, "Sepe numero," to encourage comparison with the Latin text that begins on folio 9r.

Laurent's translation from Latin to French interweaves explanatory material as amplifications in the French text. As a result, *Le livre de vieillesse* is almost twice as long as the Latin original. Laurent's textual amplifications were not neutral; they often changed the tone of Cicero's text, adding a distinctly historical—and even chivalric—twist that is in keeping with what is known about Louis of Bourbon's literary interests. Parenthetical explanations that either contextualize literary allusions to classical texts or explain historical references are by far the most common amplifications in Laurent's translation, as Stefania Marzano showed.[9] One of the most dramatic of these is a Latin text that becomes four times as long in its French translation. In a discussion between Cato and the youths Scipio and Laelius about death, Cicero cites a series of Roman leaders who approached death fearlessly, listing them in quick sequence:

> No very extended argument on this point seems necessary when I recall—not the conduct of Lucius Brutus, who was killed in liberating his country; not that of the two Decii who rode full speed to a voluntary death; nor that of Marcus Atilius Regulus, who set out from home to undergo torture and keep the faith

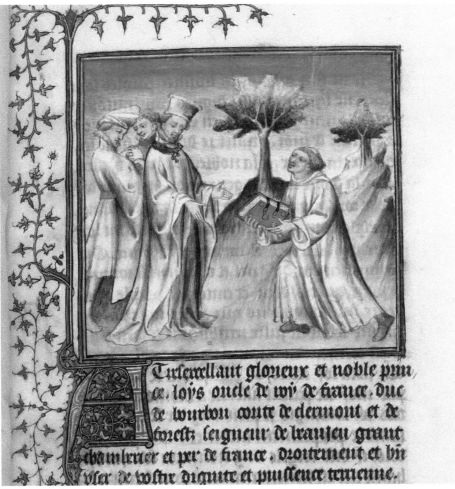

FIGURE 4.1. Laurent presents his book to Duke Louis of Bourbon. Marcus Tullius Cicero, *Oratio pro Marcello*; *De senectute*, and *Livre de vieillesse*, the French translation by Laurent de Premierfait. BnF Ms. lat. 7789, fol. 34r. Photo: BnF.

pledged to his foe; nor that of the two Scipios, who with their bodies sought to stay the Punic march; nor that, Scipio, of your grandfather Lucius Paulus who, in the shameful rout at Cannae, gave his life to atone for his colleague's folly; nor that of Marcus Marcellus, to whom not even his most piteous foe denied the honors of a funeral—but rather when I recall, as I have noted in my *Antiquities*, how our legions have often marched with cheerful and unwavering courage into situations whence they thought they would never return.

nectute msimus. ¶ Omnem autem ser
monem tribuimus non i tithono ut aul
totiles. parum enim esset autoritatis in fau
bula: sed marco Catoni seni. quo maiorem
autoritatem haberet oro. Apud quem. lelu.
et scipionem facimus amirantes. quod is tā
facile senectutem ferat. eisq; eum respondente.
¶ Qui si eruditius uidebitur disputare.
quem consueuit ipe in libris suis. attribuito
literis grecis. quarum constat eum pstudio
sum fuisse in senectute. Sed quid opus est
plura? iam enim ipsius catonis sermo expli
cabit nostram omnem de senectute senten
ciam.

Scipio amirans. Et hic incipit
tractatus preambule disputacionis.

Ego numero amirari soleo. cum
hec gaio lelio. cum ceterarum re
rum tuam excellentem maxie.
Cato. pfectamq; sapienciam. tum uel ma
xime. q' nūquam tibi senectutem graue
esse senserim. Que plerisq; senibus sic odi
osa est. ut onus se ethna grauius dicant
sustinere. ¶ Cato. Rem haud sane sa
pio. et leli. difficilem amirari uidemini.

FIGURE 4.2. Latin text page. Marcus Tullius Cicero, *Oratio pro Marcello*; *De Senectute*, and *Livre de vieil-
lesse*, the French translation by Laurent de Premierfait. BnF Ms. lat. 7789, fol. 9r. Photo: BnF.

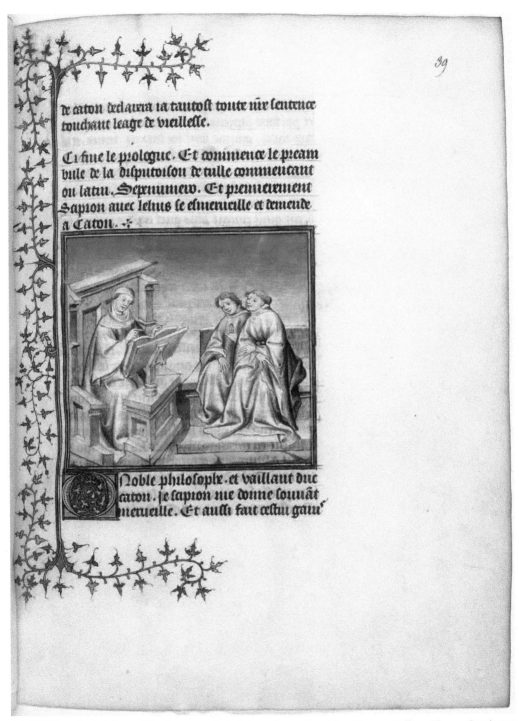

FIGURE 4.3. Scipio and Laelius marvel at Cato and question him. Marcus Tullius Cicero, *Oratio pro Marcello*; *De senectute*, and *Livre de vieillesse*, the French translation by Laurent de Premierfait. BnF Ms. lat. 7789, fol. 39r. Photo: BnF.

[De qua non ita longa disputatione opus esse videtur, cum recordor non L. Brutum, qui in liberanda patria est interfectus, non duos Decios, qui ad voluntariam mortem cursum equorum incitaverunt, non M. Atilium, qui ad supplicium est profectus ut fidem hosti datam conservartet, non duos Scipiones, qui iter Poenis vel corporibus suis obstruere voluerunt, non avum tuum L. Paulum, qui morte luit collegae in Cannensi ignominia temeritatem, non M. Marcellum, cuius interitum ne crudelissimus quidem hostis honore sepulturae carere passus est, sed legiones nostras, quod scripsi in Originibus, in eum locum saepe profectas alacri animo et erecto, unde se redituras numquam arbitrarentur.][10]

Laurent's amplified translation extends Cicero's text in order to contextualize each individual hero. In the process, he often links them genealogically by blood or by office. Thus, to give just one example, Laurent expands Cicero's phrase in the passage just quoted, "Lucius Brutus, who was killed in liberating his country," with essential background drawn from Livy about the conflict in which Lucius Brutus fought, a genealogical sketch of his opponents, and an extremely vivid and chivalric description of his death—which comes with an appended moral:

You know from histories how, after Tarquin, the proud king of Rome was dispossessed and deprived of his realm because of the villainous deed committed by his son, who corrupted by violence the chaste Lucretia, wife of noble Collatin, citizen of Rome. Tarquin had a son named Arruns who sought to recover the realm by force, to remove the freedom [*franchise*] of the people, and to lead them into servitude. But Lucius Brutus, noble consul of Rome who did not fear death and would, for an honest cause, willingly leave this life, mounted on his horse amidst the Roman host, lowered his lance, and spurred his horse against Arruns, surrounded by his host, and in such a manner that they reached one another, both delivered mortal blows and fell dead on the ground. And hence by the voluntary death of Brutus, the Roman people retained their most precious treasure—that is to say, their freedom.

[Vous savez par histoires comment, après ce que Tarquin, l'orgueilleux roy de Rome, fut dechacié et privé du roiaume pour le villain meffait que commeist le filz du dict Tarquin en corrumpend par violence la treschaste Lucrece, femme du noble Collatin, citoien romain, le dict Tarquin eut ung filz appellé Arruns, qui par armes s'efforça recouvrer le dict royaume, de oster la franchise du peuple et de le ramener en servaige. Mais Lucius Brutus, noble consul de Rome, comme cellui qui ne doubta point la mort et qui pour honneste cause voult de plein gré delesser ceste presente vie, estant avec l'ost des Rommains, monta sur

son cheval, mist sa lance en arrest, hurta des esperons son cheval contre le dict Arruns, environné de son ost, et si facilement atteingnirent l'un l'autre que tous deux navrez de plaie mortele cheirent mors sur terre; et ainsi, par la mort volun-taire du dict Brutus, demoura au peuple de Romme leur tresprecieux tresor, c'est assavoir franchise.][11]

With the addition of such amplifications, Laurent's translation interweaves discrete tales of Roman heroes with Cicero's treatise on aging.

This translation of *De senectute* was done for Louis of Bourbon when the duke was sixty-eight years old, at a moment when a book about old age would appeal to an elder statesman. Laurent's textual amplifications redefine the text's nature for Louis, making it resemble historical or genealogical accounts of the sort that we know he favored; a chronicler recorded that he liked to have read at dinner "the *gestes* [tales of the deeds] of the most famous princes, the former kings of France, and of other men worthy of honor."[12] Such acts of historicization and moralization are a characteristic that Laurent developed further from 1409 to 1414 in his French translations of Boccaccio's *De casibus* and *Decameron*.

Authorship and Audience

The illuminations in Laurent's translation of Cicero historicize and moralize in a different way than the text does. Perhaps as an analogue to the two languages presented in the book, three of seven pictures explore and complicate the notion of authorship and audience in his translation.[13] Further, they ground the book in the fifteenth century.

The initial sequence of three pictures establishes multiple identities both for the voices that speak in Laurent's translation and for the early fifteenth-century au-diences that would hear and read the text. The first three illuminations encourage associations between the same text (Cicero's prologue in its original Latin on fol. 8r and its French translation on fol. 37r), between sequential French prologues by dif-ferent authors (the prologue in French by Laurent on fol. 34r and the French trans-lation of Cicero's prologue on fol. 37r), and between the initial prologues to the Latin and French texts (Cicero's Latin prologue on fol. 8r and Laurent's original French prologue on fol. 34r).

Through strictly visual means, the associations between these three miniatures encourage viewers to merge the identities of authors and owners, associating Lau-rent de Premierfait with the historical figures of Cicero and his surrogate Cato, who are present in both Cicero's text and Laurent's translation of it. They also connect

Atticus, the recipient of Cicero's book, to Duke Louis of Bourbon, who received Laurent's translation. Through such associations, Laurent makes aspects of the Roman text applicable and relevant to contemporary life and politics in fifteenth-century France.

Artists illustrate Latin and French versions of the same text with very different compositions. In his prologue, Cicero writes that he will send his old friend Atticus advice on aging, but explains that he wishes to lend his words more authority by speaking in the voice of Marcius Porcius Cato, whom he will record in dialogue with Publius Scipio Africanus Minor and Gaius Laelius, younger contemporaries of Cicero renowned as soldiers and orators. This pair of images reinforces Cicero's conceit, which displaced the conversation from Cicero's era, circa 50 BCE, to Cato's era a hundred years earlier. The illustration to the Latin prologue (fig. 4.4), the only illustration in the Latin portion of the manuscript, shows Cicero enthroned and dressed in scholarly robes, handing a book bound in bright red to a youth who subsequently delivers it to Atticus. The image in the French translation (see fig. 4.5), complicates this cast of characters by introducing Cato (Cicero's surrogate) and Scipio and Laelius. It pictures Cicero and Cato as scholars standing together before Atticus, who is enthroned and flanked by two youths who wear fashionable fifteenth-century dress: three-quarter length, fur-collared *houppelandes*, and *chaperons* knotted and twisted on their heads. The representation of Cicero and Cato together in the illumination of the translated prologue by Cicero emphasizes the potential for different voices in the Latin text and its French translation. It may respond to the way in which Laurent's translation of Cicero's prologue reinforces the authorial slippage that Cicero had established in his text; Laurent shifts voice so that Cicero stops speaking as "I" and begins speaking as "we" at the paragraph in the prologue (1.3) where he announces that he will have Cato speak for him.[14]

A second visual pairing of the two French prologues (compare figs. 4.1 and 4.5) extends Laurent's layering of authorial voices by inviting a second chronological displacement to the fifteenth century. Figure 4.1 illustrates Laurent's totally original textual contribution, his translator's prologue, which contains the dedication to Duke Louis of Bourbon, the uncle of King Charles VI. This illumination shows Laurent presenting his vibrant red book to Louis of Bourbon, who receives it in the company of two youths. Parallels with the illumination of Cicero's prologue in figure 4.5 invite the association of Laurent with Cicero and Cato as a third voice, even as a coauthor, and the association of Louis of Bourbon with Atticus as an equally wise old man.

These images also establish contrasts that could encourage readers to further thought or discussion. For instance, although both Louis of Bourbon and Atticus are old men, Louis is represented as a member of the nobility, dressed in a high-collared long houppelande, a necklace, and a tall hat. Atticus, in contrast, is represented as a scholar, with details of dress and appearance that echo Lebègue's description of how

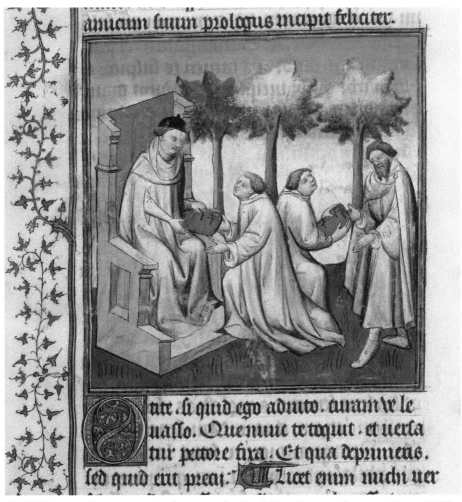

FIGURE 4.4. Cicero gives a book to a youth who delivers it to another man. Marcus Tullius Cicero, *Oratio pro Marcello*; *De senectute*, and *Livre de vieillesse*, the French translation by Laurent de Premierfait. BnF Ms. lat. 7789, fol. 8r. Photo: BnF.

to represent the classical writer Sallust: "Let there be made and portrayed a man with a great forked beard who will have a white coif on his head like they used to wear" [Soyt fait et pourtrait ung homme à grant barbe fourschue qui aura en sa teste une coiffe blanche comme l'en souloit porter].[15] Atticus has the fluffy beard and white coif that signal his dedication to study, like Sallust. In contrast, the young men in both illuminations seem to be included in order to create an opposition rather than to illustrate precisely any specific characters mentioned by Cicero or Laurent. Atticus's attentive youthful companions stand at attention by his throne, and one even

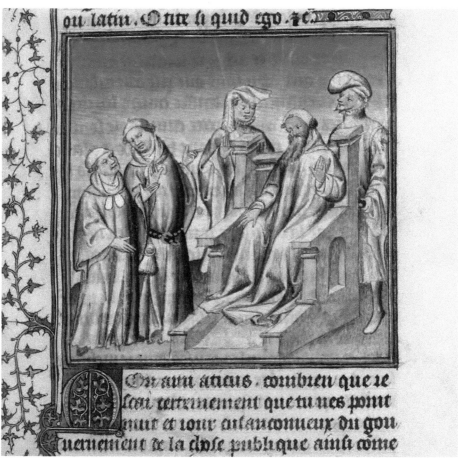

FIGURE 4.5. Cicero and Cato appear before Atticus. Marcus Tullius Cicero, *Oratio pro Marcello*; *De senectute*, and *Livre de vieillesse*, the French translation by Laurent de Premierfait. BnF Ms. lat. 7789, fol. 37r. Photo: BnF.

mimics Atticus's gesture of conversation. Wearing high-necked, furred *houppelandes* with full sleeves and either *chaperons* or bagged hats on their heads, they are as fashionably dressed as the youths standing with Louis of Bourbon. They evoke, but cannot be fully identified with, Scipio and Laelius, who both appear clean-shaven and bareheaded when they are represented in discussion with Cato (see fig. 4.3 above). The insistently fifteenth-century dress of the youths with Atticus aligns them most closely with Louis of Bourbon's fashionable companions. However, they contrast sharply with the distracted, self-absorbed youths who stand fidgeting behind Louis's back, looking at something (possibly a jewel) one of them holds. The distracted youths resonate with a section of Laurent's original prologue in which he referred to

contemporary fifteenth-century politics and the folly of youth and recounted why Louis wanted a copy of Cicero:

> Thus, noble duke, among numerous volumes you have chosen and selected the Book on Old Age that was written by the noble philosopher and prince of eloquence Tullius [Cicero], Roman consul, in whose breast natural and moral philosophy lived. You wanted to read and hear the book here written in very correct Latin and after converted into French because, in the course of nature, you approach old age to which is due reverence and honor, according to the merits and good deeds of the preceding age. I believe however that you want this book so that you will know more plainly whether *Dame Vieillesse* is not preferable in the government of the realm of France or any other lordship to foolish and excessive youth, who govern a realm like a rudderless boat made of old tables on the waves of the sea, far from port.

> [Vous doncques, noble duc, qui entre pluseurs volumes avez choisi et esleu le *Livre de vieillesse*, le quel dicta et escrivi le noble philosophe et prince de eloquence Tulle, consul rommain, dedans la poicterine du quel philosophie naturele et morale esleut son domicile, ja soit ce que vous vueilliez avoir lire et entendre le dit livre escripte cy devant en trescorrect latin et aprés converti en langaige françois, pour ce que selon cours de nature vous approuchiez a l'eage de vieillesse, a qui est deue reverence et honnour selon les merites et les bienfais de l'eage precedant. Si croy je toutevoies que vous desirez ce livre a fin que vous congnoissiez plus a plain que se ou gouvernement du royaume de France ou d'aultre quelconque seignourie dame Vieillesse, la saige et attrempee, n'est preferee et mise devant Juenesse, la folle et la desmesuree, tel royaume et si faicte seignourie est samblable a la neuf faicte de veilles tables qui est sans gouvernail tresloing de port es undes de la mer.][16]

It may be that this pair of images also offered Louis of Bourbon model princes who were open to receiving Cicero's wisdom.

The third pairing encouraged by the opening image sequence (figs. 4.1 and 4.4) was altered in order to associate and differentiate the Latin and French texts and their audiences. A change at the level of the underdrawing in one of the illuminations emphasized that Laurent's French translation was a text distinct from Cicero's *De senectute* and identified the translation with the actual physical manuscript that contains it, BnF Ms. lat. 7789. The first illumination in this pairing shows Cicero sending the Latin book to his old friend Atticus, and the second shows Laurent presenting his French translation to Louis of Bourbon. A cursory glance at these illuminations might suggest that the eye-catching bright red books represented in them

FIGURE 4.6.
Original cover. Marcus Tullius
Cicero, *Oratio pro Marcello*;
De senectute, and *Livre de
vieillesse*, the French translation
by Laurent de Premierfait.
BnF Ms. lat. 7789. Photo: BnF.

are identical. While they may have been so originally, one of the tiny books was edited before it was painted to distinguish it. Cicero's book in figure 4.4 has a red binding that is outlined around its edge by an incised line, reinforced on its spine by three paired lines, and closed by two black straps. Under magnification, pentimenti of a similar incised line around the edge and of a pair of lines at the spine are barely visible through the painted cover of the book that Laurent presents in figure 4.1. However, this underdrawing was painted over to give Laurent's presentation manuscript a binding with five gold bosses and black straps with gold clasps. This visual distinction between the Latin and French manuscripts presented in the images is intentional, for a second book, painted in a scene where Cato teaches Scipio and Laelius later in the French translation (see fig. 4.3), also features the red covers decorated with gold bosses, even though a different artist working within the Bedford Trend tradition painted it. Laurent's painted presentation manuscript echoes the surviving original binding of the manuscript that contains this altered illumination (fig. 4.6): red velvet over a wood core, with holes for five bosses and indentation and wear from two clasps that are now lost.

Textual Reinforcement

In contrast to this complex opening visual sequence dedicated to authorship and readership, the remaining five illuminations in the manuscript reinforce the textual divisions in the *Livre de vieillesse*.[17] First Scipio and Laelius question Cato about wisdom and virtue (see fig. 4.3). Then Cato outlines four claims about the unhappiness of old age that he intends to refute, and he refutes the first of them, which asserts that the old withdraw from active pursuits.

This section begins with a confusing illumination (fig. 4.7) that may have been caused by Laurent's introduction of rubrics in his translation at textual divisions that were illuminated. The short rubrics throughout the Latin and French versions of the text indicate the speaker as voices change; thus, throughout, rubrics identify Cicero, Cato, Atticus, Scipio, and Laelius. In the Latin text that folio 47r translates into French, it is quite clear that it should be Cicero who responds to Scipio and Laelius in the text transcribed under the miniature on the subsequent page, folio 47v, for his was the last voice introduced by a rubric before the illumination. Perhaps because the illumination intrudes between the texts, the French text confused the illustrator. The rubric that ends folio 47r states that Cicero's preamble has ended and the numbering of reasons why old age was unhappy is beginning. It continues by saying that Cicero would refute Scipio and Laelius's first claim about old age. In contrast, the rubric under the picture on folio 47v reports that Scipio speaks for himself and Laelius, and a rubric on the facing folio 48r identifies Cato as a speaker. Perhaps the bearded man who looks most like Atticus was introduced in an attempt to visualize a male who was not Cato.

The difficulty in devising clear and innovative illustrations of dialogue may have led to the decision to illustrate the rest of the manuscript with memorable exempla drawn from Cato's refutation of the three subsequent claims: the second claim that old age makes the body weaker; the third claim that old age deprives us of almost all physical pleasures; and the fourth claim that in old age a person is not far removed from death. In each case, the artists responded with visual exempla designed to fix the claim and its refutation in readers' minds.

The story of Milo of Crotona is the first example cited in Cato's refutation of the claim that old age weakens the body (fig. 4.8). In the two textually amplified citations of the story of Milo given in Laurent's translation, Laurent explains how Milo acquired his prodigious strength.[18] As an adolescent, he began the practice of walking the length of the race course at Olympia with a calf on his shoulder. As Milo and the calf grew, so did Milo's physical power. Cicero explains to his young charges that Milo was pitiful because he never sought to gain a reputation for his wisdom, prudence, or courage, intellectual traits that could survive into old age, but mistakenly concentrated on fleeting physical powers. He asks Scipio "which powers therefore would

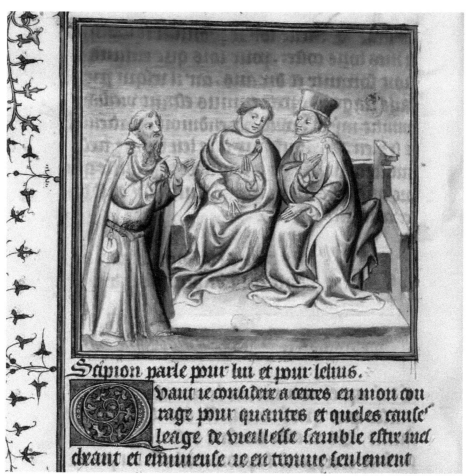

FIGURE 4.7. Scipion and Lailus speak with Atticus [sic]. Marcus Tullius Cicero, *Oratio pro Marcello*; *De senectute*, and *Livre de vieillesse*, the French translation by Laurent de Premierfait. BnF Ms. lat. 7789, fol. 47v. Photo: BnF.

you prefer should be given to you—the mental power of the philosopher Pythagoras or the [physical] power of Milo?" [Si te demande, Scipion, lesqueles forces tu aimeroies plus avoir: ou les forces de l'engin du philosophe Pitagoras ou celles du dit Milo?].[19]

The illumination (fig. 4.9) that illustrates the refutation of the claim that old age is devoid of sensual pleasures also uses an example of foolish behavior: the case of the consul Lucius Flamininus, who was once so entranced by a courtesan at a banquet that, at her request, he ordered a condemned prisoner killed. This concrete example is the first given by Cato as part of his argument "that carnal pleasure hinders the deliberation of good counsel; she is the enemy of reason; she blindfolds the eyes

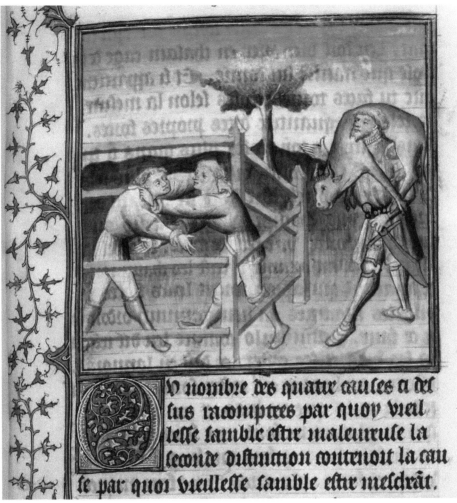

FIGURE 4.8. Milo of Crotona. Marcus Tullius Cicero, *Oratio pro Marcello*; *De senectute*, and *Livre de vieillesse*, the French translation by Laurent de Premierfait. BnF Ms. lat. 7789, fol. 56r. Photo: BnF.

of the mind which contains understanding and memory; pleasure never has fellowship with virtue" [Delectation de corps empesche la deliberacion de bon conseil, elle est ennemie de raison, elle serre et cloust les yeux de la pensee qui contiennent entendement et memoire; delectation jamais n'a merchandise avec vertu].[20]

The final image illustrates Cato's refutation of the claim that a person in old age is near death. The illumination (fig. 4.10) shows a corpse, embodying death, threatening to strike down a cringing youth and a calm older man. It concretizes Cicero's assertion that the old should not fear death, in contrast to the young who have not

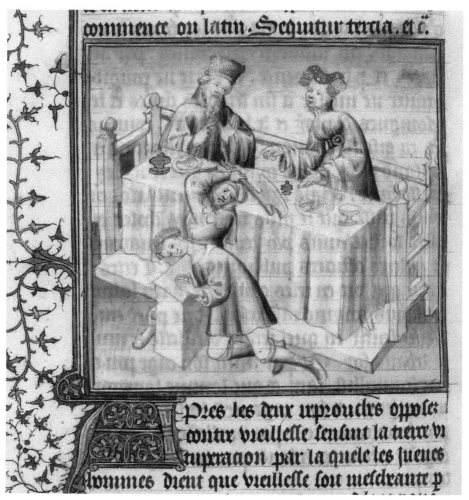

FIGURE 4.9. Lucius Flamininus orders an execution at the request of a courtesan. Marcus Tullius Cicero, *Oratio pro Marcello*; *De senectute*, and *Livre de vieillesse*, the French translation by Laurent de Premierfait. BnF Ms. lat. 7789, fol. 65v. Photo: BnF.

lived life and do not expect death, and hence are not prepared for it. Its visual form resonates with contemporary images such as the image of death (fig. 4.11) from Jacques Legrand's *Le livre de bonnes mœurs* (BnF Ms. fr. 1023), painted by the Luçon Master and presented by Legrand to Duke John of Berry on March 4, 1410.[21] Legrand's text also echoes the sentiment expressed in the *Livre de vieillesse*. Legrand wrote, "It follows that it is apparent that no one should glorify his life, because if you are young there is no more certainty that you would live long. Because to die is a law common to the old and the young" [Par quoi il appert que nul ne se doit de sa vie

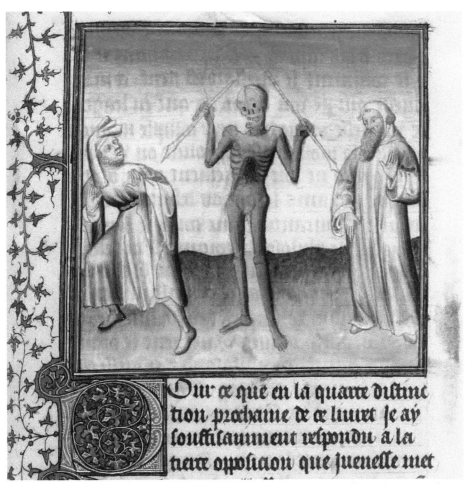

Our ce que en la quarte distinc
tion prochaine de ce liuret se ay
souffisaumment respondu a la
tierce opposiaon que iuenesse met

FIGURE 4.10. Death threatens a youth and an old man. Marcus Tullius Cicero, *Oratio pro Marcello*; *De senectute*, and *Livre de vieillesse*, the French translation by Laurent de Premierfait. BnF Ms. lat. 7789, fol. 86r. Photo: BnF.

glorifier, car se tu es joenne pource n'es tu mye certain que tu dois longuement vivre. Car mourir est loi commune à vieil et à joenne.].[22] John of Berry, who was given Legrand's *Le livre de bonnes mœurs* when he was seventy, may well have completed the image of a youth attacked by death by contemplating his own mortality, just as Louis of Bourbon may have done with the *Livre de vieillesse*.

The openness of textual readings encouraged by the visual layering of authors and audiences in Laurent's illuminated translation must have resonated with Louis of Bourbon. Laurent's prologue, which asks "whether *Dame Vieillesse* is not preferable in the government of the realm of France . . . to foolish youth who govern the

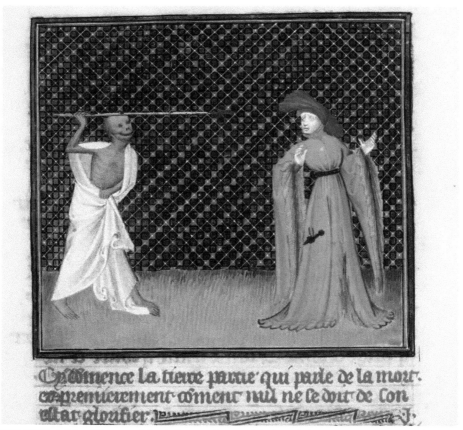

FIGURE 4.11. Allegory of death. Jacques Legrand, *Le livre de bonnes mœurs*. BnF Ms. fr. 1023, fol. 74r. Photo: BnF.

realm like a rudderless boat," encouraged Louis to consider *Le livre de vieillesse* with an eye to events from early fifteenth-century France, a practice that the visual cycle of decoration equally promotes.

As an elder statesman and uncle of the mad king Charles VI, Louis of Bourbon had a record of being involved in the education of princes and a long-established interest in encouraging good government. In the 1370s Charles V had charged Louis, along with the Duke of Burgundy and the queen, with the education of his sons, the future Charles VI and Louis, Duke of Orléans.[23] When Charles and Louis grew up, they left France with no consistent leadership; Charles was struck with mental illness and Louis was preoccupied with jockeying for power with his cousin John the Fearless, Duke of Burgundy.

Once again, the education of royal heirs, especially of Charles VI's two sons, Louis of Guyenne and John of Touraine, was a major concern, and in 1393 and 1403

different educational plans were devised.[24] The first plan charged Louis of Bourbon, among other royal uncles, with helping the queen in the education, guardianship, and government of her children. This was revoked in 1403, when Queen Isabeau of Bavaria was given sole control and required to seek, but not necessarily take, the advice of a council that included Louis of Bourbon as one of its members.[25] Events of 1405, including the attempt by the queen and Duke Louis of Orléans to smuggle the dauphin out of Paris, made clear that the solution was untenable and that moderate voices needed a stronger role in government. Indeed, in January 1406, just a short while after Laurent's completion of his translation of the *De senectute*, the structure devised in 1393 was reinstated.

The perplexing introduction of the first quire of the manuscript containing Cicero's *Oratio pro Marcello* may build on the contemporary political theme that Laurent's translator's prologue alludes to and the manuscript's illuminations reinforce. Although it is written by a different scribe, on folia with a denser and different ruling pattern, and its margins were decorated by a different artist, the *Oratio pro Marcello* is contemporary. This speech by Cicero praises Caesar for pardoning Marcus Marcellus, a supporter of Pompey on the losing side of the Roman civil war.[26] The speech presents Caesar as a model leader who put his own feelings aside for the good of the state. In this he exemplifies the kind of mature, moderate leadership that Laurent hoped Louis of Bourbon would provide. This implicit comparison of Louis of Bourbon to Caesar probably functions in the textual realm like the visual layering of authors and audiences that I have described in the visual realm. Marzano observed that Laurent certainly knew Cicero's oration by 1410 because he echoed it in his translator's prologue to *Des cas des nobles hommes et femmes*, and she speculated that it may have been Laurent who chose to have it added to Louis of Bourbon's presentation manuscript before it was bound.[27] Indeed, the addition of the *Oratio pro Marcello* in the first quire may have acted as a counterpoint to Laurent's translator's prologue that begins the French section of the manuscript. Its inclusion seems a deliberate addition to the complex textual and shifting visual models offered via this bilingual manuscript to Duke Louis of Bourbon during a time of political unrest.

GIOVANNI BOCCACCIO'S *DE CASIBUS VIRORUM ILLUSTRIUM* AND LAURENT DE PREMIERFAIT'S *DES CAS DES NOBLES HOMMES ET FEMMES*

The illustration of Laurent's translation of Cicero was an ambitious attempt to convey visually complex ideas about authorship and also demonstrate Laurent's commitment to making images of the past resonate with his fifteenth-century present.

In the period between 1405 and Laurent's supervision around 1410 of the production of twinned manuscripts of his revised and expanded translation of Boccaccio, Laurent continued to experiment with ways to represent authorship. His recognition of the importance of narrative illumination grew as he continued visualizing classical texts for prominent patrons in his revision of Bersuire's previous translation of Livy and his production of a densely illuminated *Comedies* of Terence discussed in chapter 2.[28] Through these experiences Laurent solidified his relationship with Parisian artists and scribes and the *libraires* with whom they collaborated. As manifested by the illustrations of Terence's *Comedies*, Laurent seems to have become more confident in working with and learning from artists, and in the process he became more sophisticated in his understanding of how narrative imagery could aid translation.

Boccaccio's Latin *De casibus* was structured as a series of firsthand accounts in which individuals ranging from Adam and Eve to King John the Good of France, who died in 1364, came to Boccaccio to tell him about the effect of fortune on their lives. In early fifteenth-century France, this Latin text was categorized as both moral philosophy and history. For instance, in 1408, when Jean Petit wrote his *Justification* of John the Fearless of Burgundy's assassination of Louis of Orléans, Boccaccio was the third moral philosopher, after the Greek Anaxagoras and the Roman Cicero, cited in support of his argument that it was legitimate to kill a disloyal traitor or a tyrant; Boccaccio's Latin text took its place in elite classical company.[29] Laurent himself described Boccaccio as a historian and his work as history in his prologue to the French version of *Des cas des nobles hommes et femmes* from 1410. As moral philosophy and history, *Des cas* had broad appeal to humanists such as Gontier Col, notary and secretary to both John of Berry and Charles VI. Col owned a Latin copy of Boccaccio's *De casibus virorum illustrium* (BML Pal. 228) but also seems to have acquired and studiously annotated a copy of Laurent's 1409 French translation (BnF Ms. fr. 131) almost as soon as it became available.[30]

Laurent translated Boccaccio's *De casibus virorum illustrium* in 1400 as a largely unillustrated text that stayed close to Boccaccio's Latin, and in 1409 and 1410 he revised and amplified the historical text.[31] The revised text (now bound as two manuscripts, Geneva Mss. fr. 190/1 and 190/2) was presented to Duke John of Berry as an *étrennes* gift in January 1411 by Martin Gouge, John of Berry's treasurer and counselor, who had given him the illuminated Terence at *étrennes* in 1408. A "twin" manuscript (Arsenal Ms-5193 rés.) was given to or commissioned by John the Fearless shortly thereafter.[32] In the translator's prologue to this version of *Des cas*, Laurent explained necessary adjustments made in the revision of his original translation; he had to amplify the stories to make them understandable to fifteenth-century Parisians while remaining faithful to Boccaccio's meaning.[33] Although Laurent suggested that he did not want to deviate much from Boccaccio, his expansions and explana-

tions made the text 30 percent longer, and the first two manuscripts of the revised version, completed by 1411, contained 147 and 153 illuminations.

Laurent supervised both text and images in the two dukes' books. As he had done in his translation of Cicero and revision of Livy, Laurent employed amplification and doubled synonyms, and he honed the text by selectively omitting events.[34] Florence Smith was the first to describe how Laurent's revisions, amplifications, and explanatory digressions in *Des cas* took a distinctly historical turn. He did not cite poets such as Ovid, whom he used, but reinforced the historical accuracy of the text by explicitly citing such sources as Justin, Livy, Orosius, and other distinguished Roman and medieval historians by name. His revisions fell largely within a Christian framework: he researched stories of gods in Boccaccio's Latin *Genealogy of the Gods* and incorporated in his translation the most rational explanation for myth while accepting Christian stories uncritically. The resulting text, Smith noted, destroyed Boccaccio's balance of "full-length and partial portraits" to create an uninflected encyclopedic history. Among the most distinctive features of the two manuscripts of this new translation is, first, their emphasis on distinguishing Laurent and Boccaccio as translator and author through mise-en-text and illustration and, second, their experimentation with visual amplification.

Authorship in Text and Image

The pair of presentation manuscripts made around 1410 or 1411 for the dukes made a careful distinction between Laurent's two original introductory prologues and the translation of Boccaccio's prologue and text in an attempt to establish a clear distinction between translator and author, as table 4.1 demonstrates. Because Laurent included two prologues along with a translation of Boccaccio's prologue in this revised translation, there were three distinct pieces of introductory material. Codicological disparities suggest that Laurent's first prologue, often omitted in subsequent copies of *Des cas*, may well have been an afterthought added to these manuscripts as they were being prepared. Not only does it appear in its own short quire in both books, it also lacks the running titles that appear throughout the rest of both manuscripts, and it has subdivisions identified by marginal notes to indicate the topics that it covers. Further, it refers to events of 1410. Thus, it must have been written and added to these manuscripts after Laurent completed the full revision in 1409, the date he gave in his colophon.

Laurent's paired prologues are further differentiated from Boccaccio's translated prologue and text by the inclusion of Latin incipits throughout the revised translation completed in 1409 or 1410. The beginning of Boccaccio's prologue is the point where Laurent's translation begins to echo the absent original Latin text,

TABLE 4.1. Codicological structure of the two earliest copies of the *Des cas des nobles hommes et femmes* ca. 1410–1411

Geneva Mss. 190/1 and 190/2 Presented by Martin Gouge to Duke John of Berry at *étrennes,* January 1, 1411 Transcribed by scribe T	Arsenal Ms-5193 rés., ca. 1410/11 Listed in the inventory of the library of Duke John the Fearless of Burgundy after his death Transcribed by scribe T (quires 1–4) and scribe S (quires 4–end)
Laurent's first prologue, fol. 1r (Ms. 190/1, quire 1) no running titles	Laurent's first prologue, fol. 1r (quire 1) no running titles
Laurent's translator's prologue, fol. 6r (Ms. 190/1, quire 2) running titles	Laurent's translator's prologue, fol. 7r quire 2 running titles
Boccaccio's prologue, fol. 7r (Ms. 190/1, quire 2) running titles	Boccaccio's prologue, fol. 8r (quire 2) running titles
Des cas des nobles hommes et femmes (Ms. 190/1, quires 2–23; Ms. 190/2, quires 1–24) 147 illuminations, running titles	*Des cas des nobles hommes et femmes,* fols. 8v–end (quires 2–51) 153 illuminations, running titles

Note: See Delsaux, "Textual and Material Investigation," for the attribution of scribal hands.

embedding the opening words of Boccaccio's Latin within the French rubrics for Boccaccio's prologue and text, a practice continued throughout both manuscripts. Such citations invited comparison between Boccaccio's Latin and Laurent's French translation and were a practice in many French translations from Latin in the late fourteenth and early fifteenth centuries. It was also the organizing principle behind Laurent's earlier bilingual manuscript of Cicero. Joining the Latin original and French translation in one manuscript, as Laurent had done for Cicero, would have been unwieldy for *Des cas* because the translation alone fills a heavy book of 368 folios. So, it is likely that the only people in a position to act on the rubrics' invitation to compare texts would have been readers who owned copies of both the Latin *De casibus* and the French *Des cas*.

The subtle authorial distinction between Boccaccio and Laurent established by the mise-en-page of the three prologues is reinforced by the illuminations, which are a significant component of the translated text that follows. In an approach comparable to that used for his translation of Cicero, Laurent differentiated his new French translation from Boccaccio's original Latin but still coordinated them

through incipits and illustration. Illuminations appear exclusively in the translation of Boccaccio, where they make the relentless stories about human downfall at the hands of fortune come to life for readers of Laurent's French translation. The sequences of 147 images in the manuscript belonging to John of Berry and 153 in the manuscript of John the Fearless of Burgundy visualize a chronological array of cases in which Fortune intervened in history.[35]

Because they were made almost simultaneously, the dukes' paired manuscripts offer a rare opportunity to consider how authors, artists, and *libraires* collaborated to produce two manuscripts that were particularized for the Dukes of Berry and Burgundy. These manuscripts were transcribed by the scribes who had already worked with Laurent on the Statius and Terence manuscripts (BL Burney 257 and BnF Ms. lat. 7907A), and on the bilingual Cicero manuscript (BnF Ms. lat. 7789). Hand T wrote all of John of Berry's *De cas* (Geneva Mss. fr. 190/1 and 190/2) and the first four quires of John the Fearless's copy (Arsenal Ms-5193 rés.), which was finished by Hand S. These scribes seem to have worked from copies of the translation that Laurent continued to revise as they transcribed the manuscripts. For instance, at three places in John of Berry's *De cas*, texts written in highly compressed script by a second scribe were substituted in spaces that had been erased on folio 137r in Geneva Ms. fr. 190/1 and on folios 56r and 180r to 181r in Geneva Ms. fr. 190/2. John the Fearless's manuscript contains the same texts, but one is original, while the others are crammed into an erased space or even written on an added folio (see Arsenal Ms-5193 rés., fols. 148r, 254v, and 394v–95r). In contrast, a text that was written in normal scale in another portion of John of Berry's manuscript was squeezed into an erased space so small in John the Fearless's book that the insertion had to be highly abbreviated (compare Arsenal Ms-5193 rés., fol. 377r, with Geneva Ms. fr. 190/2, fol. 165r). Because one of these changes appears in a slightly revised form in only one other manuscript (BnF Ms. fr. 226),[36] it seems that Laurent was revising his text as the two copies of the manuscripts were transcribed almost simultaneously and that Hands T and S were given textual corrections at different moments.

Marginalia written in John the Fearless's manuscript also suggest that annotations were made on different exemplars even as the two manuscripts were written, and that these annotated exemplars later circulated among *libraires*. Both dukes' manuscripts contain the marginal notes in Laurent's first prologue written in 1410 that later became rubrics, and these marginal notes, along with the prologue they accompany, were transcribed by Hand T. In the section of Arsenal Ms-5193 rés. transcribed by Hand S there are an additional thirty-nine marginal notes, written by the scribe in the same Gothic book hand as the text, and four additional notes in contemporary cursive.[37]

Libraires who produced later copies of *Des cas* seemed not to have had access to the revisions that Laurent incorporated into the dukes' manuscripts. This may be

because Laurent operated like his contemporaries Nicolas de Clamanges and Jean Gerson, who kept one, two, or even more exemplars of their works that were supplied to copyists and returned once the transcriptions were complete. Ouy observes that often changes were made to one exemplar under an author's control but not to others that were "out" with scribes.[38]

Another early manuscript of *Des cas* (ÖNB Cod. Ser. n. 12766), transcribed by Hand T, the scribe of Geneva Mss. fr. 190/1 and 190/2 and of the first thirty folios of Arsenal Ms-5193 rés., offers evidence that Laurent also worked with multiple exemplars that he parceled out to scribes. This manuscript is roughly contemporary with the dukes' books, but it has a slightly different version of the text from them. Although transcribed by a scribe who worked with Laurent, this manuscript in Vienna does not include Laurent's additional prologue that was written in 1410 after he completed his translation in 1409; one of the textual revisions that Laurent introduced into the dukes' copies of *Des cas*; or Laurent's unique visual amplifications. It also reflects an exemplar that initially did not reference Boccaccio's absent Latin text; this manuscript only incorporates Boccaccio's Latin incipits in chapter rubrics beginning on folio 201r in book 6, chapter 2, of *Des cas*.

Scattered interventions in images also show how intimately involved Laurent was in the production of what Delsaux terms *manuscrits d'edition,* or exemplars (the models on which subsequent copies of a text are based).[39] They also reveal how responsive the *libraire,* scribes, and artists collaborating with Laurent were to his emendations. Laurent seems to have given his collaborating *libraire* and scribes a textual model along with notes explaining where illuminations should go, perhaps looking somewhat like the model (fig. 4.12) that Gerson made as a guide for illustrating Honoré Bouvet's *Somnium super materia scismatis* in the early fifteenth century.[40] Gerson wrote Latin inscriptions in the margins describing subjects for illustrations in the copy that he transcribed as a model for textual and pictorial layout. For instance, the direction for the image reproduced here from Gerson's manuscript specifies that the artist should represent the king of Navarre with his counselors, before whom the author, dressed as a doctor of the Augustinian order, bows [Hic depingatur rex Navarre cum suo consilio, cui se inclinet actor in statu doctoris religiosi de Ordine Sancti Augustini].[41] Doubtless, Gerson would have translated the Latin to make a list of descriptions for artists comparable to those by Lebègue preserved in Bodl. D'Orville 141, described in chapter 2.

There is evidence in the Duke of Berry's *Des cas* that Laurent employed a two-stage process, first writing *histoire* in the margins of the textual model given to the libraire, in order to indicate where spaces for pictures would go, and then providing an additional text describing the subjects to be painted in the spaces left for the *histoires*. This may have resembled Lebègue's *Les histoires sur les deux livres de Salluste,* in which Lebègue described the subjects to be painted in the *histoires* and cited the

FIGURE 4.12.
Jean Gerson's directions for illustrating Honoré Bouvet's *Somnium super materia scismatis: Pièces relatives aux affaires de l'église pendant le grand schisme.* BnF Ms. lat. 14643, fol. 270r. Photo: BnF.

textual incipits where they should appear in a text that circulated separately from the manuscript that was being illuminated.[42]

In three places in the Duke of Berry's manuscript of *Des cas,* the word *histoire* [image] was transcribed above the space provided for a picture, while conventional rubrics summarizing the chapter and referring to Boccaccio's Latin incipit appeared below the illuminations (fig. 4.13).[43] This word must have been erroneously copied from the textual model, where it served to remind the scribe that a space should be left for an illumination. More dramatic evidence for the citation of incipits as a means for indicating image placement emerges from a comparison of illuminations in John the Fearless's manuscript with those in *Des cas* (ÖNB Cod. Ser. n. 12766), produced in the same *libraire*-artist-scribe milieu as the dukes' manuscripts. It was transcribed by Hand T, and its visual cycle was painted by *Cité des Dames* illuminators just as John the Fearless's book had been, and it was based on the same models as were used in John the Fearless's manuscript.

FIGURE 4.13.
Samuel anoints Saul. Giovanni
Boccaccio, *Des cas des nobles
hommes et femmes*, translated
by Laurent de Premierfait.
Geneva Ms. fr. 190/1, fol. 47r.
(www.e-codices.ch).

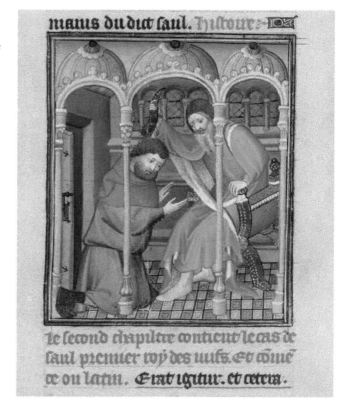

An error in the placement of illustrations for chapters 5 and 9 of book 5 of ÖNB
Cod. Ser. n. 12766 suggests that its illuminator worked from written or visual direc-
tions keyed to incipits that might have been kept by the *libraire* after he worked with
Laurent. Because both chapters begin with the incipit "Apres le racomptant," it was
easy for the *Cité des Dames* illuminator to reverse the images' placement when he
painted the *Des cas* now in Vienna. Compare the scenes from that manuscript (figs.
4.14 and 4.15) to those showing the correct placement in Arsenal Ms-5193 rés. (figs.
4.16 and 4.17). Because no one "proofread" and corrected these illuminations in
ÖNB Cod. Ser. n. 12766, precious evidence survives that the artist worked from a set
of written directions or visual models for illuminations whose placement was keyed
to textual incipits. The fact that the error went undetected further suggests that the
libraire produced the manuscript now in Vienna independently of Laurent's edito-
rial control. It seems likely that Laurent was only directly involved in the production
of the dukes' manuscripts.

Luçon and *Cité des Dames* illuminators decorated the dukes' manuscripts, and
their cycles of illumination, like their texts, are closely related. They betray a modified

FIGURE 4.14. Misplaced image for book 5, chapter 5. Giovanni Boccaccio, *Des cas des nobles hommes et femmes*, translated by Laurent de Premierfait. ÖNB Cod. Ser. n. 12766, fol. 165v. Copyright: ÖNB Vienna: Cod. Ser. n. 12766, fol. 165v.

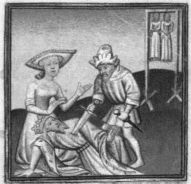

conuoitise de sa pensee eschaufee en
conuoitise. Si affubla et prist anthi
ocus vne couuerture et faulse coule
cestassauoir que il feigniy quil nauoit
de quoy payer aux romains vne grat
somme dor et danger qil leur auoit p
mise rendre et bailler selon les loix
et les condicions du tracte de la paix
pour tant anthiocus se adona a lar
recins et a robenes en tous lieux et
contre tous. Et afin que anthio
cus peust parfaire celle grant robe
rie il conigny auec soy compaignos
experts et voulentifs de rober et de
tollir par force. Et assailli de nuyct
le temple de iupiter surnome dodoin
au moult ancian et honnourable se
lon la loy payenne. Anthiocus mou
stroit par cellui fait quil auoit pdue
la seignoure des choses temporeles a
fin quil possidast plus dignemant
les choses diuines et consacrees aux
seruices des dieux. Anthiocus don
ques roba et prist les richesses de cel
lui et conust sacrilege. Tous les ho
mes du pays demourans a lenuiro
du temple se assamblerent en batail
le et soubdemenant assaillirent le
roy anthiocus et ses compaignons
et tant aduint que le roy anthiocus
hourde du pillaige de cel temple chy
mort et fut occis et aussi ses copaig
nons.

Ce nenfuesme chapitre contient
les cas de plusieurs nobles malheu
reux et oppressez par fortune

pres le racouptement
du miserable cas du
grant anthiocus roy de
surie et de asie. Jeroni
mus le filz de pero roy de siracuses v
ne tirsanciaune. puissant et riche a
re de lisle de sicile se tira par deuers moi
a fin que cestui ieronimus qui fort se
complaiguoit de fortune me mostrast
en brieues paroles quel fut le cas et la
fin de sa vie. Cestui ieronimus escores
estant ieune home apres la mort de
pero son pere sucreda au royaudie des
siracisains. au comencemant du re
gue de cestui ieronimus les siracisa
ins qui toudis ont euclins estre a son
uant changer seignoure orent entre
eulx dissension ciuile par ce que aul
cuns deulx tendoient au continue
mant de lestat royal dudict ieronim?
et les aultres queroient son despoin
temant sanz precedens demerites
durant donques le forseneux debatu
stui ieronimus fut cruelmant occis
ses propres citoiens. Et la noble dama
rata sa fille fut detrenchee en pieces de
dans le temple et deuaut les aultens
des dieux sauz ce que les siracisains

FIGURE 4.15. Misplaced image for book 5, chapter 9. Giovanni Boccaccio, *Des cas des nobles hommes et femmes*, translated by Laurent de Premierfait. ÖNB Cod. Ser. n. 12766, fol. 175r. Copyright: ÖNB Vienna: Cod. Ser. n. 12766, fol. 175r.

woyent et pesent la grant vertu
du courage et du corps du vail-
lant actilius. ¶ Car actilius
laboureur de terre auoit le cu-
ir ort et pouldreux et aspre par le
hale du souleil. Il auoit les
mains rides et durillonnees
par souuant tenir a mener
la boe et la charrue. Il estoit vestu
des robes quil faisont de tele lai-
ne comme les berbis portoient
et neautmoins en son corps fut
vne ame de si grant vertu mo-
rale et corporele que par la vraie
clarte de ses meutes il extoit
et obscurat les femmes nobles
les des aultres soy ventans de
mondaine gentillesse. Se coseil
le aux nobles du temps plent
que ilz ne se reuellent ne enuiet
contre actilius en eulx ventad
de leurs ors et debonnestes tiltre
de noblesse et quilz ne mocquent
ne ne condampnent les faits du
consul actilius qui sont trigiis.
et tresbeaulx. Les nobles home
de maintenant loent et recome
doie principalmant le noble ac-
tilius de tant plus comme ils
euuent blasmer luy et ses faits.
Car puisque vng homme aux del
seruiy gloire et renommee par sa
vertu et prouesse il ne peult plus
estre infortunes que destre loe et
recommende par aulcun home
fol et expert mal expert en oeu-
nes de vertu et vaillence. »

Le cinquiesme chapitre en brief
contient les cas dune grant co-
paignie de mallureux nobles
hommes. Et commence ou la-
tin. Longus plorantiu. etc.

Pres le incomptenant
du piteux et miserable
cas de actilius noble co-
sul iommam ie tourniay ma
plume pour briefmant descrire
les cas des aultres mallureux
nobles hommes tant anciens co-
me les aultres piourans et faisons
vng long cry et qui estoient deuat
moy tous mis en vne longue ra-
ge tous ainsi comme les histori
ans les arraigeient en taus lieu.
Les nobles mallureux la deuant
moy se estoient assembles de tou-
tes pars du monde afin que ie
les descriuisse. Et deuant tous
les aultres venoit ptolomee de
philipater roy de egipte. Cestuy
ptolomee nou pas cruel seule-
mant ainsi comme sont aulcu
hommes mais il cruel et inhumai
m a maniere dune beste sauua

FIGURE 4.16. Murder of Ptolemy IV of Egypt; his concubine and her daughter hanged. Giovanni Boc-
caccio, *Des cas des nobles hommes et femmes*, translated by Laurent de Premierfait. Arsenal Ms-5193 rés.,
fol. 194r. Photo: BnF.

FIGURE 4.17. Corpses of Hieronymus of Syracuse, his wife, and his daughter. Giovanni Boccaccio, *Des cas des nobles hommes et femmes*, translated by Laurent de Premierfait. Arsenal Ms-5193 rés., fol. 205r. Photo: BnF.

model–copy relationship for two reasons; John the Fearless's manuscript has a slightly expanded cycle, and the artists who collaborated with *Cité des Dames* illuminators on Arsenal Ms-5193 rés. also painted illustrations whose iconography is unique to that manuscript.[44] It seems likely that these collaborating artists worked at another location where they were unable to consult the models for John of Berry's manuscript that the *Cité de Dames* illuminators used for the bulk of their illuminations. The images that the collaborators painted in two full quires (fols. 127r–41v) and as individual images on seven bifolia differ iconographically from the models used for Geneva Mss. fr. 190/1 and 190/2.[45] Further, five of the eleven illuminations that these collaborators painted are based on very pale drawings that were not erased from the lower margins of Arsenal Ms-5193 rés.; this raises the possibility that the *libraire* or supervising artist provided sketches for all the images that were farmed out to be completed by other artists.[46]

Laurent seems to have "edited" the illuminations in John of Berry's *Des cas* by suggesting corrections to ambiguous miniatures after artists painted them. This would be analogous to Lebègue's actions in prescribing corrections in the margins of his directions to illuminators preserved in Bodl. D'Orville 141 once he reviewed the sketched but unpainted illustrations of his second copy of Sallust (Geneva Ms. lat. 54).[47] Latin marginal notes (fig. 4.18), erroneously preserved as sloppy red rubrics to left and right of an illumination in the Duke of Berry's manuscript, may transcribe annotations made in one of Laurent's exemplars, where he had written a note to himself designed to clarify a vague image that originally represented either Emperor Aurelian or Emperor Carus. In response to the Latin notes erroneously copied to the right of the illumination, "Lightning frightened Aurelian and killed Carus" [Fulgura aurelianu(m) perterruit et Carum occidit], and trimmed at the left of the illumination, "The [anger?] of God is above me" [-ra dei super mei est], either Laurent or a collaborating *libraire* directed the artist to fix the scene in order to clarify who among the series of emperors the picture represents by making his death conform to that described in the amplifications Laurent added to Boccaccio's text. Toward the end of the amplified French chapter illustrated by this scene, Laurent described a bolt of lightning from heaven that frightened Emperor Aurelian when he was surrounded by his men, who later killed him. A bit later he recounted how Emperor Carus was in his pavilion near the Tigris River when he was struck by lightning and died. Laurent concluded, "and thus he [Carus] found God more an enemy than man." The reminder erroneously preserved in the margins of John of Berry's manuscript clarifies that Carus was the emperor represented. Apparently a suggestion was made to the Luçon illuminator to add the river. As a result, the artist hastily added a layer of sloppy silver paint over the green grass, neglecting to clearly demarcate the water from its bank as he had done in other images of shorelines in this manuscript. The *Cité des Dames* illuminator's illustration (fig. 4.19) painted just

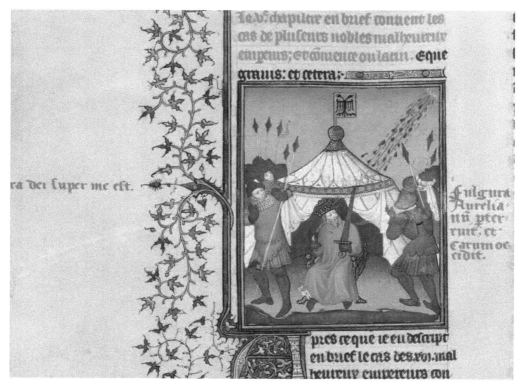

FIGURE 4.18. Emperor Carus struck by lightning. Giovanni Boccaccio, *Des cas des nobles hommes et femmes*, translated by Laurent de Premierfait. Geneva Ms. fr. 190/2, fol. 112v. (www.e-codices.ch).

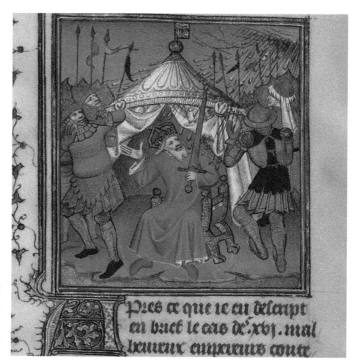

FIGURE 4.19. Emperor Carus struck by lightning. Giovanni Boccaccio, *Des cas des nobles hommes et femmes*, translated by Laurent de Premierfait. Arsenal Ms-5193 rés., fol. 321v. Photo: BnF.

a bit later for John the Fearless's manuscript incorporated this visual correction as seamlessly as the scribe transcribing that manuscript had incorporated some of Laurent's textual revisions.

The team of *libraire*, scribes, and illuminators responded with great care to Laurent's textual and visual corrections to the models they used as they produced final copies of *Des cas* for the Dukes of Berry and Burgundy in 1410 to 1411. This suggests that further analysis of unusual visual features shared by these manuscripts could offer insight into how Laurent and his collaborators sought to highlight exempla from the past thought to be particularly relevant to these particular princes of the blood. Further, the visual features that were unique to one or the other manuscript may shed light on how the editions of *Des cas* made for the dukes continued to evolve in the brief period of their making, circa 1410 to 1411, possibly either to particularize John the Fearless's slightly later manuscript or to respond to contemporary social and political circumstances at the time that the "twin" manuscripts were made.

Visual Translation and Moralization in the Illuminations of the Dukes' Manuscripts of *Des cas des nobles hommes et femmes*

The most pressing political problem in early fifteenth-century France was the deteriorating relationship between the princes of the blood, who should have helped govern during the periods when King Charles VI was struck with bouts of madness. By the time Laurent devised this visual cycle circa 1409 to 1410, two opposing political parties had been at loggerheads for several years. The Armagnac party included Duke Louis of Orléans, the brother of King Charles VI, and Charles's uncle, Duke John of Berry, among others, and the Duke of Burgundy, who from 1404 was Duke John the Fearless, headed the opposing Burgundian party. The relationship between Louis of Orléans and John the Fearless deteriorated in the early fifteenth century and was so toxic by 1407 that John the Fearless arranged Louis's assassination. In 1408 an official justification of John the Fearless's actions was written by Jean Petit, read aloud at court, and circulated in parchment and paper versions. It was this text that quoted Boccaccio's *De casibus*. The Orleans family rebutted Petit's *Justification* publicly in both 1408 and 1410. Relationships continued to deteriorate, attempts at negotiation failed, and the League of Gien of 1410 solidified Armagnac hostility to the Burgundians, effectively marking the beginning of civil war in France. This turbulent political situation had an impact on those who worked for the king and princes of the blood, who often encouraged the feuding nobility to work for the good of the monarchy.[48]

Laurent responded to this political situation when he and his *libraires* invented and edited the dense pictorial cycles for the newly revised text of the *Des cas* and

supervised the execution and emendation of them in the dukes' manuscripts. Laurent worked with his collaborators to experiment selectively with a visual version of the rhetorical mode of amplification that he had used in the texts of his translations of Cicero and Boccaccio. In the twinned manuscripts of Boccaccio's *Des cas*, seven unique visual amplifications, in the form of paired images (see appendix 5), hone Laurent's visual translation.[49] Laurent used these visual amplifications to encourage readers to explore different approaches to the densely illuminated text. The paired images not only associate disparate sections of *Des cas*, but also often resonate with contemporary political concerns in early fifteenth-century Paris or offer heightened moral instruction. Consideration of several examples of these visual amplifications demonstrates how independently pictures could relate to the text in Laurent's translation of *Des cas* while reaching beyond it to evoke contemporary politics.

One of Boccaccio's own textual devices in *De casibus* was the insertion of thirty-six chapters scattered through the nine books. These vary the sequence of first-person narratives by introducing, as Boccaccio put it, "inducements to virtue and dissuasions from vice" in chapters in which Boccaccio himself speaks rather than listening to and recording tales of woe told to him by others. Illustrations of these chapters in late fifteenth-century manuscripts typically emphasize Boccaccio's moralizations by showing him lecturing to varied audiences.[50] That was not the case in the early manuscripts presented to the dukes. There, illustrations of seven unique visual amplifications expand a visual story of woe into two images, amplifying the visual record of the tale told to Boccaccio in one chapter by adding a second image to illustrate the subsequent moralizing chapter written in Boccaccio's voice. In these manuscripts and no others, the extended visual narrative illustrates sequential chapters with two moments from the story fully contained in the first chapter that the paired pictures illustrate.[51]

By stretching a story visually in sequential illuminations, visual amplifications invite readers to pause and concentrate on specific stories and the morals that they present and even to contemplate associations external to Boccaccio's text. Visual echoes of illustrations in other manuscripts from the dukes' libraries also could draw related manuscripts into dialogue with the specially amplified *Des cas*. Finally, the illustration of subjects popular in contemporary fifteenth-century French political rhetoric could invite readers to layer contemporary political concerns over their experiences of the past historical subjects described in texts and pictured in illuminations in manuscripts of *Des cas*.

All three of these phenomena were at work in the textual and visual amplification of the destruction of Jerusalem, the most dramatic visual amplification in the dukes' manuscripts and one of the few visual amplifications to have an afterlife. The importance of reading the past against the fifteenth-century present, specifically against the deteriorating relationships between the princes of the blood, seems to

have been the primary reason for the inclusion of a large-scale illumination of the destruction of Jerusalem as an illustration of book 7, chapter 8, of *Des cas*; it is the only illumination in either duke's manuscript to be more than one column wide. Its large scale and the visual amplification of its story in the illustration to the subsequent chapter mark it as an exceptional image that was honed further between the production of John of Berry's and John the Fearless's copies of the text.

In the upper register of both representations of the destruction (figs. 4.20 and 4.21), Emperor Titus and his army break violently through the walls of Jerusalem to kill Jewish opponents and set fire to the city. In each lower register, Titus sits on his throne and supervises the sale of surviving Jews to the Saracens, who drive the Jews away toward the right. These images have different emphases. In John of Berry's manuscript, the mass of Roman soldiers flows around the emperor and explodes into Jerusalem to kill Jews, burn down the city, and drive Jewish men, women, and children out the city's gate at the right. The representation in John the Fearless's slightly later manuscript emphasizes imperial power more than military might; its two representations of Titus are aligned vertically, drawing more attention to his physical presence and actions, and the Jews are not shown fleeing the burning city. The financial transaction in the lower register of this manuscript is centered over the intercolumnar space and painted so that it overlaps both the scene at left of the emperor's order that the surviving Jews be sold and the scene at right of their sale, thereby emphasizing the emperor's agency.

One striking feature in both illuminations of the destruction of Jerusalem is the dress of the Romans and the Saracens, who wear such elements of costume as turbans, pointed hats, or sashes tied around arms or waists that usually signal people removed in time or place from early fifteenth-century France.[52] The Jewish people, on the other hand, are dressed in clothing that was worn in France. It would seem that costume choices made in illuminating this scene were intended to present the Jews as more like the contemporary French than the ancient Romans or Saracens.

The second scene in the visual amplification (figs. 4.22 and 4.23) complicates this positive reading of the Jews as "French" by featuring a moment that preceded the fall of Jerusalem. It shows a Jewish noblewoman named Marie who was starving during the siege and in desperation cooked and ate her own baby. The text explains that when her fellow Jews learned what she had done, they lost heart and Jerusalem capitulated to Titus. The illumination emphasizes the horror of Marie's act by showing two men who followed the smell of cooked meat, only to recoil when they saw Marie roasting and eating her child.

These images of the destruction of Jerusalem and Marie's cannibalism reinforce Laurent's revisions of Boccaccio's text.[53] Laurent's account of the destruction in chapter 8 of his initial translation in 1400 was very close to Boccaccio's Latin, but his

e qui estoit pensif et en esmai.
et par desdaing courrouce co
nre les hommes gloutons: ie te
noie mon visaige et ma pense
deuers la charoigne du glouto
empereur aulus vitellius qui
cedans les vuides du tybre floto
ir puis ca. puis la. Et ainsi que
tournoie mon visaige et ma si
ter contre la charoigne de vitel
lius. ie vi si grant nombre de ho
mes malheureux qui par trou
peaulx arviltoient vers moy. je
ne cuidoie pas que nature meïr
de toutes choses en eust tant en
gendre. Tous ces hommes acou
rens deuers moy disoient quilz
descendirent iadis du noble et
sainct patriarche iacob le pere
du peuple israel: ilz grinssoient

tous. ilz estoient couuers de uile
nobles et douloureuses robes. ilz
huloient ainsi comme len brait
a leurruement des mors. Et aul
si ilz racomptoient les deurime
res misères quilz souffrirent a
uant la mort. cestassauoir leur
plaies. leffusion de leur sang.
la faim. et la pestilence ainsi en
durerent. les chaines donc ilz fu
rent loiez. les prisons ou ilz fu
rent enclouz. les seruitutes en
quoy ilz furent renduz. et les
nouuelles manieres de leurs
mors. et les maulx de leure pare
et amis. ¶ Si tost que ie ref
gardai les uiss enfans d iacob
grinsseus pour leurs males for
tunes. je congneu que entreulx
tous estoient plusieurs nobles

FIGURE 4.20. The destruction of Jerusalem. Giovanni Boccaccio, *Des cas des nobles hommes et femmes*,
translated by Laurent de Premierfait. Geneva Ms. fr. 190/2, fol. 96v. (www.e-codices.ch).

E qui estoit penss et en esmai.
et par desdaing conuenue co
ure les hommes gloutons, se
tenoie mon visaige. et ma pe
see deuers la charoigne du glou
ton emperur auttrs vitellius
qui dedans les vndes du tybre floc
toit puis ca. puis la. Et ainsi q̃
ie trouurote mon visaige. et ma
pensee conre la charoigne de vitell?.
ie vi si grant nombre de hommes
malheureux qui par trop eaulx ac
conuent vers moy que ie ne cui
doie pas q̃ nature mere de toutes
choses en eust tant engendre. To
ces hommes acourens deuz moy
disorent quils descendient iadis
du noble et sanit patriarke iacob
le pere du peuple israel. fls gemilloi
ent tous. fls estorent conuers de mi
serables et douleureuses voixs. fls

hulorent ainsi comme leu braut a
leur euement des mors. Et ainsi ils
racomproient les deriemeres miseres
quils souffrirent auant la mort
test affaron: leurs plaies lessuson
de leur sang. la sann. et la pestilece
quils endurarent. les charnes dont
ils furent sotez. les prisons ou ils
furent enclouz. les seruitutes en q̃
ils furent vendus. et les nouuelles
manieres de leurs mors. et des mor
de leurs parens et amis. Si tost
que ie regardai les suifs enfans de
iacob gemissant pour leurs males
fortunes, ie congneu que entre eulx
tous estorent pluseurs nobles hom
mes et dignes de memoire. Et ais
que ie pensoie que trop longue chose
seroit de escrire souffisamment les
cas de tous les nobles malheureux
suifs: Pour ce que semblablemant

FIGURE 4.21. The destruction of Jerusalem. Giovanni Boccaccio, *Des cas des nobles hommes et femmes*, translated by Laurent de Premierfait. Arsenal Ms-5193 rés., fol. 305r. Photo: BnF.

FIGURE 4.22. Marie, famished, devours her child. Giovanni Boccaccio, *Des cas des nobles hommes et femmes*, translated by Laurent de Premierfait. Geneva Ms. fr. 190/2, fol. 101r. (www.e-codices.ch)

amplified revision of it in 1409 to 1410 developed the text. His editorial additions identify Marie's cannibalism more explicitly as a factor that demoralized the Jews and hardened Roman resolve, and therefore accelerated Jerusalem's destruction.[54] Laurent's amplification of chapter 8 described in more detail the Jews' ultimate punishment—the destruction of Jerusalem and the sale of Jewish survivors into servitude—that the chapter's illumination illustrates. Laurent also added to his textual amplification a new moral aimed at contemporary Christian readers. He warned that the example of the downfall of the biblical Jews should make Christians

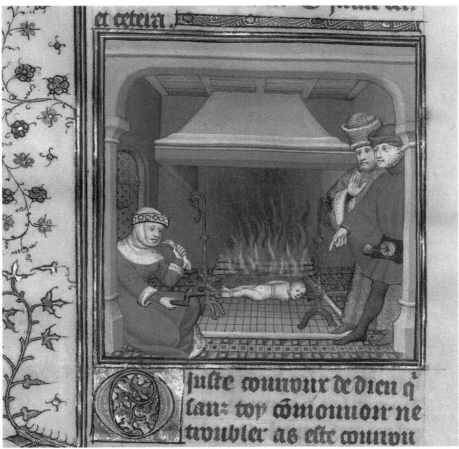

FIGURE 4.23. Marie, famished, devours her child. Giovanni Boccaccio, *Des cas des nobles hommes et femmes*, translated by Laurent de Premierfait. Arsenal Ms-5193 rés., fol. 309v. Photo: BnF.

fear that they might face a similar reversal at the hands of Fortune. Christians turned from God to worship the world, the flesh, and the devil, and thus, instead of crucifying Christ once as the Jews had done, they crucified Christ a hundred thousand times through sin.[55] Even though the text of chapter 9 illustrated by Marie's cannibalism was little altered, Laurent's revision also sharpened the inverted associations between the Jews and Christ and Marie and Mary. Reiterating the anti-Semitic trope that the Jews' punishment was due to their complicity in Christ's death, he interlaced their sufferings during the siege with those of Jesus during his passion and made more explicit the inverse relationships between the Jewish matron Marie and the woman with whom she shares a name, the Virgin Mary.[56] At the end of this chapter, Laurent introduced a new conclusion that reinforced the opening words

of both the original and revised versions of his translation by reiterating that God inspired Titus's vengeance on the Jews.[57]

Perhaps because of Laurent's intervention, the paired visualizations of Jerusalem's destruction and of Marie's cannibalism that artists painted in the dukes' manuscripts of *Des cas* differed in their precision from most historical illustrations for the story that were available in other French translations in royal and ducal collections in Paris. Illuminated sources in these collections ranged from the translation of Flavius Josephus's *Les antiquitiés judaïques* by Jacques Daudet to texts derived from Josephus, such as John of Salisbury's *Polycratique* translated by Denis Foulechat, or Jean de Vignay's translations of Vincent of Beauvais's *Miroir historial* and of Jacques de Voragine's *La legende dorée*.[58]

Consideration of surviving manuscripts of these texts from the libraries of John of Berry and his brothers suggest that they concentrated on the events of the destruction without the overt inversions of the Jews and Christ or Marie and the Virgin Mary that *Des cas* images incorporate. Most commonly, sections of the text devoted to the events from the era of Jerusalem's destruction were introduced by a single image, as for instance in John of Berry's copy of *Les antiquitiés judaïques* (fig. 4.24), in which the introductory illustration to the second book shows a prisoner brought before Titus as Jerusalem burns. Similarly, in the opening image of the second book of Charles V's copy of *Polycratique* (BnF Ms. fr. 24287, fig. 4.25), which belonged to Duke Louis of Anjou at the time Charles V died, Jews flee the massacre taking place within Jerusalem.[59] The chapter of *Les antiquitiés judaïques* that is the source for the story of Marie and the chapter of the *Polycratique* derived from it are not illustrated in these manuscripts.

In contrast, the introduction to the chapter list for the eleventh book of the *Miroir historial* introduces the idea, later developed more explicitly in Laurent's translations of Boccaccio, that the destruction was punishment for Christ's crucifixion. It categorizes book 11 as an account of a series of Roman emperors, beginning with Emperor Vespasian, "under whom the Jews of Jerusalem were destroyed in vengeance for the death of Our Lord" [sous lequel les juifs de jerusalem furent destruiz en vengeance de la mort nostre seigneur].[60] The text of the *Miroir historial*, like others based on Josephus, does not gloss the story with explicit references to Christ or Mary or include images that encourage such glosses. When *Miroir historial* manuscripts include multiple illuminations about Jerusalem, the image of Marie's cannibalism immediately follows one in which soldiers kill Jewish men who had devoured gold in order to hide their wealth, as, for instance, in John of Berry's manuscript of circa 1370 to 1380 (BnF Ms. NAF 15941, fig. 4.26). The text of the *Miroir historial* had Marie confess her actions when Jewish soldiers followed the smell of what they thought was meat to her home. They sat down at her invitation but were

FIGURE 4.24. The destruction of Jerusalem. Flavius Josephus, *Les antiquités judaïques*, BnF ms. fr. 6466, fol. 389r. Photo: BnF.

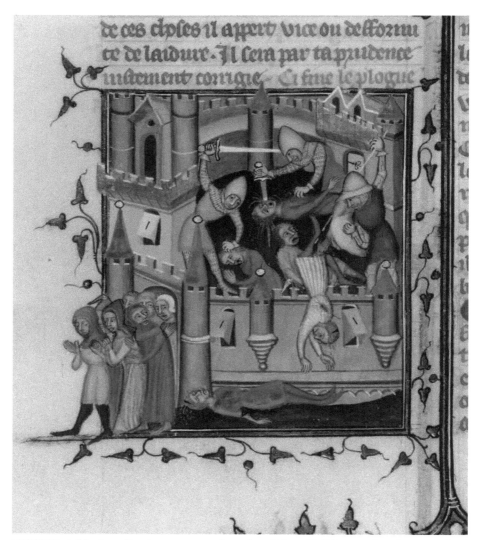

FIGURE 4.25. Jews flee the massacre at Jerusalem. John of Salisbury, *Policratique*, translated by Denis Foulechat. BnF Ms. fr. 24287, fol. 31v. Photo: BnF.

horrified when she served her child. The news spread through Jerusalem and even reached Titus's forces, who destroyed the city in the subsequent unillustrated chapter. This particular image of Marie appears in a broader visual frame that includes an imperial and an author portrait and does not illustrate the actual destruction of the city.[61]

It is striking that the individual scene of confrontation between Marie and two men in John of Berry's *Miroir historial* also appears in *Des cas* (compare figs. 4.22,

FIGURE 4.26. Soldiers kill Jewish men to recuperate gold; Marie offers the leftovers of her son to two men. Vincent of Beauvais, *Miroir historial*, translated by Jean de Vignay. BnF Ms. NAF 15941, fol. 2r. Photo: BnF.

4.23, and 4.26). However, the image in the dukes' copies of *Des cas* emphasizes Marie's identity as a noblewoman and her loss of social status even more emphatically. In John of Berry's manuscript, she wears a *bourrelet* on her head and a robe with ermine-lined sleeves, and in John the Fearless's copy she sports a coronet. Despite her noble status, she sits by the hearth, cooking as a servant would, and moreover, cooks a food that is taboo. The lack of causality implicit in the illuminations from the *Miroir historial* contrasts with the visually amplified destruction of Jerusalem in *Des cas*, which includes the sale of the Jews and Marie's cannibalism—precisely the two scenes that the translated text of Boccaccio associates with Christ and the Virgin Mary.

I make these comparisons to suggest that the stories of the destruction of Jerusalem and of Marie's cannibalism had a French context and visual tradition that would have been almost as familiar to John of Berry, John the Fearless, and Parisian artists as they were to Laurent when he translated Boccaccio. What was distinctive in the illustrations of *Des cas* was the unique scale of the destruction of Jerusalem, its emphasis on the sale of the Jews, its juxtaposition of Jerusalem's destruction exclusively with Marie's cannibalism (which appears out of chronological order), and the way in which its placement deep within the manuscript invites readers to consider it as an interior frontispiece. This function as a frontispiece was a unique role for a visually amplified story, and it was emulated only briefly in contemporary copies of *Des cas* produced circa 1410 to 1415.[62]

The story of the destruction of Jerusalem, with its subsidiary tale of Marie and its moral for contemporary Christians, could stand alone. However, when considered in isolation, the visual amplification added a layer to Laurent's textual amplification for Christians of the story of Jerusalem's destruction that encouraged viewers to interpret the destruction through an additional, contemporary political lens as a reference to the French civil war. After the partisan assassination of Louis of Orléans in 1407, civil war broke out in 1410 between the Armagnac party and the Burgundian party at the same moment that Laurent was writing his translator's prologue and the twin manuscripts of *Des cas* were being prepared for the dukes, who were on opposing sides of the conflict.[63]

Noble Parisians such as the Dukes of Berry and Burgundy would have been as aware as Laurent was that contemporary political unrest in France was regularly compared with events that took place in Jerusalem before its destruction, a special subcategory of the broader Parisian interest in Roman history.[64] For instance, Pierre Salmon, a royal notary and secretary, wrote a letter to King Charles VI in 1410 preserved in *Les demandes faites par le roi Charles VI* (Geneva Ms. fr. 165) that offers a succinct contemporary example of the impact of the fall of Jerusalem and of fifteenth-century politics on courtly writing at the time that Laurent revised *Des cas*. Salmon compared the lamentation over Jerusalem by the prophet Jeremiah ex-

plicitly to the potential desolation of France due to the civil war.[65] Toward the end of his letter, Salmon shifted from addressing the king to appealing directly to the princes of the blood to unify for the good of the royal house.[66] The ways in which this letter freely associated first-century Jerusalem's destruction with fifteenth-century France's woes is reinforced by Salmon's rubric introducing it. He describes 1410 as a time of "dolorous debates and pitiable speeches which were begun between lords of royal blood" [douleureux debas et piteables descors qui ja estoient meuz entre nosseigneurs du sang royal].[67] This noble audience of partisans in the civil war was probably also the anticipated audience for *Des cas des nobles hommes et femmes*—certainly for the copies belonging to John of Berry and John the Fearless.

The resonance between first-century Jews and the fifteenth-century French provided a background for the active approach that Laurent hoped readers would bring throughout his new translation of Boccaccio. The presentation manuscripts of *Des cas* made for John of Berry and John the Fearless used political imagery that resonated with contemporary political polemic in the case of the large miniature of the destruction of Jerusalem and amplified it with the emotionally wrenching, and therefore memorable, story of Marie's cannibalism in the smaller miniature paired with it. These would train careful readers to notice and think about the other visual amplifications that were unique to the dukes' manuscripts, each anchored chronologically in their texts and a single column wide. These also addressed contemporary concerns. The sophisticated reading that *Des cas* encouraged through the interior frontispiece and these visual amplifications would have its readers dip into the book here and there. They would cut across chronological sequences to follow textual and visual leads that associated images—and their texts—in unexpected ways to resonate both within the text and within contemporary literary and visual culture. This active practice of reading and looking was designed to provide those in a position to govern France with exempla that were as powerful and resonant as any offered in more traditional *Miroirs des princes*.

The smaller-scale amplified illuminations are more moralizing than historically resonant; they function even more tightly with each other and directly with texts in different portions of Laurent's amplified translation of Boccaccio.[68] Thus, for instance, the illustration of book 2, chapter 11 (fig. 4.27) shows Dido's brother killing her husband before her eyes, the event that led Dido to flee her brother's kingdom and found Carthage. Although described at the end of chapter 11, the second illumination (fig. 4.28) representing Dido's death is placed as an illustration at the beginning of chapter 12, which contains Boccaccio's praise of Dido and celebration of her chastity.

The two chapters about Sardanapalus (book 3, chapters 13–14) that follow immediately after those devoted to Dido also visually amplify the themes of Dido's story, to contrast more explicitly Dido and Boccaccio's celebration of her

FIGURE 4.27.
Pygmalion murders
Dido's husband, Sychaeus.
Giovanni Boccaccio,
*Des cas des nobles hommes
et femmes*, translated by
Laurent de Premierfait.
Geneva Ms. fr. 190/1, fol.
56r. (www.e-codices.ch).

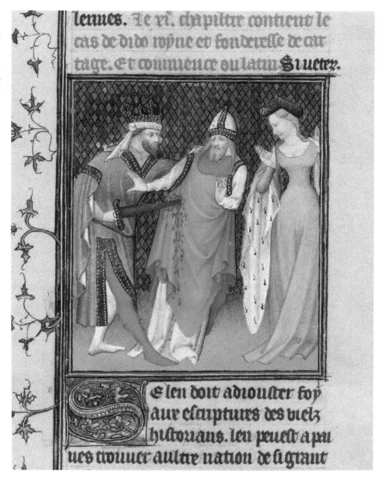

chastity with Sardanapalus and Boccaccio's condemnation of his licentiousness. In the first image of the pair dedicated to Sardanapalus (fig. 4.29), he spins wool with his wives, an action that resonates with Laurent's textual amplification, which added to the translation that Sardanapalus lived "like a woman" with his wives, categorized negatively as *un troupeau de putins* [a herd of prostitutes]. The second image (fig. 4.30) shows Sardanapalus's selfish death; he chose to burn himself and his goods on a pyre rather than to surrender his kingdom and himself to Arbachus, who had realized that Sardanapalus was an unfit ruler. These four sequential scenes of Dido and Sardanapalus create conceptual and visual contrasts between virtue and vice, woman and man, and order and disorder. Visual amplifications like these pose a puzzle for careful readers, who would need to read their accompanying texts to try to discover why they received extended visual attention and then think about the contrast that such interlaced chapters create. Reading and discussing the text

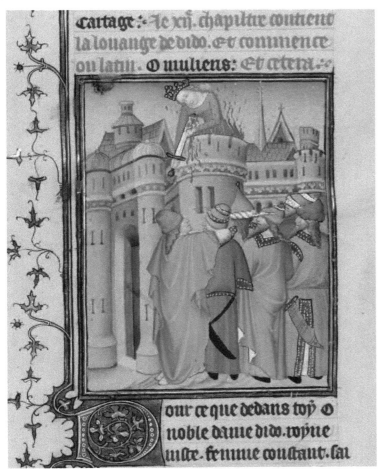

FIGURE 4.28.
Suicide of Dido. Giovanni
Boccaccio, *Des cas des
nobles hommes et femmes*,
translated by Laurent de
Premierfait. Geneva Ms.
fr. 190/1, fol. 59v.
(www.e-codices.ch).

and puzzling out the illuminations would doubtless have fixed these moralizing
exempla in readers' minds more strongly than some of the other illustrated stories
in *Des cas*.

Other visually sequenced pairs encourage different kinds of nonlinear readings
of the discrete tales presented in *Des cas*. For example, one of the remaining visual
amplifications concerns the story of Alcibiades, which appears forty folios after the
story of Sardanapalus and yet was consciously associated with it by Laurent. In book
3 chapter 12, Laurent's translation categorizes Alcibiades, a successful Athenian mili-
tary leader, as an ambitious, charming, and rash ruler who first betrayed his fellow
Athenians and then betrayed the Spartans who sheltered him when he was forced to
flee Athens. Alcibiades' machinations from his haven in Sparta stirred conflict be-
tween the commoners and the nobles of Athens and resulted in an invitation to him
to return as duke of Athens when the noble Athenian "senators" were driven into

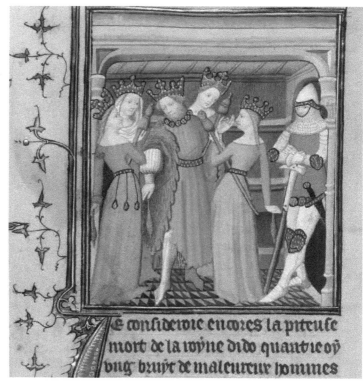

FIGURE 4.29.
Arbachus sees
Sardanapalus spinning with
his wives. Giovanni Boccac-
cio, *Des cas des nobles
hommes et femmes*,
translated by Laurent de
Premierfait. Geneva Ms.
fr. 190/1, fol. 60r.
(www.e-codices.ch).

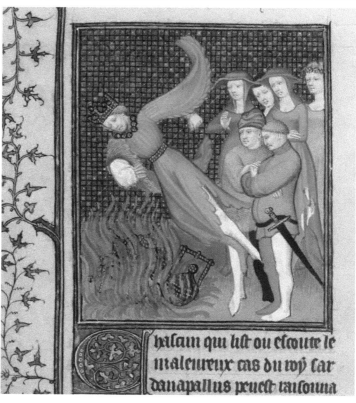

FIGURE 4.30.
Suicide of Sardanapalus.
Giovanni Boccaccio, *Des cas
des nobles hommes et femmes*,
translated by Laurent de
Premierfait. Geneva Ms.
fr. 190/1, fol. 63r.
(www.e-codices.ch).

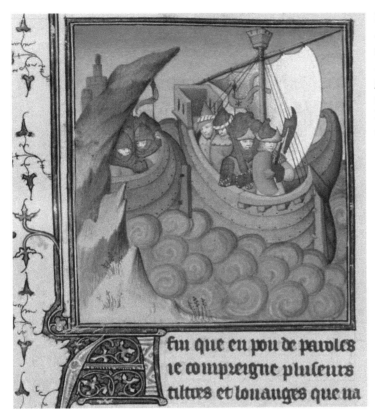

FIGURE 4.31.
Alcibiades, duke of Athens,
at sea. Giovanni Boccaccio,
*Des cas des nobles hommes et
femmes*, translated by Laurent de Premierfait. Geneva
Ms. fr. 190/1, fol. 111v.
(www.e-codices.ch).

fin que en pou de paroles
ie compreigne plusieurs
titres et louanges que na

exile. Alcibiades was not content with governing Athens, however. When Cyrus succeeded Darius as emperor of Persia, Alcibiades persuaded the Athenians to attack Asia. Then fortune caught up with him. He was defeated, stripped of his dukedom, and banished. Lysander, the Spartan who had defeated Alcibiades and the Athenian forces during the Asian campaign, put thirty Athenians—the Thirty Tyrants—in charge of governing Athens in Sparta's name. When they discovered that Alcibiades had sought refuge at Artaxerxes' court in Persia, they sent assassins to track him down and burn him alive as he slept.

This story of Alcibiades is largely the same as that given by Boccaccio's Latin version and Laurent's initial translation in 1400. In Laurent's revised version of 1409, the only significant textual amplifications added to Alcibiades were explicit cross-references to other books and chapters in *Des cas* that contained fuller stories about figures Boccaccio mentioned as comparisons to Alcibiades, such as Ulysses or Sardanapalus. On at least one level, then, Alcibiades' visually amplified story (figs. 4.31 and 4.32) shows him sailing with his army at the height of his power and being assassinated at his most vulnerable, thereby reinforcing Laurent's explicit textual cross-reference to Sardanapalus's illuminated tale. In the moralizing chapter

FIGURE 4.32.
Alcibiades, duke of Athens,
burned alive. Giovanni
Boccaccio, *Des cas des nobles
hommes et femmes*,
translated by Laurent de
Premierfait. Geneva Ms.
fr. 190/1, fol. 114r.
(www.e-codices.ch).

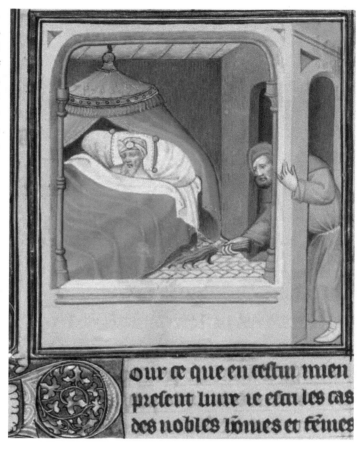

13 of book 3, when Boccaccio discussed Alcibiades in a condemnation of those who are idle and lazy, he cited Sardanapalus who "we spoke of in the twelfth chapter of the second book." Sardanapalus and his military inaction are thus intertwined with Alcibiades, who erred in the opposite direction by taking excessive military action, and both men were unethical and selfishly motivated.

The amplified pairs of Dido, Sardanapalus, and Alcibiades occur in both John of Berry's and John the Fearless's copies of *Des cas*. However, the illustration of Alcibiades by the *Cité des Dames* illuminators in John the Fearless's manuscript shows how visual imagery could be a flexible tool for intensifying the response of one duke or the other. The story of Alcibiades is a clear example of this happening in a shared iconographical cycle. Variations in the compositions of the miniatures in John the Fearless's manuscript place special emphasis on Alcibiades and encourage the comparison of the image of his murder to the assassination of Louis of Orléans ordered by John the Fearless in 1407. In the first scene (fig. 4.33), which represents Alcibiades' ship sailing to one of the naval battles described in the chapter, John

FIGURE 4.33. Alcibiades, duke of Athens, at sea. Giovanni Boccaccio, *Des cas des nobles hommes et femmes*, translated by Laurent de Premierfait. Arsenal Ms-5193 rés., fol. 119r. Photo: BnF.

the Fearless's manuscript places Alcibiades prominently in the center of the illumination and gives him a noble coronet to signal his ducal status. Alcibiades still wears his ducal coronet in the second image (fig. 4.34) in this manuscript, in which he is burned to death. The striking addition to this image of assassination of one of Louis

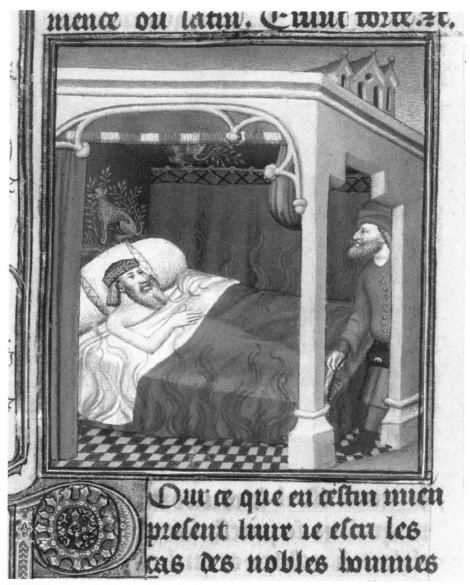

FIGURE 4.34. Alcibiades, duke of Athens, burned alive. Giovanni Boccaccio, *Des cas des nobles hommes et femmes*, translated by Laurent de Premierfait. Arsenal Ms-5193 rés., fol. 122r. Photo: BnF.

of Orléans' emblems, the wolf (*loup*), on the tapestries enclosing Alcibiades' bed encouraged readers to gloss him as Louis. This addition of a simple heraldic charge to the Burgundian manuscript sharpened its contemporary political gloss for John the Fearless.

FIGURE 4.35. Pierre Salmon in discussion with Charles VI. Pierre Salmon, *Dialogues*. BnF Ms. fr. 23279, fol. 19r. Photo: BnF.

Some might object to the suggestion that this inclusion of a wolf was a deliberate allusion to Louis of Orléans. After all, the image of Alcibiades on his deathbed is a variation on an established *Cité des Dames* workshop model of a bed of state that was also used around 1409 in Salmon's *Dialogues* (fig. 4.35). However, this kind of

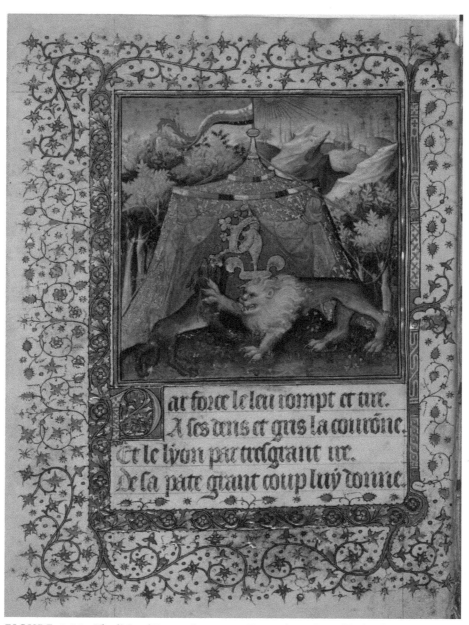

FIGURE 4.36. The lion of Burgundy protects France from the wolf of Orléans. Jean Petit, *Justification du duc de Bourgogne.* ÖNB, Cod. 2657, fol. 1v. Copyright: ÖNB Vienna: Cod. 2657. fol. 1v.

visual allusion through the introduction of emblems and devices happened in the illumination of other texts by the *Cité des Dames* workshop.[69]

Two further observations support this political interpretation for the addition of the emblem of the wolf to the picture in Laurent's translation of Boccaccio's *Des cas*. First, actual emblems or coats of arms are very rare in the *Cité des Dames* illuminators' illustrations to *Des cas*; this is the sole emblem in the Duke of Burgundy's manuscript, which includes coats of arms in only 7 of its 153 miniatures.[70] Second, the *Cité des Dames* artists were very careful to distinguish the animals decorating the ceremonial bed in their adaptation of a workshop model. While King Charles VI's bed in the miniature of Salmon's *Dialogues* is decorated with his emblem of a *tigre* with its distinctly feathered tail, Alcibiades' bed is decorated by an animal with a plain tail that is strikingly similar to Louis of Orléans's emblem of a wolf, which stood in for Louis in the emblematic frontispieces for the illuminated manuscripts of Petit's *Justification* (fig. 4.36) made at the order of John the Fearless circa 1408.[71]

It would have been easy for the artist, whether acting on his own or at Laurent's or the *libraire*'s suggestion, to complement Laurent's additions to the chapter against tyranny by slipping Louis's wolf into the image of Alcibiades. This simple addition of an emblem featured in contemporary Burgundian polemic could associate the assassinations of the tyrannical Alcibiades and of Louis of Orléans in the manuscript specially prepared for the Duke of Burgundy without making the same point explicit in the book made for the Duke of Berry. Adding the emblem of Louis's wolf to the miniatures amplified Alcibiades' story in John the Fearless's manuscript, thus encouraging a contemporary, specifically pro-Burgundian reading for the Duke of Burgundy.

Lucretia and Tyranny

Such specific visual political glosses were rare in manuscripts of Laurent's *Des cas*. It was much more typical for manuscripts like the dukes' copies to include politically charged commentary in visual amplifications that could be meaningful to an audience on both sides of the conflict. For example, certain visual amplifications, such as that of the tale of the Roman matron Lucretia in the dukes' manuscripts and other copies of the text, address tyranny and its punishment in a way that would appeal to members of both sides in the civil war between Armagnacs and Burgundians.[72] Politically charged visual amplifications had the potential to engender distinct reactions in John the Fearless and John of Berry, even when the illustrations were strikingly similar.

The visualization of Lucretia's story and its textual amplification within the dukes' manuscripts clearly exemplify how the visual and textual communities that

flourished around early fifteenth-century princes of the blood also potentially shaped their experience of past history. Livy's *History of Rome* was the ultimate source for Lucretia's story and would have been a familiar tale in French fifteenth-century networks of authors, translators, public and private readers, owners, and artists. It had been translated into French between 1354 and 1359 by Pierre Bersuire for King John the Good and was revised for Charles V in the 1370s and then again circa 1408 to 1410, possibly by Laurent de Premierfait himself.[73]

Livy describes how Lucretia was raped by Sextus Tarquinius, son of the Roman king Lucius Tarquinius Superbus, who took advantage of her hospitality when her husband Collatin was away. When Collatin returned with Lucretia's father and a friend, Lucretia described to them what had happened to her and committed suicide in their presence to preserve her honor. The uproar that ensued led to the overthrow of the Roman monarchy.

Lucretia's story was well known in late fourteenth- and early fifteenth-century France through a series of illuminated translations from Latin that were available in royal and ducal libraries.[74] The French translation by Simon de Hesdin and Nicolas de Gonesse of Valerius Maximus's *Facta et dicta memorabilia*, begun in the 1370s and finished for John of Berry in 1401, recorded Lucretia's story as the first example in the chapter on chastity. Lucretia was also featured as one of the women in the anonymous translation of Boccaccio's *Des cleres et nobles femmes*, also completed in 1401 and surviving in manuscripts owned by John of Berry and John the Fearless from 1402 and 1403 (BnF, Mss. fr. 12420 and 598). She also served as an example of chastity in Legrand's *Livre de bonnes mœurs* (BnF Ms. fr. 1023), presented by the author to John of Berry in March 1410. Finally, Laurent featured her in his translation of *Des cas des nobles hommes et femmes*, where her exemplary death highlighted concerns about justice, tyranny, and assassination that were central to political discussion in early fifteenth-century France.

The illustrations of Lucretia in these French translations feature her suicide in the presence of her husband, her father, and one or more other men, and they are strikingly conservative representations. The illustrations from the *Des cleres femmes* belonging to John of Berry and John the Fearless (figs. 4.37 and 4.38) concentrate on her dramatic death, perhaps in keeping with the brief moralizing paragraph in the text that stresses she did it for her honor, and that the franchise and the liberty of Rome resulted from the political firestorm set off by her action.[75] The illustration to Valerius Maximus (fig. 4.39) from John of Berry's collection presents the story in two scenes within one illumination. The left-hand scene stages key narrative details of the moment of Lucretia's violation, when Sextus Tarquinius came into her bedroom with a sword in his hand and put his hand on her chest as he threatened her. The right-hand scene takes place the next day. It shows Lucretia's suicide after she

FIGURE 4.37.
Suicide of Lucretia. Giovanni
Boccaccio, *Livre des femmes
nobles et renommées*,
anonymous translation.
BnF Ms. fr. 12420, fol. 73r.
Photo: BnF.

FIGURE 4.38.
Suicide of Lucretia.
Giovanni Boccaccio,
*Livre des femmes nobles
et renommées*, anonymous
translation. BnF Ms. fr. 598,
fol. 72v. Photo: BnF.

FIGURE 4.39.
Rape and suicide of Lucretia.
Valerius Maximus, *Faits et dits mémorables*, translated by Simon de Hesdin and Nicolas de Gonesse. BnF Ms. fr. 282, fol. 242r. Photo: BnF.

delivers her speech describing the rape to her father, Collatin, and Lucius Junius Brutus. Lucretia's loose hair in this scene shows that her violation had happened.[76] This miniature is a visual amplification that creates a causal relationship between the two scenes; those who read the text after seeing its illustration would attribute Lucretia's suicide to Sextus's violation of her.

In contrast, the illustration of Lucretia painted by the Luçon illuminators (fig. 4.40) in John of Berry's copy of Legrand's *Livre de bonnes mœurs* (BnF Ms. fr. 1023) accompanies a chapter devoted to the effects of the vices of anger and hate. This is strange because, as A. Châtelet observed, that chapter did not cite Lucretia as a textual exemplum.[77] It seems that Lucretia was sufficiently important to the author that her image was included, but displaced to this location; the chapter on chastity that begins five folios later (fol. 23r) mentions Lucretia but is illustrated by classic Christian models of chastity: John the Evangelist, the Virgin Mary, and Saint Catherine.

The Luçon illuminator's illumination for the *Livre de bonnes mœurs* and the text it illustrates are particularly evocative when juxtaposed with the text and illustration of *Des cas,* which may have been in production when the *Livre de bonnes mœurs* entered John of Berry's collection as a gift from the author in 1410. While the image of

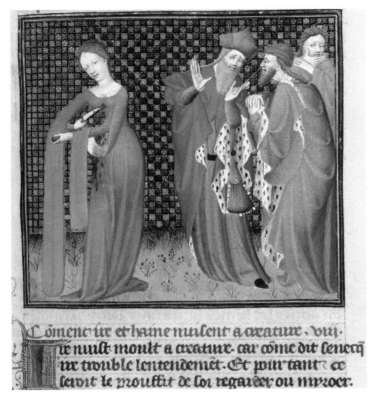

FIGURE 4.40.
Suicide of Lucretia.
Jacques Legrand, *Le livre de bonnes mœurs*. BnF Ms. fr. 1023, fol. 18r. Photo: BnF.

Lucretia killing herself before her male companions in the *Livre de bonnes mœurs* conforms to the visual type already used in manuscripts of Valerius Maximus and *Des cleres femmes*, her description in its text implicates the scene in a different causal relationship that parallels its use in *Des cas*. Legrand framed Lucretia's exemplum of chastity as a lesson for contemporary young noblemen. He observed that the actions of a knight who would take a woman by force are vile and ugly, and urged them to remember Valerius Maximus's account of how Tarquin's rape of Lucretia led the Romans to overthrow his father and terminate royal rule in Rome.[78]

Illustrations in both ducal manuscripts of *Des cas* resonated with this contemporary textual and visual tradition but used it differently. They exploited Lucretia's suicide within an innovative visual amplification, exemplified here by the images painted by Luçon illuminators for John of Berry's manuscript. While the Luçon illuminator's image of Lucretia's suicide (fig. 4.41) draws on the traditional iconography found in other manuscripts in John of Berry's collection, this illumination shares with the illustration of the *Livre de bonnes mœurs* a clear differentiation of Lucretia's old father and clean-shaven husband from Lucius Junius Brutus, who subsequently led the forces that overthrew the government in response to Lucretia's death.

FIGURE 4.41.
Suicide of Lucretia. Giovanni
Boccaccio, *Des cas des nobles
hommes et femmes*, trans-
lated by Laurent de Premier-
fait. Geneva Ms. fr. 190/1,
fol. 89v. (www.e-codices.ch).

The emphasis on male reaction and the increased concentration on Brutus that results plays well within the unusual visual amplification of which this image of Lucretia is a part. Rather than illustrating a moralizing chapter, this illumination of Lucretia's suicide subdivides book 3, chapter 3, and appears directly above the text that describes it. It is the only image in the manuscript to amplify through the subdivision of a chapter. Thus it functions as an amplification designed to make readers dig into the chapter differently than did the other visual amplifications in the dukes' *Des cas* manuscripts. Lucretia's suicide amplifies the picture that begins chapter 3 (fig. 4.42), which shows an earlier event in which Lucius Tarquinius Superbus, the father of Lucretia's rapist, murders his predecessor, King Servius Tullius, and usurps power. The placement of these miniatures of murder and suicide at the beginning and middle of a single chapter encourages a causal association of the suicide as a response to the assassination and usurpation of power rather than a response to a personal affront.

Unusual image pairs such as this one play an important role in the nonlinear reading that Laurent promoted when he added textual cross-references to encourage readers to flip back and forth in the ducal manuscripts of the 1409 version of *Des cas*. Just as these cross-references encouraged readers to juxtapose fuller ac-

FIGURE 4.42.
Lucius Tarquinius Superbus
murders his predecessor,
King Servius Tullius.
Giovanni Boccaccio, *Des cas
des nobles hommes et femmes*,
translated by Laurent de
Premierfait. Geneva Ms.
fr. 190/1, fol. 88v.
(www.e-codices.ch).

counts in previous or subsequent chapters with an image, this visual amplification
of the story of Lucretia encouraged association with the textual passage in Bocac-
cio's famous chapter on tyranny (*Des cas*, book 2, chapter 6) that Petit had cited in
his justification of the Burgundian assassination of Louis of Orléans. After describ-
ing rulers who do not follow good counsel, Boccaccio turned his attention to exam-
ples of men who accomplished great things, one of whom was Lucius Junius Brutus.
In the amplified version of the chapter on tyranny, Laurent expands a single line of
text from his translation of 1400, "Junius Brutus of Rome roused all the people of
Rome against Tarquin the Proud" [Junius Bruttus de Romme bestourna tout le
people de Romme contre Torquinion l'orgueilleux], to thirty-four lines in which he
categorized Brutus as "a citizen of Rome and cousin of the very chaste Lucretia" [un
citoien de Romme et cousin de la treschaste Lucrece] and recounted how Brutus
turned all the citizens of Rome against Tarquin the Proud. He summarizes the story,
mentioning Lucretia's rape, her address before her suicide, and her call for ven-
geance, and then describes Brutus's actions. Brutus pulls the knife from Lucretia's

wound, tells the people of the disloyal action of the king's son, and inspires the residents of Rome and neighboring lands to overthrow the king and all his line.[79] This textual expansion anticipates the political outcome described in the chapter containing the representation of Lucretia's suicide, almost forty folios later.[80] Whether deliberately done or not, the increased prominence of Brutus in the images concerning Lucretia complements his greater significance elsewhere in the text of the manuscript; the distinctive visual amplification would be recalled whenever Brutus was mentioned in *Des cas.*

This image of Lucretia and its associated texts may have had partisan appeal in the wake of the assassination of Louis of Orléans. Although the iconography of the two scenes was identical in both dukes' manuscripts, the ideas about assassination and usurpation of power could well have struck John of Berry, who supported the Armagnac party, differently from John the Fearless, a member of the opposing political party. John had ordered the assassination of Louis of Orléans and then commissioned Jean Petit's *Justification,* which presented Louis as a tyrant who deserved death and cited Boccaccio's chapter on tyranny as he developed his arguments.

The graphic description of Brutus waving Lucretia's bloodied knife to incite a political reaction, which Laurent added to the translation in 1409 or 1410, echoes a response to Petit's *Justification* sponsored by members of the Orléans family in 1408. Their rebuttal not only emphasized the duplicity of John the Fearless and the innocence of Louis of Orléans but also sought to evoke emotion in supporters by emphasizing the gruesome nature of the assassination, in which Louis was hacked to bits on a Parisian street.[81] While comparison to Lucretia was never explicitly made in *Justification* or in the Orléans rebuttal, it would be a likely association to make for John of Berry, an Orléanist sympathizer who was present when Louis of Orléans's sons orchestrated their argument and who owned at least four distinct illuminated manuscripts that illustrated Lucretia's death.

Though illustrating a chronologically arranged series of histories, the illuminations that Laurent devised for the "twin" manuscripts of *Des cas* suggested an alternate way of reading and experiencing the translation of Boccaccio. The illuminations, which occur at frequent intervals, encourage readers to focus on single chapters where they would find tales of individuals, such as Adam and Eve, and learn about the weaknesses that led to their downfall at the hand of Fortune. A small group of illuminations disrupts this status quo by using visual amplification to stretch the tales out, either to illustrate two chapters or to subdivide one. These visual stories encourage readers to work harder, to follow the lead of the images and try to associate their texts, or in some cases to discover comparisons that are not text based, such as that of Dido and Sardanapalus as contrasting exempla of chastity and licentiousness. Sometimes textual references suggest associating separated doubled pairs, as was the case with the doubled illustrations of tales of Sardanapalus and Alcibiades, where ref-

erence to Sardanapalus and memory of his vivid visual representation heightens the negative reading of Alcibiades introduced by his paired images. The ducal readers of *Des cas* imagined by Laurent actively engage with text and illuminations, navigating the manuscript in a nonsequential way, ready to compare tales from the past with the events from their present.

GIOVANNI BOCCACCIO'S *DECAMERON* AND LAURENT DE PREMIERFAIT'S *DES CENT NOUVELLES*

Boccaccio's *Decameron* is a series of one hundred stories presented within a frame narrative that describes seven young women and three young men who fled Florence for the countryside for two weeks, seeking refuge from the Black Death that struck Europe in 1348. To entertain themselves, they decided that each would tell one tale every evening for ten days. They took turns being the "king" or "queen" for the day and in that capacity had the power to establish the theme for the night's stories or to declare that there was no theme. For example, day one has no assigned theme, but on day five stories are told of lovers who pass through disasters before their love ends in a fortunate outcome. The hundred tales placed within this narrative frame of ten days expose human folly and foibles with humor.

Almost immediately after *Des cas des nobles hommes et femmes* was completed, Laurent began collaborating in 1411 on the translation of the *Decameron* for John of Berry at the request and with the financial support of Bureau de Dammartin, a merchant and treasurer of France who often acquired manuscripts for the duke.[82] Because of concern about his own grasp of Italian, Laurent worked for three years in collaboration with Antonio d'Arezzo, a Franciscan. Working closely with Laurent in Bureau's house, Antonio translated Boccaccio's Italian original into a Latin intermediary text that Laurent in turn translated into French as *Des cent nouvelles*.[83]

Laurent's translator's prologue for *Des cent nouvelles* emphasizes the need for cultural translation as he had in his prologue to *Des cas*. Although Laurent never addressed the role of pictures directly in his description of this double translation, his awareness of the need to bridge cultures and his observations about literary genres in his translator's prologue provide an avenue for examining the role of visual imagery in accomplishing visual translation.[84] Copies of Laurent's dedicatory prologue to John of Berry survive in later manuscripts, but the presentation copy does not exist.[85] However, the propensity to make "twin" manuscripts for aristocratic bibliophiles makes it likely that the dense visual cycle with one picture for each of the hundred tales preserved in the earliest surviving manuscript of *Des cent nouvelles* (BAV Pal. lat. 1989) reflects the visual cycle planned for both dukes' copies of *Des*

cent nouvelles.[86] The visual cycle of this book, made for John the Fearless of Burgundy circa 1416 to 1418, will be analyzed here.

Glyn P. Norton suggested that Laurent used his translator's prologue for *Des cent nouvelles* to recast his translation of the *Decameron* as something approaching moral philosophy.[87] Laurent introduces this changed view in his prologue by situating Terence's *Comedies*, Boccaccio's *Des cas des nobles hommes et femmes*, and Boccaccio's *Des cent nouvelles* in relation to one another. He explains that foolish men are troubled in thought and confused by the blows of Fortune, but that the wise are less vulnerable to her vagaries. As a result, wise men use fiction to guide the foolish, to offer them solace, and to chase away the thoughts that trouble human hearts. He offers the example of Terence's *Comedies* as fiction that offers common people fables that "represent the true mirror and form of all human life" [le vray miroer et la forme de toute vie humaine]. These fables hearten the common people, diverting them from opportunities to misbehave and displaying models drawn from the lower and middle estates. Laurent argues that Boccaccio's one hundred *nouvelles* embodied a higher form of fiction than that written by ancient playwrights such as Terence. Whereas ancient writers of fiction depicted people from lower social classes and addressed a popular audience, Boccaccio's tales mix together "emperors, sultans, kings, dukes, counts and other princes and earthly lords, men and women of all estates, be they Christian, Jewish, or Saracen, noble or not noble, cleric or lay, married or unmarried" [des empereurs, des souldans, des roys, des ducs, des contes et autres princes et seigneurs terriens, et hommes et femmes de touz estatz, soient crestiens, juifz, ou sarrasins, noble ou innobles, ecclesiastiques ou laiz, ou soient affranchiz ou astrains en lieu de marriage]. Thus, the *nouvelles* are suited to divert and refresh princes or other men as joyous and honest material to "solace and comfort [their] spirit" [pour leesser et esbaudir les esperitz des hommes].

Laurent mentions *Des cas des nobles hommes et femmes* explicitly toward the middle of his prologue of *Des cent nouvelles*, when he first describes John of Berry's desire to have the *Decameron* translated. His description is laudatory; he writes that *Des cas* contains "only valuable stories/histories and pleasant things" [histoires approuvees et choses ferieuses] and reminds the duke how well he had received it: "the book was scarcely translated by me, the above mentioned Laurent, before it found its place among your other noble and precious volumes" [lequel livre de vostre commandement n'a guere fut translaté par moy Laurens dessusnommé et lequel livre, comme je croy, avez begninement receu et coloqué entre voz autres nobles et precieux volumes]. Laurent ends this section of the prologue with an analogy from the classroom that effectively invites the Duke of Berry to interweave the genres exemplified by Terence's *Comedies* with Boccaccio's *Des cent nouvelles* and *Des cas des nobles hommes et femmes*. He writes that teachers often interrupt lessons by telling joyful fictions in order to refresh students' understanding and allow them to en-

gage more vigorously with their studies.[88] His discussion of the three texts invites readers to consider them in that ascending order of relevance and complexity.

Because Laurent had been intimately involved in producing illuminated copies of precisely these three texts (and no others) for John of Berry's collection, their categorization in Laurent's translator's prologue also suggests a framework for considering the visual translations offered by these manuscripts' cycles of illumination. It seems that the hierarchy of audience and the ascending complexity of text outlined in Laurent's translator's prologue to *Des cent nouvelles* was reinforced by his carefully graduated plan for visual cycles in the earliest manuscripts of these texts. There, the images and the cycles of which they are a part ramp up in complexity as the textual genres that Laurent outlined shift. We have already seen that the illustrations of the Latin Terence (BnF Ms. lat. 5907A), discussed in chapter 2, visualize the settings and characters who speak in the scenes that they accompany, whereas the illustrations of *Des cas des nobles hommes et femmes* manipulate scale and employ visual amplification in their mise-en-page and mise-en-image to achieve a complex visual translation of Boccaccio that even enabled this example of moral philosophy to offer political commentary on contemporary events. Consideration of the surviving ducal copy of *Des cent nouvelles*, painted by the *Cité des Dames* illuminators and transcribed by the same Scribe T who had worked with Laurent since around 1405, reveals that the illuminations planned for *Des cent nouvelles* respect the hierarchy established for their text, falling somewhere in complexity between the illustrations of the *Comedies* and those of *Des cas*. The illuminations "translated" *Des cent nouvelles* visually by smoothing the chronological and cultural dislocation between it and the fourteenth-century Italian *Decameron* in order to meet the horizon of expectations of a ducal fifteenth-century French audience.

Laurent's translator's prologue suggests that *Des cent nouvelles* will be fictional like Terence, but will differ from it in both a concentration on a broader range of society, extending from lower classes to kings and princes, and an ability to offer edifying tales suitable for princes and other men. Illuminations in the text enhance this distinction, offering more visual complexity than that of the *Comedies*, occasionally even approaching some aspects of the moralizing content and visual complexity of the images that decorate *Des cas des nobles hommes et femmes*.

Laurent's revisions to both the text and the mise-en-page of *Des cent nouvelles* encourage reading them within a moralizing frame. Linda Beck and Paolo Cucchi examine the structure and content of the final product of Antonio and Laurent's collaborative translation.[89] They tease apart the ways in which Laurent followed through on the promise made in his translator's prologue to convert Antonio's Latin translation into French, "preserving the truth of the words and sentences according to the two languages except that I extended the too brief into the longer, and the obscure into clearer language so as to easily understand the substance of the book"

[(O)u en gardant la verité des paroles et sentences, mesmement selon les deux lan-
gages, forsque j'ay estendu le trop bref en plus long et le obscure en plus cler lan-
gaige, afin de legierement entendre les matieres du livre].[90] Their analyses reveal that
Antonio and Laurent's translation did not simply amplify and clarify. Beck observes
that the translated text concentrated on presenting Boccaccio's *nouvelles* as exempla,
framing them more didactically by introducing judgmental statements if the point
of the *nouvelle* was not clear. She compares Laurent's French to Boccaccio's original
Italian text and suggests that the French translation elevates Boccaccio's language,
heightening the registers of speech for peasants and the nobility and often shifting
from direct to indirect discourse in order to more fully develop moral points. Lau-
rent also adds cultural explanations and geographical, historical, and economic
asides that would be necessary for French readers. In five of the shortest *nouvelles*, he
expands Boccaccio's text by adding new material. Even if this were primarily moti-
vated by the desire to create a pleasing and balanced layout with *nouvelles* of equal
length in the manuscript, the content of the insertions further adapted the story for
Laurent's first ducal audience by adding, for example, a substantial passage on the
role of the king as arbitrator of justice. This was the kind of content that rulers
might expect in a mirror of princes or a history.[91]

Laurent also revised the mise-en-page, introducing multiple rubrics, sum-
maries, and thematic statements before each tale.[92] In its division into discrete visual-
textual chunks with miniatures of consistent size and placement, this organization
recalls the approach to the illustration of Terence. However, the *nouvelles* are largely
independent from each other, unlike the Terence illustrations, in which characters
appear in identical guise in the complete sequence of images from a play that asso-
ciates them in an ongoing narrative. As a result, the illustrations of *nouvelles* are in-
dividualized. In that, they resemble more closely the structure of the nonamplified
illustrations to *Des cas des nobles hommes et femmes*, as will become apparent.

The beginning of day 5, *nouvelle* 7 (fig. 4.43) offers a good example of the struc-
ture of the densely layered introductory materials that accompanied each of the
hundred stories in Laurent's translation. The running title centered at the top on
facing pages establishes that this is the fifth of ten days, and the rubric at the top of
the left column announces the summary, indicating the *nouvelle*'s number from one
to one hundred and identifying the king or queen for the day and the storyteller.
The summary of the tale follows in a paragraph beginning with a red *U*. Then a ru-
bric announcing this *nouvelle* as a continuation of a previous one and reiterating
who is telling the tale and who is king or queen on the day it is told fills the last line
in the left column above the picture and the first three lines of the second column.
Next, a short paragraph beginning with a blue *L* echoes or amplifies the theme,
and then a three-line rubric announces the *nouvelle*. Finally, a large, two-column-

Cy comence la some de la xlbij. nou
uelle comptee par laurete sur la .v. io
nee dont flamete est royne.

Ung iouuencel nomme theodo
re auua bne iouuencelle no
mee biolante fille dun cheualier appelle
amerige qui auoit achate ledict theodo
re come serf. Et cestui theodore par nul
tiel consentemab conqueut et engroissa
la dicte biolante. pour cestui meffait
fut theodore condempnez a estre penduz
Tandiz que len menoit theodore au gi
bet il fut recongneu de p son pere natu
rel et legitime. Et le iouuencel deliurez
du gibet pris en femme biolante par
consentemab comun entre les parens
et amis des parties.

Cy apres sensuit continuatio de la xlbij.

a la xlbij. nouuelle racomptee par lau
rete sur la quinte tournee dont flame
te est royne.

Les femes toutes doubteuses
escouterent la fin de la xlbij. no
uelle a sauoir non se les deux amis
seroieb brulez en feu. Quat elles ouy
rent dire q deliurez estoieb du peril elles
louerent dieu et firent ioie Et quant
la royne flamete ouy la fin de la precedab
nouuelle elle donna a laurete la charge
de compter la xlbij. nouuelle ensiwant
Et laurete ioieusemant commenceuch
ainsi dire.

Cy apres sensuit au loug le comp
te de la xlbij. nouuelle comptee p lau
rete sur la quinte tournee.

res belles dames sauoir de
uez que ou temps de guil
laume le bon roy de lisle
de sicile. en icelle estoit.i.

noble homme nomme sire amerigue lab
be de trapane bne cite de sicile. il entre
ses aultres biens estoit garnis de fis
par quoy sire amerigue quiot besoig

FIGURE 4.43. Day 5, *nouvelle* 7. Giovanni Boccaccio, *Des cent nouvelles,* translated by Laurent de Premierfait. BAV Pal. lat. 1989, fol. 168v. Photo © 2019 Biblioteca Apostolica Vaticana.

FIGURE 4.44. A noblewoman from Gascony returning from pilgrimage is robbed in Cyprus; she seeks redress from the king. Giovanni Boccaccio, *Des cent nouvelles,* translated by Laurent de Premierfait. BAV Pal. lat. 1989, fol. 29v. Photo © 2019 Biblioteca Apostolica Vaticana.

wide picture cuts across the page, dividing the introductory material above from the *nouvelle* proper and taking almost as much space as the introductory apparatus of rubrics and summaries. This format is followed for each *nouvelle* in the manuscript. Within this framework, illuminations are clearly a significant and integral part of the apparatus of the translation, physically slashing across the page and dividing the introductory material from the *nouvelle.* These illustrations often reinforce changes made in the translation or encourage active engagement with individual stories, as consideration of illustrations of one text that was significantly amplified in translation by Laurent and of a second that was not, will demonstrate.

The first image (fig. 4.44), an illustration of day 1 *nouvelle* 9, accompanies one of the most altered texts in *Des cent nouvelles.* In the French translation, it has a radically expanded summary and *nouvelle.*[93] Boccaccio's summary had been very short: "The King of Cyprus is transformed from a weakling into a man of courage

after receiving a sharp rebuke."[94] As Beck shows, Laurent amplified this for his readers with a blend of geographical, geological, and historical information about Cyprus, but also with more of a preview of the story that the *nouvelle* would subsequently present. Several of the details provided in the amplification of Boccaccio's summary, as, for instance, the description of Cyprus as an island, are reinforced in the image. Both the summary and the fuller *nouvelle* that follows the miniature describe how a noble Gascon woman, returning from pilgrimage to the Holy Sepulcher, was attacked by bad Cypriots and grievously wounded. After talking to a native who assured her that she would not receive help from the timid, lazy, and negligent king of Cyprus, she went before the king to seek redress and managed to move him to action with a courteous jibe.

It is clear that the moments outlined in the summary and described more fully in the *nouvelle* are what is portrayed in the left and right images of figure 4.44. However, careful study of the dress, gesture, and glance of the female pilgrim offers more information, conveying the emotional impact of what happened to her in ways that even the amplified text does not. The representation of the woman in the left half of the illumination emphasizes her modesty when she was traveling with her female companion and was attacked in the forest; she wears a high-necked robe, carries a pilgrim's satchel, and has downcast eyes as two brigands close in on her. Because of the ambiguity introduced by the brown-colored robes and the inclusion of a tall tree in the foreground that overlaps the pilgrim, her arms, at first glance, appear crossed on her chest. Careful inspection of the illumination in the area of the dagger and the lower portion of the billowing sleeve of the brigand to the right reveals that this is not the case. The pilgrim raises her right hand ineffectually, protesting or attempting to fend off either the brigand who touches her chest or the second brigand at the left who closes in behind her. It requires careful looking to tease out this detail, which was made deliberately ambiguous; the artists of this manuscript normally rendered foreground trees smaller than the figures behind them for clarity, but here the tree seems deliberately used to mask the action.[95] Only close looking at and contemplation of the image in relation to the text would reveal the artist's implication that the pilgrim had been raped.[96]

The pilgrim is transformed in dress and deportment in the right-hand scene. She kneels before the king and glares at him, eyes wide open. She seems to be dressed in an undergarment laced down the front, perhaps as a dramatic reminder of her attack. It resembles the illustration of day 2 *nouvelle* 2 (fig. 4.45), in which a man wears a similarly laced undergarment under the robe that is being stolen from him.

The rape and the contrast between the woman's glance and dress in the two halves of the miniature for day 1 *nouvelle* 9, are not described in Laurent's translation. Nonetheless, this image pair would key the reader to look for the words that the woman speaks in the right-hand scene that transform the king from a timid ruler

FIGURE 4.45. Rinaldo d'Asti is robbed and has his property restored to him. Giovanni Boccaccio, *Des cent nouvelles,* translated by Laurent de Premierfait. BAV Pal. lat. 1989, fol 37r. Photo © 2019 Biblioteca Apostolica Vaticana.

into a brave and magnanimous one who avenges her. By reading the summary and studying the image, a reader would approach the *nouvelle* knowing where to delve in order to find what happened in the gap between the two halves of the miniature. What readers would find, in addition to the pilgrim's transformative jibe, was a speech about justice that was added to the French translation. In it, a Cypriot responds to the Gascon pilgrim's assertion that a good king would promptly render judgment and justice. Just an excerpt from the lengthy addition is sufficient to illustrate how appropriate this added message would have been for its noble French audience, the Dukes of Berry and Burgundy, who were, respectively, the uncle and cousin of the French king:

> If our king manifested full royal office he would profit all and deny no one. Each would follow, honor, and love him sufficiently that they would not do evil or attack others. But it is necessary to punish the evildoers and bad people so that they stop. Justice gives our king a sword with two points and made with two edges to punish and chase away the guilty and to defend the just. A good king is

husband to widowed women, father of orphans, help for the oppressed, mirror of virtues, example of noble works, patron of public religion, sentinel and guard of the people subject to him.

[Se nostre roy feist plein office royal, il proufitast a tous, et ne nuysist a aulcun. Chascun lors l'ensuivist honnorast et amast; il ne lui souffisist pas de non nuyre et non grever aultrui, mais il s'efforçast de punir les nuysens et mauvais, afin que ilz cessassent. Justice donna a nostre roy espee a deux pointes et tranchant de deux costez a punir et dechacher les nocens, et a deffendre les justes. Bon roy est mari des femmes vefves, per des orphanins, secours des oppressés, mirouer des vertus, exemple de nobles oeuvres, patron de religion publique, eschargueteur et garde du peuple a lui subject].[97]

Clearly, this picture was carefully devised for its expanded *nouvelle* in order to pique the curiosity and emotion of an observant reader who would then, through Laurent's amplified text, receive the kinds of moral teachings more characteristic of the mirror of princes genre than of Boccaccio's *Decameron*.[98] The image helps achieve Laurent's tonal transformation.

The second example (day 1, *nouvelle* 2) illustrates a more typical text in Laurent's translation because it was not as heavily amplified in translation as the story of the pilgrim in Cyprus. Nonetheless, its illustration also invites careful study because it includes a visual gloss that represents the subject of a conversation without revealing the twist that gives Boccaccio's *nouvelle* its punch. The summary that precedes the image outlines the story:

Jehannot de Chevigny, Parisian merchant, was a very unique friend of a Jew living in Paris and called Abraham. This Jehannot requested and simply exhorted him to become Christian. Before Abraham would be baptized, he wanted to go to Rome to see and consider the customs of the Pope, cardinals, and other churchmen. This enterprise displeased Jehannot so much that he lost all hope that he had to convert Abraham, who, returning to Paris from the Roman court, had himself baptized and lived as a holy Christian and valiant man.

[Jehannot de Croygny, marchant parisien, fut tressingulier ami d'un Juif demorant a Paris et appele Abraam. Cestui Jehannot lui requist et bellement enhorta qu'il se feist cristian. Ains que Abraham se baptisast, voult aler a Romme veoir et considerer les constumes du Pape, des cardinaux at aultres gens d'eglise. Ceste entreprise desplasi a Jehannot et tant que il cuida perdre tout l'esperence que il avoit de faire cristianner Abraam; lequel retournant de court romaine a Paris se fist baptizer et vesqui sainct Cristian et vaillant homme.][99]

FIGURE 4.46. Jehannot de Chevigny, Parisian merchant, tries to convert his Jewish friend, Abraham; Abraham baptized at Notre Dame in Paris. Giovanni Boccaccio, *Des cent nouvelles,* translated by Laurent de Premierfait. BAV Pal. lat. 1989, fol 16r. Photo © 2019 Biblioteca Apostolica Vaticana.

The left side of the illumination (fig. 4.46) introduces the two protagonists of the tale: Jehannot de Chevigny and his friend Abraham, who were each prosperous Parisian merchants. Jehannot is identified as a merchant through his dress; a bright red purse hangs from his belt. Because Abraham's status as a Jew is more important than his identity as a merchant within the format of the story, he wears the red-and-white badge on his chest that identified French Jews, rather than the attribute of a purse that would also categorize him as a merchant.[100] The right image shows Abraham's baptism at the cathedral of Notre Dame in Paris.

Though not described in the text, the images painted on the wall behind Abraham and Jehannot in the left-hand image concretize the substance of the discussions concerning Christian faith and Jewish law during which Jehannot tried to convert his friend. They show a cross-nimbed Christ holding a chalice filled with a red substance that evokes the commemoration of Christ's sacrifice in the mass. The horned Moses holding the tablets of the law and the rod recalls Moses's reception of

the law on Mount Sinai and his moment of doubt while leading the Israelites through the desert (Numbers 20:11–12). God commanded Moses to strike a rock to provide water to his people. However, because Moses lacked faith and struck the rock twice, he was not allowed to lead the Israelites into the Promised Land. With their emphases on faith and doubt, these wall paintings invite viewers to imagine the terms of the debates between the two merchant friends. They also draw on a rich visual tradition that opposed the old and new law via the symbols of the Eucharist and the tablets of Mosaic law that illustrated the canon page of missals and found their way into some frontispieces of *Bibles historiales*.[101]

This visual juxtaposition of the scenes of debate and baptism and the visual encouragement to meditate on the content of Jehannot and Abraham's discussion sets up a false expectation that the textual narrative will demonstrate that Abraham's conversion was the result of his friend's persuasive rhetoric. This was not the case. The *nouvelle* offers a surprise when it reveals that after his discussions with Jehannot, Abraham went to Rome to examine the church more closely. Although astonished by the corruption and decadence that he found in the Roman church, Abraham concluded unexpectedly that the Christian religion must have value and be powerful if it could flourish despite its weak, corrupt, and decadent leadership. Therefore, he converted.

These images in *Des cent nouvelles* offer a more complex interaction with their text than did the images illustrating Terence's *Comedies*. Pictures in *Des cent nouvelles* emulate the visual rhetoric employed in the Terence illuminations by using distinctive elements of dress, such as the merchant's purse or Jewish badge, to distinguish Jehannot from Abraham in figure 4.46, and the contrast between concealing dress and revealing undergarment worn by the female pilgrim in figure 4.44. However, images illustrating *Des cent nouvelles* also divide the story into two parts, sometimes deliberately omitting the "punch line" that was the tale's moral while guiding the reader to concentrate more carefully on the text that describes the events that took place between the two moments represented in the opening illustration. Thus, the images serve both to identify character types and, more importantly, to pique the curiosity of readers and guide them toward a fundamental moral message.

By the time Laurent turned to the illustration of Boccaccio's *Des cent nouvelles*, he was a master at working with *libraires* and artists to use subtly graded visual translation as both a substitute for and a complement to textual translation. Indeed, the ascending visual complexity in the painted cycles of Terence's *Comedies* and Boccaccio's *Des cent nouvelles* and *Des cas des nobles hommes et femmes* supervised by Laurent offer insight into how he wanted Boccaccio to be received by the Dukes of Berry and Burgundy, and reinforce the distinctions he outlined in his translator's prologue to *Des cent nouvelles*. There, Laurent described classical fiction such as Terence's *Comedies* as representing the mirror of human life and presenting the lower

and middle classes. In contrast, the translator's prologue presents the fiction in *Des cent nouvelles* as incorporating all classes of men in tales suited to divert and refresh princes and *Des cas des nobles hommes et femmes* as a valuable history that quickly found its place among John of Berry's other precious volumes.

The illuminations devised by Laurent and his collaborating *libraires* and artists for these texts reinforce the textual distinctions that Laurent's translator's prologue to *Des cent nouvelles* established. The visual cycle in *Des cent nouvelles* and the textual apparatus that frames it are much more complex than the images Laurent devised to subdivide scenes and identify character types in the *Comedies*. In *Des cent nouvelles*, images familiarize readers with the characters featured in the *nouvelles* through details of costume or setting that function as indicators of class, but the images also stage two moments from each narrative in such a way as to pique curiosity about and shape the reader's approach to the text that follows. These visual narratives often establish expectations in readers that are undone once they plunge into the *nouvelle* and have the pleasure of discovering the rest of the story. Nonetheless, the pictures illustrating *Des cent nouvelles* are firmly embedded in the weighty textual apparatus that separates one *nouvelle* from another in Laurent's translation. Finally, although the majority of images in the visual cycle of *Des cas des nobles hommes et femmes* are firmly embedded in the narrative of their chapters, a small group of images overtly encourages another level of interpretation. The doubling of images that amplify a narrative within an individual chapter or a sequence of chapters and the emphasis through changes in scale or density of illustration that signal visual amplification invite readers to contemplate the images in a different framework and to interpret their texts as glosses on fifteenth-century events. These visual translations were an integral part of Boccaccio's transmission in France.

The work expected of readers to decipher these visual translations resonates with the different roles that Laurent outlined for history and fiction in his prologue to *Des cent nouvelles*. These illuminated books reinforce the French perception of Boccaccio as a moral philosopher who had something to teach John of Berry and John the Fearless. In the dukes' libraries, Boccaccio's *Des cent nouvelles* would serve the same purpose as the "fables ou nouvelles joyeuses" told by masters that Laurent mentions in his translator's preface to it. Their moralized visual cycle and text would offer honest solace and diversion, refresh understanding, and prepare the duke to return to books such as *Des cas des nobles hommes et femmes*, in order either to look at and read vigorously or to listen with absorption to their moral lessons.

PART 3

The Cycles Escape

Normalization

The collaboration of Laurent de Premierfait and Jean Lebègue with Parisian *libraires* and the scribes who worked with them, including Monfaut and Hands T and S, established a new normal for illuminated humanist texts in early fifteenth-century France. Instead of producing sparsely illustrated manuscripts of the classics or of Boccaccio, as had happened in the early fifteenth century when these texts were first retooled for a noble clientele, *libraires* and artists worked in collaboration with Laurent and Lebègue to produce carefully constructed and densely illuminated manuscripts for patrons or, in the case of Lebègue, themselves. Analysis of Laurent's supervision of manuscripts of Statius, Cicero, and translations of Boccaccio and of Lebègue's supervision of manuscripts of Sallust over twenty years reveal how these humanists learned to integrate images into their manuscripts and to exploit them in order to create a visual translation of their classical or Italian sources that would communicate effectively with elite early fifteenth-century French audiences of humanists and nobles.

Once these texts and their visual cycles became available for circulation within the Parisian book industry, however, the manuscripts produced would not necessarily experience the same vetting that copies directly supervised by Laurent and Lebègue had. It seemed that the *libraires* and their patrons embraced the newly illuminated texts but were not interested in the level of precision that Laurent and Lebègue had insisted on in the manuscripts they supervised. How were the original cycles received, and how were they redeployed? The answer to this question offers insight into the impact that early French humanists like Laurent and Lebègue had on the Parisian book trade.

With the exception of a few books owned by humanists, the manuscripts produced in Paris once these texts and their illuminated cycles escaped Laurent's and Lebègue's control were of two types. Copies were made that often constituted visual facsimiles. At the same time, newer versions were produced, variations that often manifested the kind of normalization that transformed the humanist cycles

into visual cycles more typical of texts of history or moral philosophy. What is strik-
ing, though not surprising, is that the most successful texts in this process of nor-
malization were those that had been translated into French.

THE LATIN TEXTS

Laurent's and Lebègue's illuminated Latin texts had a limited impact on the visual
culture of the Parisian book trade. There are no illuminated manuscripts that re-
semble Statius's Latin *Thebaid* and *Achilleid* (BL Burney 257), made circa 1405
under Laurent's supervision.[1] There is only one surviving manuscript (Trivulziano,
Triv. 693) that includes Laurent's bilingual translation of Cicero from 1405.[2] It is es-
sentially a facsimile whose text was copied from BnF Ms. lat. 7789 and corrected,
and it is attributed to the Master of Barthélemy l'Anglais, who was active circa 1430
to 1450 in western France.[3] Most notably, it copies the experimental illuminations in
Louis of Bourbon's manuscript (BnF Ms. lat. 7789) (compare figs. 4.4 and 4.1 to 5.1
and 5.2), and it also replicates the unusual textual layout that isolates Cicero's letter
to Marcello, *De senectute*, and Laurent's translation, the *Livre de vieillesse*, on sepa-
rate quires, suggesting that the design of the manuscript's layout and its visual cycle
were copied directly from Louis of Bourbon's book.[4] The twenty-six other surviv-
ing copies of *Livre de vieillesse* do not appear bound together with Cicero's original
Latin.[5] With the exception of a fragmentary copy whose original manuscript context
is unknown, these manuscripts group Laurent's translation with other translations
by Laurent, Jean Courtecuisse, or Jacques Legrand and with French texts by Chris-
tine de Pizan and others. When these copies of the *Livre de vieillesse* are illustrated, it
is usually with a single miniature or an initial.

The illuminated manuscript of Terence's plays produced under Laurent's su-
pervision for John of Berry had a limited impact, but the two copies based on it
that survive show how a visual cycle could be adapted and honed even within
courtly and humanist circles once it became available to Parisian book makers.
The visual rhetoric deployed with such care in the Duke of Berry's Terence, de-
scribed in chapter 2, was part of a language understood by artists, by authors of vi-
sual programs, and by readers of the luxurious manuscripts produced in early fif-
teenth-century Paris. Its vocabulary was deployed with particular care in John of
Berry's Latin manuscript, but it was also stock-in-trade for artists who adapted
cycles like Laurent's to illuminate many new luxurious manuscripts produced for
members of the French court in the early fifteenth century, often with very differ-
ent goals.

FIGURE 5.1.
Cicero gives a book to a youth who delivers it to another man. Marcus Tullius Cicero, *Oratio pro Marcello*; *De senectute*, and *Livre de vieillesse*, the French translation by Laurent de Premierfait. Milan Cod. Triv. 693, fol. 9r. Copyright © Comune di Milano. All rights reserved.

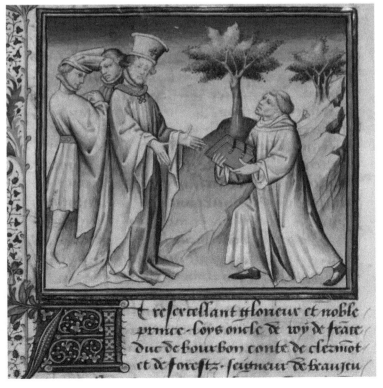

FIGURE 5.2.
Laurent presents his book to Duke Louis of Bourbon. Marcus Tullius Cicero, *Oratio pro Marcello*; *De senectute*, and *Livre de vieillesse*, the French translation by Laurent de Premierfait. Milan Cod. Triv. 693, fol. 33r. Copyright © Comune di Milano. All rights reserved.

Two Manuscripts Respond to John of Berry's Terence

Two early illuminated Parisian Terence manuscripts offer insight into the mechanisms by which new cycles devised in collaboration with Laurent "escaped" into the Parisian book trade and changed in response to their new environment. The first example is an early fifteenth-century copy of Terence's *Comedies* (BnF Ms. lat. 8193) left incomplete by an illuminator identified as the Roman Texts Master.[6] It was neither associated directly with Laurent nor written by the scribes who collaborated with him. Gilbert Ouy identified the scribe of this manuscript as Monfaut, who worked for humanists and scholars in Paris; he wrote portions of the Sallust manuscripts produced by Lebègue for the Orléans brothers and himself (BnF Mss. lat. 5762 and 9684) discussed in chapter 2, manuscripts of Valerius Maximus and Cicero for Jean Courtecuisse (BnF Ms. lat. 6147 and Bern, Burgerbibliothek Ms. 254), and a copy of Nicolas de Clamanges's treatises (BnF Ms. lat. 16403) that belonged to Jean d'Arsonval, who was Duke Louis of Guyenne's tutor.[7] BnF Ms. lat. 8193 does not include any version of Laurent's original commentary, but instead begins with Petrarch's life of Terence (folios 1r–2v), a text that was known in Paris to humanists such as Jean de Montreuil.[8] It shares a partial transcription of the scene summaries identical to those transcribed after Laurent's commentary at the end of John of Berry's manuscript (BnF Ms. lat. 7907A, fols. 143v–52r), but it integrates the summaries more closely with Terence's text by placing them in the lower or side margins close to the beginnings of each scene. The image of the abduction of Calida (fig. 5.3) that begins act 2, scene 1 of *The Brothers* shows the characteristic placement of the summary in relation to Terence's text in BnF Ms. lat. 8193; the summary in its lower margin corresponds to that on BnF Ms. lat. 7907A, folio 151r, where the text appears within the set of summaries transcribed at the end of that manuscript. The summaries in BnF Ms. Lat. 8193 only run up through folio 223r, which ends a quire. BnF Ms. lat. 8193 includes interlinear glosses, but only to folio 46r, which is also the end of a quire. It seems that the scribe, who may have been the glossator, stopped working at those two distinct points, leaving the rest of the manuscript unsummarized and unglossed. The transcribed text left blanks for 144 illuminations, but artists only completed 15 of them; they left all of the remaining spaces totally blank, except for 6 illuminations for which preparatory drawings had been executed.[9]

The relationship between these two manuscripts has been the subject of debate. On the basis of analysis of their visual cycles, Meiss suggested that the Duke of Berry's manuscript, which was made in 1407, was the oldest, and that it served as the prototype for the other two.[10] He proposed that BnF Ms. lat. 8193 was either contemporary or a bit later in date than John of Berry's Terence. In contrast, on the basis of the differing textual readings, the density of its planned cycle of 144 images, and their similarity in spatial conception to illuminated Carolingian exemplars, Marie-

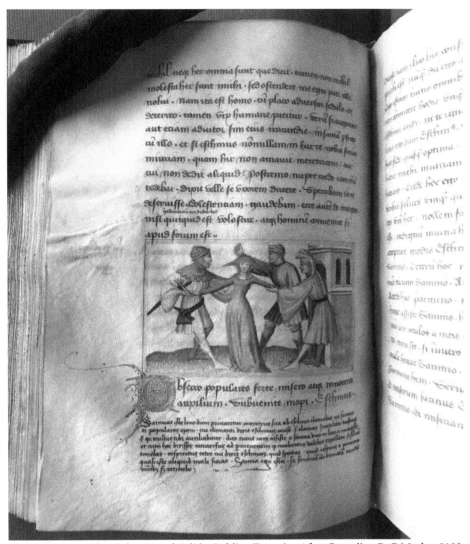

FIGURE 5.3. The abduction of Calida. Publius Terentius Afer, *Comediae*. BnF Ms. lat. 8193, fol. 100v. Photo: BnF.

Hélène Tesnière believed that BnF Ms. lat. 8193 was made circa 1405 and was older than the others; she concludes that all three may have gone back independently to Carolingian models.[11] In a recent study of the fifteenth-century annotations of the Carolingian manuscript of Terence (BnF Ms. lat. 7899) that was available in the library of Saint-Denis, Turner observes that the fifteenth-century commentaries in this Carolingian copy are much more accurate than many other medieval commentaries and speculates that they were used in the preparation of the texts for John of Berry's and Louis of Guyenne's deluxe manuscripts.[12]

I suspect that the relationship between the visual cycles in BnF Ms. lat. 8193 and John of Berry's Terence may resemble that between Lebègue's Sallust in Geneva and the Sallust in a private collection, the luxury manuscript described in chapter 3. Lebègue was a humanist who had contact with a *libraire* who gave him access to a visual cycle for Sallust that had been developed independently for the luxury manuscript. Both manuscripts of Sallust were executed by different scribes. Their textual readings and, occasionally, the placement of illuminations in their text varied, yet they shared thirty-one iconographically identical images painted by artists associated with the Bedford and Orosius illuminators. Further, like BnF Ms. lat. 8193, a large number of images in both Lebègue's copy of Sallust and the luxury manuscript were initially left unfinished.

Comparison of BnF Ms. lat. 8193 and John of Berry's *Comedies* suggests that BnF Ms. 8193 was compared to the duke's book, and possibly even to its textual source, only after its scribe had transcribed his Carolingian model and left blanks for illuminations. That was the moment when the decision was made to consult John of Berry's manuscript in order to annotate BnF Ms. lat. 8193's margins with summaries of scenes and to begin illuminating it. Neither the annotations nor the illuminations were ever finished.

The evidence that the scribe of BnF Ms. lat. 8193 consulted John of Berry's Terence and copied the textual summaries is suggestive. The scribe of the marginal summaries in BnF Ms. lat. 8193 seems to have responded to summaries in John of Berry's book that questioned the division of the text. For instance, despite the fact that spaces were left for pictures, there is no marginal commentary written at the beginnings of *Woman of Andros* act 5, scenes 2 and 3 (BnF Ms. lat. 8193, fols. 29v and 30v) at the point where the summaries in John of Berry's Terence (BnF Ms. lat. 7907A, fol. 145v) explain, "According to the correct partition, this last act is not a scene" [Secundum rectam partitione[m] hui[us] ultimi actus esta non est scena] and "This division does not serve as a scene" [Hic recta divisione servata non est scena]. The comments in John of Berry's manuscript continue, suggesting that the scene actually ends at *Woman of Andros* act 5, scene 4. The same thing happens in the relationship between *The Brothers* act 4, scenes 6 and 7, where blanks were also left for images on folios 117v and 118r in BnF Ms. lat. 8193, but no commentaries were written adjacent to them. These seem to respond to the summary on folio 152r at the end of John of Berry's manuscript of *The Brothers* act 4, scene 6, which has the incipit *Ibo illis dicam*. The summary ends with the thought "I believe then this scene correctly begins *Defessus sum*" [Credo tu[nc] hanc scena[m] recte i[n]cipere *defessus sum*], which is the incipit for *The Brothers* act 4, scene 7. Possibly confused about what to do, the scribe of BnF Ms. lat. 8193 neglected to write summaries beside both acts. In the place where the duke's manuscript did not break for a miniature for *The Brothers* act 3, scene 5 (BnF Ms. lat. 7907A fol. 86r), the scribe of BnF Ms. lat. 8193 did not include

a summary at the equivalent text on fol. 111r, and a second hand wrote "about the preceding scene" [de scena precedens]. This second hand annotated the marginal summaries in BnF Ms. lat. 8193 eight times with indications for acts of plays (for instance "quint[us]"act[us]" in the margin of act 5, scene 1 of *The Self-Tormentor* on fol. 90r). Six of these annotations provide information that is an integral part of the summaries at the end of John of Berry's manuscript, a striking observation given that the duke's manuscript itself only has eight annotations of this sort.[13] These observations suggest that BnF Ms. lat. 8193 may indeed be roughly contemporary with or even slightly later than John of Berry's Terence, dating circa 1407.

The second example (Arsenal Ms-664 rés.) was made for the dauphin, Duke Louis of Guyenne, circa 1411 or 1412 and was decorated by Luçon, *Cité des Dames*, Bedford Trend, and Orosius illuminators.[14] Whoever produced it looked to John of Berry's manuscript (BnF Ms. lat. 7907A) as a model for the visual cycle but not as a source for its text, which was not copied by any of the scribes who typically worked with Laurent.[15] Furthermore, the order of the plays in the dauphin's Terence differs from that in John of Berry's manuscript, in BnF Ms. lat. 8193, and in the Terence in the library of Saint-Denis. While they present the plays in the order *Woman of Andros (Andria), Eunuch, The Self-Tormentor (Heautontimoroumenos), The Brothers (Adelphoe), The Mother-in-Law (Hecyra)*, and *Phormio*, the Duke of Guyenne's book reverses the order of the last two plays.[16] Because Arsenal Ms-664 rés. contains a more fully developed version of Laurent's commentary, it seems likely that the manuscript originated within the humanist milieu in Paris to which Laurent belonged.[17]

Changes to the layout of Arsenal Ms-664 rés. seem designed to make it more accessible to the young prince, who was about fourteen or fifteen years old when he received it. The Duke of Guyenne's manuscript contains the text of Terence written in long lines rather than as verse, although it is marked for scansion.[18] The *libraire* who produced it included an expanded version of Laurent's original commentary (*accessus*) on folios 2r and 2v, and then repeated a pattern in which each play begins with a few lines of summary followed by a prologue that underlines Calliopus's role. Each scene within the play begins with a summary that resamples and expands those that had been so carefully clustered at the end of the manuscript made for John of Berry. Textual layout and the scale of the script establish distinctions between these summaries and Terence's play. The opening scene of Pamphilius and Mysis from act 1, scene 5 of *Woman of Andros* (figs. 5.4–5.5) is a good example of this structure; the summary immediately precedes the illustration and transcription of Terence's play, and it is written on lines that are ruled to be twice as dense. Further, individual synonyms or clarifications written between lines of the plays' texts gloss individual words. With its revised layout and textual contents, this manuscript, as Tesnière observed, does not come from the same intellectual milieu as had John of Berry's manuscript.[19]

FIGURE 5.4. Summary of act 1, scene 1 of *Woman of Andros*. Publius Terentius Afer, *Comediae*. Arsenal Ms-664 rés., fol. 11v. Photo: BnF.

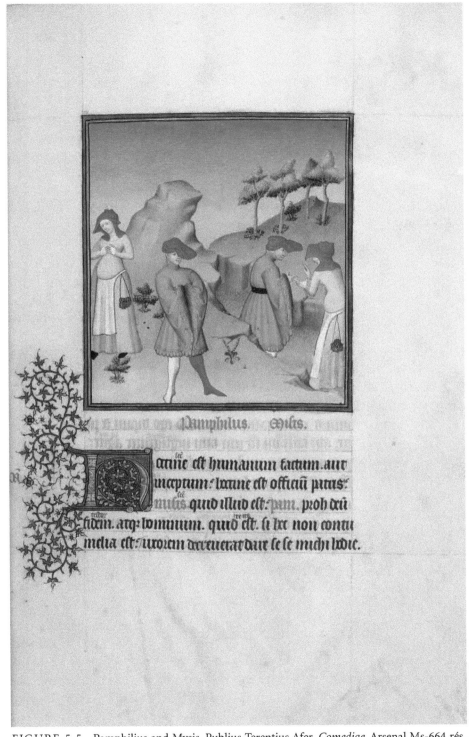

contīe est humanum tactum.aut
inceptum: lacute est officiū pitus:
mūsis quid illud est:pam. proh deū
fidem. atqz hominum. quid est. si loc non contu
melia est:uxorem drcenerar dare se se michi hodie.

FIGURE 5.5. Pamphilius and Mysis. Publius Terentius Afer, *Comediae.* Arsenal Ms-664 rés., fol. 12r. Photo: BnF.

Consideration of the illustration of these three associated manuscripts shows that *libraires* and artists understood the visual rhetoric of costume employed in Laurent's manuscript for John of Berry.[20] It is fortunate that BnF Ms. lat. 8193 is unfinished because its underdrawings and written directions to artists offer insight into the mechanism by which Laurent's more accessible "visual translations" of Terence—that is, the paintings for individual scenes, rather than the frontispiece—escaped into the world of the Parisian *libraires* who produced both BnF Ms. lat. 8193 and Arsenal Ms-664 rés. It also reveals which of Laurent's concerns, expressed in illuminations, seem to have been peculiar to him and which appealed to a broader audience.

While the construction of visual cycles in both of these books reveals the importance of John of Berry's manuscript, the uses made of the visual cycle by the artists or *libraire* reveal that they did not approach illustration with the same goals that Laurent, his *libraire*, or the illuminators of BnF Ms. lat. 7907A had done. The images copied by the artists of BnF Ms. lat. 8193 and the Duke of Guyenne's manuscript often served different purposes. For instance, the frontispiece to the manuscript made for the Duke of Guyenne was not as concerned with clarifying Calliopus's relationship to Terence. Although that frontispiece, painted by a Luçon illuminator (fig. 5.6), is clearly based on the model of John of Berry's manuscript (compare fig. 2.20), the relationship between the two zones is less clearly established. A bearded man wearing a hat receives the book from Terence in the bottom scene of Louis of Guyenne's book, and a beardless one reads in the *scena* above, with the result that the image no longer emphasizes Calliopius's role as strongly.

Those who planned BnF Ms. lat. 8193 and Louis of Guyenne's book approached each play as a unicum in which types are distinguished by costume, but not through cross-comparison. They used the kind of distinction through costume that was commonly employed by Parisian illuminators. An example from act 2, scene 1 of *The Brothers* in BnF Ms. lat. 8193 and Arsenal Ms-664 rés. shows when the artists of the two related manuscripts felt comfortable departing from the visual models of John of Berry's manuscript (see fig. 2.33). In the scene of the abduction of Calida in John of Berry's book, the youthful lover Eschinus appears at the left with his name inscribed in gold above his head, and the pimp Sannio is at right with his name in gold above the roof of his house. They tug on the arms of the prostitute at the center of the miniature as Parmeno, Eschinus's enslaved companion, looks on. The golden captions within the miniature of John of Berry's manuscript seem designed to enhance his use of the image in relation to the play's text because both the rubrics on the preceding folio (*Sannio leno, Eschinus adulescentes,* and *Parmeno servus* [Sannio pimp, Eschinus youth, and Parmeno slave]) and the red rubrication embedded within the text of the play proceed in the order of the characters' speech,

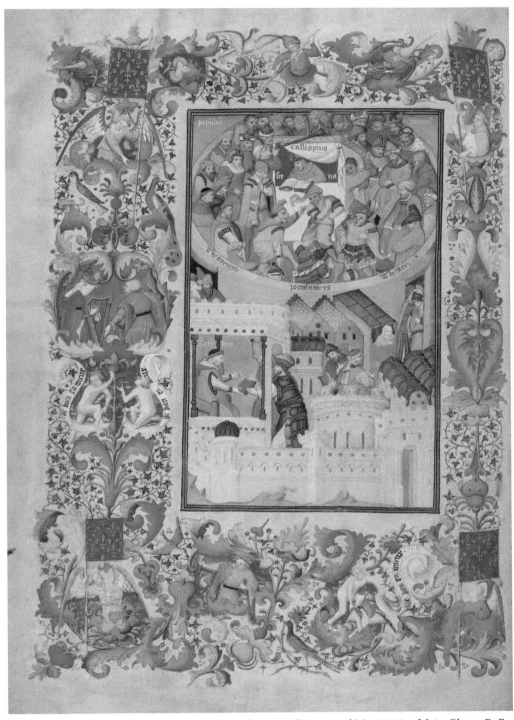

FIGURE 5.6. Frontispiece. Publius Terentius Afer, *Comediae*. Arsenal Ms-664 rés., fol. 1v. Photo: BnF.

FIGURE 5.7. The abduction of Calida. Publius Terentius Afer, *Comediae*. BnF Ms. lat. 8193, fol. 100v. Photo: BnF.

each beginning with Sannio, and not in the order of their arrangement within the miniature.

Surviving directions to the illuminator written to the left and above the miniature in BnF Ms. lat. 8193 (fig. 5.7) make clear that the Roman Texts illuminator was supposed to do a simple variation on the classic confrontation painted in John of Berry's manuscript. Pale marginal directions in the left margin (*amoureaux* [lover]) and in the space left blank above the miniature (from left to right, *putin* [prostitute],

FIGURE 5.8.
The abduction of
Calida. Publius
Terentius Afer, *Comediae.*
Arsenal Ms-664 rés.,
fol. 131v. Photo: BnF.

valet [servant], and *houlier* [a debauched or ribald man]) indicate that those who
planned the composition wished to duplicate the original in John of Berry's manu-
script, with a variation that allowed the servant to intercede more actively. The artist,
possibly at the request of someone who knew the Latin play, ignored the placement
suggested by the order of the written directions and flipped the positions of Sannio
and his opponent, perhaps to expand Sannio's gesture and show his extravagant
dress to better effect or even to integrate image and text more effectively by making
the first speaker in the play (Sannio the pimp) appear at the left of the illustration.

The artist or designer of the image in the Duke of Guyenne's book (fig. 5.8)
seems to have worked from the visual image in John of Berry's manuscript. The

composition retained the arrangement of the youthful lover and the pimp in their conflict over the prostitute, but it gave her and the lover's slave more space in the image, and it constructed a more complex space in which the protagonists interact. The *Cité des Dames* illuminator may have been misled by the blue rather than brown robe of the servant in his model and transformed him into another youth with a dagger and purse on his belt. This image includes rubrics below the image that draw attention to the opposition between the pimp and the lover: *Sannio leno, Eschinus adulescentes* [Sannio pimp, Eschinus youth].

Consideration of the scene between the two brothers Micio and Demea in all three manuscripts reveals how flexible this visual rhetoric of costume could be. It also shows how simple characterizations introduced by the directions to the illuminator offer important insight into how artists collaborated with the *libraires* in making illuminations that shade interpretation of Terence's plays. In John of Berry's manuscript (see discussion of fig. 2.30 above) the brothers were represented as a lawyer and an old man, with the opposition established by the written directions to the illuminator (*avocat* [lawyer] and *paisant* [peasant]) that the artists only followed partially.

The illustration (fig. 5.9) in the unfinished manuscript painted by the Roman Texts Master reveals that the careful manipulation of costumes from different social categories played an important role in differentiating the brothers in that manuscript as well. After looking at John of Berry's book, someone wrote directions to dress the country brother as a *labourer* [laborer] and designated the city brother as *frere* [brother] rather than classing him as lawyer or member of another social group. The country brother, at left, wears baggy hose and a shorter brown robe with an uneven hem, of a type and in the nondescript colors typically used for servants in the manuscript. In contrast, the city brother at right wears traditional garb for old men—almost exactly the same clothes that old men wore throughout John of Berry's manuscript and that the country brother wore in his book (compare fig. 2.30). While Laurent differentiated the brothers from each other in John of Berry's manuscript by "elevating" Micio, the city brother, to represent him as a lawyer, the designer of BnF Ms. lat. 8193 differentiated them by "lowering" Demea, the country brother, to represent him as a laborer. Both book designers understood that the categorization would come across most clearly if one brother retained the traditional "old man" dress, but they varied their choice of which brother wore it.

The illumination painted by the Bedford Trend illuminator in the manuscript made for the dauphin (Figure 5.10) copies John of Berry's book but is less precise in its visualizations. Micio wears the same long pink robe with a purse and added sword to indicate that he has traveled, and he has a clean-shaven face and a balding head as he did in John of Berry's Terence. However, his brother wears a long robe of

FIGURE 5.9. Demea and Micio. Publius Terentius Afer, *Comediae*. BnF Ms. lat. 8193, fol. 99r. Photo: BnF.

a similar length to those worn by other old men painted by the Bedford Trend and Luçon illuminators in this manuscript. In Louis of Guyenne's Terence, however, the pink robe does not establish an overt association with the quibbling lawyers in the scene from a different play as it had done in John of Berry's book (compare figs. 5.10 and 5.11 with 2.30 and 2.31), either because the second scene in the Arsenal manuscript was painted by a Luçon illuminator rather than a Bedford Trend illuminator, or because the artists worked directly from the earlier book image by image, without the intervention of someone who knew and sought to nuance the Latin texts, as had happened in both John of Berry's book and BnF Ms. lat. 8193.

Analysis of the surviving written directions and sketched or completed illuminations in *The Brothers* in BnF Ms. lat. 8193 reveals that those who devised the cycle

FIGURE 5.10.
Demea and Micio.
Publius Terentius Afer,
Comediae. Arsenal
Ms-664 rés., fol. 129v.
Photo: BnF.

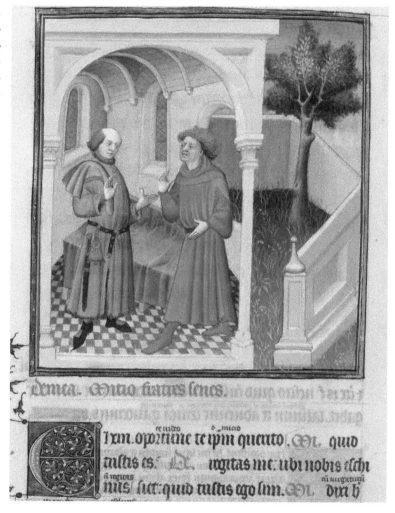

FIGURE 5.10.
Demea and Micio.
Publius Terentius Afer,
Comediae. Arsenal
Ms-664 rés., fol. 129v.
Photo: BnF.

for that manuscript relied on the model provided by John of Berry's book but sought to clarify familial relationships between characters and their role in the visual narrative even more. The written French directions identify one from each pair of brothers as *frere* [brother]; Micio and Demea, the older pair of brothers, are described as *labourer* [laborer] and *frere* [brother]; Aeschinus and Ctesipho, the sons of Demea, are described as *lamoureux* [the lover] and *frere* [brother]. Further, Pamphilia, whom Aeschinus made pregnant, and her mother, Sostrata, are described as *lagrose* [the pregnant one] and *mere* [mother].

In adapting images from John of Berry's manuscript, the Roman Texts Master repeatedly used composition to underline these important familial relation-

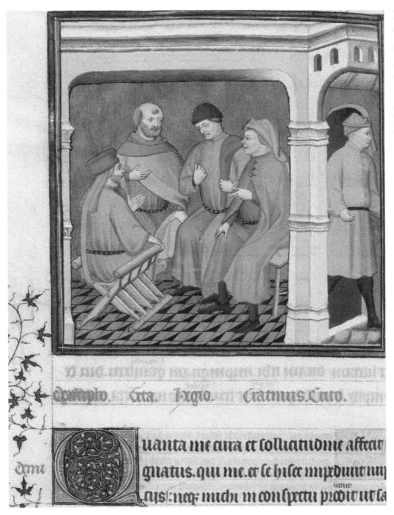

FIGURE 5.11.
Geta, Demipho, Hegio,
Caratinus, and Crito in
conversation. Publius
Terentius Afer,
Comediæ. Arsenal
Ms-664 rés., fol. 181v.
Photo: BnF.

ships in BnF Ms. lat. 8193. For instance, the illustration of *The Brothers* act 2, scene 4
(fig. 5.12) makes the relationship between the brothers Aeschinus and Ctesipho central. As Sannio the pimp lurks at the left, Aeschinus, wearing red-and-white hose,
speaks with Ctesipho, in pink and blue, and then Ctesipho talks to Syrus, his uncle
Micio's servant. This image conveys the gist of the act's contents: Aeschinus, having
successfully stolen the prostitute with whom Ctesipho has fallen in love from Sannio, her pimp, reports his success to Ctesipho and leaves. Then Ctesipho urges
Syrus, his uncle's servant, to pay Sannio for the prostitute. Because of its repetition
of Ctesipho, this image conveys the action of the text more clearly than did its model
(fig. 5.13), painted by Orosius Master illuminators.

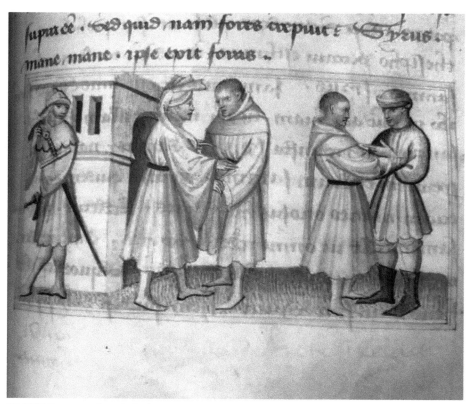

FIGURE 5.12. Sannio lurks as Aeschinus and Ctesipho speak and Ctesipho talks to Syrus. Publius Terentius Afer, *Comediae*. BnF Ms. lat. 8193, fol. 104r. Photo: BnF.

Consideration of these three early fifteenth-century Terence manuscripts shows both the impact on the Parisian book trade of Laurent de Premierfait's innovations in visual translation and, inversely, the impact of artist's visual practice on Laurent's approach to visual communication. It seems clear that Laurent's textually researched reconstruction of a late antique theater and of its performance practices had a limited afterlife.[21] His iconographic formulation for illustrating characters, devised with the help of his *libraire*, reinterpreted Carolingian models through the early fifteenth-century visual rhetoric of costume and had a direct impact on contemporary manuscripts, which often used costume to indicate social types and moral qualities. Almost immediately after John of Berry's manuscript was produced, a limited circle of patrons who wanted densely illuminated manuscripts of Terence's plays worked with *libraires* who secured texts and had them transcribed; they also adapted illuminations that were based on the visual model of Jean de Berry's manuscript to suit their intended audience. What their *libraires* did not seem

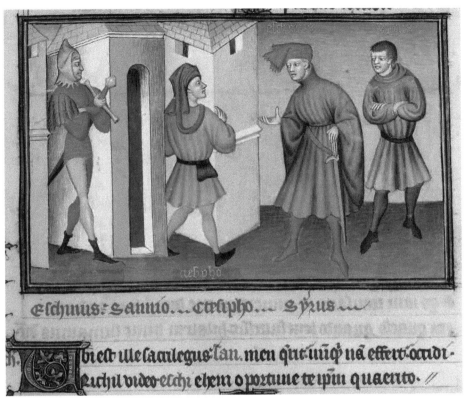

FIGURE 5.13. Sannio lurks as Aeschinus and Ctesipho speak and Ctesipho talks to Syrus. Publius Terentius Afer, *Comediae*. BnF Ms. lat. 7907A, fol. 80r. Photo: BnF.

to absorb from looking at Laurent's visual cycle was the way in which artists working with Laurent deliberately associated visualizations of characters from one play with those from another, as for instance the city brother's resemblance to a lawyer in a later play, which invited readers to remember striking visual images and associate their texts, in the process establishing comparisons and more active engagement with Terence's *Comedies*.

THE FRENCH TEXTS

Based on surviving manuscripts, Laurent's and Lebègue's French translations seem to have had a greater success than the Latin manuscripts with which they were associated. Marzano, Bozzolo, and Vittore Branca know of 142 surviving illuminated and nonilluminated copies of Laurent's translations or adaptations of Cicero and

Boccaccio. Nicole Pons, Tesnière, and others identify at least 23 illuminated and nonilluminated copies of the two versions of Lebègue's translation of Leonardo Bruni's *De bello Punico primo* (*La premiere guerre punique*).[22] The success of these translations is not surprising, given the taste of Parisian audiences for vernacular historical and literary texts.

<div style="text-align:center">

Laurent de Premierfait's Translation of Boccaccio's
De casibus virorum illustrium: *Des cas des nobles hommes et femmes*

</div>

Des cas des nobles hommes et femmes was immediately diffused in manuscripts and retained its popularity through the fifteenth century and, in printed versions, into the sixteenth century. As had happened with the *Livre de la vieillesse*, Laurent's translation of Cicero, and with Terence's *Comedies*, a tightly knit group of manuscripts of the *Des cas* either emerged from the same *libraire*-artist nexus or were copied directly after the presentation manuscripts made under Laurent's supervision for the Dukes of Berry and Burgundy.

The earliest of these is a manuscript in Vienna (ÖNB Cod. Ser. n. 12766) that is missing at least fourteen illuminations, six of which are now in Pavia (Pavia, Museo Civico, Sezioni Arte Minori nos. 921–26). This manuscript was written by Hand T, who had transcribed several manuscripts containing works that Laurent supervised. Although transcribed by a scribe who worked with Laurent and almost exactly contemporary with the dukes' manuscripts, this *Des cas* seems to have been made independently of Laurent's direct oversight. It integrates all but one of the textual changes that Laurent introduced to the dukes' copies of *Des cas*, but it does not include Laurent's second preface, which was written in 1410 after he completed his translation in 1409, or his unique visual amplifications that survive in the dukes' manuscripts.[23] As discussed in chapter 4, Laurent seemingly operated like contemporary scholars, who would have several exemplars of their work circulating among those who transcribed them. Often, they made changes to one exemplar but not all of them, and that seems to be the case in this particular copy of the *Des cas* now in Vienna. It could have been copied from an exemplar that had not been fully updated by Laurent as he worked on the dukes' manuscripts. It may even derive from a version of the *Des cas* that the *libraire* who worked with Hand T had copied to use independently. As a result of these relationships, ÖNB Cod. Ser. n. 12766 could have been transcribed and painted anytime from 1410 onward.

The visual cycle of the *Des cas* in Vienna was painted by *Cité des Dames* illuminators, as Arsenal Ms-5193 rés. had been, and had a close but not identical iconographical program of decoration.[24] The differences are telling and in keeping with the idea that the manuscript was made outside Laurent's editorial control. Not only

did the manuscript in Vienna omit some of the more complex pairings of Laurent's visually amplified images, such as the interweaving of Dido and Sardanapalus through four sequential images that presented them as examples of chastity and licentiousness, but its visual cycle was also not corrected as carefully as the dukes' books had been. For instance, as discussed in chapter four, written descriptions to the illuminator keyed to incipits seem to have been used by the *Cité des Dames* illuminators who painted this manuscript, and the artist on at least one occasion mixed up the placement of two images that had the same incipit (see figs. 4.14 and 4.15) without subsequent correction.

The *Cité des Dames* illuminator who painted the manuscript in Vienna often simplified spaces or compositions, as for instance in the illumination of the suicide of Lucretia (compare figs. 5.14 and 5.15) in which Lucretia is centralized and balanced by two men, presumably her father and husband. The omission of Brutus, who led the rebellion that ensued, in the manuscript in Vienna suggests that the complex interweaving that Laurent had constructed around the image to develop parallels with its political repercussions was either not noticed when this book was produced or, more likely, was not as relevant to the *libraire* or to the patron of this manuscript.

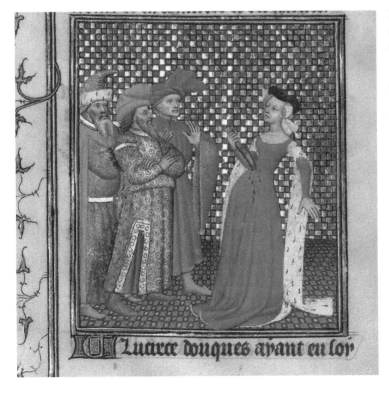

FIGURE 5.14. Suicide of Lucretia. Giovanni Boccaccio, *Des cas des nobles hommes et femmes*, translated by Laurent de Premierfait. Arsenal Ms-5193 rés., fol. 94v. Photo: BnF.

FIGURE 5.15.
Suicide of Lucretia. Giovanni
Boccaccio, *Des cas des nobles
hommes et femmes*, translated by
Laurent de Premierfait. ÖNB
Cod. Ser. n. 12766, fol. 76v.
Copyright: ÖNB Vienna: Cod.
ser. n. 12766, fol. 76v.

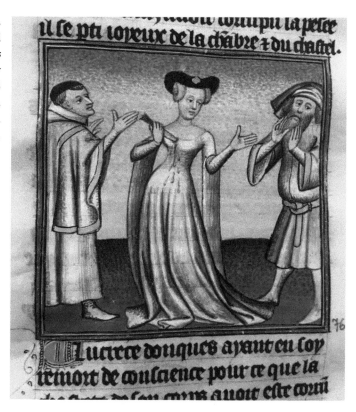

Still other edits to the visual cycle made the images more precise than those in the dukes' manuscripts in response to the artist or, more likely, the *libraire* reading the French text. For instance, the illustration to book 1, chapter 15 in the manuscript in Vienna (fig. 5.16) conveys the story of Agamemnon's assassination more effectively than did the corresponding image in the Duke of Burgundy's book (fig. 5.17). Neither the rubric above the picture, "The fifteenth chapter recounts the case of Agamemnon, King of Mycenae, and of certain other nobles" [Le xvᵉ chapitre racompte le cas de agamenon roy de mecenes et daulcuns aultres nobles], nor the text that immediately follows it fully explains the illumination. The story that both manuscripts illustrate comes at the very end of the chapter, several folios after the illumination. It recounts King Agamemnon's return to Mycenae from the Trojan War to discover that Aegisthus, whom the text describes as the bishop of Mycenae, had usurped Agamemnon's place as king and was living with Agamemnon's wife, Clytemnestra, who plotted with Aegisthus to kill Agamemnon. After a wonderful feast, Clytemnestra presented Agamemnon with a robe that had no neck opening. As the defenseless king struggled to pull the robe over his head, the bishop ran him through with a sword and killed him. The illumination in the manuscript in Vienna

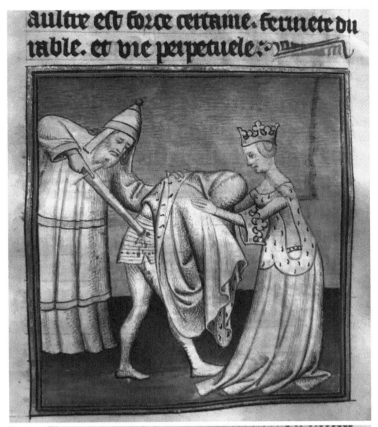

aultre est force certaine. fermete du
table. et vie perpetuele.

FIGURE 5.16.
Agamemnon's assassina-
tion. Giovanni Boccaccio,
*Des cas des nobles hommes
et femmes*, translated by
Laurent de Premierfait.
ÖNB Cod. Ser. n. 12766,
fol. 25r. Copyright: ÖNB
Vienna: Cod. ser. n. 12766,
fol. 25r.

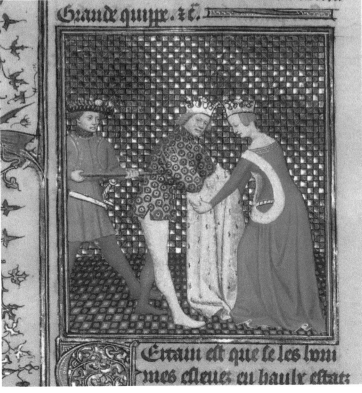

Grande quipe. ?c.

Certain est que se les hom
mes esleuez en hault estat:

FIGURE 5.17.
Agamemnon's assassina-
tion. Giovanni Boccaccio,
*Des cas des nobles hommes
et femmes*, translated by
Laurent de Premierfait.
Arsenal Ms-5193 rés.,
fol. 37v. Photo: BnF.

is more accurate and more vivid than the image in the duke's book in its visual emphasis on the blame shared by Aegisthus and Clytemnestra. It shows Aegisthus himself attacking the king with a sword instead of a nobleman running him through with a spear. Still other changes emphasize Clytemnestra's active role in the assassination. Thus, the deposed king Agamemnon's crown hangs on her arm as she tightens the robe around his covered head so he cannot escape.

Given the tendency of the artists and *libraire* who devised the illuminations for the *Des cas* in Vienna to rework, condense, or expand the visual cycle that had been prescribed for Duke John the Fearless's manuscript, it is striking that one image remains unaltered and is as close to being a faithful copy as possible. The image of the destruction of Jerusalem (fig. 5.18) is also used in the manuscript in Vienna as an embedded frontispiece image. It is derived from the same *Cité des Dames* artist's model that was used in John the Fearless's book (compare fig. 4.21), and there is a striking similarity between the ways that scribes planned the placement of the unusual frontispiece, which suggests that both books may have been overseen by the same *libraire* who specified the size of the spaces left for these large illuminations.

When Hand S transcribed John the Fearless's book, he left a full column of text empty on folio 304v so that the large image could be placed at the top of folio 305r. There, it occupies a blank space ruled for nineteen lines above two columns, each of which is filled with twenty-one lines of text. In copying out the manuscript in Vienna (see fig. 5.18), Hand T copied the text continuously without leaving any empty spaces, but he left a space ruled for nineteen lines of text blank for the illumination at the bottom of a page on which he had transcribed at the top two columns of text that were each twenty-one lines tall.

Both of the *Cité des Dames* illuminators worked to make their images even larger than the nineteen-line-high ruled spaces allotted to them by the scribe. The image in the Duke of Burgundy's manuscript in figure 4.21 explodes into the upper margin around the city of Jerusalem with a projection at the right above the ruling that is about five lines high. This layout enhances the iconography to amplify the fury with which the soldiers break down the walls, kill Jews, and set fire to Jerusalem in that manuscript. In contrast, the illumination of the manuscript in Vienna in figure 5.18 spills into the lower margin by the equivalent of about seven lines of ruled text and extends into the left margin by the equivalent of four lines of ruled text. These expansions create an image contained within a large rectangle. Rather than bumping a section of the image out in order to amplify the fury of the Roman army, as had happened in the Duke of Burgundy's manuscript, this illumination raises the frame above the left section of the lower register by the equivalent of a line, with the result that the viewer's attention is less drawn to the dynamic action of destruction, death, and servitude than it is to the left half of the illumination, in which Emperor

tolz gloutons est noble, qui veu-
rent setardie, et preste par tele-
mant dormir quilz sambleint
estre saus ame. Ilz sour tulques a
la mort en tourmens de mala-
dies. Ilz seruent ou ventre seulemt.
et continuelemat. Ilz apresteut ta-
bles chargees de viandes et beuura-
ges. Quat le glouton a le ventre
emple de plusieurs et fors vins il
cuide quil puisse surmonter tous
trauaulx. et veincre tous labours
saus estre recreant ne lasse. Et au
vrai dire la vie des gloutons est
detestable et maudicte. Car se se-
lon la trempance des anciens ilz
ne veulent viure de gland et de
eaue. Au moins leur vauldroit il
mieulx viure selon la trempance
des homes de maintenant A tre-
pance de mangier et de boire ab-

baisse les vices. et nourrit les vertus
les pensees des homes atrampees sour
tautost esleuees ala contemplation
des haultes choses. par atrempance toute
la force du corps est garde ferme et
saine. Quat lempereur vitellius
desprisa la vertu datrempance Il q
seoit en haulte chaiere imperiale
trouua logieremat gens qui despri-
serent. Et ia soit mesmement qu le cō-
tre gloutisseur saoulast et farcist
son ventre de viandes et vins. neant
moins la gloutonie ne lui osta
pas la honte quil souffrit a son vi-
saige. ne les tourmens quil souf-
frit en son corps.

¶ Le viii. chapitle contient le
cas et la destruction de la cite Je-
rusalem. et dit le peuple des Juifz.
Et commence ou latin. Adhuc
aute eum unirstione. et ceten...

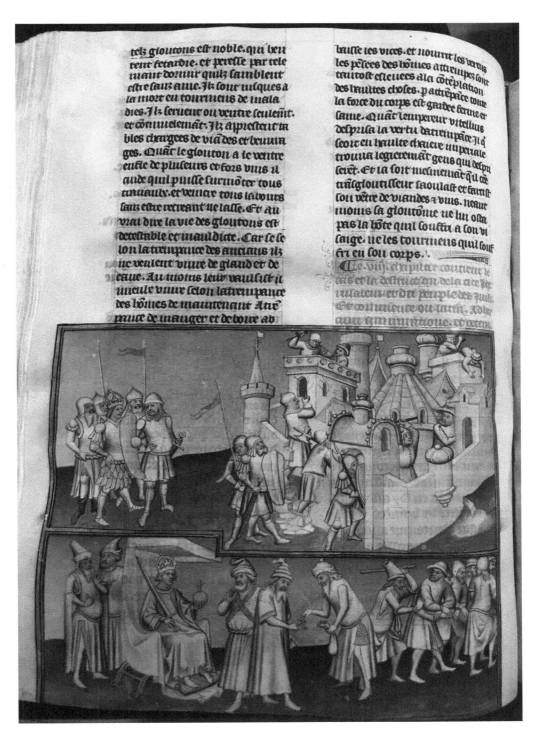

FIGURE 5.18. The destruction of Jerusalem. Giovanni Boccaccio, *Des cas des nobles hommes et femmes*, translated by Laurent de Premierfait. ÖNB Cod. Ser. n. 12766, fol. 270r. Copyright: ÖNB Vienna: Cod. Ser. n. 12766, fol. 270r.

FIGURE 5.19.
Marie, famished, devours her child. Giovanni Boccaccio, *Des cas des nobles hommes et femmes*, translated by Laurent de Premierfait. ÖNB Cod. Ser. n. 12766, fol. 275v. Copyright: ÖNB Vienna: Cod. Ser. n. 12766, fol. 275v.

Titus is celebrated as a military leader in the upper register and enthroned in majesty in the lower register.

The manuscript in Vienna preserves the interior frontispiece that was such a powerful invitation to read the past history of Jerusalem as relevant to the strife surrounding the outbreak of the French civil war, but it is not as careful as the ducal manuscripts had been with the visual amplification of Jerusalem's destruction by the scene of Marie's cannibalism (compare fig. 4.23 with 5.19). While those volumes emphasized Marie's identity as a noblewoman in order to emphasize her dire straits, the manuscript in Vienna showed her with a fanciful headdress typical of those employed for people from the East and less likely to emphasize class divisions. The use of these amplified interior frontispieces was short-lived. In contrast to the manuscript in Vienna, the only other *Des cas* to include the large-scale image of the destruction of Jerusalem muted its function as an interior frontispiece by introducing a traditional, generic presentation scene and a large opening illumination at the beginning of the manuscript.[25]

A group of three highly unusual copies of the *Des cas* depart from the visual model devised in consultation with Laurent for the two dukes' manuscripts and then modified in the book in Vienna. These three copies testify both to a different kind of normalization of the visual cycle for the *Des cas* and to the educational and humanistic receptions of Boccaccio.[26] The first (BnF Ms. fr. 131) belonged to Gontier Col, who was one of the most successful secretaries in the chancellery, serving King Charles VI from 1381 to 1418 and offering additional service to Duke Philip the Bold of Burgundy, Duke Louis of Orléans, and Duke John of Berry.[27] Col was involved in both financial affairs and diplomacy. He was *secrétaire des finances* in 1391 and both *trésorier général* and *conseiller général* of the Chambre des comptes in 1402. He participated in embassies and diplomatic missions in service to the king, as did his fellow secretary Jean de Montreuil. Between 1388 and 1417 Col traveled to Germany, Avignon, Florence, Brittany, and England. In 1412, as an Armagnac involved in politics, he was banished from Paris. He returned in 1413 and died in 1418 during the massacre following the Burgundian entry into Paris. Col was a humanist, and he was a close friend of both Jean de Montreuil and Laurent de Premierfait—so close, in fact, that their relationship caused familial friction. Jean reported in a letter of 1400 or 1401 (letter 161) that Gontier's wife thought Laurent was a bad influence who drew her husband away from his family.[28]

Col systematically collected manuscripts of the classics and of contemporary Italian literature, including an unillustrated Latin copy of Boccaccio's *De casibus* and an illustrated French copy of Laurent's retranslation of it.[29] He was one of the participants, along with his brother Pierre, Jean de Montreuil, Jean Gerson, and Christine de Pizan, in the literary debate about the *Roman de la Rose*, and he transcribed in pamphlet form the second redaction of Christine de Pizan's *Les epistres du debat sur le romant de la rose* in a manuscript (UCB Ms. 109) that belonged to John of Berry.[30] His literary reputation was sufficiently strong that he was named as one of four *présidents* of the Cour amoureuse, a courtly society founded around 1400 by Dukes Philip the Bold of Burgundy and Louis of Bourbon, with King Charles VI as its head, dedicated to the defense of women and the promotion of poetry. Through his friendship with Laurent, his role as secretary and diplomat, and his position in the Cour amoureuse, Col was in contact with everyone associated with the earliest copies of the *Des cas*: Duke John the Fearless of Burgundy, Duke John of Berry, and Martin Gouge were listed among the many members of the Cour.[31]

Col's *Des cas* included all but two of the textual alterations made to the dukes' manuscripts as they were transcribed.[32] However, the textual glossing and the visual cycle of his copy, made around 1413 to 1415, were drastically different from the dukes' and other contemporary copies of the text.[33] Carla Bozzolo has shown that Col was closely involved in the manuscript's production. Not only did he write an extensive series of marginal annotations throughout the manuscript that will be dis-

FIGURE 5.20. Poems in praise of Boccaccio. Giovanni Boccaccio, *Des cas des nobles hommes et femmes*, translated by Laurent de Premierfait. BnF Ms. fr. 131, fol. 312r. Photo: BnF.

cussed further below, but he also copied a Latin poem by Laurent in praise of Boccaccio at the end of the manuscript (see fig. 5.20). He had included Laurent's poem and comparable marginal annotations in his own Latin copy of Boccaccio's *De casibus* (BML Med. Pal. 228), but Col also included his own French abridgement of

Laurent's poem adjacent to the Latin original in BnF Ms. fr. 131.[34] He clearly over-saw production of his book, since he wrote a note to the binder indicating that one quire had been misbound.

Comparison of Col's manuscript with two that copied its visual cycle suggests that Col, like Lebègue before him, may have annotated this manuscript or planned to copy it to make it more useful as an educational text, possibly even as a gift.[35] A manuscript (Bodl. 265) signed by a man with the surname Plesseboys was made around 1420 to 1425 and decorated by the Master of the Royal Alexander, an artist active in Paris and Rouen.[36] The Talbot Master decorated a second copy (BL Royal 18 D. VII) made in Rouen in the 1440s.[37] Both of these manuscripts draw independently on Col's textual additions and visual cycle, and both could have been made in Rouen, where their artists were active and where Col's manuscript was inventoried in the collection of the *échevinage* of Rouen by 1647.[38] Col's book may have found its way to Rouen any time after his murder by the Burgundians in Paris in 1418.

Analysis of the textual dependence of these manuscripts on Col's *Des cas* shows that they copied BnF Ms. fr. 131 and not each other. Bodl. 265 replicated the visual cycle and almost all of the marginal notes in Col's *Des cas*, and Plesseboys replicated the cycle and marginal notes and, when he signed the manuscript, also copied the form and layout of Col's signature placed after BnF Ms. fr. 131's explicit at the end of the manuscript (compare figs. 5.21 and 5.22).[39] BL Royal 18 D. VII also copied Col's visual cycle and made several of the corrections that Col's notes suggest. It replicates all but twenty-five of Col's marginal notes, including those that the second of three scribes of Bodl. 265 did not copy when he transcribed the tenth to twelfth quires of that manuscript, and it transcribes Laurent's poem in praise of Boccaccio and Col's paraphrase of it at the end of the manuscript (compare figs. 5.20 and 5.23). Thus Bodl. 265 and BL Royal 18 D. VII are independent of each other and mutually dependent on the text and images of BnF Ms. fr. 131.

Given the independence of Bodl. 265 and BL Royal 18 D. VII from each other, it is noteworthy that they both contain didactic texts that have nothing to do with Boccaccio, copied at the beginning on an independent folio in one case and a bifolium in the other (compare figs. 5.24 and 5.25 with 5.26). Because the textual contents of these are identical, it seems likely that a similar independent single leaf or bifolio originally existed at the beginning of Col's manuscript, only to be lost in subsequent rebinding.

Fritz Saxl outlined the contents of these texts, which are arranged as mnemonic lists of three, four, seven, ten, twelve, and sixteen items.[40] He did not describe their function, which appears to be didactic. The leaves assemble memorable digests of religious, moral, and scientific instruction. Some material originated with John of Metz, a Franciscan active in Paris at the end of the thirteenth century, and circulated in a series of diagrams now referred to as an "Orchard of Consolation" or a *Specu-*

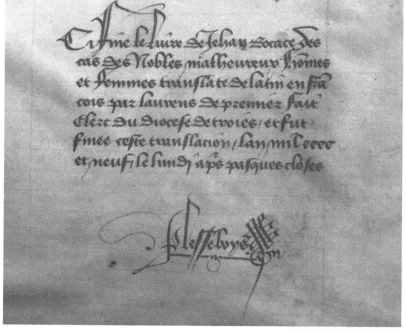

FIGURE 5.24. Mnemonic text on recto. Giovanni Boccaccio, *Des cas des nobles hommes et femmes*, translated by Laurent de Premierfait. Bodl. 265, fol. 1r. Permission Bodleian Libraries, University of Oxford.

FIGURE 5.25. Mnemonic text on verso. Giovanni Boccaccio, *Des cas des nobles hommes et femmes*, translated by Laurent de Premierfait. Bodl. 265, fol. 1v. Permission Bodleian Libraries, University of Oxford.

FIGURE 5.26. Mnemonic text. Giovanni Boccaccio, *Des cas des nobles hommes et femmes*, translated by Laurent de Premierfait. BL Royal 18 D. VII, fol. 1r. © The British Library Board.

lum theologie (mirror of theology) after its most complex image.[41] These sources were elaborated, however, in the texts introducing the *Des cas* by someone who has done the kinds of meditative compositional imagining that Mary Carruthers describes and that often resulted in distinctive content.[42] For instance, while the second row of twelves in the chart of BL Royal 18 D.VII is identical to the Table of the Twelve Articles of Faith in the *Speculum theologie*, with its columns dedicated to the twelve prophets, their prophecies, the subjects of their prophecies, the articles of faith, and the twelve apostles (compare figs. 5.26 and 5.27), other portions of the chart in the *Des cas* differ. The row of tens just above contains two intertwined, glossed lists of the ten commandments and the ten plagues of Egypt that are a creative rearrangement and variation on the mnemonic Table of the Ten Commandments in the *Speculum theologie* (compare figs. 5.26 and 5.28). The charts in BL Royal 18 D.VII and Bodl. 265 rearrange the position of the columns dedicated to the ten commandments and what they are against, and the ten plagues of Egypt and their significance, and add two columns with the headings *unde dicitur* [that is why] in order to elaborate further on the significance of the commandments and the plagues themselves.

Still other inclusions in the charts in Bodl. 265 and BL Royal 18 D. VII blend diverse sources together, as, for instance, when the content of one of the three rows dedicated to groups of seven parallels and expands a verse about the seven ages of man known from a thirteenth-century medical text from Salerno, the *Flos medicinae*, and the seven eras of the world first defined by Augustine.[43] Items at the end of the chart integrate science and astronomy by interweaving the four elements, the cardinal directions, the signs of the zodiac, and the twelve winds "according to Isidore of Seville," and then adding the sixteen winds "according to sailors."[44] The very last item in the prefatory chart is an excerpt from the prologue to Pseudo-Cyprian's *De duodecim abusivis* [*Of the Twelve Abuses of the World*] that includes a series of memorable contradictions categorizing bad behavior: "the wise man without works, the old man without religion, the young man without obedience, the rich man without alms-giving, the woman without decency, the lord without strength, the Christian who loves the world, the proud poor man, the unjust king, the negligent bishop, a community without punishment, and a people without the law."[45] These are annotated with a bracket and the next line of Pseudo-Cyprian's prologue: "through which justice suffocates."[46]

The categories of negative exempla evoked by the excerpt from the *De duodecim abusivis*, which are often discussed in relation to mirrors of princes, have an uncanny resonance with the kinds of notes that Col incorporated into the text of Laurent's translator's prologue and wrote in the margins throughout his *Des cas*, and which both Bodl. 265 and Royal 18 D. VII copied. Both offer examples to follow and avoid of the sort that were characteristic of princely mirrors, even though the text

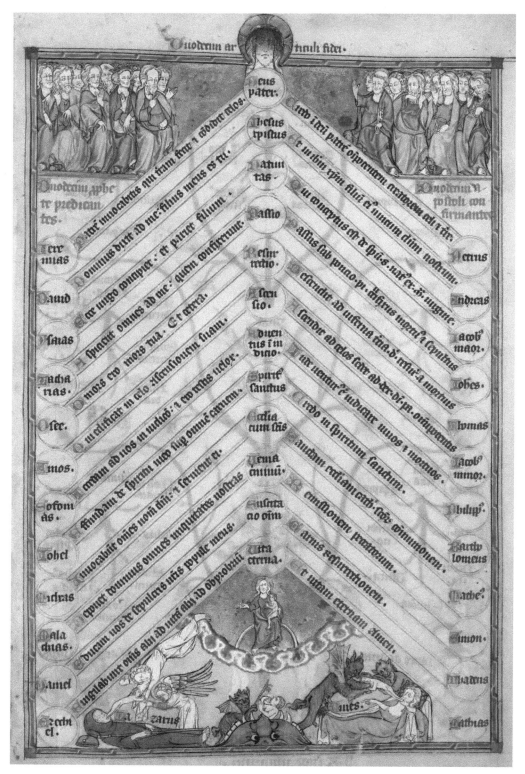

FIGURE 5.27. Table of the Twelve Articles of Faith. *The De Lisle Psalter.* BL Arundel 83 II, fol. 128r. © The British Library Board.

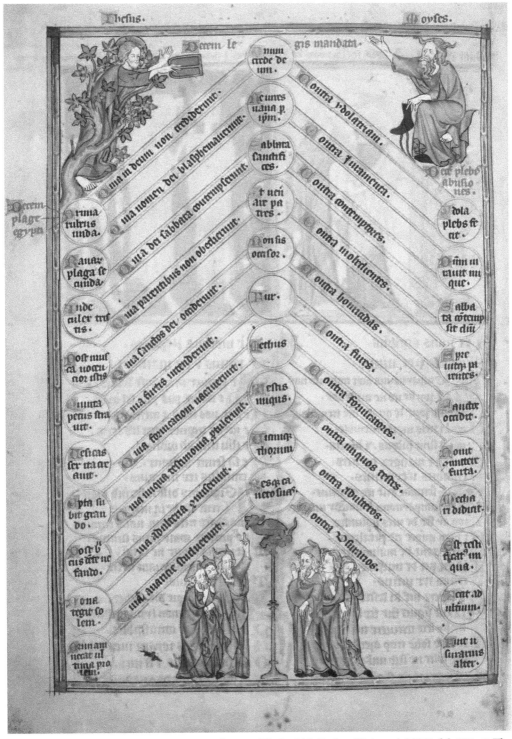

FIGURE 5.28. Table of the Ten Commandments. *The De Lisle Psalter.* BL Arundel 83 II, fol. 127v. © The British Library Board.

inserted at the beginning of Bodl. 265 and Royal 18 D. VII was independent of the *De cas*.[47] Most of the 337 notes written by Col in the *De cas* margins of BnF Ms. fr. 131 act as finding guides to stories about male rulers of Aleppo, Armenia, Asia, Assyria, Athens, Auvergne, Babylon, Bactria, Bulgaria, Cappadocia, Carthage, Constantinople, Crete, Damascus, Egypt, Epirus, France, Gaul, the Gepids, the Goths, Greece, Hungary, Israel, Jerusalem, Lacedonia, Libya, Lombardy, Macedon, Majorca, Mauritania, Parthia, Persia, Phrygia, Pisa, Privernum, Rome, Sardinia, Scythia, Sicily, Swabia, Syracuse, Syria, Thebes, Thrace, and the Vandals.[48] While women are rarely mentioned in the marginal notes, some appear in their roles as wives and mothers to rulers. Still other women included are exceptional, such as Pope Joan and the Amazons Marpesia and Orithia, or are examples of infamous female rulers, like Cleopatra.

In contrast, exceptional marginal notes call attention to Dante ("Concerning Dante Alighieri, famous poet" [De Dant Aligier renomme poete]) in book 9, chapter 23; to one vice in book 9, chapter 6 ("Against the proud and others" [Contre les orguilleux et autres]) and one virtue in book 9, chapter 22 ("Of the virtue of constancy" [De la virtue de constance]; and to a chapter concerning dreams (book 2, chapter 19). The most unusual sequence of twenty-one marginal notes tracks the give and take of Boccaccio's conversation with the ruthless Merovingian queen Brunhilda about her evil deeds in book 9, chapter 1.

Given Col's careful planning and supervision of BnF Ms. fr. 131, it is highly likely that he worked with a *libraire* to select the illustrations, which were done by a range of *Cité des Dames* illuminators.[49] The visual cycle is concise, consisting of ten images: a frontispiece placed at the beginning of the sequence of three prologues and one at the beginning of each of the nine books. My prior analyses of Col's manuscript considered its opening frontispiece illustration as an example of normalization and its visual cycle as revealing humanist tendencies.[50] The frontispiece normalizes the manuscript by providing the elaborate multipart opening at the beginning of the book that was customary in contemporary copies of history and moral philosophy such as the *Grandes chroniques de France* or Valerius Maximus.[51] However, it also educates readers about how they should interrelate the text and image in the rest of Col's *De cas*. Indeed, when the visual cycle of BnF Ms. Fr. 131 is considered in relation both to textual guides like the marginal notes preserved in it and in Bodl. 265 and BL Royal 18 D. VII and to the didactic chart preserved in both manuscripts that copy Col's, the broadened educational purpose of Col's original becomes clear.

Consideration of the frontispiece (fig. 5.29) in relation to its text—the first of Laurent's two prologues—reveals how it was designed to guide readers in their interaction with Laurent's translation. In both of the dukes' copies of the *Des cas*, this unillustrated translator's prologue was written sometime after 1410, and its

FIGURE 5.29. Frontispiece. Giovanni Boccaccio, *Des cas des nobles hommes et femmes*, translated by Laurent de Premierfait. BnF Ms. fr. 131, fol. 1. Photo: BnF.

execution seems to have been rushed, for it lacks the running titles that appear in subsequent prologues and run throughout the rest of the book. Perhaps as part of Laurent's tendency to keep editing, both dukes' books contain marginal annotations in the prologue that subdivide it. Col's manuscript incorporates these marginal annotations as rubrics and adds an introductory prologue illumination.[52] The last three of the rubrics in the prologue—The case of the present church and of priests [Le cas de l'eglise presente et des prestres], The case of earthly nobility [Le cas de noblesse mondaine], and The cases of laborers in the field [Les cas des laboureurs champestres]—are the source for three of four scenes in the frontispiece. Laurent's text begins the case of the present church with a phrase suggesting that hearts would be hardened and tears not shed when men see clearly and know the state of the three estates, the priests, the noblemen, and the laborers.[53]

The four-part frontispiece incorporates the presentation of the book to John of Berry within an expanded visual representation of the three estates that reads from left to right by register, starting in the upper left. The case of the present church and priests is represented by the enthroned pope flanked by cardinals in the upper left and the case of earthly nobility by a French king surrounded by nobles in the upper right. The presentation of the book to John of Berry, at the lower left, could be seen as an amplification or subset of the representation of the nobility in the upper right, just as the last scene, in the lower right, amplifies the representation of field laborers within a single image by adding two better-dressed carpenters at the left who hold tools of their trade.[54]

Subsequent illuminations in the condensed visual cycle invite readers to group disparate texts or contemplate Boccaccio's actions within the translation. Thus, two images represent the debate of Poverty and Fortune and the debate of Petrarch and Boccaccio (fols. 71v and 241r). They draw carefully on textual detail—including, for instance, Petrarch's laurel crown—but occasionally use artistic devices that contradict the text to make the visual image striking and memorable. For instance, the image of Poverty and Fortune (fig. 5.30) paints Poverty as a man who attacks Fortune, rather than a woman, perhaps to heighten the combatants' differences visually through gender opposition.

The marginal additions made by Col encourage further associations between images within the book. The illumination of the death of Brunhilda (fig. 5.31) is striking for its detail. It represents the queen as she is torn apart by horses tied by ropes to her hair, a hand, and a foot. Her death was described (fol. 282r) over five folios after its illustration, at a point where Col drew attention to the text with an added marginal note: "the death of Brunhilda" [la mort de brunchilde]. He also marked the beginning of the section describing Boccaccio's conversation with Brunhilda with a note on folio 279, "Concerning Brunhilda, queen of France" [De

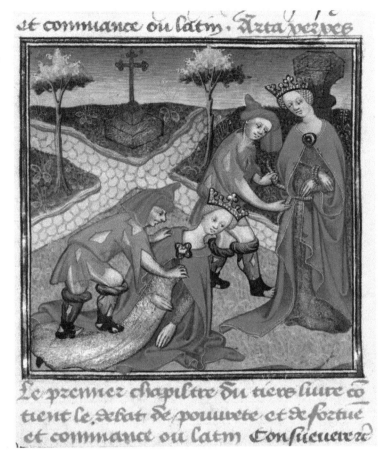

FIGURE 5.30.
Struggle between Poverty and Fortune. Giovanni Boccaccio, *Des cas des nobles hommes et femmes*, translated by Laurent de Premierfait. BnF Ms. fr. 131, fol. 71v. Photo: BnF.

Brunchilde Royne de France], and twenty-one scattered marginal notes on folios 279v to 282r that indicate when Brunhilda and Boccaccio alternate speaking. These marginal changes seem to offer a counterpart to Boccaccio's debate with Petrarch, which already had rubrication integrated into the text in order to indicate when Boccaccio and Petrarch took turns speaking. Such a juxtaposition of "debates" would play with good and bad exempla and with gender in order to create a contrast of the sort that abounded in mirrors of princes. For instance, Brunhilda's bad example and comeuppance through her excruciating death was popular as a negative example among princely mirrors such as the *Grandes chroniques*.[55]

Col's reworking of the annotations and images in the body of the *De cas*, his addition at the end, and the possibility that he devised the prefatory moral guidelines now only preserved in Bodl. 265 and Royal 18 D. VII suggest that Col reworked his manuscript of the *Des cas* to offer a spectrum of moral guidance and exempla,

FIGURE 5.31.
Death of Brunhilda.
Giovanni Boccaccio,
*Des cas des nobles hommes
et femmes*, translated by
Laurent de Premierfait.
BnF Ms. fr. 131, fol. 276v.
Photo: BnF.

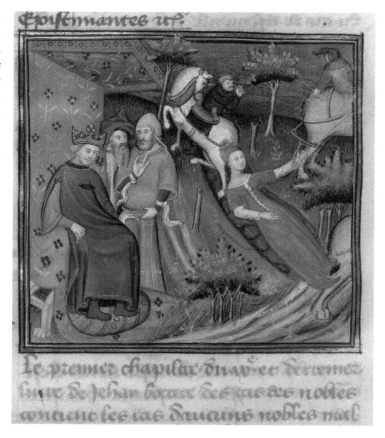

perhaps in preparation for making an exemplar to present to a patron. While it is impossible to know for sure, it is tempting to consider to whom such an educational book might be addressed. Col had many possible readers whose deaths would have curtailed production of a presentation copy based on BnF Ms. fr. 131. These range from John of Berry, who died in 1416, to Louis of Guyenne, who died in 1415, or even Louis of Orléans's sons, who were captives in England starting in 1412 and 1415. If Col had been able to supervise production of such a book before he himself died in 1418, it does not survive.

Laurent de Premierfait's Translation of Boccaccio's *Decameron*: *Des cent nouvelles*

The fifteen surviving illuminated manuscripts of *Des cent nouvelles* manifest different relationships to Laurent's original cycle, discussed in chapter 4. Laurent almost

certainly oversaw production for John the Fearless of Burgundy of the earliest surviving French illuminated copy of *Des cent nouvelles* (BAV Pal. lat. 1989). This book entered his library and subsequently passed into the library of John's son, Duke Philip the Good.[56] Not surprisingly, Laurent, his *libraire*, and his artists produced the book with a firm understanding of the text, which they had reinforced with one hundred illuminations, one for each of the hundred tales. The visual structure embodied in this manuscript's mise-en-page locked pictures into an interpretive frame that encouraged reading one tale at a time as a discrete unit. Visual imagery shaped Laurent's translation for its noble or socially prominent audiences in order to guide their experience and reading of the text.

Only three of the surviving illuminated manuscripts of *Des cent nouvelles* copy this densely illuminated model. Arsenal Ms-5070 rés., painted by the Master of Guillebert de Mets and the Mansel Master circa 1430 to 1450 and inventoried in 1467 in the library of Duke Philip the Good, is closely modeled after John the Fearless's manuscript, which was available in Philip's library.[57] The two others are earlier and less directly dependent on this visual model: BnF Ms. fr. 12421, dating from the second quarter of the fifteenth century; and ÖNB Cod. 2561, painted circa 1415 to 1420 by the Guise Master and two other, unknown Parisian artists and given at an unknown date to Humphrey, Duke of Gloucester (d. 1447), by his cousin Richard Beauchamp, Count of Warwick.[58] Because of their relative independence, they offer insight into the reception of the hundred-image visual cycle when it escaped Laurent's control.

As had happened in the production of later copies of the *Des cas*, artists and *libraires* approached illustrating these derivative manuscripts of *Des cent nouvelles* with more focus on clear visual narrative than on preserving the intricacies of Laurent's visual translation. A comparison of the representations of the same two scenes considered in the analysis in chapter 4 of John the Fearless's manuscript bears this out. The scene illustrating day 1, *nouvelle* 2, of the merchant Jehannot de Chevigny and his friend Abraham, is essentially the same (compare fig. 4.45 with figs. 5.32 to 5.34). All three are careful to distinguish the merchants from each other both by dress, including the purse that categorized Jehannot as a merchant and the red-and-white badge, which becomes a gold badge in Philip the Good's copy, that categorized Abraham as a Jew. They also visualized the subject of the merchants' debate above their heads in the left half of the illumination.[59] Interestingly, in both the earlier ÖNB Cod. 2561 and in Philip the Good's copy, there is at least one change; Abraham stands in the baptismal font with head and beard shaved.

All three later copies of *Des cent nouvelles* simplify the illustration of the tale of the noble Gascon pilgrim in day 1, *nouvelle* 9 by eliminating some of the puzzling visual elements in the left half of the image that were designed to encourage viewers

FIGURE 5.32. Jehannot de Chevigny, Parisian merchant, tries to convert his Jewish friend, Abraham; Abraham baptized at Notre Dame in Paris. Giovanni Boccaccio, *Des cent nouvelles*, translated by Laurent de Premierfait. Arsenal Ms-5070 rés., fol. 18v. Photo: BnF.

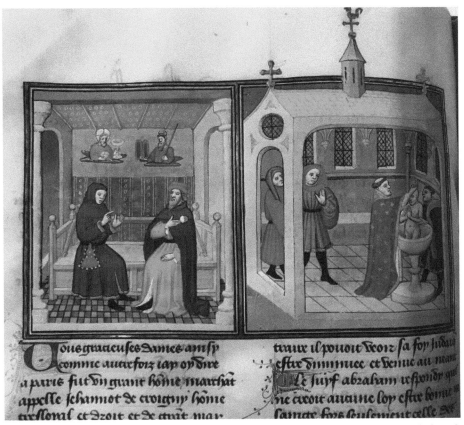

FIGURE 5.33. Jehannot de Chevigny, Parisian merchant, tries to convert his Jewish friend, Abraham; Abraham baptized at Notre Dame in Paris. Giovanni Boccaccio, *Des cent nouvelles,* translated by Laurent de Premierfait. ÖNB Cod. 2561, fol. 24v. Copyright: ÖNB Vienna: Cod. 2561, fol. 24v.

to look carefully in John the Fearless's manuscript (compare fig. 4.44 with figs. 5.35 to 5.37). For instance, the ambiguity of the rape of the pilgrim in the original image established by the color of robes is clarified, even in the closest of subsequent copies. The Master of Guillebert de Mets changes the color of the main aggressor's robe to rose so that his gesture of touching the pilgrim's chest would be clear. The artist also changed the direction of the pilgrim's glance so she looks out toward the manuscript's viewer, almost encouraging him to assume the position of the king who would be moved to action in the second scene by her presence and words. The artists of the manuscripts less closely associated with the model belonging to John the Fearless went even further. They minimized or eliminated the trees in the foreground to make the confrontation expressed by the brigands touching her elbow,

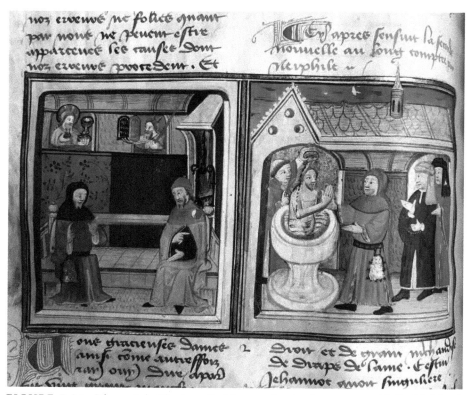

FIGURE 5.34. Jehannot de Chevigny, Parisian merchant, tries to convert his Jewish friend, Abraham; Abraham baptized at Notre Dame in Paris. Giovanni Boccaccio, *Des cent nouvelles*, translated by Laurent de Premierfait. BnF Ms. fr. 14241, fol. 20v. Photo: BnF.

forearm, or shoulder easier to see, and they eliminated the contrast in the Gascon pilgrim's dress established in the two scenes, only varying her robes from one scene to the other by color or the elaboration of her sleeves. Even these examples of close iconographical dependence between manuscripts show the kinds of simplification that comes with normalization of a visual cycle.

The illustrations in the other surviving copies of *Des cent nouvelles* work differently with their texts, which are often edited and abbreviated and which offer insight into the later reception or appropriation of Laurent's textual translation.[60] In these mid- to late fifteenth-century books, producers and patrons used illumination to reinforce different structural aspects of the text, such as the opening prologue, the shift from prose to verse song that ends each day, or the chronological division into ten days of storytelling. In each case, the manuscript looks very different from both the original produced with Laurent de Premierfait's aid and the three densely illuminated copies related to it.

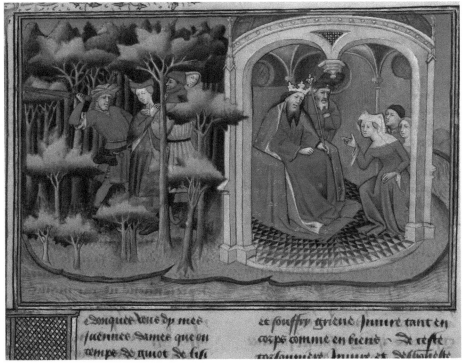

FIGURE 5.35. A noblewoman from Gascony returning from pilgrimage is robbed in Cyprus; she seeks redress from the king. Giovanni Boccaccio, *Des cent nouvelles,* translated by Laurent de Premierfait. Arsenal Ms-5070 rés., fol. 34v. Photo: BnF.

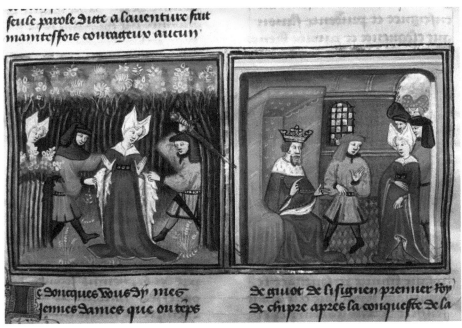

FIGURE 5.36. A noblewoman from Gascony returning from pilgrimage is robbed in Cyprus; she seeks redress from the king. Giovanni Boccaccio, *Des cent nouvelles,* translated by Laurent de Premierfait. ÖNB Cod. 2561, fol. 40r. Copyright: ÖNB Vienna: Cod. 2561, fol. 40r.

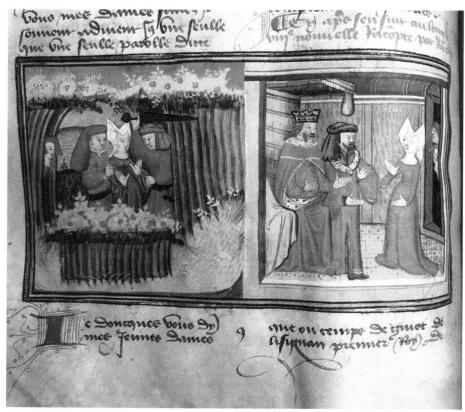

FIGURE 5.37. A noblewoman from Gascony returning from pilgrimage is robbed in Cyprus; she seeks redress from the king. Giovanni Boccaccio, *Des cent nouvelles,* translated by Laurent de Premierfait. BnF Ms. fr. 14241, fol. 38v. Photo: BnF.

For instance, the only two manuscripts that preserve the dedication to Duke John of Berry illustrate the text with single illustrations of the prologue. In one case (Bodl. Douce 213), a manuscript that was inventoried in Philip the Good's collection and thus predates 1467, Laurent's translator's prologue is illustrated by a scene showing Boccaccio seated outside a walled garden as he listens to and copies the story that a male storyteller recounts to the queen of the day and her nine other companions (fig. 5.38).[61] Still another manuscript (BnF Ms. fr. 129), made for the Échevinage of Rouen circa 1460, has two frontispieces (figs. 5.39 and 5.40). The first illustrates Laurent's translator' prologue with an illumination of a funeral mass and burials of those dead from the plague within a city labeled "Florence," while outside the city's walls the seven women and three men gather in a garden at their country retreat. These scenes illustrate Laurent's description in his prologue of the causes for Boccaccio's book. The second illumination illustrates Boccaccio's prologue but is

FIGURE 5.38. Boccaccio sits outside the garden and takes down the tellers' tales. Giovanni Boccaccio, *Des cent nouvelles,* translated by Laurent de Premierfait. Bodl. Douce 213, fol. 1r. Permission Bodleian Libraries, University of Oxford.

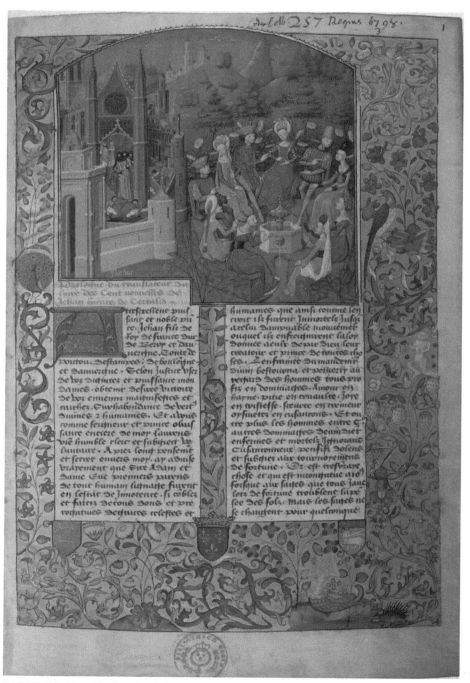

FIGURE 5.39. The dead buried; seven women and three men gather in a country retreat. Giovanni Boccaccio, *Des cent nouvelles*, translated by Laurent de Premierfait. BnF Ms. fr. 129, fol. 1r. Photo: BnF.

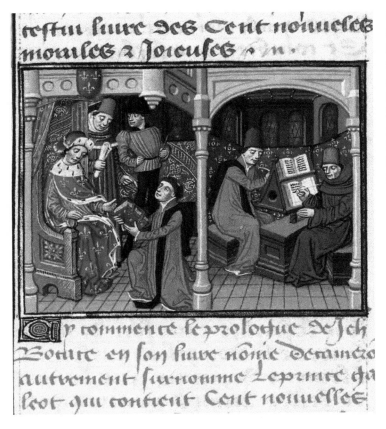

FIGURE 5.40.
Presentation to John of
Berry; Laurent de Pre-
mierfait and Antonio
d'Arezzo translate
Boccaccio. Giovanni
Boccaccio, *Des cent
nouvelles,* translated by
Laurent de Premierfait.
BnF Ms. fr. 129, fol. 4r.
Photo: BnF.

placed above and represents the extensive rubric in which Laurent explains the two-stage translation accomplished by Laurent and Antonio d'Arezzo for John of Berry. Images like this emphasize the whole collection assembled in the volume and the multiple authors of the translated text.

In contrast, the cycle in a manuscript in the Hague (KB 133 A 5), painted by the Bruges Master of 1482, reinforces the structure of ten days and the performed nature of the tales. Its opening illumination, placed at the introduction to the first day in which Boccaccio described the onslaught of the plague, shows Boccaccio and the ten youths assembling inside and outside of the Florentine church (fig. 5.41). Subsequent illuminations placed at the beginning of a day or at the transition between days represent the king or queen for the day surrounded by their court and listening to the storyteller.[62] Occasionally these scenes embed a small image from a story in the background; for instance, at the beginning of the third day, Queen Nefile and her companions listen to the first story of the day, Filostrato's tale about a convent and its gardener, which is visible in the distance through the window at the right (fig. 5.42).

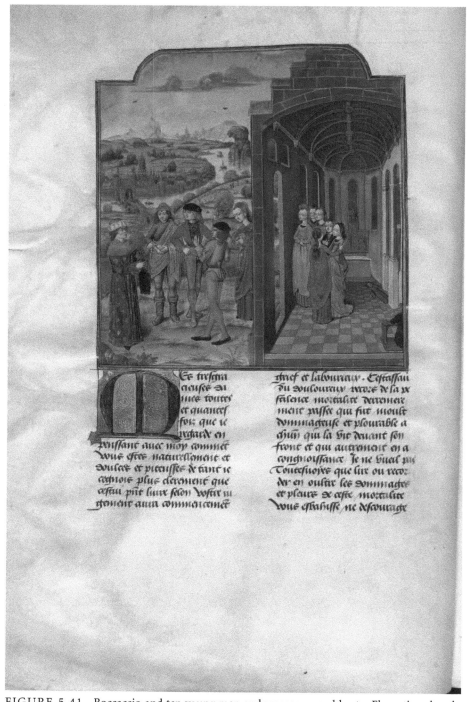

FIGURE 5.42. Queen Nefile and her companions listen to Filostrasto's tale. Giovanni Boccaccio, *Des cent nouvelles,* translated by Laurent de Premierfait. KB 133 A 5, fol. 121r. Photo: KB National Library of the Netherlands.

Still other manuscripts illustrate each of the ten days with a picture that features one of the ten stories told that day. These illuminations often are placed at the conclusion of the tenth tale from the previous day, at the point where the overarching theme for the next day was announced. For instance, the illustration of the first tale of day 8 in one *Des cent nouvelles* (BL Add. Ms. 35322-23), painted circa 1473 by the Master of the Harley Froissart (fig. 5.43), appears directly after the tenth tale of day 7 ends, but before both the author's conclusion to day 7 and the subsequent song of Filomena that fill folios 67r to 68v. This illumination's two scenes anticipate moments from the tale of Gulfardo and Ambrougia that actually begins a few folios later. It is a visual equivalent of the summary, which outlines the story: a soldier Gulfardo was enamored of Ambrougia, the wife of Guasparruolo, his friend who was a Milanese merchant. Ambrougia demanded a large sum of money from Gulfardo for the privilege of sleeping with her, and he borrowed the necessary funds from her husband. When it was time to pay Guasparruolo's loan back, Gulfardo told him that he had already paid Ambrougia, and she was forced to concede that he had.[63]

But the notable presence of a young companion in both scenes with Gulfardo encourages careful consideration of the fuller tale, which begins on folio 69v, to understand exactly what is happening in the illumination. The *nouvelle* provides more information about Gulfardo's emotional reaction to Ambrougia's greed and helps explain some unusual details in the illumination.[64] Gulfardo's desire for Ambrougia turned to abhorrence, and he decided to punish her because he was taken aback by her crass agreement to sleep with him only if he would keep their tryst a secret and pay two hundred gold florins. To punish her, he agreed to her conditions but said that a trusted companion-at-arms who was always with him would have to know about their encounter. When a date was set, Gulfardo borrowed the two hundred florins he needed from Guasparruolo. Accompanied by his companion, Gulfardo met Ambrougia in the scene represented at the left and handed her the money saying, "Madame, please take this money and return it to your husband when he comes home." She took the money, assuming he had mentioned the loan as a way of deceiving his companion, and then she welcomed Gulfardo into her bed. After Ambrougia's husband returned, Gulfardo and his companion went to see Guasparruolo, first making sure that his wife was home. Gulfardo said to Guasparruolo, "It turned out that I did not need the money that I borrowed from you, so I returned it to your wife." Guasparruolo called in Ambrougia to ask if that were true, and because the companion who had witnessed the financial transaction was present, she was forced to agree and return the money to her husband in the scene represented at the right. So, the dishonest and greedy wife received her comeuppance.

Two particularly distinctive manuscripts of the *Des cent nouvelles* were painted by a collective of artists known as the Dunois Master, a name of convenience for an artistic group that collaborated on a recognizable style in Paris from about the 1430s

through the 1450s and illuminated a wide range of manuscripts.[65] In both, the Dunois artists worked creatively to hone traditional cycles and expand them with new imagery. The earlier of the two (BnF Ms. fr. 239), painted circa 1440, contains a cycle of seventy-eight illuminations illustrating a version of *Des cent nouvelles* with a fairly standard text.[66] It experiments ambitiously with the placement and subjects of images and, in the process, interweaves several distinct visual narrative solutions to illustrating Boccaccio. For instance, the scene placed at the head of Boccaccio's prologue in BnF Ms. fr. 239 is typical of a prologue illustration in drawing attention to the historical context of the tales by illustrating the prologue's description of the plague and the decision of the ten young people to flee Florence (fig. 5.44). This illumination shows the burial of the dead in a churchyard at the left while, in the center, the three men and seven women who will recount the *nouvelles* meet in a church and subsequently leave as a group to take refuge in the country.

Other scenes in this manuscript are more unusual. Beginning in earnest on folio 92 with the illustration of the eighth tale of day 3, the artists shifted to illustrating specific tales directly in response to artists' sketches of the sort that occasionally survive in adjacent margins.[67] This shift in illustration may be the result of a change in plan while the text was being transcribed. There are no images between folios 1v and 98v, and when the illustrations starts on folio 98v in the thirteenth quire, the quire is marked with the signature *a*, which suggests that it might have been part of a revision of the book's layout introduced as it was being transcribed, perhaps in response to the *libraire* with whom the Dunois illuminators collaborated gaining access to a fuller visual model.[68] From this point onward, seventy-one single-column illuminations usually incorporate scenes drawn from two moments of a specific tale and appear just above the tale's beginning. The Dunois artists composed these scenes with a minimum of figures and usually set them in a landscape or very simplified interior, as, for example, the illustration of the story of Gulfardo placed above the first tale of day 8 (fig. 5.45). Such simplifications make the moment represented more open in relation to the story. For instance, because the illustration omits Gulfardo's companion, who played such an essential role as witness to the financial transactions at the center of the tale, the moment represented in the right half of figure 5.45 is ambiguous. The visualization only makes sense if it reads from right to left. Then the right scene would show Guasparruolo with a red purse hanging at his belt, speaking with Gulfardo, who holds the money that he had borrowed from Guasparruolo, and the left scene would show Gulfardo giving the money he had borrowed to Ambrougia. The repetition of Gulfardo makes clear that he is the protagonist, but readers would have to delve into the story to try to figure out what was happening. Even then, it could be unclear whether the right-hand scene showed Gulfardo borrowing the money or beginning to pay it back.

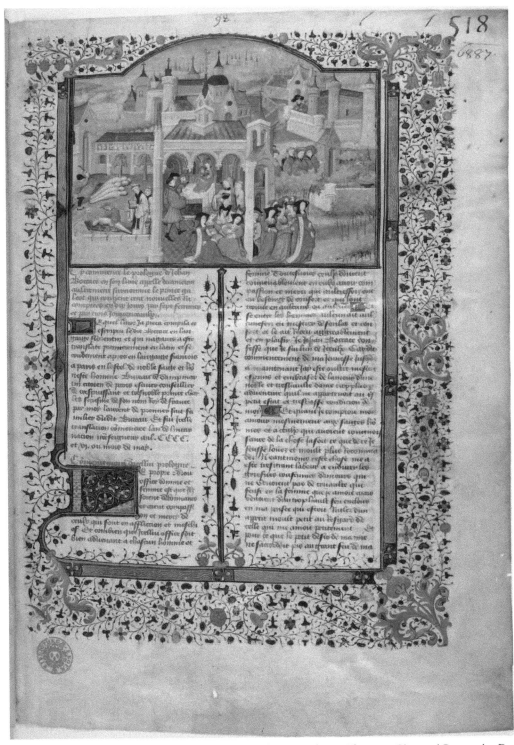

FIGURE 5.44. Burial of the dead; young men and women depart Florence. Giovanni Boccaccio, *Des cent nouvelles*, translated by Laurent de Premierfait. BnF Ms. fr. 239, fol. 1r. Photo: BnF.

The stripped-down aesthetic devised for the narrative illustrations in the manuscript works better for the illustrations of the songs that end each storyteller's day, however. Starting at the same point in the thirteenth quire, all the songs in the remainder of the text are illustrated with an image that marks the distinct shifts in the text from prose to verse.[69] Filomena's song about her lover at the end of day 7, for instance (fig. 5.46), shows her speaking with him in a walled garden.

The other manuscript illustrated by Dunois artists was made circa 1455 to 1460 for Étienne Chevalier, a royal administrator who worked for Kings Charles VII and Louis XI of France. Étienne first served Charles as a notary and secretary and then became a financial officer, rising through the ranks to be named treasurer of France by Charles VII in 1452, a position he retained after Louis XI became king in 1461. Étienne's position of power and relationships established through marriage associated him with a group of powerful men who celebrated their new position in society with artistic purchases, often commissioning works from the same artists.[70] Either because it was made later, or because it was made for a sophisticated bibliophile, Étienne's copy of *Des cent nouvelles* (Houghton Richardson Ms. 31) differed from the other Dunois manuscript in that it had a revised text complemented by a cycle of sophisticated miniatures expressly designed for Étienne. This manuscript does not have some of the heavy textual apparatus that separated the tales in other copies of

FIGURE 5.46.
Filomena sings about her
lover. Giovanni Boccaccio,
Des cent nouvelles,
translated by Laurent de
Premierfait. BnF Ms. fr.
239, fol. 211v. Photo: BnF.

Des cent nouvelles. For example, it omits all but seven of the "continuations" that appear between the summary and the actual beginning of the hundred tales, and it omits the songs at the end of the second, third, fifth, sixth, seventh, eighth, and ninth days. The resulting text is more streamlined, and its most distinctive feature is the way that its eleven illuminations work successively to encourage Étienne to consider the images as sequential groups designed to gradually encourage him to read the images of the cycle as forming a visual story arc partially independent of their text. It builds in complexity to offer a culminating statement about fortune that was relevant to Étienne Chevalier's own life.[71]

A Visual Echo of Jean Lebègue's Translation of
Leonardo Bruni's Punic Wars: *La première guerre punique*

Leonardo Bruni drafted the *De bello Punico primo* from 1419 to 1421 as a way of completing Livy's *History of Rome* by replacing its lost second decade.[72] Later, after

receiving a copy from an Italian friend, Jean Lebègue translated it into French as *La première guerre punique* in 1445 and dedicated his translation to King Charles VII. In her analysis of the text, Nicole Pons suggested that Lebègue may have circulated his translation, *La première guerre punique*, in two versions.[73] The first was a more literal translation whose earliest surviving copy (Ass. nat. Ms. 1265) was dated 1452 in a scribe's inscription; it circulated joined to Pierre Bersuire's translation of the three decades of Livy's *History of Rome* (*Tite-live*). This translation incorporates Lebègue's prologue dedicating the translation to Charles VII and, in one surviving manuscript, amends the prologue to name Duke Philip the Good of Burgundy as the dedicatee. The second version, whose earliest surviving copy (BnF Ms. fr. 23085) dates to 1454, circulated independently. It was a self-contained copy of *La première guerre punique* with an abridged and revised text, and it contained the prologue dedicating the book to Charles VII. Pons speculated that this independently circulating version was also early and may well have been the textual version actually presented to the king once Lebègue finished the translation. She observed that all the surviving copies of *La première guerre punique* are riddled with textual errors and thus probably none of them were produced under Lebègue's direct supervision.

However, faithful copies of visual cycles often appear in manuscripts that contain flawed textual transcriptions, and one especially intriguing manuscript of *La première guerre punique* (BnF Ms. fr. 23085) gives insight into Lebègue's lost original manuscript. This book was painted by southern Netherlandish artists from the circle of the Johannes Gielemans Master and, possibly, by grisaille artists who are given a name of convenience, the Maître aux grisailles fleurdelisées.[74] Dated June 9, 1454, in its colophon (fol. 68r), it is the only surviving manuscript of the independent version of *La première guerre punique* securely dated within Lebègue's lifetime, and it contains a unique visual cycle that has affinities with known works illustrated under his supervision. Although we do not have Lebègue's original presentation manuscript for Charles VII, I suspect that this copy of *La première guerre punique* is comparable to the near-facsimile manuscripts made of Laurent's translations of Cicero and Boccaccio. If this is true, it could offer insight into the visual cycle of the presentation manuscript that Lebègue devised for King Charles VII. The rapid normalization evident in subsequent early manuscripts of the text shows how quickly Lebègue's idiosyncratic cycle was smoothed out and normalized.

This manuscript of *La première guerre punique* employs the core elements of Lebègue's verbal and visual rhetoric previously discussed in the analysis in chapter 3 of his French directions to illuminators on how to illustrate Sallust. Notes in the margins of Lebègue's French directions indicated the need for artists to "correct" the iconography of their preliminary drawings in the illuminated manuscript of Sallust (Geneva Ms. lat. 54) that Lebègue supervised. They offer insight into the core elements of his verbal and visual rhetoric. Consideration of Geneva Ms. lat. 54 and Le-

bègue's corrections together highlights how important the manipulation of a picture's scale and the juxtaposition of color and grisaille miniatures were to Lebègue in framing the experience of a text. They also reveal his awareness that the manipulation of fifteenth-century costume could signal social and moral qualities of individuals and that selective use of heraldic charges could easily identify groups. Finally, they show how he used occasional visual references to modern fifteenth-century institutions and practices in order to make the past present and Roman events comprehensible to a fifteenth-century French audience.

Even though the text of BnF Ms. fr. 23085 is corrupted and could not be Lebègue's original, the format, visual cycle, and individual images in this *copie isolée* made during Jean Lebègue's lifetime incorporate many features that Lebègue himself used previously in planning his illustration of Sallust. Its visualization of history differs in significant ways from that in the other early manuscripts of *La première guerre punique*, such as the Thompson-Yates manuscript painted by artists related to the Bedford style that is one of the few manuscripts to contain the same rubrics and text breaks for illuminations as BnF Ms. fr. 23085; or BnF Ms. fr. 23086, which dates after 1461; or even Arsenal Ms-5086 rés., which can be dated between 1457 and 1461. Given the distinct differences between BnF Ms. fr. 23085 and these contemporary illuminated copies of the text, it seems likely that this manuscript reflects a now-lost visual cycle, devised by Lebègue himself, that these other manuscripts made shortly after Lebègue's death began to normalize.[75] Indeed, all the visual strategies that were at work in Lebègue's Sallust—the manipulation of colored and grisaille illuminations, of costume and heraldry, the modernization of iconography, and the scale or density of images—are also at work in the visual translation of *La première guerre punique* in BnF Ms. fr. 23085.

Color differentiates the first image of BnF Ms. fr. 23085 from those that follow, as it had in Lebègue's Sallust manuscript. However, in *La première guerre punique*, the initial image illustrating the translator's prologue shows Lebègue presenting his translation to King Charles VII rather than an author portrait (compare fig. 3.13 with 5.47), and it shows Lebègue as an older man with grey hair. This is a realistic detail because he was seventy-seven when he completed the translation. The use of color in this presentation scene differentiates it from the grisaille illuminations that illustrate the translation of Bruni's prologue (fig. 5.48) and all the subsequent illuminations that follow in BnF Ms. fr. 23085, as it had previously done in Lebègue's Sallust in Geneva.

The dramatic color shift and iconographic distinction between Lebègue's scene of presentation and Bruni's representation as author provide a much sharper categorization than in any other early versions of the translation: either the version of the text from 1457 to 1461 painted by Dunois illuminators, which layers Lebègue's presentation to Charles VII over Bruni's presentation to the emperor

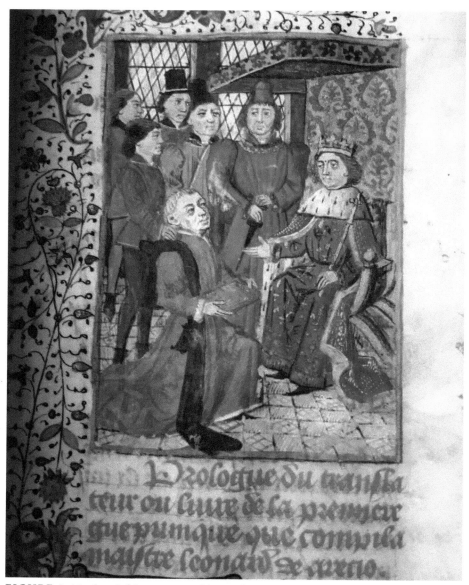

FIGURE 5.47. Jean Lebègue presents his translation to King Charles VII. Leonardo Bruni, *La première guerre punique*, translated by Jean Lebègue. BnF Ms. fr. 23085, fol. 1r. Photo: BnF.

(figs. 5.49–5.50), or the manuscript painted after 1461 that juxtaposes Lebègue's presentation with Bruni writing, but shows both in living color.[76]

The section of grisaille miniatures illustrating the first Punic war in BnF Ms. fr. 23085 carefully manipulates heraldic charges, just as the artists who completed Geneva Ms. lat. 54 in the 1430s had done for Lebègue's earlier Sallust. Artists in-

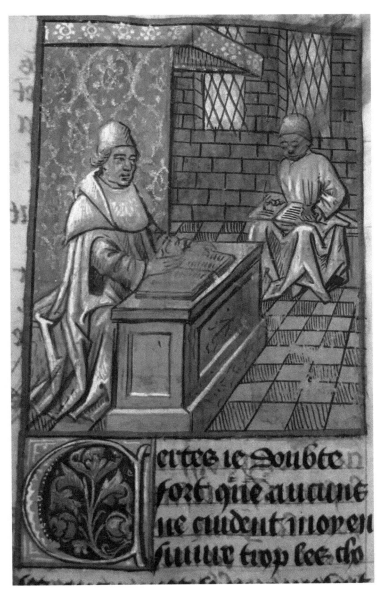

FIGURE 5.48.
Leonardo Bruni
composing. Leonardo
Bruni, *La première guerre
punique,* translated by
Jean Lebègue. BnF Ms. fr.
23085, fol. 3r. Photo: BnF.

cluded specific armorial bearings to identify the Roman and Carthaginian forces, particularly when they confront one another. In fifteen images of BnF Ms. fr. 23085, fully half of those in the manuscript, the black imperial eagle on gold identifies the Roman forces, and the armies of Carthage bear a white castle on a black ground in six miniatures (Fig. 5.51). Like the use of color, these armorial devices differ from those used in all other early manuscripts of the text, which tend to present the battle scenes with inconsistent generic armorial bearings.

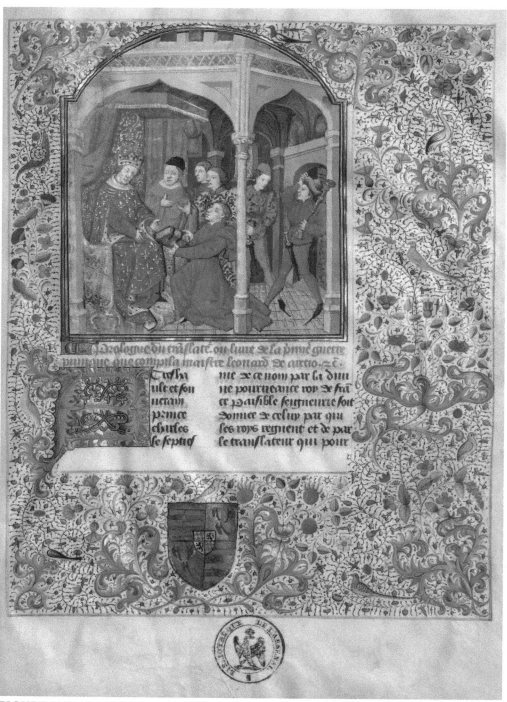

FIGURE 5.49. Jean Lebègue presents his translation to King Charles VII. Leonardo Bruni, *La première guerre punique*, translated by Jean Lebègue. Arsenal Ms-5086 rés., fol. 3r. Photo: BnF.

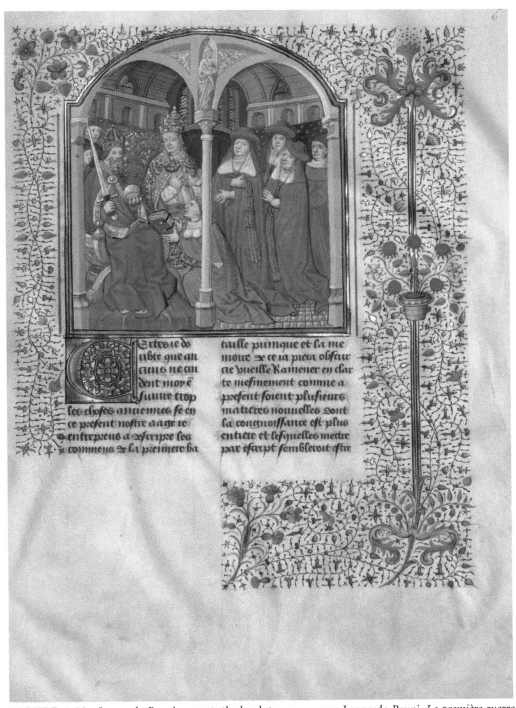

FIGURE 5.50. Leonardo Bruni presents the book to an emperor. Leonardo Bruni, *La première guerre punique,* translated by Jean Lebègue. Arsenal Ms-5086 rés., fol. 6r. Photo: BnF.

FIGURE 5.51.
First battle between the Romans and
Carthaginians. Leonardo Bruni, *La
première guerre punique,* translated
by Jean Lebègue. BnF Ms. fr. 23085,
fol. 4r. Photo: BnF.

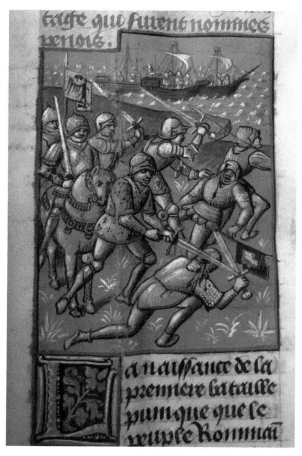

The artists of BnF Ms. fr. 23085 also manipulated dress to clarify the history for its readers. They embellished armor with gold and provided plumed helmets to distinguish Roman consuls from others, and they showed a rare sensitivity to the text or, more likely, to artists' directions, so that the images are careful to clarify whether both consuls or a single consul were present at an event, even when different artists illustrated the scene (compare fig. 5.52 with two consuls and fig. 5.53 with one). The gold-stroked armor and plume was a flexible symbol that was adapted to represent Carthaginian leaders in the portion of Bruni's text in which the Carthaginians battled non-Romans (fig. 5.54).

Other features of the visual cycle in BnF Ms. fr. 23085 echo the concerns voiced by Lebègue in his directions for illustrating Sallust. For instance, Lebègue's marginal direction specifying that the Roman legates should be represented as laymen in the Sallust image (see fig. 3.29) finds echoes in three images of Roman consuls receiving legates in *La première guerre punique* (BnF Ms. 23085, fols. 25v, 46r, and 47r). The

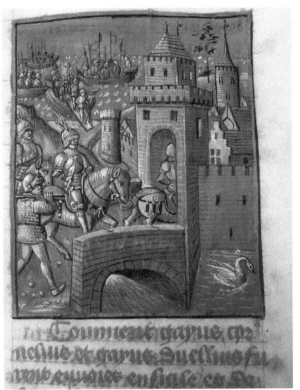

FIGURE 5.52.
Gnaeus Cornelius and Gaius Duillius arrive in Sicily. Leonardo Bruni, *La première guerre punique,* translated by Jean Lebègue. BnF Ms. fr. 23085, fol. 17r. Photo: BnF.

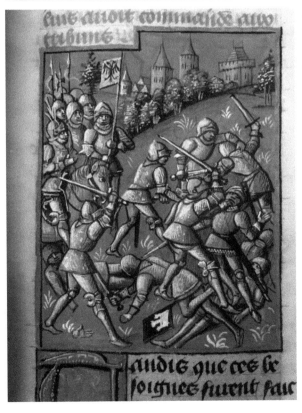

FIGURE 5.53.
Gaius Duillius fights Carthaginians. Leonardo Bruni, *La première guerre punique* translated by Jean Lebègue. BnF Ms. fr. 23085, fol. 20r. Photo: BnF.

FIGURE 5.54.
Battle between Hamilcar and his
Carthaginians and Spondius and
his army. Leonardo Bruni, *La première
guerre punique*, translated by
Jean Lebègue. BnF Ms. fr. 23085,
fol. 50v. Photo: BnF.

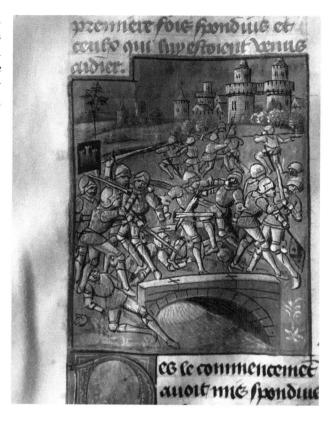

direction to the artist that partially survives next to one of these (fig. 5.55), "Here let
there be made several councilors who come" [ici soit fait plusieurs gens de conseil
qui vienne] makes clear that the artist was directed to insert men in secular dress.[77]
Like Lebègue's secular legates in Sallust, these contrast with a more customary fif-
teenth-century representational tradition of visualizing "legates" as papal legates,
that is, as cardinals, as they appear in corresponding scenes in the Arsenal manu-
script (fig. 5.56), although most slightly later manuscripts of *La première guerre pu-
nique* preserve the secular identity of the legates.[78]

The illustrations of Hannibal Gisco's death in BnF Ms. fr. 23085 (fig. 5.57) echo
Lebègue's practice of updating illuminations with contemporary references, as he
had done earlier in the scene of Lentulus's execution by hanging in Sallust. There
seems to have been some equivocation on the folio showing Hannibal's death in *La
première guerre punique*, perhaps in response to its model, because the manuscript's
rubric and text are at odds. While the rubric directly above the illumination ends
with the observation that Hannibal "was taken by the soldiers and hung" [fut par les
compaignons prins et pendu], the text of the chapter differs: "But soon he was cap-

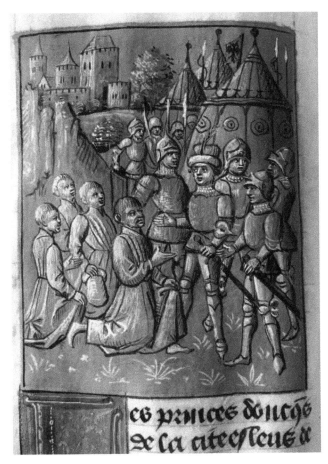

FIGURE 5.55.
Princes of Carthage seek to make
peace with Marcus Atilius Regulus.
Leonardo Bruni, *La première guerre
punique*, translated by Jean Lebègue.
BnF Ms. fr. 23085, fol. 25v.
Photo: BnF.

tured from his men and raised on the cross, and there his life ended" [Mais tantost il
fut prins de ses gens et esleve en la croix et illec fina sa vie]. The upper-right corner
of the illumination, placed right below the rubric's "taken and hung," shows a deli-
cately painted Hannibal first being captured and then hanged from a gibbet with his
hands restrained behind his back, shortly after his executioner pushed him off the
ladder. I cannot help but wonder whether the rubric was changed early in the life of
the translation in order to accommodate a disjunctive image that Lebègue had
specified in a (hypothetical) list of directions to the illuminator—*Les histoires que
l'on peut raisonnablement faire sur la première guerre punique.* The other early manu-
scripts of Lebègue's translation contain the same rubric and contradictory text (fig.
5.58), but they conform with the text itself by illustrating Hannibal's crucifixion.
The only exception is the copy (KBR Ms. 10777) painted by Guillaume Vrelant,
which was listed in the inventory after death of the collection of Philip the Good

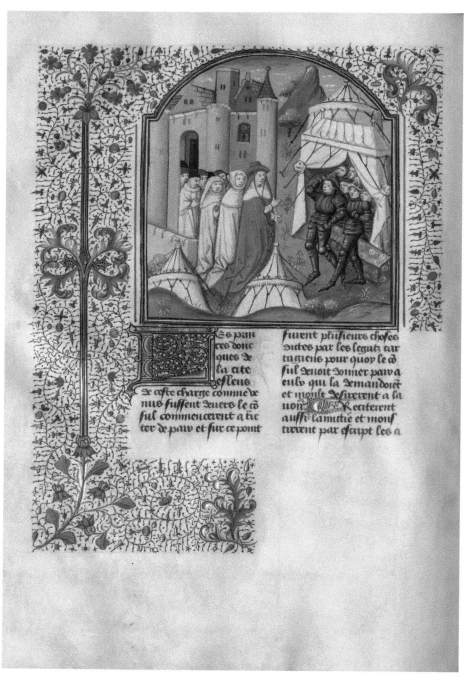

so pau
res donc
ques de
la cite
esseus
De ceste charge comme de
nus fussent Devers le co
ful commencerent a tic
ter de paix et sur ce point

furent plusieurs choses
Dites par les legatz car
tagiens pour quoy le co
ful Denoit Donner paix a
eulx qui la Demandoient
et moult Desirerent a la
noir Reciterent
aussi la amitie et mons
turent par escript les a

FIGURE 5.56. Princes of Carthage seek to make peace with Marcus Atilius Regulus. Leonardo Bruni, *La première guerre punique*, translated by Jean Lebègue. Arsenal Ms-5086 rés., fol. 44v. Photo: BnF.

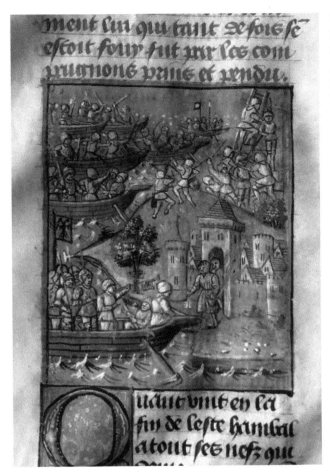

FIGURES 5.57.
Hannibal captured and put to death. Leonardo Bruni, *La première guerre punique,* translated by Jean Lebègue. BnF Ms. fr. 23085, fol. 20v. Photo: BnF.

(fig. 5.59); it shows Hannibal being hanged from the mast of a ship rather than crucified.

Lebègue's use of illuminations of different scale to structure narrative is the only device that he used in the manuscript of Sallust that is not employed in the unusual early copy of *La première guerre punique.* There is no equivalent in BnF Ms. fr. 23085 to the visual rewriting of Sallust via scale (see figs. 3.23–3.25, and 3.32) in order to underline the causal relationship between the decision of the Senate to condemn the conspirators and the execution of Lentulus, the death of Catiline, and the Triumph of Marius that ended the Jugurtha.

However, the distribution of illuminations in the early *La première guerre punique* reinforces Lebègue's textual structure, which divides the text into two books that deal first with the war and then with the fortunes after peace of the Romans and Carthaginians. A pair of single-column-wide scenes (BnF Ms. fr. 23085, fols. 4r and

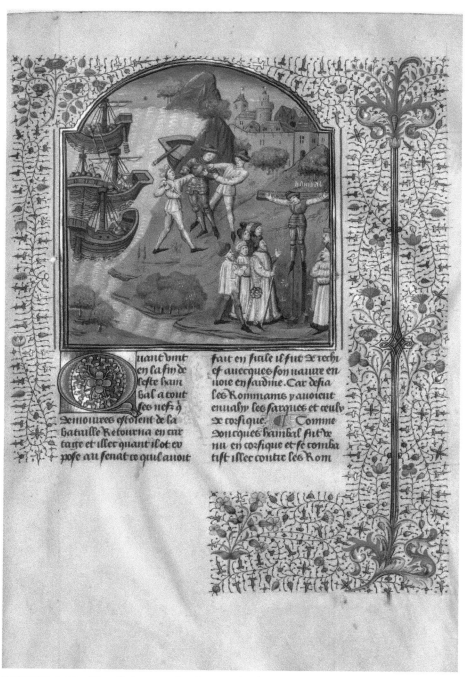

FIGURE 5.58. Hannibal captured and put to death. Leonardo Bruni, *La première guerre punique,* translated by Jean Lebègue. Arsenal Ms-5086 rés., fol. 35r. Photo: BnF.

Et dilec sen alerent les Roinnains dvant
macelle la cite Si lainroinnerent et cypn
gnerent Coinent hainbal fut de rechief
enuoye en fardine et aultres lieuy contr
les roinains et coinmet lui qui tant de
fois sen estoit fui fut par ses coinpaignons
prins et pendu

Qvant vint en la fin de leste ha

FIGURE 5.59. Hannibal captured and put to death. Leonardo Bruni, *La première guerre punique*, translated by Jean Lebègue. KBR Ms. 10777, fol. 50v. Photo: KBR.

FIGURE 5.60.
The Romans conquer Sicily.
Leonardo Bruni, *La première guerre
punique,* translated by Jean Lebègue.
BnF Ms. fr. 23085, fol. 13r.
Photo: BnF.

48r), representing a generalized image of Romans defeating Carthaginians and the Carthaginians' return to Africa, illustrates these textual divisions. Each of the two books is divided in two, with differing results. The two parts of book 2, beginning on folios 48r and 57r, neatly divide the account of the fate of the Carthaginians after the war from that of the Romans.

The subdivision of book 1 into two parts is not as neat in BnF Ms. fr. 23085, but the artist worked to categorize the second part of book 1, whose rubric erroneously describes it as the beginning of book 2, as pertaining to the war for Sicily. Possibly because the confusing rubric needed clarification, doubled images mark this important spot; the bottom of the second column on folio 13r ends with an image of a Roman consul conquering Sicily (fig. 5.60) placed just above the rubric. Immediately upon turning the page, the top of the first column opens with a beautiful landscape (fig. 5.61) representing the island of Sicily. These paired images may represent

FIGURE 5.61.
The island of Sicily. Leonardo Bruni, *La première guerre punique,* translated by Jean Lebègue. BnF Ms. fr. 23085, fol. 13v. Photo: BnF.

both the "destruction of Sicily" mentioned in the mangled rubric that they bracket and the "description of Sicily" offered in the chapter beginning directly below the landscape. Other early manuscripts, such as the former Thompson-Yates manuscript, Arsenal Ms-5086 rés., and BnF Ms. fr. 23086, simplify this transition by including a rubric that refers to the "description of Sicily" and simply illustrating it with an image of the island.

Analyses of the partial reflection of a Lebègue cycle in *La première guerre punique* preserved in BnF Ms. fr. 23085 in relation to the other early illuminated copies of his translation suggest that this early copy, made during Lebègue's lifetime, reflected his concerns with both identifying Roman leaders through a combination of costume and armorial bearings and updating forms of capital punishment to reflect fifteenth-century practices. Other early manuscripts of the translation only incorporate aspects of this visual program of decoration, as when KBR 10777 includes a representation of Hannibal's death by hanging. However, that manuscript was more conventional; elsewhere in its cycle it differentiated Roman from Carthaginian forces not through specific heraldic charges, but by more exotic and traditional

means. For instance, on folio 68 it shows the Carthaginians advancing in howdahs on the backs of elephants, as they had done in manuscripts from the early fifteenth century.[79]

The normalization through visual and textual translation of texts by Cicero, Terence, Sallust, Boccaccio, and Bruni shows the impact that Laurent de Premierfait and Jean Lebègue, their sponsors (including Martin Gouge and Bureau de Dammartin), and their teams of scribes, artists, and *libraires* had in countering the phenomenon that Jean de Montreuil had observed at the beginning of the fifteenth century.[80] Jean's lament—that the neglect of the authors and historians of antiquity by the nobility and powerful men had resulted in the loss of cultural patrimony—was countered by the books made by Laurent and Lebègue during the first half of the fifteenth century for members of the nobility. Illuminated manuscripts made for Dukes Louis of Bourbon, Louis of Orléans, John of Berry, and John the Fearless, and Charles VII, among others, introduced carefully crafted images that smoothed the chronological and cultural gaps between distant times and distant places in order to expand French cultural patrimony with knowledge of antique texts and history. The appeal of these densely illuminated books, particularly of those translated into French, was immediate. Comparison of the copies made under Lebègue's and Laurent's supervision with those later copies that responded to and sometimes transformed them shows how the cycles devised with the help of early French humanists were appropriated and modified by artists and *libraires* once they were normalized. They became part of the mainstream and shaped new visual cycles in France and Flanders throughout the fifteenth century.

APPENDICES

Comparison of the Layout of the *Conspiracy of Catiline*:
The Twin Manuscripts in Paris and Geneva Ms. lat. 54

Chapter divisions defined by flourished and acanthus initials are not numbered in these manuscripts; I insert sequential chapter numbers based on the placement of initials. The number of illuminations (if any) per chapter appears within brackets.

BnF Ms. lat. 5762 *Fol. #: Chapters* *[Illuminations]*	*BnF Ms. lat. 9684* *Folio #: Chapters* *[Illuminations]*	*Geneva Ms. lat. 54* *Folio #: Chapters* *[Illuminations]*	*Corresponding* *textual incipit* *in the critical edition*
Fol. 3r: Ch. 1 [1]	Fol. 1r: Ch. 1 [1]	Fol. 1r: Ch. 1 [1]	Cat. 1.1
Fol. 5r: Ch. 2	Fol. 3r: Ch. 2	Fol. 2v: Ch. 2	Cat. 5.1
Fol. 5r: Ch. 3	Fol. 3v: Ch. 3		Cat. 5.9
		Fol. 2v: Ch. 3	Cat. 6.1
Fol. 8v: Ch. 4	Fol. 7r: Ch. 4	Fol. 5r: Ch. 4 [1]	Cat. 14.1
		Fol. 6r: Ch. 5	Cat. 17.1
		Fol. 7r: Ch. 6 [1]	Cat. 20.2
		Fol. 7v: Ch. 7	Cat. 21.1
		Fol. 8r: Ch. 8 [2]	Cat. 23.1
Fol. 14v: Ch. 5	Fol. 13r: Ch. 5		Cat. 26.5
		Fol. 9v: Ch. 9 [1]	Cat. 28.2
		Fol. 10r: Ch. 10 [1]	Cat. 30.1
		Fol. 10v: Ch. 11 [1]	Cat. 31.4
Fol. 17r: Ch. 6	Fol. 15v: Ch. 6		Cat. 32.3
		Fol. 11r: Ch. 12 [1]	Cat. 33.1
		Fol. 11v: Ch. 13 [1]	Cat. 34.2
Fol. 18v: Ch. 7	Fol. 17r: Ch. 7		Cat. 36.2
		Fol. 12v: Ch. 14	Cat. 36.4
Fol. 20v: Ch. 8	Fol. 18v: Ch. 8	Fol. 13v: Ch. 15 [2]	Cat. 39.6

Fol. 22r: Ch. 9	Fol. 20v: Ch. 9	Fol. 14v: Ch. 16 [1]	Cat. 43.1
		Fol. 15r: Ch. 17 [2]	Cat. 44.5
Fol. 25r: Ch. 10	Fol. 23v: Ch. 10		Cat. 50.1
Fol. 25v: Ch. 11	Fol. 24r: Ch. 11		Cat. 50.5
		Fol. 17v: Ch. 18 [1]	Cat. 51.1
Fol. 29r: Ch. 12	Fol. 27r: Ch. 12		Cat. 52.1
		Fol. 20r: Ch. 19 [1]	Cat. 52.2
Fol. 31v: Ch. 13	Fol. 30r: Ch. 13	Fol. 22r: Ch. 20 [1]	Cat. 53.1
Fol. 32v: Ch. 14	Fol. 31r: Ch. 14		Cat. 55.1
Fol. 33r: Ch. 15	Fol. 31v: Ch. 15	Fol. 23r: Ch. 21	Cat. 56.1
Fol. 33v: Ch. 16	Fol. 32r: Ch. 16		Cat. 57.5
		Fol. 23v: Ch. 22 [1]	Cat. 58.1
Fol. 35v: Ch. 17	Fol. 33v: Ch. 17	Fol. 24v: Ch. 23 [3]	Cat. 59.4

Comparison of the Layout of the *Jugurthine War*

Chapter divisions defined by flourished and acanthus initials are not numbered in these manuscripts; I insert sequential chapter numbers based on the placement of initials. The number of illuminations (if any) per chapter appears within brackets.

Geneva Ms. lat. 54	Paris, BnF Ms. lat. 5762 text added in the 1430s	Corresponding incipit for text in critical edition
Fol. 27r: Ch. 1= prologue	Fol. 38v: Ch. 1 [1] = prologue	Iug. 1.1
Fol. 28r: Ch. 2 [1]	Fol. 40v: Ch. 2	Iug. 5.1
Fol. 28v: Ch. 3		Iug. 5.4
Fol. 29r: Ch. 4		Iug. 7.2
Fol. 29v: Ch. 5		Iug. 9.2
Fol. 30r: Ch. 6 [1]	Fol. 43r: Ch. 3	Iug. 10.1
Fol. 30v: Ch. 7 [2]		Iug. 11.2
Fol. 31v/32r: Ch. 8 [1]	Fol. 45v: Ch. 4	Iug. 14.1
Fol. 33v: Ch. 9	Fol. 48v: Ch. 5	Iug. 15.1
Fol. 34v/35r: Ch. 10 [1]		Iug. 17.3
Fol. 36r: Ch. 11 [3]	Fol. 51v: Ch. 6	Iug. 20.1
Fol. 37v: Ch. 12	Fol. 53v: Ch. 7	Iug. 24.2
Fol. 38r: Ch. 13 [2]	Fol. 54v: Ch. 8	Iug. 25.1
Fol. 40r: Ch. 14 [1]	Fol. 57v: Ch. 9	Iug. 31.1
Fol. 42r: Ch. 15 [1]	Fol. 59v: Ch. 10	Iug. 32.1
Fol. 42v: Ch. 16 [3]		Iug. 35.1
Fol. 46r: Ch. 17 [15]	Fol. 65v: Ch. 11	Iug. 43.1
	Fol. 68r: Ch. 12	Iug. 47.3
	Fol. 79v: Ch. 13	Iug. 66.1
	Fol. 82v: Ch. 14	Iug. 73.3
	Fol. 85v: Ch. 15	Iug. 79.1

	Fol. 86r: Ch. 16	Iug. 79.10
	Fol. 87r: Ch. 17	Iug. 82.2
Fol. 62v/63r: Ch. 18 [1]	Fol. 88v: Ch. 18	Iug. 85.1
Fol. 65v: Ch. 19 [4]	Fol. 92r: Ch. 19	Iug. 86.1
Fol. 70r: Ch. 20 [3]	Fol. 98r: Ch. 20	Iug. 97.1
Fol. 73r: Ch. 21	Fol. 102r: Ch. 21	Iug. 102.5
Fol. 73v: Ch. 22 [5]	Fol. 102v: Ch. 22	Iug. 102.12
	Fol. 106r: Ch. 23	Iug. 111.1
	Fol. 107v: Ch. 24	Iug. 113.1

APPENDIX 3

Fourteenth- and Fifteenth-Century Texts Describing Triumphs

l. Pierre Bersuire's translation of Livy, mid-fourteenth century. Within the glossary of difficult words is the following neologism quoted from a manuscript that belonged to Charles V (Ste-Gen, Ms. 777, fols. 2v–3r):

> TRIUMPHE Triumphe estoit celui grant honneur que l'en faisoit à aucun prince romain quant revenoit à Rome d'aucune bataille où il avoit eue tres noble victoire quar le pueple li venoit à l'encontre et il estoit portez en un char à nobles painnes et à chevaus blans. Et les nobles hommes que il avoit pris estoient amené lié apres lui et les vaillanz hommes qui l'avoient bien fait avecques lui venoient delez lui sur grant destriers. Et celui honneur estoit apelé triumphe en l'ost des chevaliers qui avoient esté avecques lui en besougnes venoient apres joieusement et ordeneement coronnez de lorier en signe de la victoire eue.

2. Valerius Maximus, French translation completed circa 1402 by Simon de Hesdin and Nicolas de Gonesse. This passage is quoted from BnF, Ms. fr. 282, fol. 121r, from a chapter in which the translator cites Isidore of Seville as the source for this amplification:

> [T]riumphe est deu pour plaine victoire et est triumphe dit selon Vegece de tris en grece qui vault à dire en francois trois et phon qui vault à dire son pour ce que ainçois que triumphe fust decenre à aucun il y convenoit trois voix, c'est à dire trois jugemens: les premerains que jugoient estoient les gens d'armes lesquelz avoient esté à la victoire et ceulx ci pouoient mieulx juger que nulz aultres se leur prince avoit desservi triumphe ou non ; le second jugement estoit du senat, et le tiers estoit du peuple. Apres ces jugemens, celui lequel devoit triumpher estoit mis en un char à quatre chevaulx pour ce que les anciens avoient maniere deulx combatre en chars.
>
> Item puisqu'il avoit vaincu en combatant il estoit couronne de une couronne de palme d'or, car la palme a aguillons et point. Et cellui lequel vencu sanz avoir de fait combatu mais avoit laissié les ennemis et tué ou pris en fuyant, il estoit

couronne d'une couronne de lorier pour ce que le lorier n'a nulz aguillons et ne
point pas. Et ce estoit preprement nommé tropheum et estoit joyeuse victoire,
car, selon Ysodore ou lieu devant dit, la victoire n'est point joyeuse laquelle vient
avec son grant dommage, et pour ce loe salusce les princez qui raportent les vic-
toires sans ensanglanter leurs gens de leur propre sang.

Item quant cellui qui triumphoit devoit entrer à Romme le peuple venoit
au devant en lui faisant joye et les prisonniers venoient a pié devant son char les
mains loyees derrieres et les gens d'armes venoient apres lesquelz louoient leur
prince en faisant liee chiere et joieuse. . . .

3. Laurent de Premierfait's edition of Bersuire's translation of Livy, circa 1408, quoted
from a manuscript produced circa 1410, BnF Ms. fr. 264, fol. 11v:

Triumphe estoit celle grant honneur que on faisoit à aucun prince roumain
quant il revenoit a Roume d'aucune bataille ou il avoit eu très noble victoire.
Car le peuple lui venoit a l'encontre. Et il estoit porté en un char à nobles pare-
mens et à chevaulx blans. Et les nobles hommes qu'il avoit prins estoient adme-
nez liez devant lui. Et les vaillans hommes qui s'estoient bien portez aloient delez
lui sur grans destriers. Et icellui honeur estoit appellee triumphe. Et les chevaliers
qui avoient esté avecques lui en la besoingne venoient apres lui joieusement et
ordonneement, couronnez de lorier en signe qu'il avoient eu victoire.

4. Laurent de Premierfait's second translation of Boccaccio's *De casibus* of circa 1409,
quoted from Geneva, Ms. fr. 190/1, fols. 128v–29r.

Saichent les nobles hommes s'il leur plaist que triumphe est l'onneur qui doit
estre rendue au duc ou au chevetaine de aulcune bataille apres ce qu'il a obtenue
victoire des ennemis. Et ceste honneur qui est en lieu de salaire a nom
"triumphe" pour ce que avant que l'en doive rendre a aulcun le triumphe, on
prend l'adviz et le jugemant des gens des trois estatz, c'est assavoir des hommes
d'armes qui ont esté presens en la bataille, du clergie, et du peuple. Le duc ou le
chevetaine doit estre en ung cheriot en tel habit qu'il entra en la bataille qui soit
mené a quatre chevaulxs blancs. Se la victoire est acquise par bataille rangee, le
duc doit estre coronnee de palmes d'or, pour ce que la palme est poinctue. Mais
se la victoire est obtenue par desconfiture et occision de ennemis fuyans les dos
tournez, le duc doit avoir coronne de lorier pour ce qu'il est sanz aguillons.

Sa cote de armes doit estre de simple pourpre ou de poupre semee de
palmes. Il tient en sa main ung baston, et au bout dessuz doivent estre peinctes
les armes du souverain seigneur pour qui l'en a combatu. Cellui baston est oinct
de couleur rousse. Et avec le duc dedans le cheriot est ung bourreau qui le frape

d'un baston et lui dict villenie et laidure et si lui crie a haulte voix en grec "noti-solitos," c'est à dire "ayes congnoissance de toy mesme," afin que le duc ne s'en-orgueille de celle honneur mondaine, qui est la plus grant et la plus haulte qui soit. Les prisonniers vont devant le cheriot, c'est assavoir les plus nobles au plus pres. Apres est le duc mené en son plus noble hostel. Et à l'environ de lui les poetes et les aultres musicians chantent en vers et motiaulx et jouent en tous instrumens les louenges de lui pour encourager les aultres à faire les nobles faits de vertus.

Juxtaposition of the Physical Structure, Decoration,
and Equivalent Latin and French Texts in Cicero,
De senectute/Livre de vieillesse (BnF Ms. lat. 7789).

For ease of reference, textual citations are to Cicero, *Cicero Orations*, and Cicero, *On Old Age*. The textual structure of the Latin and French texts in the manuscript divides Cicero's *De senectute* into a prologue and five sections of text, corresponding to a preamble to the disputation followed by the presentation and refutation of the four claims about old age.

LATIN	CORRESPONDING FRENCH TRANSLATION
Quire 1, fols. 1r–8v (fol. 8v blank) Cicero, *Oratio pro Marcello* 1.1	**NO EQUIVALENT FRENCH TEXT**
NO EQUIVALENT LATIN TEXT	**Quire 6, fols. 34r–41v** Fol. 34r Illumination and initial: Laurent de Premierfait presents his translation to Duke Louis of Bourbon. Laurent's translator's prologue, *Livre de vieillesse.*
Quire 2, fols. 8r–15v Fol. 8r Illumination & initial: Cicero presents his book to a youth who delivers it to Atticus. Cicero's Latin prologue to *De senectute* 1.1.	Fol. 37r Illumination & initial: Cicero and Cato appear before Atticus. French translation of Cicero's Latin prologue *Livre de vieillesse* 1.1.
Fol. 9r initial *De senectute* 2.1	Fol. 39r Illumination & initial: Scipio and Laelius question Cato. *Livre de vieillesse* 2.1 Preamble to disputation of Cicero.
Fol. 12v initial *De senectute* 5.15	**Quire 7, fols. 42r–49v** Fol. 47v Illumination & initial: Scipio and Laelius speak with Atticus(?). *Livre de vieillesse* 5.15 First claim about old age.

Quire 3, fols. 16r–23v
Fol. 16r initial *De senectute* 9.27

Quire 8, fols. 50r–57v
Fol. 56r Illumination & initial: Milo of Crotona.
Livre de vieillesse 9.27 Second claim about old age.

Quire 9, fols. 58r–65v
Fol. 65v Illumination & initial: Lucius Flamininus
orders an execution at the request of a courtesan.
Livre de vieillesse 12.39 Third claim about old age.

Fol. 19r initial *De senectute* 12.39

Quire 10, fols. 66r–73v
Quire 11, fols. 74r–81v

Quire 4, fols. 24r–31v
Fol. 27r initial *De senectute* 19.66
Quire 5, fols. 32r–33v

Quire 12, fols. 82r–89v
Fol. 86r Illumination & initial: death threatens
a youth and an old man. *Livre de vieillesse* 19.66
Fourth claim about old age.
Quire 13, fols. 90r–97v
Quire 14, fols. 98r–104v

Visual Amplifications in the *Des cas des nobles hommes et femmes*

Visual amplifications unique to Duke John of Berry's and Duke John the Fearless's manuscripts of the *Des cas des nobles hommes et femmes*

- Bk. 2, ch. 8–9, Executioners drag Queen Athaliah by her hair; Beheading of Athaliah (bk. 2, ch. 9: Against covetousness of things)
- Bk. 2, ch. 11–12, Dido's husband murdered by her brother; Suicide of Dido (bk. 2, ch. 12: In praise of Dido)
- Bk. 2, ch. 13–14, Sardanapalus spins with his wives; Suicide of Sardanapalus (bk. 2, ch. 14: Against Sardanapalus and those like him)
- Bk. 2, ch. 16–17, Zedekiah blinded at the command of Nebuchadnezzar; Zedekiah dies in prison (bk. 2, ch. 17: The condition of mortality)
- Bk. 3, ch. 3–4, Lucius Tarquinius murders King Servius; Suicide of Lucretia; David and Bathsheba (bk. 3, ch. 4: Against princes prone to luxuria)
- Bk. 3, ch. 9–10, Verginius beheading Verginia; Suicide of Appius Claudius (bk. 3, ch. 10: Against false legists)
- Bk. 3, ch. 12–13, Expedition of Alcibiades sailing to Sicily; Bed of Alcibiades set on fire (bk. 3, ch. 13: *Excusation* of Alcibiades; Against *oisiveté*)

Visual amplifications unique to Duke John the Fearless's manuscript of the *Des cas des nobles hommes et femmes*

- Bk. 1, ch. 13–14, Priam's murder by Achilles' son Pyrrhus in the Temple of Jupiter; Hecuba witnesses the murder of her grandson, the infant Astyanax (bk. 1, ch. 13: Against pride)
- Bk. 1, ch. 15–16, Aegisthus, bishop of Mycenae, has Agamemnon killed with Queen Clytemnestra's help; Diogenes in barrel observes boy drinking from hands (bk. 1, ch. 16: In praise of poverty)
- Bk. 1, ch. 17–18, Samson destroys the temple; Jupiter and Danaë (bk. 1, ch. 18: Against women)

Visual amplifications shared by the two dukes' manuscripts and by a
small group of additional manuscripts: JPGM, Ms. 63;
ÖNB, Cod. Ser. n. 12766; and BnF, Ms. fr. 226

- Bk. 7, ch. 8–9, Destruction of Jerusalem in which Titus receives tribute money and Jews are sold into captivity; Jewish noblewoman Marie eats her child (bk. 7, ch. 9: Against the Jews)

Visual amplifications shared with other manuscripts of the
Des cas des nobles hommes et femmes

- Bk. 2, ch. 2–3, Samuel anoints Saul; Saul kills himself (bk. 2, ch. 3: In praise of obedience)
- Bk. 2, ch. 5–6, King Rehoboam holds court; King of Egypt imposes conditions of peace on Rehoboam; The Etruscan king Porsenna pulls Mucius Scaevola's hand from the fire (bk. 2, ch. 6: Against proud kings)
- Bk. 2, ch. 18–19, Cyrus nursed by a wild dog; Dream of Simonides (bk. 2, ch. 19: On dreams)
- Bk. 2, ch. 23–24, Tullus Hostilus watches Mettius Fufetius drawn in two; The writer speaks (bk. 2, ch. 24: Against fraud)
- Bk. 3, ch. 6–7, Xerxes I and army cross bridge; Xerxes I dismembered by the commander of his bodyguard (bk. 3, ch. 7: Against the blindness of mortal man)
- Bk. 4, ch. 3–4, frame left blank; Assassination of Clerchus (bk. 4, ch. 4: Against tyrants)
- Bk. 9, ch. 5–6, Imprisonment of Desidarius, king of the Lombards, and his family; Pope Joan giving birth (bk. 9, ch. 6: Against pride)

NOTES

PREFACE

1. This formulation is Milner's. For discussion of humanism, see the foundational work by Kristeller, "Humanism," and Hankins, *Virtue Politics*; for careful analysis of fifteenth-century Europe, see Rundle, "Humanism across Europe"; Milner, "The Italian Peninsula," and Taylor, "The Ambivalent Influence of Italian Letters," all in Rundle, *Humanism in Fifteenth-Century Europe*. For a state of research on the emergence of humanism in France that clarifies the complex relationship between French and Italian scholars and provides a rich bibliography, see Ouy, "Les recherches sur l'humanisme français."

2. Martinale, "Reception," quoted by Kallendorf, *A Companion to the Classical Tradition*, 2.

3. For the classical tradition in the Middle Ages and Renaissance, see Ziolkowski, "Middle Ages," and Kallendorff, "Renaissance"; and for discussion of a theoretical approach to the reception of the classical tradition, see Martindale, "Reception," all in Kallendorf, *A Companion to the Classical Tradition*. For a meditation on the classical tradition in relation to art, literature, and thought, see Silk, Gildenhard, and Barrow, *The Classical Tradition*.

4. See Zink, preface to vol. 1 of Galderisi, *Translations médiévales*.

5. Galderisi, introduction to vol. 1 of Galderisi, *Translations médiévales*, 13–43.

6. See Duval, "Quels passés pour quel Moyen Âge?," in Galderisi, *Translations médiévales*, 1:47–92, especially 86–90.

CHAPTER 1

1. See, for instance, Monfrin, "Humanisme et traduction"; Monfrin, "Les traducteurs et leur publique"; Monfrin, "La connaissance de l'antiquité."

2. See Ornato, *Jean Muret et ses amis*; Ornato, "La redécouverte des classiques," in Cecchetti, Sozzi, and Terreaux, *L'aube de la Renaissance*, 83–101.

3. For Parisian humanism and chancellery culture, see Ouy, "Le collège de Navarre"; Pons, "Les chancelleries parisiennes," in Gualdo, *Cancelleria e cultura nel Medio Evo*, 137–68; the contributions to Bozzolo and Ornato, *Préludes à la Renaissance*; contributions to Ornato and Pons, *Pratiques de la culture écrite en France*; Gorochov, *Le collège de Navarre*; and Taylor, "Ambivalent Influence of Italian Letters," in Rundle, *Humanism in Fifteenth-Century Europe*, 203–36.

4. See Bozzolo and Loyau, *La Cour amoureuse.*

5. See Bamford, "Remember the Giver(s)"; and Cayley, *Debate and Dialogue.* The queen's dossier appears in the collection of Christine de Pizan, collected works (BL Harley Ms. 4431, fols. 237r–54r), and John of Berry's manuscript is in Berkeley (UCB 109).

6. Col annotated his personal copies of Laurent de Premierfait's translation of Boccaccio (BnF Ms. fr. 131), discussed in ch. 5, and Lebègue added Laurent's compendia on the *Thebaid* and *Achilleid,* texts discussed in ch. 2, to one of his copies of the *Achilleid* (BAV Ottobein. lat. 1475). He also copied the beginning of Laurent's compendium on the *Thebaid* in a manuscript anthology containing the *Thebaid* (BnF Ms. lat. 7936).

7. See Jean de Montreuil, *Epistolario,* for editions of the letters, and Jean de Montreuil, *Monsteroliana,* 75–300, for Ornato's summaries and analyses of the letters. In what follows, I will cite the letters by the number used for them in this edition and analysis.

8. See Jean de Montreuil, *Epistolario,* for an edition of the letter, and *Monsteroliana,* 237–39, for its analysis.

9. See Avril, "Gli autori classici illustrati in Francia," in Buonocore, *Vedere i classici,* 87–98; and Buonocore, *Vedere i classici,* 330–31, no. 78.

10. For this and the following, see Delahaye, *Paris 1400,* 239–40, no. 143.

11. "I wish that all those who were able thus far, and whose duty it was, had loved that alike Livy and the other historiographers and authors, to the (same) extent that your nobility (noble station) tended/tends to them. We would not then lack such a great portion of Livy himself, nor the massive hoard of other learned and most valuable writers. But the genius of powerful, literate men has grown so very numb, and leans so much on active and earthly pursuits, that it deeply scorns and rejects contemplative matters, which Virgil calls 'noble leisure.' But, since many have already complained about the negligence of modern men concerning the aforementioned books, I have no inclination to go on about it now" [O utinam hactenus omnes qui poterant et eorum fuerat officium, eundum Livium ceterosque historiographos et auctores, quemadmodum vestra nobilitas eos colit, amavissent! Non enim ipsius Livii tanta portione nec ceterorum doctorum venerabilissimorum scriptorum maxima congerie careremus! Sed litteratorum ingenia potentum maxime adeo refrixerunt, et sic incumbunt activis et terrenis, ut contemplativa, que Virgilis *otium nobile* vocat, penitus contempnant ac respuant. Quod cum id iam a multis deploratum sit, circa modernorum de dictis libris negligentiam, modo insistere non est animus]. For the full text of letter 157, see Jean de Montreuil, *Epistolario,* 224–25, and for Ornato's French summary of it, see Jean de Montreuil, *Monsteroliana,* 237–39. I would like to thank Tara Welch for her help in translating this letter and other unpublished Latin texts in this book.

12. For this and the following, see Pitti, *Bonaccorso Pitti marchand,* 81–82. Delsaux, "Traductions empêchées," in Galderisi and Vincensini, *La fabrique de la traduction,* 84n13, referred to this anecdote.

13. Laurent de Premierfait began his translation of Cicero's *De amicitia* for Louis of Bourbon shortly after the completion of his translation of Cicero's *De senectute.* However, Louis died before Laurent completed it, and he presented it to Duke John of Berry in 1416. For discussion of the prologue see Mattéoni, "L'image du duc Louis II de Bourbon," in Au-

trand, Gauvard, and Moeglin, *Saint-Denis et la royauté*, 151–52. For an edition of the text, see Laurent de Premierfait, *Le livre de la vraye amistié*. For discussion of a trilingual presentation in German, Latin, and French organized at Charles V's court in 1378, see Hedeman, "Performing Documents and Documenting Performance."

14. See Laffitte, "Les ducs de Bourbon," 171, who cites Boislisle, "Inventaire," 306–9. In addition to law books, Boislisle lists Ovid's *Metamorphoses* and several books on paper, including Terence's *Comedies*, a gloss on Terence, Seneca's *Tragedies*, a gloss on Seneca, and books on logic. He also lists an unidentified volume, "Ung livre sur la généalogie des Dieux gentilz, qui commence: *Si satis ex relatis*, et y a une peau noire dessus," that can be identified as Boccaccio's *Genealogy of the Pagan Gods*. Compare the quoted incipit with that in Boccaccio, *Genealogy of the Pagan Gods*, 2. Mombello, "I manoscritti," 148, also made this connection.

15. This point was made often by Jacques Monfrin. See, for instance, Monfrin, "La connaissance de l'antiquité," 131–33.

16. For discussion of the Orléans brothers and these books, see chapters 1 and 3. Though the young princes used the classics in their studies, they may not have been as adept at transcribing Latin; Ouy describes John of Angoulême's autograph copy of a text by Gerson that he copied (or had copied) in 1430 as being riddled with errors. See Ouy, "Discovering Gerson the Humanist," 91, cited by Taylor, "Ambivalent Influence of Italian Letters," in Rundle, *Humanism in Fifteenth-Century Europe*, 229. Taylor implied that Ouy stated that John of Angoulême transcribed the book. Actually, Ouy was more circumspect; he suggested that Jean transcribed the book or had it transcribed.

17. See the entries by Veronique de Becdelièvre in the BnF online *Archives et manuscrits* for a synthesis of scholarship and further bibliographic references about these manuscripts. Louis of Orléans and his wife, Valentina Visconti, wished to ensure that their sons Charles of Orléans, Philip, Count of Vertus, and John of Angoulême were carefully educated. They ordered unspecified books in 1402 for Philip and Jean and hired Nicolas Garbet to be their tutor. See Bauermeister and Laffitte, *Des livres et des rois*, 36; and Rouse and Rouse, *Manuscripts and Their Makers*, 2:54.

18. For more on BnF Ms. lat. 6147, see Ouy, "Jean Lebègue," in Croenen and Ainsworth, *Patrons, Authors and Workshops*, 143–71, no. 40. Ouy identifies the manuscript as no. 12 in the inventory of Jean Courtecuisse. See Omont, "Inventaire des livres de Jean Courtecuisse."

19. Notable exceptions are Sherman, *Imaging Aristotle*, and Buettner, *Boccaccio's Des cleres et nobles femmes*. For early fifteenth-century developments, see Hedeman, "Making the Past Present," in Croenen and Ainsworth, *Patrons, Authors and Workshops*, 173–96; Hedeman, "L'humanisme et les manuscrits enluminés"; Hedeman, "Visual Translation"; and Hedeman, "Making the Past Present in Laurent de Premierfait's Translation."

20. In her examination of the illustration devised by Nicole Oresme to illustrate his translation of Aristotle, Sherman analyzed how Oresme used images to "select and explain important concepts." Her rich examination of Oresme's visual translation has stimulated my thinking about visual translation. See Sherman, *Imaging Aristotle*, xxii and passim.

21. On Parisian humanism and chancellery culture, see Ouy, "Le collège de Navarre"; Pons, "Les chancelleries parisiennes" in Gualdo, *Cancelleria e cultura nel Medio Evo,* 137–68; contributions to Bozzolo and Ornato, *Préludes à la Renaissance;* contributions to Ornato and Pons, *Pratiques de la culture écrite;* Pons, "Les humanistes et les nouvelles autorités." For discussion of translations in the fourteenth and early fifteenth centuries, see Monfrin, "Humanisme et traduction"; Monfrin, "Les traducteurs et leur publique "; Monfrin, "La connaissance de l'antiquité"; and Sherman, *Imaging Aristotle.* For an introduction to Laurent and for further bibliography, see Bozzolo, *Un traducteur;* Tesnière, "Un remaniement"; and Hedeman, *Translating the Past.*

22. See Delsaux, "Textual and Material Investigation," in which he identified Statius, *Achilleid and Thebaid* (BL Burney 257), ca. 1405; Cicero, *De senectute* and *De vieillesse* (BnF Ms. lat. 7789) ca. 1405; Terence *Comedies* (BnF Ms. lat. 7907, fols. 1r–56r), unillustrated and of uncertain date; Terence *Comedies* (BnF Ms. lat. 7907A) ca. 1407; Boccaccio, *De cas des nobles hommes et femmes* (Geneva, Mss. fr. 190 1/2) ca. 1410; Boccaccio, *De cas des nobles hommes et femmes* (Arsenal Ms-5193 rés.), ca. 1410–11; Boccaccio, *De cas des nobles hommes et femmes* (ÖNB Cod. Ser. n. 12766) ca. 1412; and Boccaccio, *Les cents nouvelles* (*Decameron*) (BAV Pal. lat. 1989) c. 1416–18 as written wholly or in part by scribes T and S. He also speculates that Laurent may have proofread one of the earliest copies of his first translation of the *De cas des nobles hommes et femmes* (KBR, IV 920) ca. 1400 and several among the manuscripts mentioned above: BL Burney 257, BnF Ms. lat. 7907, BnF Ms. lat. 7907A, Arsenal Ms-5193 rés., and BAV Pal. lat. 1989. See as well Delsaux, "Traductions empêchées et traductions manipulées," in Galderisi and Vincensini, *La fabrique de la traduction,* 81–111.

23. For discussion of the Parisian book trade, see Rouse and Rouse, *Manuscripts and Their Makers;* and Fianu, "Métiers et espace," in Croenen and Ainsworth, *Patrons, Authors and Workshops,* 21–45. For evidence that Laurent was directly involved in producing manuscripts of the *De cas des nobles hommes et femmes,* see Hedeman, *Translating the Past.*

24. On Lebègue, see Ouy, "Le songe et les ambitions"; Pons, "Erudition et politique"; Pons, "Leonardo Bruni, Jean Lebègue et la cour"; Ouy, "L'humanisme et propaganda politique"; and Ouy, "Jean Lebègue (1368–1457)," in Croenen and Ainsworth, *Patrons, Authors and Workshops,* 143–71. For Lebègue's relations to the arts, see Porcher, "Un amateur de peinture sous Charles VI"; Lebègue, *Les histoires que l'on peut raisonnablement faire;* Byrne, "An Early French Humanist and Sallust"; Hedeman, " Making the Past Present: Visual Translation"; Hedeman, "L'humanisme et les manuscrits enluminés"; and Hedeman, "Jean Lebègue et la traduction visuelle." For an edition of and new research on his *Libri Colorum,* a recipe book for pigments assembled in 1431, see Merrifield, *Original Treatises,* 1:16–321; Villela-Petit, "La peinture médiévale vers 1400"; Turner, "The Recipe Collection of Johannes Alcherius"; Guineau, Villela-Petit, Akrich, and Vezain, "Painting Techniques"; Villela-Petit, "Copies, Reworkings and Renewals," in Nadolny, *Medieval Painting in Northern Europe,* 167–81; Villela-Petit, "Palettes comparées"; and Turner's entry on Lebègue's copy of the recipe collection of Johannes Alcherius in Panayotova, *Colour,* 101–102, no. 21.

25. For discussion of these books see Hedeman, "Jean Lebègue et la traduction visuelle," and ch. 3.

26. On Lebègue's manuscript collection, see Ouy, "Jean Lebègue (1368–1457)," in Croenen and Ainsworth, *Patrons, Authors and Workshops,* especially 161–68, where he lists thirty-seven surviving manuscripts. Thanks to Marianne Pade, we can add to this list a manuscript in the Berlin Staatsbibliothek (Dietz.B. Sant. 4) signed by Lebègue with one of his anagrams: "A. Beleviegne." See Pade, "Un nuovo testimone," who identifies the fifteenth-century extracts of the partial translation of and commentary on the Iliad by Leonzio Pilato (fols. 169v–87r) as written by a French hand (Lebègue's?) and says that this text is an extraordinary witness to Leonzio Pilato's work.

27. For transcription of the note about Laurent's death, see Jean de Montreuil, *Epistolario,* 1, 62. For a study of Lebègue's annotations in other manuscripts, see Pons, "Erudition et politique."

28. On these, see Avril, "Un manuscrit d'auteurs classiques." I would like to thank Nicole Pons for sharing her unpublished notes on BnF Ms. lat. 6416 with me. She identified the sources for Lebègue's addition in the quire at the beginning of the *Polycraticus* of Jean of Salisbury's Latin *Entheticus* (fols. 1r–2v), followed by Denis Foulechat's French translation of it (fols. 3r–5v), followed on fols. 6r–6v by the French colophon that appears at the end of Charles V's copy of the translation (compare BnF Ms. fr. 24287, fol. 296r).

CHAPTER 2

1. The *Achilleid* was part of the *Liber catonianus* by the late twelfth century, which assured its use in schools. By the thirteenth century Statius was one of the standard school poets with Vergil, Ovid, and Lucan. See Anderson, *The Manuscripts of Statius,* 1:iii; and Clogan, *The Medieval Achilleid.*

2. I checked published inventories of Kings Charles V and Charles VI and Dukes John of Berry, Louis of Bourbon, Philip the Bold, John the Fearless, and Charles of Orléans and could find no record of manuscripts of Statius in their collection. The *Achilleid* was translated into Italian in the fourteenth century, Irish in the fourteenth through sixteenth centuries, and French and Spanish only in the seventeenth century. Anderson, *The Manuscripts of Statius,* 2:9. For the medieval reception of Statius, see Edwards, "Medieval Statius," in Dominik, Newlands, and Gervais, *Brill's Companion to Statius,* 497–511.

3. On these *Romans d'antiquités,* see Spiegel, *Romancing the Past;* Jung, *La Légende de Troie;* Battles, *The Medieval Tradition of Thebes;* Harf-Lancner, "L'élaboration d'un cycle"; Morrison, "Illuminations of the *Roman de Troie*"; and Stahuljak, *Bloodless Genealogies.*

4. This text is catalogued in modern collections as the *Histoire ancienne jusqu'à César.* On these manuscripts, see Avril, "Trois Manuscrits Napolitains"; and Morrison and Hedeman, *Imagining the Past in France,* 266–69, no. 50, with further bibliography.

5. See Guiffrey, *Inventaires,* 1:245, no. 937. This manuscript has not been identified, but the incipit of its second page, quoted by Guiffrey, "Edipus qui estoit avec Polibon," appears on BnF Ms. fr. 301, fol. 1v, so it easily could have begun the second folio of a different manuscript of that same text.

6. See Guiffrey, *Inventaires* 1:257, no. 969. Duke Louis of Bourbon owned a Latin Terence and commentary on Terence, both written on paper, but it is unlikely that either of them was illustrated. See Boislisle, "Inventaire," 308.

7. This manuscript was inventoried in Orléans collections from 1417 on. See Champion, *La librairie de Charles d'Orléans*, 105–6; Ouy, *La librarie des frères captives*, 37; and Véronique de Becdelièvre's entry on BnF Ms. lat. 7917 in *Archives et manuscrits*.

8. See Delsaux, "Textual and Material Investigation."

9. For a transcription of the *argumenta antiqua* and a list of the manuscripts that contain them, see Andersen, *Manuscripts of Statius*, 2:21–26.

10. For discussion of Laurent's additions of accessus, compendia, and periochae to Statius and Terence and for editions of these added texts, see Bozzolo and Jeudy, "Stace et Laurent de Premierfait"; Jeudy and Riou, "L'Achilléide de Stace"; Anderson, *Manuscripts of Statius*, 1:xxviii–xxix, 196, and 2:18–19, 21–23, 43–45, and 47; and Bozzolo, "Laurent de Premierfait et Térence," reprinted in Bozzolo, *Un traducteur*, 145–79. This chapter's discussion uses the editions of Statius by Bailey and by Klotz and Klinnert, and the edition of Terence by Barsby. See Statius, *Thebaid, Books 1–7*; Statius, *Thebaid, Books 8–12*; Terence, *The Woman of Andros*; and Terence, *Phormio*. For Statius's *argumenta antiqua*, see Statius, *Thebais*, 476–82, and 588.

11. Jean Lebègue transcribed Laurent's compendia on the *Thebaid* and *Achilleid* on fifteenth-century paper added to a copy of the *Achilleid* that he owned (BAV Ottobein. lat. 1475, fols. 23r–28v), and he copied the beginning of Laurent's compendium on the *Thebaid* in spaces left at the beginning and end of the *Thebaid* in the margins of a manuscript of classical texts dating to ca. 1200 that he also owned (BnF Ms. lat. 7936, fols. 80v and 140r–140v). The owner of the only other copy of Laurent's compendium to the *Thebaid* (a thirteenth-century manuscript with annotations from the second half of the fifteenth century, BAV Reg. lat. 1375) is unknown, but it copied Lebègue's manuscript in Paris. See Bozzolo and Jeudy, "Stace et Laurent de Premierfait," 414–15, 239–42; and Anderson, *Manuscripts of Statius*, 1:xxviii–xxix, 195–96, 306, 387, 404–6; 2:18–26, and 43–44.

12. See Jeudy and Riou, "L'Achilléide de Stace," 159. The authors concluded that the texts on fols. 225r–226r of BL Burney 257 and on fols. 36v–38r of Lebègue's BAV Ottoboni lat. 1475, were so close that Lebègue must have copied the text in the Vatican manuscript from the manuscript now in London.

13. For an analysis of seven manuscripts containing Laurent's commentary on Terence, see Bozzolo, "Laurent de Premierfait et Térence," 93–105. These include: BnF Ms. lat. 7907; Cambridge University Library, Ff vi 4; BnF Ms. lat. 7907A; Arsenal Ms-664 rés.; BAV Vat. lat. 6794; BAV Reg. lat. 1875; and Library of the Castle of Křivoklát, Ms. 149. As Bozzolo's article was in press, Claudia Villa notified her of another manuscript: Gotha, Forschungsbibliothek, II 96. For a summary of the scholarship, see Riou, "Les commentaires médiévaux," 44–45.

14. In the first volume of his book, Anderson catalogues the 463 manuscripts of Statius's *Achilleid, Thebaid,* and *Silvas* and 85 manuscripts of independent commentary. He identifies thirty illuminated copies among these, of which only three beside BL Burney 257

have substantial narrative cycles: a fourteenth-century Italian manuscript (Dublin, Chester Beatty Library, n. 76) with twelve miniatures; a thirteenth-century manuscript belonging to Jean Lebègue (BnF Ms. lat. 7936) with nine historiated initials; and a fourteenth-century French manuscript (Reims, Bibliothèque municipale Ms. 1093) with excerpts from the *Thebaid* whose historiated initials have been excised. Anderson, *Manuscripts of Statius*, 1:1–487.

15. The only unillustrated chapter of the *Thebaid* is book 9, ch. 14, which begins in BL Burney 257 on fol. 15r. For discussion of the Master of the *Ovide moralisé*, see Villela-Petit, "Les enluminures du Salluste"; and Reno and Villela-Petit, "Du *Jeu des échecs moralisés*." François Avril attributes the first image in Statius's *Thebaid* and *Achilleid* (see BL Burney 257, fol. 4r) to an artist from the Bedford Trend in Bousmanne, Van Hemelryck, and Van Hoorebeeck, *La librairie*, 100. Often art historical literature identifies a master (for instance, the *Cité des Dames* Master) as the painter of a visual cycle. Because artists working in the Parisian book trade often collaborated and were perfectly capable of working in a shared style, I will often refer to the painters as a group (i.e., *Cité des Dames* Masters) or as an individual working in a group style (*Cité des Dames* Master illuminator). For discussion of this artistic phenomenon, see Andrews, "The Boucicaut Masters," and Andrews, "The Boucicaut Workshop."

16. For a summary of the contents of Laurent's compendium and an edition of its text, see Bozzolo and Jeudy, "Stace et Laurent de Premierfait," 418–19 and 422–26.

17. For the edition of Laurent's chapter summaries for the *Thebaid*, see ibid., 426–28. In citing texts hereafter I will give the book and verse numbers in parentheses, in conformity with citations of published critical editions of the *Thebaid* and *Achilleid*.

18. "The tenth chapter tells of the mother of Parthenopeus, disturbed in a dream by a horrible vision, which she expiated with water and she prayed to Diana for aid (with many ways) with sacrifices for the health of her son Parthenopeus. And it begins: *Tristibus interea*" [Capitulum decimum refert matrem Parthenopei turbatam per somnum horribili visione, quam piavit aqua et rogabat auxilium Dianae multis partibus et sacrifiis pro salute filii sui Parthenopei. Et incipit: Tristibus interea]. For the Latin, see Bozzolo and Jeudy, "Stace et Laurent de Premierfait," 435, no. 10.

19. For discussion of the Virgil Master and of the *Livre de la prinse et mort du roy Richart d'Angleterre*, see Meiss, *French Painting*, 1:408–11; and Hedeman, "Advising France."

20. Statius, *Thebaid, Books 8–12*, 65.

21. For the Latin summary, see Bozzolo and Jeudy, "Stace et Laurent de Premierfait," 427, no. 6.

22. For discussion of BnF Ms. lat. 7890, see Delahaye, *Paris 1400*, 239–40, no. 143; Avril, "Gli autori classici illustrate," in Buonocore, *Vedere i classici*, 87–98; and Fachechi, "Plauto Illustrato," 192–95. Fachechi observes that Plautus did not seem to have an authoritative late antique visual tradition that influenced fifteenth-century representations, like Terence did. She suggests that the surviving manuscripts seem to be independent of each other. BnF Ms. lat. 7890 is the earliest illuminated manuscript that she found, and she

suggested that the strange "bovine-headed" figure of Mercury came from Bersuire's *Ovide moralisé.*

23. "The first chapter shows Jove angry because the Argives were delaying too much around the funeral mound of Archimorus. And so he sent Mercury as a messenger to Mars, telling Mars to rouse them for war. Mars, when he heard the command of Jove, filled the tasks of the embassy (legation)" [Capitulum primum ostendit Iovem indignatum propter Argivos circa bustum Archimori nimium immorantes. Quapropter misit Mercurium nuntium ad Martem, ut eos ad bellum excitaret. Mars audito Iovis imperio, partes legationis implevit]. For the Latin, see Bozzolo and Jeudy, "Stace et Laurent de Premierfait," 433, no. 1.

24. W. D. Reynolds, "The *Ovidius Moralizatus*," 17–19, 46–55, and 70–75.

25. Ibid., 46–53.

26. "In the ninth chapter Statius shows the speech of Capaneus, rousing the people and King Adrastus to war against the counsel of the prophet Amphiaraus, and how Argia complaining to her father Adrastus urged him toward war against Thebes. And it begins: *Illum iterum*" [Nono capitulo ostendit Statius dicta Capanei populum et regem Adrastum excitantis ad bellum contra consilium Amphiarai vatis, et quomodo Argia conquerens patrem, Adrastum monebat ad prelium contra Thebas. Et incipit: *Illum iterum*]. For the Latin, see Bozzolo and Jeudy, "Stace et Laurent de Premierfait," 430, no 9.

27. For a related reading of the image, but one lacking discussion of Laurent's apparatus, see Dominik, Newlands, and Gervais, *Brill's Companion to Statius*, 3.

28. See, for instance, the representation of imperial crown in images painted by the Master of the *Cité des Dames*, one of the artists who collaborated on BL Burney 257, for the *Grandes chroniques*. Hedeman, *The Royal Image*, fig. 103.

29. See Lendering, "Pontifex Maximus."

30. Charras, "La traduction de Valère-Maxime," xxviii.

31. "In the first chapter of the earlier book the poet Statius pursues two actions . . . the second action of his purpose is where the poet directs his book to the Emperor Domitian, so that, (having been) accepted into his benign favor and defended from the envious, he might be enrolled in the public records" [In primo prioris libri capitulo poeta Statius duos actus exequatur . . . Secundus propositi actus est quo poeta ad Domitianum imperatorem librum dirigit, quatinus favore eius benigno acceptus inter publica monimenta et defensus ab invidis conscribatur]. For the Latin, see Bozzolo and Jeudy, "Stace et Laurent de Premierfait," 426, no. 1.

32. For the summary of Laurent's compendium outlined here, and for an edition of its text, see Jeudy and Riou, "L'Achilléide de Stace," 153–54 and 167–68.

33. For this and the following, see Roubilles, "Martin Gouge." The discussion of BnF Ms. lat. 7907A in this chapter revisits and expands prior research. See Hedeman, "Laurent de Premierfait and the Visualization of Antiquity."

34. For discussion of the presentation manuscript of the translation, the *Des cas des nobles hommes et femmes*, and for discussion of Laurent's role in crafting its visual cycle, see Hedeman, *Translating the Past*, and ch. 4.

For discussion of the social significance of the performance of the *étrennes*, and for discussion of Gouge's presentation of the Terence and Boccaccio as one example, see Buettner, "Past Presents." For a broad statistical and historical analysis of the *étrennes* that includes study of the quantity of recorded gifts traceable through archives and inventories, see Hirschbiegel, *Étrennes*.

Gouge gave gifts to Duke John of Berry at seven *étrennes* ceremonies between 1403 and 1416; only members of the royal family eclipsed him in their number of gifts to the duke. Gouge's presents ranged from metalwork and crystal to manuscripts, and he received in return gifts of jewelry and books of hours. See Hirschbiegel, *Étrennes*, 198–99; and Hedeman, *Imagining the Past*, 56–57 and 234–38.

35. For the following, see Bozzolo, "Laurent de Premierfait et Térence," 113–14 and 127, citing Jean de Montreuil's letters 147 and 165 respectively. For the edition of these letters, see Jean de Montreuil, *Epistolario*, 214 and 251–54. While the manuscript that preserves the letters (Paris, BnF Ms. lat. 13062) dates circa 1417, Ornato established that the contents of the section that contains both these letters dated from 1407 at the latest. For the dating of the manuscript, see Jean de Montreuil, *Epistolario*, xxxvi–xxxvii.

36. Guarda, *La bibliothèque*, 74, 84, 129, 218, 268, 280, 287, and 379. This manuscript is digitized on Gallica at ark:/12148/btv1b84525513.

37. In her notice about BnF Ms. lat. 7907A on *Gallica*, Véronique de Becdelièvre observes that interlinear or marginal additions only appear on fols. 19v, 23v, 74v, 77v, 79v, 85v, 87v, 95v, and 155r.

38. The presentation copy of Cicero for Duke Louis of Bourbon ca. 1405 (BnF Ms. lat. 7789), discussed in ch. 3, contains individual texts on distinct quires. Only one subsequent copy of Laurent's translation of Cicero follows Laurent's practice of making codicological distinctions between sections of the manuscript containing Cicero's original text, Laurent's translation of that original, and Laurent's new supplementary material.

39. Claudia Villa was the first to suggest that the "Laurentius" whose name appeared in two manuscripts containing versions of an early fifteenth-century commentary on Terence was Laurent de Premierfait. Bozzolo studied the content of the diverse versions of the commentary deployed in the earliest manuscripts, BnF Ms. lat. 7907A, Arsenal Ms-664 rés., and BnF Ms. lat. 7907, in order to trace its development, and I summarize her analysis of BnF Ms. lat. 7907A in what follows. See as well Delsaux, "Textual and Material Investigation." The commentary varied in size in each successive manuscript that contained it. See Bozzolo, "Laurent de Premierfait et Térence," or Bozzolo, *Un traducteur*; and Villa, "Laurencius."

40. Building on research by Bozzolo, Albert Châtelet was the first art historian to suggest that Laurent played a role in devising the subject for the frontispiece of this Terence manuscript. See Châtelet, *L'âge d'or*, 123. For further analysis of the frontispiece, see Meiss, *French Painting*, 1:50–54.

41. For discussion of these notes and of what is known about Calliopius, see Wright, "The Organization"; Wright, "The Forgotten Early Romanesque Illustrations"; and Wright's contributions to Buonocore, *Vedere i classici*, 168–76, 200–202, and 218–23.

42. For eighth- to sixteenth-century commentaries that discuss the figure of Callio-pius, see Pade, "Hvad er Teater?" For the popularity of public reading at late medieval courts, see Coleman, *Public Reading*.

43. See the traditional ending in BnF Ms. lat. 7907A: *Calliopius recensui*, at the ends of *The Woman from Andros* (fol. 25v), *The Eunuch* (fol. 50v), *The Self-Tormentor* (fol. 73v), *The Brothers* (fol. 97v), *The Mother-in-Law* (fol. 118v), and *Phormio* (fol. 141r).

44. See BnF Ms. lat. 7907A, fol. 143r (summary of prologue for *The Woman from Andros*):

"Prologus vero que[m] licet terencius confecerit p[er] calliopiu[m] tamen eius recita-tore[m] videtur descriptus: na[m] in comediis lex est ut nunq[uam] autor ex sua persona sed ex alia semp[er] loquatur."

45. See BnF Ms. lat. 7907A: "Prologus autem incipiens *Si quisquam etc.* conscriptus est ut premisi per terencium sed per calliopium recitatur" (fol. 146r, summary of prologue for *The Eunuch*); "Prologus autem est *& ne cui vostrum.* Factus est ut predixi a terencio sed per calliopium recitatus in scena habetur" (fol. 148v, summary of prologue for *The Self-Tormentor*); "Prologus autem incipiens *Postquam poeta etc* conscriptus est ut premisi per terencium sed per calliopiu[m] recitatur" (fol. 150v, summary of prologue for *The Brothers*); "Prolog[us] v[er]o p[er] tere[n]tiu[m] script[us] et p[er] calliopiu[m] recitat[us] ad co[n]futatione[m] ravidor[um] et dectractor[um] i[n]cipit *hechira est*" (fol. 153r, summary of prologue for *The Mother-in-Law*); and "Prologus autem *Postq[uam] poeta etc* conscriptus est ut premisi per terenciu[m] sed per calliopiu[m] recitatur" (fol. 155r, summary of prologue for *Phormio*).

46. For an analysis of artists' manipulation of fashion in the fourteenth and early fif-teenth centuries, see Waugh, "Style-Consciousness"; and Blanc, *Parades et parures.*

47. Images of the full cycle of Laurent's probable model, the Carolingian manuscript kept in the library of Saint-Denis (BnF Ms. lat. 7899), are available on *Gallica.*

48. I would like to thank Elizabeth Randell Upton for identifying these instruments for me.

49. See Meiss, *French Painting,* 1:50–54.

50. S. O. D. Smith, "Illustrations of Raoul de Praelles' Translation" especially 158–61, and 273–79, where she dated the manuscript around 1408–1410. For analysis of the dated inventories of John of Berry, see Meiss and Off, "The Bookkeeping of Robinet d'Estampes." In 1967 Catherine Scott identified the text as corresponding to that transcribed by Jules Guiffrey: "A book of the *Cité de Dieu,* written in French in round letters; and at the begin-ning of the second folio is written "pluseurs ont usurpé", very richly illustrated at the be-ginning and in many places" [Un livre de la *Cité de Dieu,* escript en françoys de letter roonde; et au commancemant du second feuillet a escript: 'pluseurs ont usurpé,' très riche-ment historiée au commancement et en pluseurs lieux]. See C. Scott, "The French *Cité de Dieu*"; and Guiffrey, *Inventaires,* 1:241–42, no. 927. In her dissertation Smith did not accept Scott's identification of the manuscript in Philadelphia with that in John of Berry's inven-tory because the textual incipit cited in the inventory appears on folio 6r, rather than folio 2r. However, as Sandra Hindman suggested, the text does appear on the second folio of the

text proper, which begins on folio 5r after the preliminary folios containing the prologue and chapter lists. For Hindman's discussion see Tanis, *Leaves of Gold*, 199–202.

This practice of quoting the second text folio to appear after preliminary materials was common in inventories of Charles V and the Burgundian dukes, as for instance in their inventory entries for the *Grandes chroniques*. Indeed, in an exceptional inventory entry for a *Grandes chroniques* in John of Berry's collection, in which Robinet d'Estampes provided an incipit from the second folio of preliminary materials in a manuscript, he specified that he cited the second "folio of the table [of contents] of the said book" [fueillet de la table dudit livre] as opposed to the unspecified—and apparently customary—second folio of text. For this, see Hedeman, *The Royal Image*, 249, 252, and 258. Once it is accepted that the *Cité de Dieu* in Philadelphia is the manuscript mentioned in the inventory, then the *Cité de Dieu* can be dated ca. 1405–1406 because of its position in the Duke of Berry's inventory, which has been so carefully analyzed by Meiss and Off.

51. On the translation of Valerius Maximus, see Schullian, "A Preliminary List"; Charras, "La traduction de Valère-Maxime"; Dubois, "Tradition et transmission"; and Dubois, *Valère Maxime*.

52. Isidore of Seville discussed the theater in book 18, ch. 42, and its properties and performers in chapters 43–51 of the *Etymologies*. See Isidore of Seville, *The Etymologies*, 369–70.

53. "On this marvelous event told by the said poet Pacuvius in the middle of a theater round in the manner of a circle . . . the Roman people being around this theater" [Sur lequel merveilleux cas racompté par ledit poete Pacuvius ou milieu d'un theatre roond en maniere d'un cercle . . . le people rommain estant entour cellui theatre]. For this see Bozzolo, "Laurent de Premierfait et Terence," 126.

54. For commentary about the *scena* from seventh-century writings of Isidore of Seville to writings by Coluccio Salutati in 1381, see Pade, "Hvad er Teater?" 13–16. See as well Marshall, "Theater in the Middle Ages."

55. For Trevet's glosses on the *scena*, see Marshall, "Theater in the Middle Ages," 26–27; and for Laurent's use of Trevet's commentary on Livy, see Tesnière, "Un remaniement." Marshall suggests that Trevet's commentary influenced later representations of the theater, though she does not identify any images by name.

56. See BnF Ms. lat. 7907, fol. 4r: "Et licet scena vere dicatur umbraculum habens cortinam protensam a quo emittuntur persone qui locuntur vocem recitatoris imitantes," cited and translated into French by Bozzolo, *Un traducteur*, 161.

57. See "Alta" and "Instrumentation and Orchestration" in Oxford University Press, *Oxford Music Online*.

58. See "Moresca [morisca]" in Oxford University Press, *Oxford Music Online*. For a discussion of the German figures dancing the Moresca, see Eikelmann and Kürzeder, *Bewegte Zeiten*.

59. Odile Blanc noted this distinction between the contemporary dress of this young man and the Roman setting in BnF Ms. lat. 7907A in passing, and in discussion of the later *Terence des ducs*, she commented on the distinction between the dress of its frontispiece

and the dress worn within the images decorating the plays' scenes. See Blanc, *Parades et parures,* 64–67.

60. For this usage of orientalizing dress, see Kubiski, "Orientalizing Costume," 161–80; and Berenbeim, "Livy in Paris."

61. Isidore of Seville, *The Etymologies,* 369. For a frontispiece to an early printed Terence that shows prostitutes accosting men outside a theater under the label *fornices* (a word for "arch" that came to mean "brothel" because prostitutes gathered in arched spaces outside buildings to solicit clients), see Terentius, *Comoediae* (Lyon: Treschel, 1493), reproduced and discussed in Meiss, *French Painting,* 1:50–54, and 2: pl. 214.

62. Flavius Josephus Master illuminators painted the frontispiece and quires 1–5, and Orosius Master illuminators completed the manuscript. Tennison attributed quire 6 and 10–19 to an Orosius Master illuminator (whom she terms Hand A) and quires 7–9 to a collaborating artist (whom she terms Orosius Master Paris Associate 3). For these attributions, see Tennison, "Tradition, Innovation, and Agency," ch. 2.

63. See Norton, "Laurent de Premierfait," 386; and Boccaccio, *Boccace Decameron,* 1–2.

64. For the text of Terence's plays, I cite the name and line numbers of the plays provided in Terence, *Comoediae,* edited by Kauer and Lindsay. For act 2, scene 4 of *The Woman of Andros,* see *Andria* 404–11.

65. See BnF Ms. lat. 7907A, fol. 144r–144v: "*Revisio quid agant.* When Davus departs out of Simo's sight, Simo begins to think to himself and he says thus: 'I know that Davus will announce all those things to my son. And he will urge him not to marry Philomena. Whom I want him to marry. I'll go therefore and see what they are doing'" [*Revisio quid agant.* Davo recedente a conspectu simonis. Cepit secum Simo cogitare, ac sic dicere; Scio quia davus Omnia ista renunciabit filio meo. Simulque hortabitur illum ne ducat philomenam. Quam ego volo ei dare. Vadam igitur et videbo quid traitent].

66. Both Odile Blanc and Albert Châtelet stress the innovative use of contemporary costumes in the Duke of Berry's Terence, and Châtelet also emphasizes the use of gesture. See Blanc, *Parades et parures,* 64–67; and Châtelet, *L'âge d'or,* 121–23. For an earlier discussion of the role of dress in constructing meaning in France, see Waugh, "Style-Consciousness."

Marcel Thomas was the first to describe a combination of French notes written under the paint layer within miniatures and detailed notes in the margins "that described minutely the position and the attitude that each character should assume." See Thomas, "Une prétendue signature." Meiss clarified that these directions are visible in a single quire on fols. 76r–82r and that a marginal direction for the scene of the Abduction of Callidia, one of the few action scenes, survives on BnF Ms. lat. 7907A, fol. 77v. Meiss, *French Painting,* 1:41–54, 347–50.

67. For the categorization of such hoods as nonaristocratic, see Scott, *Fashion in the Middle Ages,* 53.

68. For discussion of the French inscriptions, including this observation about Demea and Micio, see Meiss, *French Painting,* 1:347–50. In contrast to the French inscriptions for the illuminators, the Latin rubrics in BnF Ms. lat. 7907A categorize both Demea

and Micio as old men. See the rubrics on fol. 75v: *Demea Micio fraters senes*; fol. 82v: *Demea senex*; fol. 83r *Syrus servus demea senex*; fol. 90v *demea senex*; fol. 91r: *Micio demea senes duo*; fol. 92r *Demea senex*.

69. Meiss, *French Painting*, 1:347. For the English translation, see Terence, *Phormio*, 256–57; and for the Latin, *Adelphoe*, 17–20.

70. It is notable that one of the exceptions, the character of the adolescent Chremes in *The Eunuch*, wears clothes like those worn by two old men, equally named Chremes, in both *The Woman of Andros*, the play that precedes *The Eunuch* in this manuscript, and *The Self-Tormentor*, the play that follows *The Eunuch*. The adolescent Chremes is one of the few characters in *The Eunuch* not to be characterized in the Latin captions that survive above, below, or sometimes inside the miniatures in the John of Berry's Terence manuscript beginning on fol. 22r. It appears that the *libraire* who wrote the notes for the artists in French may have occasionally relied on these Latin identifications, because the adolescent Cremes who first appears uncaptioned on fol. 36r is dressed like the Cremes of *The Woman of Andros*, who is consistently identified as a *senex*. In this case, it seems that the artist or *libraire* reinforced the shared name given the old man and the adolescent by an identity in representation.

71. For lawyers' dress in medieval France, see Hargreaves-Mawdsley, *A History of Legal Dress*, 19–39.

72. For their contradictory advice, see *Phormio*, 441–64.

73. For discussion of the later reception of illuminated manuscripts produced under Laurent de Premierfait's and Jean Lebègue's supervision, see ch. 5.

CHAPTER 3

1. See Villela-Petit, "La peinture médiévale," especially chapter 3, 340–52. I would like to thank Inès Villela-Petit for sharing this unpublished chapter of her dissertation with me. See, as well, Villela-Petit, "Copies, Reworkings and Renewals," in Nadolny, *Medieval Painting in Northern Europe*, 167–81; and Villela-Petit, "Palettes comparées."

2. For an overview of the circulation of Sallust in the Middle Ages and Renaissance, see L. D. Reynolds, *Texts and Transmission*, xxvi–xxviii, 341–52; and for the period up to the twelfth century, Olsen, *L'étude des auteurs classiques latins*, 2:307–63. For an orientation to the commentary tradition on Sallust and his reception, see Osmond and Ulery, "Sallustius Crispus, Gaius," and Osmond and Ulery, "Sallustius Crispus, Gaius. Addenda et Corrigenda." For Sallust's popularity in the schools, see Smalley, "Sallust in the Middle Ages."

3. See Guenée, "La culture historique des nobles," in Contamine, *La noblesse au Moyen Âge*, 261–88.

4. For the translation of Livy, see Tesnière, "Un remaniement du *Tite-Live*"; Tesnière, "Les Décades de Tite-Live," in Hoffmann and Zöhl, *Quand la peinture*, 345–52; Tesnière, "Un manuscrit exceptionnel des Decades," in Galderisi and Pignatelli, *La traduction*, 149–64; and for the translation of Valerius Maximus, see Charras, "La traduction du Valère-Maxime."

5. Christine de Pizan, *Livre des fais*, 1:47–48, cited by Coleman, "Reading the Evidence," in Morrison and Hedeman, *Imagining the Past*, 54.

6. Lalande, *Le"Livre des fais*," 416, 433, cited by Coleman, "Reading the Evidence," in Morrison and Hedeman, *Imagining the Past*, 54.

7. For a modern edition of Sallust, see Sallust, *Works*.

8. None of the surviving inventories of early fifteenth-century royal and princely collections include Latin manuscripts of Sallust. See Boislisle, "Inventaire," 306–9; Delisle, *Recherches*; Douët-d'Arcq, *Inventaire*; Guiffrey, *Inventaires*; Barrois, *Bibliothèque prototypographique*; Doutrepont, *Inventaire de la "librairie"*; de Winter, *La bibliothèque de Philippe le Hardi*; and Falmagne and Van den Abeele, *Dukes of Burgundy*.

9. For this uninventoried manuscript, see Bauermeister and Lafitte, *Des livres et des rois*, 40–41.

10. The inventory of 1423 contains an entry stating that on October 2, 1420, Jean Lebègue recovered several books for the royal library with the help of two *libraires* and a *sergent à verge*. One of these included a French translation of the *Conspiracy of Catiline*: "La Conversion Katheline [*Conspiracy of Catiline*] & aucuns des conseils Julius César, & continent *croniques* au commencement." For this see Douët-d'Arcq, *Inventaire*, 209. The first Latin Sallust manuscript to appear in a royal or princely inventory was in the inventory after the death of Duke Philip the Good in 1467. See Falmagne and Van den Abeele, *Dukes of Burgundy*, 352.

11. Gerson's *Tractatus* [*de considerationibus quas debet habere principes*] was edited by Antoine Thomas in 1930. Thomas speculated that Gerson addressed the *Tractatus* around 1410 to Jean d'Arsonval, tutor to Dauphin Louis of Guyenne, who died in 1415. In the early 1950s Max Liberman proposed a different scenario in which the *Tractatus* was made for the future Charles VII around 1417. Palémon Glorieux accepted this date in his edition of 1960.

Jacques Verger summarizes the problem with dating that Thomas, Liberman, and Glorieux put forth in their publications: Gerson, *Jean de Gerson et l'éducation*; Liberman, "Chronologie gersonienne, II" and "Chronologie gersonienne, III"; and Gerson, *L' Œuvre épistolaire*, 203–15, 335–38. Verger questions their dating of Gerson's *Tractatus*, pointing out that each scholar dated the text on the basis of erroneous readings of the manuscripts—as Verger put it, making "wishful errors." Given the faulty state of the texts in surviving manuscripts of the *Tractatus*, Verger suggests that it is futile to try to date them precisely. He then offers a persuasive analysis of the specialized nature of the educational program outlined by Gerson, which ignored the traditional curriculum of the schools and princely education in chivalry or government to concentrate on the formation of kingly wisdom. See Verger, "*Ad prefulgidum sapiencie*," in Boutet and Verger, *Penser le pouvoir au Moyen Age*, 427–40, especially 433–39.

12. Although Gerson wrote that he recommended texts in French, many listed survive only in Latin: "item collecorium quorumdam opuscolorum in gallica nuper editorum: de preceptis Dei; die examination consciencie; de scientia bien moriendi; de contemplatcione; de mendicitate anime; sermo de passion Christi qui incipit *Ad deum vadit*; sermo de mortuis incipiens *Sancta ergo et salubris est cogitacio*; idem exhortacio de triplici vita Regis:

Vivat rex, de scola mistica, sub metro; collacio exhortatoria ad pacem: Fiat pax; collacio exhortatoria ad justiciam et concordiam juridictionum ecclesiatice et temporalis, et quedam alia." See Gerson, *Jean de Gerson et l'éducation,* 50.

13. The *Economics* was believed in the Middle Ages to be Aristotle's work, but is no longer accepted as his. For an analysis of the illuminated copies of Aristotle's work in the royal library, see Sherman, *Imaging Aristotle.*

14. Cato, Theodolus, and Aesop are usually grouped with others as a central school text. See Clogan, "Literary Genres."

15. "pro aliquali cognicione phisica hujus mundi." Gerson, *Jean de Gerson et l'éducation,* 51.

16. For an analysis of illuminated copies of the *Grandes chroniques de France* and the *Cité de Dieu,* see Hedeman, *Royal Image;* and S. O. D. Smith, "Illustrations of Raoul de Praelles' Translation."

17. Verger, "*Ad prefulgidum sapiencie,*" in Boutet and Verger, *Penser le pouvoir au Moyen Age,* 433–39.

18. On the phenomenon of "twinned" aristocratic manuscripts as reflections of both shared taste and competing collectors, see Alexander, *Medieval Illuminators,* 138; Buettner, *Boccaccio's* Des cleres et nobles femmes, 23; and Hedeman, "Making the Past Present: Visual Translation," in Croenen and Ainsworth, *Patrons, Authors and Workshops,* 173–96.

19. Byrne, "An Early French Humanist and Sallust."

20. This manuscript lacks the traditional rubric to the *Faits des Romains* that credits its ancient sources: "Here begins the *Fais des Romains* compiled from Sallust, Suetonius, and Lucan" [Cy commencent les *Fais des Rommains* compilez ensemble de Saluste, de Suetoine et de Lucan]. For the text of the *Fais des Romains,* see McCormick, *A Partial Edition.*

21. BnF Ms. fr. 23083, fol. 206r, contains both the ex libris of Jean Lebègue and the slightly later ex libris of Charles of Anjou.

22. For discussion of these manuscripts, see Ouy, "Humanisme et propaganda politique"; Byrne, "An Early French Humanist and Sallust"; and Hedeman, "Making the Past Present: Visual Translation," in Croenen and Ainsworth, *Patrons, Authors and Workshops,* 173–96. The distinction between the ex libris legible with ultraviolet light on fols. Av and 42r and the observation that a note on fol. 41r shows that the book was in the library at Blois until 1501 (Charles of Orléans moved his father's library to Blois) was published in Bauermeister and Laffitte, *Des livres et des rois,* 40. See Véronique de Becdelièvre's entry on BnF Ms. lat. 9684 in *Archives et manuscrits* for a summary of findings and transcriptions of the effaced notes: fol. Av "Constat domino meo comiti de Angolesme"; fol. 42r "[Karolo duci Aurelianensi spectat] codex iste." Charles identified himself as Count of Angoulême until his father died. After his father's death, Charles signed as Duke of Orléans. Gilbert Ouy found neither BnF Ms. lat. Ms. 9684 nor BnF Ms. lat. 5747 in the inventories of Charles of Orléans or John of Angoulême. See Ouy, *La librarie des frères captives,* 31–32, 90, 94, and 95–96.

23. Ouy identified the hand of the scribe Monfaut, who signed a manuscript of Cicero (Bern Burgerbibliothek Cod. 254) that was left to Notre Dame Cathedral by Jean

Courtecuisse, in the following manuscripts: Lebègue's early Sallust (BnF Ms. lat. 5762, fols. 1r–36r); the Sallust of the Orléans family, ca. 1404–1407 (BnF Ms. lat. 9684); a copy of Valerius Maximus ca. 1400 (BnF Ms. lat. 6147) also given by Courtecuisse to Notre Dame, Paris; and a collection of treatises by Nicolas de Clamanges (BnF Ms. lat. 16403) that had belonged to Jean d'Arsonval, the tutor of Charles VI's son Louis of Guyenne. Almost all of these are classical texts, and all belonged to members of Lebègue's circle of contact. See Ouy, Dossier Lebègue, consulted June 24, 2013; Ouy, "Jean Lebègue (1368–1457)," in Croenen and Ainsworth, *Patrons, Authors and Workshops*, 164–65, 168–69; and Von Steiger, "Aus der Geschichte der Bongars-Handschriften," 89 and pl. 2.

24. Ouy, Dossier Lebègue, consulted June 24, 2013.

25. See Bodl. D'Orville 141, fol. 42v. This transcription and subsequent ones are based on Lebègue, *Les histoires que l'on peut raisonnablement*, and corrected after Bodl. D'Orville 141. Unless otherwise indicated, the translations into English are my own.

26. For the use of the term *escripvain* as meaning either a scribe or a writer, see Delsaux, "Qu'est-ce qu'un escripvain."

27. Byrne, "An Early French Humanist and Sallust," 18–19.

28. Ouy, "Humanisme et propaganda politique."

29. Véronique de Becdelièvre identifies Garbet's hand in the transcribed poem by Charles of Orléans. See the entry for this manuscript in BnF, *Archives et manuscrits*.

30. In citing Sallust by book and line number, I follow the practice of classicists in modern editions of the Latin text. The medieval manuscripts analyzed here were subdivided differently so as to create "chapters," as I will describe later in this chapter.

31. For the relationship of images and history, see Morrison and Hedeman, *Imagining the Past*.

32. For a transcription of the accessus and a categorization of the commentary in Bodl. D'Orville 141 as close to the Anonymus Ratisbonensis A and B, see Osmond and Ulery, "Sallustius Crispus, Gaius. Addenda et Corrigenda," 380–83, 386–88.

33. Aside from the publication of its magnificent map of Rome, the illustrations of the manuscript of Sallust in the private collection were first analyzed by Millard Meiss and Donal Byrne, who were not able to study the manuscript in person. Meiss thanks Irving Lavin for consulting the manuscript for him, and Byrne reproduces and discusses one image published by Meiss. See Meiss, *French Painting*, 1:210–14, 219, 224, 399, 467n543, 468nn556–59; 2: figs. 4, 734, 737, and 781; and Byrne, "An Early French Humanist and Sallust," 65. The scholarly research group of which I am a member hopes to publish our findings.

34. See Briquet Online, *Les filigranes*, no. 1834, available by searching "Armoires/ Fleur de Lis/ Trois Fleurs de Lis accompagnee de besants ou de trèfles"; Byrne, "An Early French Humanist and Sallust," 52 and 64n135; and Van Buren, *Illuminating Fashion*, 18–19, 23, and 35nn119–21. I would like to thank Anne van Buren for giving me her notes on this matter, including an unpublished letter (September 8, 1986) from Albina de la Mare that discusses the scribal hand and identifies the papers' watermark, and a beta radiograph of fols. 4r–5r that shows the watermark. She also shared a handwritten note by Gilbert

Ouy, a specialist on Lebègue's paleography, that suggested the manuscript dated ca. 1460 and described the script as a "vilaine petite écriture."

35. This error in the transcription of Bodl. D'Orville 141 occurs on fol. 43v. In addition, line skips are corrected on fols. 44r, 49r, 49v, and 54v.

36. For an edition of the directions, see Lebègue, *Les histoires que l'on peut raisonnablement.*

37. Byrne had already noted that the directions for the frontispiece were descriptive of a composition used earlier for Lebègue's manuscript ca. 1404–1407. See Byrne, "An Early French Humanist and Sallust," 50–53.

38. Van Buren divided the images in Geneva Ms. lat. 54 into three groups on the basis of style and costume. Given the multitude of hands that collaborated in her first two groups, and the presence of artists related to the Orosius Master in both of them, I am most comfortable considering the illustrations on folios 1r–38r as one group with a date ca. 1410–15, and the illuminations on folios 39v and following done in a style related to that of the Master of Dunois as a second group of illuminations (these were van Buren's "third" group) that includes images incorporating dress that "did not exist before the late 1430s." See van Buren, *Illuminating Fashion,* 35n120. Villela-Petit believes that the Orosius Master was responsible for the painted initials throughout the manuscript, and for the frontispiece and the large miniature of the Roman Senate on folios 1r and 20r. She suspects that his collaborators may have belonged to his workshop, drawing as they did on models used in the miniatures from Terence's *Comedies* (BnF Ms. lat. 7907A) made circa 1408. I thank Inès Villela-Petit for sharing her unpublished work with me.

39. For evidence of the use of guide letters to indicate placement of miniatures, see Hedeman, *Translating the Past,* 178–81 and 251. For *libraire*-owned lists of directions, see Hedeman, *Royal Image,* 145–52; Rouse and Rouse, *Manuscripts and Their Makers,* 248–51; and Hedeman, *Translating the Past,* 136–45. For evidence that Christine de Pizan, Jean Gerson, and Laurent de Premierfait devised visual cycles that serve as glosses or commentaries on texts, and supervised the production of manuscripts containing them, see Villela-Petit, "Introduction sur les peintres enlumineurs," in Ouy, Reno, and Villela-Petit, *Album Christine de Pizan,* 91–170; Villela-Petit, *L'atelier de Christine de Pizan;* Hedeman, "Making the Past Present in Laurent de Premierfait's Translation,"; and Hedeman, *Translating the Past,* each with further bibliography.

40. See Meiss, *French Painting,* 1:209–14, 219, 224, 399, 467n543, 468nn556–59. He dates the manuscript in the private collection circa 1418 on the basis of its "attenuated, linearized figures" and its incomplete state. Because he did not see the manuscript in person, he did not notice that, although the execution of the illuminations was not finished until later, their underdrawings were completed by the Orosius Master throughout both the *Conspiracy of Catiline* and the *Jugurthine War.* I thank Inès Villela-Petit and Patrick Gautier-Dalché for discussing the illuminations with me.

41. The Orosius Master often collaborated and shared compositions with the Bedford Master. See Villela-Petit, *Le bréviaire de Châteauroux,* 51; Delahaye, *Paris 1400,* 204–5; and Tennison, "Tradition, Innovation, and Agency," ch. 2.

42. Bodl. D'Orville 141, fol. 51v.

43. See Bodl. D'Orville 141, fols. 53r–53v.

44. "Quae postquam oppidani cognovere, res trepidae, metus ignens, malum improvisum, ad hoc pars civium extra moenia in hostium potestate coegere uti deditionem facerent." See Sallust, *Works*, 332–33.

45. Byrne, "An Early French Humanist and Sallust"; and Buettner, *Boccaccio's* Des cleres et nobles femmes.

46. This excerpts the full direction on Bodl. D'Orville 141, fol. 43r:

La d ij^e histoire puet estre assise environ demi cayer après le prologue du livre ou chapitre ou paraf illec: *itaque in tanta* au dessus de ces motz *Nam quicumque impudicus.* Et sera pourtrait Catilina en guise d'un compaignon gaillart vestu d'ung coint pourpoint ung chapel à une plume en sa teste, l'espée au costé à une sainture de Behaigne sur le cul et autour de lui seront plusieurs compaignons mal profitans vestus de divers habiz chascun son espée ou aultre baton au costé qui tous auront leurs regart à Catiline, qui fera samblant de parler à eulx.

47. For a discussion that mentions books that mix full-color illustration with more muted illuminations, see Villela-Petit, "Historié de blanc et de noir," in Boudon-Machuel, Brock, and Charron, *Aux limites de la couleur,* 25–34.

48. Bodl. D'Orville 141, fols. 43r–43v.

49. Sallust, *Works*, 44–45: Sed ei cariora semper Omnia quam decus atque pudicita fuit; pecuniae an famae minus parceret, aud facile discerneres; Iubio sic accensa, ut saepius petered viros quam perteretur. Sed ea saepe antehac fidem prodiderat, creditum abiuraverat, caedis conscia fuerat, luxuria atque inopia praeceps abierat.

50. Bodl. D'Orville, fol. 43v.

51. See, for instance, Buettner, *Boccaccio's* Des cleres et nobles femmes; Blanc, *Parades et parures*; and Waugh, "Style-Consciousness."

52. See Bodl. D'Orville 141, fol. 43v. Where I have placed // in this text, there is an insertion mark on fol. 43v referring to a marginal note with a text to insert "a ung baston de pelles pardessus."

53. In Bodl. D'Orville 141 the spaces of the Senate that were painted in these five single-column miniatures in Geneva Ms. lat. 54 are described as follows: fol. 43v (for image painted on Geneva Ms. lat. 54, fol. 10r), "soit fait une manière de conseil de ses assiz sur bancs ou milieu desquelx sera Ciceron comme plus hault assiz et les aultres a dextra et senestre"; fol. 44r (for image painted on Geneva Ms. lat. 54, fol. 10v), "soyt fayt le conseil Cicero ou Senat assiz plus hault que les aultres qui seront plus bas assiz à dextre et à senestre touz en habit de gens de conseil" and (for image painted on Geneva Ms. lat. 54, fol. 12r) "soit fait ung consel ou quel sera le conseil Cicero en son mantel et chapel cum dessus assiz au plus hault et à dextre et senestre de chacun costel seront trois conseillers"; fol. 44v (for image painted on Geneva Ms. lat. 54, fol. 16r), "soit fait le consul Cicero en chaière comme dessus vestu d'un mantel et chapel fourré et à grant barbe et emprès lui seront assiz autres gens de conseil" and (for image painted on Geneva Ms. lat. 54, fol. 17v) "Soit encores fait

ledit consul Cicero assiz en chaière et pluseurs senateurs envers lui assiz en divers ordres et autres tout bas assiz qui tourneroient leurs visages devers les aultres."

54. Bodl. D'Orville 141, fol. 45r. For discussion of this miniature, see Byrne, "An Early French Humanist and Sallust"; for the physical proximity of the Chambre des comptes to the great hall, see Tesnière, *L'histoire romaine de Tite-Live,* 47–48.

55. Bodl. D'Orville 141, fol. 45r.

56. For fifteenth-century practice, see Gauvard, *"De grace especial"*; Gauvard, "Pendre et dépendre"; and Gauvard, "Les humanistes et la justice," in Ornato and Pons, *Pratiques de la culture écrite,* 217–44.

57. Compare, for instance, the treatment of landscape, dress, and figural types in the Dunois Master's eponymous manuscript, the *Dunois Hours* (BL, Yates Thompson Ms. 3) fully digitized at British Library, Digitised Manuscripts.

58. Byrne was the first to publish and analyze this colophon. See Byrne, "An Early French Humanist and Sallust," 46 and n44.

59. The images for chapter 16 include: fol. 46v, Metellus arrives in Africa and takes over the decimated Roman army [Iug. 44.1]; fol. 47r, Jugurtha's envoys come before the Consul Metullus [Iug. 46.2]; fol. 48r, Romans approach Numidian ambush in hills above the Muthul river [Iug. 48.3]; fol. 49r, Jugurtha's men attack the Romans [Iug. 50.4]; fol. 50v, Romans rout Jugurtha and the Numidians [Iug. 53.4]; fol. 51r, Metellus and his men burn and pillage fertile lands in Numidia [Iug. 54.6]; fol. 52r, Metullus's siege of Zama is interrupted by Jugurtha's attack on the Romans [Iug. 57.2]; fol. 53v, Metellus meets secretly with Bomilcar and persuades him to betray Jugurtha and Bomilcar goes to Jugurtha [Iug. 61.1]; fol. 56r, Roman prefect of Vaga, Titus Turpilius Silanus, flees from ambush in which Romans were slain while feasting and he is pelted from the roof with stones [Iug. 67.1]; fol. 57r, Romans recapture Vaga and take vengeance [Iug. 69.2]; fol. 57v, Nabdalsa's secretary takes a letter revealing a conspiracy to Jugurtha and Jugurtha puts to death Bomilcar and others [Iug. 71.5]; fol. 59r, Romans besiege Thala, where the greater part of Jugurtha's treasure was kept in an image that conflates two moments from text: the rain that came at the place where Metellus and his forces were to meet Numidians bringing water, and siege of Thala the next day with Jugurtha's flight [Iug. 75.9]; fol. 59v, Romans take the city of Vaga, and the residents, fearing the Romans, set fire to the palace [Iug. 76.6]; fol. 60v, The conflict between Carthage and Cyrene is resolved by the act of the Philaeni brothers, who were buried alive to establish the boundary between the two cities and were commemorated by altars [Iug. 79.1]; fol. 61r, The Moorish King Boccus becomes an ally of King Jugurtha, and they approach Cirta as Metellus and his men wait nearby [Iug. 80.3]; and fol. 62v, Marius, appointed consul to Numidia, speaks before the Senate [Iug. 85.1].

60. Chapter 18 shows the change of consul on fol. 62v: Marius, appointed consul to Numidia, speaks before the Senate [Iug. 85.1]. Images for chapter 19 feature his campaigns in Numidia: fol. 65v, After landing at Utica, Roman troops plunder and capture towns; in the background Romans besiege Thala [Iug. 86.4 and Iug. 89.6]; fol. 67v, Surrender of Capsa to Marius and his forces [Iug. 91.6]; fol. 68v, Marius attacks fortress on craggy hill near the Muluccha river [Iug. 93.4]; fol. 69v, Trumpets sound and the Romans attack [Iug.

94.6]. Chapter 20 focuses on the impact of King Bocchus joining Jugurtha: fol. 70r, King Bocchus joins Jugurtha and they surprise the Romans [Iug. 97.1]; fol. 71v, Kings Bocchus and Jugurtha's forces put to flight by Marius and his army [Iug. 99.2]; fol. 72v, Forces of Marius and Sulla rout those of Bocchus and Jugurtha [Iug. 101.11]. Chapter 22's images celebrate the final triumph: fol. 73v, King Bocchus speaks with Roman embassy led by Lucius Scilla and Aulus Manlius [Iug. 102.12]; fol. 74v, Envoys of King Bocchus appear before the Senate in Rome [Iug. 104.5]; fol. 76r, King Bocchus's negotiations in private with Sulla [Iug. 110.1]; fol. 77v, After Bocchus lures Jugurtha and his forces into the open, Sulla and the Romans fall upon them [Iug. 113.6]; fol. 78r, Marius's triumph as Jugurtha is brought prisoner to Rome [Placed at the end of Iug. text].

61. See Bodl. D'Orville 141, fols. 47v–48r.

62. See Bodl. D'Orville 141, fol. 48v.

63. "Représentant du Pape, ambassadeur du Saint-Siège," in ATILF CNRS – Nancy Université, *DMF,* consulted September 23, 2016.

64. See Bodl. D'Orville 141, fol. 53v.

65. See the entry for *vigne* in ATILF CNRS – Nancy Université, *DMF.*

66. See Bodl. D'Orville 141, fol. 45v, for the full descriptive notice of the first appearance of Roman troops: *Interea Catilina* sera faite une grande bataille à pié d'entre ceulx de Romme qui auront pour bannière un aigle de sable et le champ d'or et les gens de Catalina qui auront ung pennon ou estandart et illec sera fait Catilina armé comme dessus qui se combatra fort et ses compaignons aussi et y aura foison gens mors et sang respendu.

67. These additions were made on folios 46v, 51r, 52r, 57r, 59r, 61r, 65v, 67v, and 77v.

68. See Bodl. D'Orville 141, fol. 47v.

69. See Bodl. D'Orville 141, fol. 52r.

70. See Bodl. D'Orville 141, fol. 52v.

71. Compare the images in Geneva Ms. lat. folios 70r, 71v, 72r, 73v, 76r, and 77v with the directions in Bodl. D'Orville 141, fols. 54r–54v and 55r.

72. See the images on Geneva Ms. lat. 54, folios 72v, 73v, and 74v and the directions on Bodl. D'Orville 141, fols. 54v–55r, which call for "the king of the Moors Bocchus and his sons all black" [le roy des Mores Boccus et son filz tous noirs] for the image on fol. 72v; a practice continued on fol. 73v, where the Africans in the tent receiving Roman envoys with Bocchus are black despite the less precise direction, "The king of the Moors Bocchus all black in his tents" [le roy de Mores Boccus tout noir en ses tantes]; and fol. 74v, where envoys of King Bocchus appear before the Roman Senate, "and before them will be the messengers of King Bocchus, all black" [et devant eulx seront les messages du roy Boccus tous noirs].

73. Sallust, *Works,* 378–80.

74. See Bodl. D'Orville 141, fol. 55r. In my translation, I leave the word *char* in French because its use impacted the artists. While Lebègue may well have understood that Romans made their triumphal entries in two-wheeled chariots in antiquity, the French word *char* signified a four-wheeled cart in the fifteenth century. See the entry for *char* in ATILF CNRS – Nancy Université, *DMF.*

75. See Bodl. Ms. D'Orville 141, fol. 55r.

76. "Qui cupit ignotum Iugurte noscere letum/Torpeis rupibus plusus ad ima ruit." On this see Smalley, "Sallust in the Middle Ages," 172.

77. See BnF Ms. fr. 23083, fol. 20v: Note cy que ce translater parlant de France deust. . . . Car au temps de Julius Cesar nestoit encores le pays appellee france. Et ne vindrent les francois ou pays de gaulle plus de v^c ans après Julius Cesar.

78. On the Dunois Master, see Avril and Reynaud, *Les manuscrits à peintures*, 36–38; and Clark, *Art in a Time of War*, 270–78.

79. Gilbert Ouy consulted with me in June 2000 and suggested that it was quite possible that Lebègue himself wrote the pictures' captions. The captions were written before the underdrawings were drawn; details of the paintings, such as feet, frequently overlap captions.

80. Byrne, "An Early French Humanist and Sallust," 45.

81. BnF Ms. lat. 5762, fol. 37r: "Intentio sua est deortari homines ut non ad dignitatem per prodicionem contendant ne ad malum finem inde perveniant sicuti Iugurta qui per prodicionem sibi regnum acquisivit et inde ad malum devenit." I quote from Byrne, who did not realize that the accessus on fols. 37r–38r was part of the addition made to the manuscript in the 1430s. See Byrne, "An Early French Humanist and Sallust," 45 and n38. For a full transcription of this text, and an indication that it is fuller than the accessus given in the commentary on Sallust that Lebègue had copied in Bodl. D'Orville 141, see Osmond and Ulery, " Sallustius Crispus, Gaius. Addenda et Corrigenda," 387–88.

82. Du Fresne de Beaucourt, *Histoire de Charles VII*, 2:547–49.

83. See Bozzolo, "L'intérêt pour l'histoire romaine," 109–29; and Bozzolo, "Familles éclatées, amis dispersés," 1:115–28.

84. Cited by Du Fresne de Beaucourt, *Histoire de Charles VII*, 2:542.

85. Quoted from Sallust, *Opera*, 200–201. For a discussion of Lebègue's *trefles*, see Pons, "Erudition et politique," 28.

CHAPTER 4

1. Laurent de Premierfait, *Des cas*, 89.

2. Laurent de Premierfait, *Livre de vieillesse*, 46–47.

3. Laurent de Premierfait, *Des cas*, 89–90.

4. Boccaccio, *Boccace Decameron*, 5. In the translator's prologue to Laurent's translation of Cicero's *De amicitia*, Laurent also describes the difficulty of linguistic translation: "And because certain who see this book put into the French language will say, as I think, that the majesty and the gravity of words and sentences are much humiliated and diminished by my vernacular language, which by the necessity of words is small and light, and for this reason I should not have undertaken or brought to conclusion this translation" [Et pour ce que aucuns qui cest livre verront mis en langaige de France, diront, come je pense, que la majesté et la gravité des paroles et sentences sont moult humiliees et amendries par mon langaige vulgair, qui, par neccessité de mots, est petit et legier, et pour ce je ne deusse avoir entreprins ne mis a fin ceste translacion]. See Laurent de Premierfait, *Livre de*

la vraye amistié, 286. I would like to thank the anonymous reader who brought this to my attention.

5. There was one earlier translation of the *De inventione* made at Acre in 1282. On translations of Cicero, see Laurent de Premierfait, *Livre de la vraie amistié*, 115–16.

6. For prior studies of this text, see Marzano, "Le *Pro Marcello*"; Laurent de Premierfait, *Livre de vieillesse*; and for discussion of the illustration, see Hedeman, "Making the Past Present in Laurent de Premierfait's Translation"; and Hedeman, *Translating the Past*, 24–34. On Louis of Bourbon's reputation for embodying chivalric and courtly virtues, and for what we know about his reading practices, see Mattéoni, "L'image du duc Louis de Bourbon," in Autrand, Gauvard, and Moeglin, *Saint-Denis et la royauté*, 145–56; and Coleman, "Reading the Evidence," in Morrison and Hedeman, *Imagining the Past*, 53–67. For an edition, see Cicero, *On Old Age*.

7. Delsaux, "Textual and Material Investigation." Hand S also wrote out all but thirty pages of John the Fearless, Duke of Burgundy's copy of Laurent's translation into French, *Des cas des nobles hommes et femmes*. The first quire, discussed below, was added just before the manuscript was bound.

8. François Avril attributes this manuscript to an artist from the Bedford Trend. He argues for a reexamination of the vast number of manuscripts classed as products of this artistic group, and attributes the first image in Statius's *Thebaid* and *Achilleid* (BL Burney 257, fol. 4r) to the same artist. See Bousmanne, Van Hemelryck, and Van Hoorebeeck, *La librarie*, 100.

9. Laurent de Premierfait, *Livre de vieillesse*.

10. See Cicero, *On Old Age*, 20.75.

11. See Laurent de Premierfait, *Livre de vieillesse*, 147.

12. This translation of an excerpt of Jean Cabaret d'Orville's *La cronique du bon duc Loys de Bourbon* is by Coleman. See Coleman, "Reading the Evidence," in Morrison and Hedeman, *Imagining the Past*, 53. On the Duke of Bourbon, see Mattéoni, "L'image du duc Louis II de Bourbon," in Autrand, Gauvard, and Moeglin, *Saint-Denis et la royauté*, 145–56.

13. It is unfortunate that a bilingual illuminated manuscript of Laurent's translation of Cicero's *De amicitia* does not survive (if it ever existed) because that translation also may have played with the mirroring of authors, translators, and voices. Laurent de Premierfait, *Livre de la vraie amistié*.

14. The change happens on fols. 38r–38v. One sentence uses the first-person singular, "Certainly after I [je] had considered writing this book which is moral philosophy" [Aprés certes que je eu consideré escrire ce livre, qui est de philosophie morale], and two sentences later (1.3) sentences shift to the first-person plural: "And as to the other things belonging to Philosophie, we have said enough about it, and will speak about it often in other books; and for this we have sent you this present book in which we speak of old age. But in order that our book have greater authority, we attribute and address all our words to Old Cato. . . . We make our book in such a way that these two noble youths, Lailus and Scipion, are astonished and question between themselves how Cato bears and endures his

old age so lightly, and after we make the old Cato respond with reasons and examples." [Et quant est des aultres choses appartenens a Philosophie, nous en avons assez dit, et si en dirons souvant en aultres livres; et pour ce nous te avons envoié ce present livre ou quel nous parlons de vieillesse. Mais a fin que nostre livre eust plus grant autorité, nous attribuons et adreçons toute nostre parole au vieil Caton. . . . nous faisons nostre livre si faitement que ces deux nobles jouvenceaux, Leilus et Scipion, font entre eulx esmerveillance et question comment Caton porte et endure si legierement son eage de vieillesse, et aprés nous fasions que le vieil Caton respond par raisons et par exemples.] Laurent de Premierfait, *Livre de vieillesse*, 51. There is no comparable voice shift in the Latin. See Cicero, *De senectute*, 1.3.

15. See the discussion of frontispieces to Sallust in ch. 3.

16. BnF Ms. lat. 7789, fol. 35v, quoted in Laurent de Premierfait, *Livre de vieillesse*, 46.

17. These fall at the following divisions: 2.1, 5.15, 9.27, 12.39, and 19.66.

18. For the amplified texts, see BnF Ms. lat. 7789, fols. 56v and 60r–60v and compare them to Cicero, *De senectute*, 9.27 and 10.33.

19. For this passage, see Cicero, *De senectute*, 41–43, and Laurent de Premierfait, *Livre de vieillesse*, 91.

20. For this see Cicero, *De senectute*, 12.42, and Laurent de Premierfait, *Livre de vieillesse*, 103.

21. See Châtelet, "Un traité de bonnes meurs." See as well Delahaye, *Paris 1400*, 244, cat. 147.

22. See BnF Ms. fr. 1023, fol. 74r.

23. Charles V promulgated three ordinances in 1374 that established conditions for the majority, the regency conditions, and the tutelage of his heirs. See Secousse, *Contenant les ordonnances*, 26–32, 45–54; and Cazelles, *Société politique*, 579–81.

24. For the following, see Famiglietti, *Royal Intrigue*, 53–54.

25. Louis of Bourbon's reputation as an educational advisor may also explain his growing association with Cicero, for soon after completing the *Livre de vieillesse*, Laurent may have begun his translation of Cicero's *De amicitia*. Until recently, and on the basis of prologues and explicits, this translation was thought to have been begun for Louis of Bourbon, put aside when Louis died in 1410, and completed later for John of Berry after Laurent completed the translation of the *Decameron*, circa 1414–1416. The *Livre de la vraye amistié* survives in fifteen later manuscript copies which have two distinct first prologues and explicits. One prologue dedicates the work to John of Berry with an explicit saying it was completed in the house of Bureau de Dammartin, and a second dedicates it to Louis of Bourbon. Delsaux questioned in his analysis of the text whether it was begun for Louis of Bourbon, and he concluded that it was probably made for John of Berry. He suggests that the references to Louis of Bourbon that were introduced in the translator's prologue may have been planned to associate it with *Le livre de vieillesse* in the thirteen surviving anthologies where they appear together. For discussion of the chronology of Laurent's execution of the text and for the presentation of multiple hypotheses concerning the possibility

of Louis of Bourbon or John of Berry as its first audience, see Laurent de Premierfait, *Livre de la vraye amistié*, 15–29.

26. For the historical circumstances that provoked the *Oratio pro Marcello*, see Cicero, *Cicero Orations*, 417–21, and for the text, 422–51.

27. Marzano, "Le *Pro Marcello*," 81–83.

28. On the translation and illustration of Livy, see Tesnière, "Un remaniement du *Tite-Live*"; and for further discussion of its illustration, Hedeman, *Translating the Past*, 34–53.

29. For a fuller discussion of Jean Petit's defense, and its relationship to Boccaccio, see Hedeman, *Translating the Past*, 102–3.

30. On known books in Col's library and the suggestion that BnF Ms. fr. 131 was his manuscript, see Bozzolo, "L'humanist Gontier Col et Boccace." For Tesnière's proposal (following Delisle) that Estienne Gaultier, a *libraire* who offered a manuscript of the *Cité de Dieu* (BnF Mss. fr. 23–24) to the city of Rouen, owned this manuscript, see Branca, *Opera d'arte d'origine francese*, 86–87.

31. A reference to the schism in Laurent's first prologue allowed Bozzolo to date its writing to 1410, in contrast to the colophon of *Des cas*, which situates the completion of Laurent's translation in 1409. Bozzolo, "La conception de pouvoir," in Bozzolo and Ornato, *Préludes à la Renaissance*, 201.

32. See Hedeman, *Translating the Past*, for discussion of these manuscripts and further bibliography. Also see Laurent de Premierfait, "Édition critique du *Des cas*"; and for Laurent's process of translation and revision see Marzano, "La traduction du *De casibus*," in Galderisi and Pignatelli, *La traduction vers le moyen français*, 283–96; Marzano, " Traductions de Laurent de Premierfait"; Marzano, "Itineraire français de Boccace"; Delsaux, "La ou les traduction(s) (I)"; and Delsaux, "La ou les traduction(s) (II)." The articles by Delsaux prepare the ground for the edition he is preparing that will examine the construction and revision of *Des cas* over the *longue durée* from ca. 1400 to 1410.

33. For an edition of the prologue, see Laurent de Premierfait, *Des cas*, 75–93.

34. See F. A. Smith, "Laurent de Premierfait's French Version of *De casibus*."

35. For prior discussion of these visual cycles, see Hedeman, *Translating the Past*; and Hedeman, "Translating Power."

36. Compare the expanded passage about Dante in Geneva Ms. fr. 190/2, fols. 180r–81r, and Arsenal Ms-5193 rés., fols. 394v–95r, with the slightly different version in a later manuscript, BnF Ms. fr. 226, fol. 268r–68v.

37. For further discussion of these and other marginal annotations, see the analysis of BnF Ms. fr. 131, Bodl. 265, and BL Royal 18 D. VII in ch. 5.

38. See Ouy, "Manuscrits autographes," in Delsaux and Van Hemelryck, *Les manuscrits autographes*, 169 and 185.

39. For discussion of the sequence of manuscripts—the author's draft (*manuscrit de composition*), the models made for *libraires* to use in producing copies (*manuscrits d'éditions*), and the final copies made for a patron (*manuscrits de publication*)—that lies behind production of several authors' works in the early fifteenth century, see Delsaux, *Manuscrits*

et pratiques autographes. For slightly different terminology focused on authorial production, see Delsaux and Van Hemelryck, *Les manuscrits autographes*, especially 7. There they define manuscripts in which the author drafted the text (*manuscrit de travail*), in which the author established a model for the copy (*exemplar*), and those destined to be circulated (*manuscrit de diffusion*), including but not limited to those given to the patron or dedicatee of the text. They would categorize the copies of *Des cas* made for the dukes as *manuscrits de publication* or *manuscrits de diffusion*.

40. On this manuscript, see Ouy, "Une maquette"; and on its directions, Alexander, *Medieval Illuminators*, 165n29.

41. For an edition of Gerson's Latin directions to artists, see Ouy, "Une maquette," 43–51.

42. See ch. 3.

43. This happened in Geneva Ms. fr.190/1, fols. 10r, 47r, and 49r.

44. For analysis of the relationship between the two manuscripts and of stylistic attributions, see Meiss, *French Painting*, 1:283–87, and Avril et al., *Marco Polo*, 324. Meiss attributed eleven illuminations in Arsenal Ms-5193 rés. to artists (the Bedford and Adelphi illuminators) outside the group of *Cité des Dames* illuminators. Avril suggested that there were influences from the Boucicaut style of the artist he calls the "Mazarine Master" in the images that Meiss attributed to the Bedford Trend. These collaborating artists painted folios 30r, 107r, 127r–41v, 208r, 213r, 305r, 378r, 385r, 389v, and 393v.

45. For a parallel situation, see *Des cas* (JPGM Ms. 63) illustrated by Boucicaut Master illuminators around 1413–1415, discussed in Hedeman, *Translating the Past*, 129–54.

46. Meiss reported seeing drawings in the margins of folios 107r, 130v, 133v, 212r, and 213r. See Meiss, *French Painting*, 1:283.

47. See above, ch. 3.

48. On the efforts of such writers as Christine de Pizan, Pierre Salmon, and Jean Gerson to encourage others to support the monarchy rather than their partisan goals, see Hindman, *Christine de Pizan's Epistre Othéa*; Hedeman, *Royal Image*, 153–77.

49. For initial analysis of these, see Hedeman, *Translating the Past*, 86–127.

50. For this, see the catalogue of images in all surviving copies of *Des cas* in Branca, *Opere d'arte d'origine francese*, 32–34, 67–198.

51. For fuller discussion of these visual amplifications, see Hedeman, *Translating the Past*, 86–112, 116–27.

52. For discussion of this practice, see Hedeman, "Presenting the Past," in Morrison and Hedeman, *Imagining the Past*, 69–85.

53. For Boccaccio's original Latin text, see Boccaccio, *De casibus virorum illustrium.* For Laurent's translation of 1400, see Laurent de Premierfait, "Édition critique du *Des cas.*"

54. For example, see Laurent de Premierfait, "Édition critique du *Des cas,*" 279 for the description of the actions of the Jewish woman and for the sale of the Jewish captives: "A noblewoman found herself constrained by hunger to eat the flesh of her murdered child. Neither the citizens, having seen this, powerless in battle because of their weakness,

nor the Jews from all parts, felled by chagrin, were able to reverse their courage failing in their final destruction. . . . All the other multitude who could be captured . . . were submitted to the place and the servitude of pagans." [(U)ne noble femme fut trouvee constraint par faim mengier la char de son enfant occis. Ne ceste chose avoir veu les citoiens, fais non puissans a bataille pour leur foiblesse, ne avoir veu les Juifz de toute part cheans par mesaise, ne pot abatre leurs couraiges tombans en leur derrenier destruiement. . . . toute lautre multitude qui pot ester prinse. . . . fut soubzmise a ort et lait servaige des paiens.]

These passages become longer and more precise in 1409–1410. Compare Geneva Ms. fr. 190/2, fol. 99r, for the story of Marie:

And so that I do not list particularly all the abominable and repugnant meats that the wicked Jews were constrained to use; it is true [that] among the others a noble Jewish woman named Marie found herself so constrained by hunger in Jerusalem that for lack of other meat she ate the flesh of her own child whom she herself had murdered. The horror that the Jews absorbed from this noblewoman who had killed and eaten her child and their weakness from sickness that made the Jews not strong enough to fight because of [their] malaise and lack of all goods could not lessen their hardness of heart or the pride in their hearts, so that they succumbed to the final destruction.

[Et afin que je ne compte particulieremant toutes les abhominables et ordes viandes dont les mescheans juifs furent constreints de user vrai, est entre les aultres que une noble femme juifve appellee Marie fut en Jherusalem trouvee si constreinte par faim que par disette d'aultre viande elle mangea la char de son enfant qu'elle mesme avoit occis. L'orreur qui les juifs virent de ceste noble femme qui avoit occis et mangié son enfant et la floiblesse de maladie par quoy les juifs estoient devenus non puissens à combatre par mesaise et disette de tous biens ne pot abatre la durté ne l'orgueil de leurs couraiges combien qu'ilz cheissent en leur derrenier destruiemant.]

See Geneva, Ms. fr. 190/2, fol. 99v, for the sale of Jewish men: "All the other multitude of Jews, that is to say 10,080, who could be found and captured were sold into servitude and handed over to paying Saracens who bought thirty Jews for one denier of silver" [(T)oute l'aultre multitude des juifs, c'est assavoir iiijxx et xm, qui peurent estre trouvez et prins furent venduz en servaige et livrez aux payans sarrasins qui accheterent trente juifs pour ung denier d'argent].

55. See Geneva, Ms. fr. 190/2, fol. 100v:

We Christians, who by the title of holy baptism and the Catholic faith given by Jesus Christ and approved by the church, should have great fear that we and our possessions come to more grief and a more sudden fall of fortune than the Jews came to expect, [because] our misdeeds are greater in number and weight. Because at baptism we, who became knights and vassals of Jesus Christ, promised expressly to serve and obey him and no other. But in place of a single and good lord to whom we betray our faith and break

our promises, we serve three evil and disloyal lords: the world, the flesh, and the devil. And we crucify Jesus Christ not just one time like the Jews, but crucify him one hundred thousand times, that is to say as much as we sin mortally against him. And though the goodness and tolerance of God was long [extended] towards the sinful Jews, however by divine order they were punished once for all their sins by foreign people; this should launch great fear in our hearts, obstinate and hardened by sin.

[(N)ous cristians qui par le tiltre du saint baptesme et de la foy catholique donnee par Jhesu Crist et approuvee par l'eglise devons avoir grant paour que nous et noz choses ne venions à plus grief et à plus soubdain trebuchet de fortune que ne vindrent les juifs attendu que noz meffaits sont plus grans en nombre et en pois. Car au baptesme nous qui devenons chevaliers et vassaulx de Jhesu Crist promettons expressemant servir et obéir à lui et non à aultre. Mais en lieu d'un seul et bon seigneur contre lequel nous faulsons nostre foy et enfreignons noz promesses, nous servons a trois seigneurs mauvais et desloyaulx: au monde, à la char, et au deable. Et si crucifions Jhesu Crist non pas une seule foiz comme les juifs, mais le crucifions cent mil foiz, c'est assavoir par aultretans comme nous peccchons contre lui mortelemant. Et ja soit que la benigne et souffrence de Dieu ait esté longue envers les juifs pecchens, toutevoies par ordonnance divine ilz ont esté par gens estranges puniz de leurs pecchiez à une foiz pour toutes, laquelle chose nous doit lancer grant fraiour en noz cuers obstinez et endurciz en pecchiez.]

56. See Laurent de Premierfait, "Édition critique du *Des cas*," 281 for the inversion introduced by the translation of 1400: "The Jews who had struck the son of Mary, those who had seen at the end of the destruction of their city another Marie eating her son, incited by widespread famine" [Les juifz qui avoient feru le filz de Marie, iceulz ont veu ou derrenier de leur destruiement de leur cite une autre Marie, mengant son filz par faim publique amonnestant]. This passage becomes in Geneva Ms. fr. 190/2, fols. 101r–101v: "the Jews who struck and beat Jesus the son of the Virgin Mary, issued from a royal lineage. These same Jews saw another noblewoman named Marie on the last day of the destruction of their city who, constrained by public famine, ate her own child whom she had killed and roasted" [les juifs qui fraperent et batirent Jhesus le filz de la vierge Marie extraicte de royale lignié. Ces mesmes juifs ont veu ou derrenier jour de destruiemant de leur cité une aultre noble femme nommee Marie qui par constreincte de faim publique mangeoit son propre enfant qu'elle avoit et occis et rosti].

This juxtaposition of the Virgin Mary and Marie, the Jewish woman, is often considered a Eucharistic inversion. For this interpretation, see Price, *Consuming Passions*, 65–82.

57. See the addition in Geneva Ms. fr. 190/2, fols. 101v–102r: "And God incited Emperor Titus to take such vengeance on the cruel Jews so that they would feel and know that the blood of their just king Jesus had come onto them and their children, just as they cried before Pilate who did not want to take the blood or the sin of the death of Jesus Christ so that he washed his hands before the Jews so wickedly" [Et Dieux mist en courage à l'empereur Tytus qu'il prensist tele vengence des cruelz juifs afin qu'ilz sentissent et congneussent

que le sang de leur juste roy Jhesus estoit venu sur eulx et sur leurs enfans ainsi comme ilz crièrent devant Pylate qui ne vouloit prendre le sang ne le pecchié de la mort Ihesu Crist dont il lava si mauvaisemant les mains devant les juifs].

58. For an examination of English, Italian, Netherlandish, and German manuscripts illustrating the texts of Flavius Josephus before 1400, see K. Smith, "The Destruction of Jerusalem Miniatures." The *Golden Legend* integrated the story of the destruction of Jerusalem and of an unnamed woman who cooks and eats her child in the account of Saint James given for May 1. This text is always illustrated by an image of Saint James. See Maddocks, "The Illuminated Manuscripts of the Légende Dorée."

59. For Louis of Anjou's ownership, see Delisle, *Recherches sur la librarie*, 2:85, no. 501.

60. Cited after BnF Ms. NAF 15940, fol. 171r, one of three volumes of a *Miroir historial* that belonged to John of Berry.

61. At the beginning of book 11 (BnF Ms. NAF 15941) there are two illuminations on fol. 1r (Emperor Vespasian enthroned and Flavius Josephus), one illumination on fol. 1v (Romans begin the siege of Jerusalem), and two illuminations on fol. 2r (Soldiers kill Jewish men to recuperate gold; Marie offers the remains of her child to two men). The destruction of Jerusalem is described beginning on fol. 2v and not pictured, despite the fact that the rubric transcribed for ch. 6 includes the word *histoire*, suggesting that there should have been an illumination: "Concerning the destruction of the temple and of the city. Picture. vj" [De la destruction du temple et de la cité. histoire. vj].

62. The visual amplification of the destruction of Jerusalem is in large scale in two contemporary books: the manuscript in Vienna transcribed by Hand T and painted circa 1410–1412 (ÖNB Cod. Ser. n. 12766) whose earliest owner is unknown, and a second painted circa 1413–1415 (JPGM Ms. 63) that belonged to Girard Blanchet, a member of the administrative class who became *maître des requêtes* for Charles VII. Because the last manuscript of *Des cas* to illustrate the cannibalism of Marie (BnF Ms. fr. 226), dating from around 1420, shows the amplification in two single-column-wide images, the amplification ceases to function as an interior frontispiece. For an analysis of these manuscripts, see Hedeman, *Translating the Past*, 194–99; for a description of the illuminated manuscripts of French translations of Boccaccio, see Branca, *Opere d'arte d'origine francese*.

63. On the civil war, see Famiglietti, *Royal Intrigue*; Autrand, *Charles VI*; and Guenée, *Un meurtre, une société*.

64. On Laurent and other authors who described the civil war using biblical or historical analogies, see Bozzolo, "Familles éclatées, amis dispersés"; and Bozzolo, "L'intérêt pour l'histoire romaine."

65. See Geneva Ms. fr. 165, fol. 98r: "According to the sense of the letter, as Jeremiah the prophet cried and lamented most piteously and tenderly with his whole heart as is said the destruction of the City of Jerusalem and desolation of the realm of Israel, there will also be great sadness to hear about the piteous decline and annihilation of your royal house, of your noble city of Paris, and in conclusion, of your realm" [(S)elon le sens de la lettre ainsy comme le dessus dit Jeremie le prophete plouroit et lamentoit moult piteuse-

ment et tendrement de tout son cuer comme dit est la destruction de la cité de Jherusalem et desolation du royaume d'Ysrael, moult grant pitié seroit aussy a oyr parler de la piteuse declinacion et adnichilement de vostre dicte maison royal de votre noble cité de Paris et en conclusion de vostre royaume].

66. See Geneva Ms. fr. 165, fol. 99v: "First have pity and compassion on the noble and royal house of which you are a part so that its glory will not be dissipated and desolated by you but sustained and guarded as the head of which you are altogether the same and only body" [(P)remierement avoir pitié et compassion de la noble maison et hostel royal dont vous estes partis et issus afin que par vous ne soit pas dissipee et desolee la gloire d'icelle mais la soustenir et garder comme le propre chief dont vous estes tous ensemble le mesme et seul corps].

67. Geneva Ms. fr. 165, fol. 95r.

68. Because, with few exceptions, these pairs of images are iconographically identical in the two dukes' manuscripts, this discussion illustrates the scenes from only one manuscript.

69. For the use of emblematic motifs in Christine de Pizan's works and in the *Grandes chroniques de France*, see Hindman, *Christine de Pizan's Epistre Othéa*; and Hedeman *Royal Image*, 163.

70. Fols. 349v, 370r, 377r, 386r, 389v, 395r, and 403v show the arms of King Arthur, Charlemagne, England and Normandy, the Angevin king of Jerusalem, France, and England. One *ciel* (fol. 329r) has a bird with a branch in its beak, and another (fol. 278r) may represent sunrays emerging from a cloud, but these are repeated motifs, not centralized like the wolf.

71. See Willard, "Manuscripts of Jean Petit's Justification"; and Nordenfalk "Hatred, Hunting and Love"; for a discussion of John the Fearless's use of emblems, see Hutchison, "*Pour le bien du roy*"; and Hutchison, "Partisan Identity in the French Civil War." For prior discussion of the passages from Petit's *Justification*, although not in direct relation to Alcibiades, see Hedeman, *Translating the Past*, 102–104.

72. Twelve of the surviving illuminated manuscripts of *Des cas* inventoried by Branca in *Opere d'arte d'origine francese* contain illuminations of Lucretia in book 3, ch. 3.

73. On translations of Livy for John the Good and Charles V, see Tesnière, "Les Décades de Tite-Live," in Hoffmann and Zöhl, *Quand la peinture*, 345–52; and Tesnière, "Un manuscrit exceptionnel des Décades," in Galderisi and Pignatelli, *La traduction*, 149–64. On Laurent's revision of Livy, see Tesnière, "Un remaniement du *Tite-Live*"; Tesnière, "À propos de la traduction du Tite-Live"; Hedeman, *Translating the Past*, 34–53; and Morrison and Hedeman, *Imagining the Past*, 81–84.

74. John of Berry acquired copies of the French translation of Livy in 1403 and 1405, and John the Fearless owned two, one of which, inherited from his father, he gave away in 1417. They also owned illuminated manuscripts of the French translation of Valerius Maximus. Several of these remain unidentified. See Hedeman, *Translating the Past*, 239–40, and Falmagne and Van den Abeele, *Dukes of Burgundy*, 134, 136. Lucretia was also featured but not illustrated in Christine de Pizan's *Cité des dames*, written in 1405. Her account

draws on those of Livy and Boccaccio and uses Lucretia as the primary example in a chapter entitled "Refuting those men who claim women want to be raped, Rectitude gives several examples, and first of all, Lucretia." See Christine de Pizan, *The Book of the City of Ladies*, 160–62 and 207. In 1420, the inventory after death of John the Fearless lists a copy he owned. See Falmagne and Van den Abeele, *Dukes of Burgundy*, 139, no. 112.

75. Boccaccio, *Des cleres et nobles femmes* 1:160–61. See Quilligan, *The Allegory of Female Authority*, 156–61; and Buettner, *Boccaccio's Des cleres et nobles femmes*.

76. For comparable examples of loose or disheveled hair after a rape, see Wolfthal, *Images of Rape*, 43–45.

77. See Châtelet, "Un traité de bonnes moeurs," 46–48. He observes that several of the images are displaced from the portions of text that they illustrate.

78. See BnF Ms. fr. 1023, fol. 25r: "They [knights who would ravish a maiden] should remember Lucretia, the mirror of all chastity, about whom Valerius Maximus recounts in his sixth book how Tarquin, the son of Tarquin the Proud, took her by force and accomplished his false will. The next day the said Lucretia called her friends and, in recounting the villainy which had been done to her, killed herself before them. And because of this, Tarquin lost his seigniory and then the kings of Rome ended, because the Romans said that they would not have the profession of a lord commit such outrages" [Ilz devroient avoir memoire de Lucresse, le miroer de toute chasteté, de laquele racompte Valere en son vjᵉ livre comment Tarquin filz de Tarquin l'orguilleux la prist à force et en acompli sa fausse voulente. Laquele Lucresse lendemain appela ses amys, et en racomptant la villenie qui lui avoit esté faitte devant eulx se tua. Et à cause de ce Tarquin perdi sa seigneurie et lors cesserent les rois a Romme, car les rommains disoient qu'ilz n'avoient mestier de seigneur pour faire telx oultrages].

79. Laurent expanded his translation of Boccaccio from 1400: "Junius Brutus of Rome roused all the people of Rome against Tarquin the Proud" [Junius Bruttus de Romme bestourna tout le people de Romme contre Torquinion l'orgueilleux]. Compare Laurent de Premierfait, "Edition critique," 79 with the amplified version in Geneva Ms. fr. 190/1, fols. 52v–53r, describing Brutus's actions after the suicide, which is much longer: "And thus Junius Brutus, cousin as he was of the said Lucretia, took the knife from inside the wound and exposed the disloyal act to the people, with the result that he attracted them to his party and moved all from Rome and neighboring countries. And from that moment they called for franchise and they chased away the king and all his line, by which action is was clear what great power the people had" [Et lors, Junius Brutus cousin comme dict est de la dicte Lucrece prist le coustel de dedans la plaie, et au peuple descouvri le très desloyal fait en tant que il tira en sa partie et esmeut tout le peuple de Romme et du pays voisin. Et fut lors criee franchise. Et dechacerent le roy et toute sa lignie par quoy il apparut clerement com grant puissance ait le people].

80. Compare the additions to the chapter on tyranny and proud kings concerning Brutus to the description of the aftermath of Lucretia's suicide in Geneva Ms. fr. 190/1, fol. 90v: "Because as soon as Junius Brutus, the brother-in-law of Lucretia, had drawn the knife from the wound, Brutus and Lucretius, the father, and Collatin, the husband of Lucretia,

assembled in council and parlement all the people of Collace and Rome, and the friends of Lucretia showed them the disloyal and horrible act. And they agreed among themselves that they would exhort the people to call for liberty as they had before the time of the kings" [Car depuiz que Junius Brutus, serourge de Lucrece, eut tiré hors de la plaie le fer du coustel, le dict Brutus et Lucrecius, le pere, et Collatin, le mari de ceste Lucrece, assemblerent à conseil et à parlement tout le peuple de Collace et de Romme et leur monstrerent les amis de Lucrece le desloyal et horrible meffait. Et accorderent entre eulx que ilz enhorteroient le peuple à crier et demander franchise tele comme il avoient devant le temps des roys].

81. See Enguerran de Monstrelet. *La cronique,* 1:269–334, especially 285, when the speaker imagines how the spirit of Louis of Orléans would speak to the king.

82. On Bureau de Dammartin, see Loyau, "Une approche monographique," in Ornato and Pons, *Pratiques de la culture,* 259–78.

83. For an edition of *Des cent nouvelles,* see Boccaccio, *Boccace Decameron.* For analysis of the text, see also Cucchi, "The First French Decameron"; and Beck, "Laurent de Premierfait's *Les Cent Nouvelles.*" For a fully digitalized version of the *Les cents nouvelles* in Rome, see http://digi.vatlib.it/view/bav_pal_lat_1989 or http://digi.ub.uni-heidelberg.de/diglit/bav_pal_lat_1989.

84. For visual translation, see Sherman, *Imagining Aristotle*; Buettner, *Boccaccio's Des cleres et nobles femmes*; and Hedeman, *Translating the Past.*

85. For Laurent's translator's prologue addressed to John of Berry, see Boccaccio, *Boccace Decameron,* xvi and 1–6. Di Stefano explains that Antonio d'Arezzo's intermediate Latin translation from Italian does not survive, with the result that it is impossible to isolate the contributions of the two translators. However, Laurent is responsible for the original French translator's prologue that is preserved in BnF Ms. fr. 129 and Oxford, Bodleian Library, Douce 213, both dating from the late fifteenth century.

86. On the phenomenon of "twinned" manuscripts as reflections of both shared taste and competing collections, see Alexander, *Medieval Illuminators and Their Methods of Work,* 138; Buettner, *Boccaccio's Des cleres et nobles femmes,* 23; and Hedeman, "Making the Past Present: Visual Translation," in Croenen and Ainsworth, *Patrons, Authors and Workshops,* 173–96. For discussion of the visual cycles in BAV Pal. Lat. 1989, see König, *Boccaccio Decameron*; Schwall, "Erzählstrukturen"; and Schwall-Hoummady, *Bilderzählung im 15. Jahrhundert,* 21–105. On the layout, see Wilhelm, "Alle soglie della narratività." It is possible that the presentation manuscript planned for John of Berry was never completed and presented to him because John died in 1416.

87. For this and the following, see Norton, "Laurent de Premierfait"; for an edition of Laurent's translator's prologue, see Boccaccio, *Boccace Decameron,* 1–6.

88. "This thing I have seen and verified in schools of general studies, because the masters and doctors in the middle of their lessons recount to the students any fables or joyous news, so that, by inserting words of honest solace and amusement, the readers and listeners wake up and refresh their sense and understanding to vigorously read and listen to the rest of the ordinary lessons" [Ceste chose j'ay veue et esprouvee es escolles de toutes

generales estudes, car les maistres et docteurs ou milieu de leurs leçons racomptent aux escoliers aucunes fables ou nouvelles joyeuses, afin que par interposees paroles de honneste soulaz et esbatement les liseurs et escouteurs resveillent et rafreschissent leurs sens et entendemens a viguereusement lire et escouter le remenant des leçons ordinaires]. See Norton, "Laurent de Premierfait," 384; and Boccaccio, *Boccace Decameron*, 4.

89. See Cucchi, "The First French *Decameron*"; and Beck, "Laurent de Premierfait's *Les Cent Nouvelles.*" See as well Purkis, "Laurent de Premierfait's translation"; Labère, "Du jardin à l'étude"; Di Stefano, "Il *Decameron* da Boccaccio"; Di Stefano, "Tradurre il *Decameron*"; Delsaux, "Laurent de Premierfait, dernier poète."

90. See Boccaccio, *Boccace Decameron*, 5. For the discussion of Laurent's text that follows, see Cucchi, "The First French Decameron"; and Beck, "Laurent de Premierfait's *Les Cent Nouvelles.*"

91. This expansion with material suitable for moral instruction was also noted by Bozzolo, "Un '*homme populaire,*'" in Fresco, *Authority of Images/Images of Authority*, 159–71.

92. See Beck, "Laurent de Premierfait's *Les Cent Nouvelles*," 83–117.

93. For the textual analysis that I summarize here, see Beck, "Laurent de Premierfait's *Les Cent Nouvelles*," 34–35, 91–93, 134–38, and 195–98; and Cucchi, "The First French Decameron," 249–53.

94. Here is the amplified summary provided in the French translation with bold type indicating the portions that Beck shows were added in Laurent's translation:

> **There is an island in the southern lands now called Cyprus. This name was formerly given because of a city named Cyprus which previously was called Paphos. This island sits under the southern sky and is enclosed by the Carpathian sea. Cyprus was famous for riches, and especially for gold and sand which was first found there in veins in the earth. In this island not long ago there reigned** a king first named Guiot, Lord of Lisignan and Poitou. After finishing the battle that Godfrey of Lorraine, otherwise called Duke of Bouillon, did in the Holy Land, this Guiot conquered and possessed the island of Cyprus **by arms. He thus became king, became by nature or otherwise indolent, pusillanimous, and nonchalant about punishing injuries, crimes, and outrages committed and perpetrated in his realm, as much against himself as against his subjects and foreigners.**
>
> It happened in his time that a noblewoman from Gascony, **returning pilgrim from the Holy Sepulcher, was grievously injured by some bad Cypriots. The lady therefore going to seek a remedy from the king, stung and** provoked him **by a courteous mockery** so that he who had previously lived cowardly, **lazily, and negligently** became magnanimous **and a diligent avenger of injuries and crimes, whether private or foreign, and woke up his dormant courage.**
>
> [**Une isle est ou pays de Midy maintenant appellee Chipre. Cestui nom fut anciannemant donné du nom d'une cité d'illeuc jadis nommee Cyprus, et qui paravant fut**

appelle Paphos. Ceste isle est assise soubz le soleil de mydi: et est enclouse de la mer Capathie. Chipre fut moult jadiz renommee de richesses, et par especial de or et de arein, qui es veines de la terre fut illeuc premiermant trouvé. En ceste isle, de puiz pou de temps passé regna ung roy premieremant nommé Guiot, seigneur de Lisignan en Poytou. Aprés finee la Bataille que Gothifroy de Lorreine, aultrement nommé Duc de Bueillon, fist ou pays doultremer, cestui Guiot par armes conquist et posseda le royaume de Chipre. Il ainsi devenu roy, devint par nature ou aultremant alentiz, pusillanime, et nonchalant de punir les injures, crimes, et oultraiges commis et perpetrez en son royaume, tant contre soy mesme, comme contre ses subjetz et estranges.

Si advint en son temps que une noble femme de Gascoigne, retournant pelerine du Saint Sepulcre, avoit par aulcunes mauvaiz Chipriens esté griefmant injuriee. La dame doncques, venant querir remede dever le roy, le poigny et esguillonna par ung courtoiz brocart, en tant que cellui qui paravant avoit vescu pusillanime, fetart, et negligent, devint magnanime et diligent vencheur des injures et forfaitz tant privez comme estranges, et esveilla ses esperitz endormie.]

See Beck, "Laurent de Premierfait's *Les Cent Nouvelles*," 91–93; and Boccaccio, *Boccace Decameron*, 96.

95. See for example, the exterior scenes on folios 43v, 114r, 134r, and 150v, where trees in the foreground are about half the size of people behind them. Large trees do overlap characters on folios 158r and 221r, but in neither case do they mask action.

96. Compare this image to that of the rape of Lucretia in fig. 4.38.

97. This excerpt is part of a longer discussion of justice:

At the beginning of earthly seigniories, kings by the consent of the people were elected and principally instituted as ministers of legal justice which contained three parts: one regarding God and public religion, the other regarding himself, and the other regarding foreign persons. Justice was found by Dame Nature and ordered by human wisdom to render to each the thing belonging to him. If our king made full royal office, he profited all and did not harm anyone. Each then followed, honored, and loved him; it did not suffice for him to not harm and not encumber anyone, but he should try to punish those who harm and the bad, in order that they cease. Justice gives our king a sword with two tips and cutting on two sides to punish and pursue the guilty and to defend the just. A good king is husband to widowed women, father of orphans, help to the oppressed, mirror of virtues, example of noble works, patron of public religion, sentinel and guard of the people subject to him.

[Au commencemant des seignories terriennes les roys par consentemant de peuple furent esleuz et principalement instituez ministres de justice legale contenant trois parties: l'une resgarde Dieu et religion publique, l'autre regarde soy mesme; et l'autre resgarde les estranges personnes. Justice fut trouvee de par Dame Nature et ordonnee

par humaine saigesse pour rendre a chascun la chose qui lui compete. Se nostre roy feist plein office royal, il proufitast a tous, et ne nuysist a aulcun. Chascun lors l'ensuivist honnorast et amast; il ne lui souffisist pas de non nuyre et non grever aultrui, mais il s'efforçast de punir les nuysens et mauvais, afin que ilz cessassent. Justice donna a nostre roy espee a deux pointes et tranchant de deux costez a punir et dechacher les nocens, et a deffendre les justes. Bon roy est mari des femmes vefves, per des orphanins, secours des oppressés, mirouer des vertus, exemple de nobles oeuvres, patron de religion publique, eschargueteur et garde du peuple a lui subject.]

See discussion in Beck, "Laurent de Premierfait's *Les Cent Nouvelles*," 33–35 ; and Boccaccio, *Boccace Decameron*, 98.

98. For mirrors of princes, see Krynen, *L'empire du roi*.

99. See Boccaccio, *Boccace Decameron*, 54.

100. During the reign of John the Good (r. 1350–1364), the badges that Jews were required to wear were particolored red and white. See Cyrus Adler and Joseph Jacobs, "Badge," *Jewish Encyclopedia* (2021), http://www.jewishencyclopedia.com/articles/2317 -badge. This mode of representation persisted even after the Jews were expelled from France in 1394. See, for instance, a book made in 1399 that was in the royal library by 1410, Jean de Montaigu's copy of Honoré Bouvet's *Apparition Maistre Jean le Meun* (BnF Ms. fr. 810), in which on folio 6v Jean de Meun speaks to Bouvet and sees his subsequent interlocutors lined up behind him. Although the text only identifies them as a doctor, Saracen, Jew, and Jacobin, the artist introduces elements of dress and objects to differentiate them. The doctor wears an elegant furred hood; the Saracen wears a turban, the Jew wears a red-and-white badge; and the Jacobin holds a manuscript. The *Apparation* is fully digitalized on Gallica: ark:/12148/btv1b84471792.

101. See Kumler, "Faire translater, faire historier," 93–97.

CHAPTER 5

1. See Anderson, *Manuscripts of Statius*, for an analysis of illuminated manuscripts of the *Thebaid* and *Achilleid*. Of the twenty-two manuscripts to survive that are decorated with one or more historiated initials or miniatures, only one (BL Add. Ms. 11995) is French and postdates BL Burney 257, but it is illuminated with one initial of a monk holding a book.

2. Elizabeth Pellegrin was the first to sort out the relationship between the manuscripts in Milan and Paris. She noted how close they were but also observed, after a partial collation of the texts, that the French translation in the manuscript in Milan had been corrected after another manuscript than BnF Ms. lat. 7789. She also observed that the overpainted arms on folios 1r and 33r had "a bordure de gueules et des traces de bleu en chef." See Pellegrin, "Note sur deux manuscrits." See, for further bibliography, Bussi and Piazza, *Biblioteca Trivulziana*, 100–103. The most recent work on the text has been done by Stefania Marzano. See Marzano, "Laurent de Premierfait"; and Marzano, "Le *Pro Marcello*."

3. I would like to thank François Avril, who first suggested this attribution to me in 1999. On the Master of Barthélemy l'Anglais, see Avril and Reynaud, *Manuscrits à peintures*, 106–8; and Avril, Reynaud, and Cordellier, *Enluminures du Louvre*, 163–64, no. 84. For the dependence of Trivulziano, Triv. 693 on BL Burney 257, see Pellegrin, "Note sur deux manuscrits," 279.

4. The result of this effort to distinguish the texts via codicological structure results in occasional deviations from the normal quire of eight folios in the manuscript now in Milan, just as it had in BnF Ms. lat. 7789. The *oratio* is contained in its first quire, which ends with a blank and ruled folio 8v; the *De senectute* fills quires 2–5, with quire 5 containing only two folios, the last of which has a verso that is blank and ruled; and quires 6–15 contain Laurent's translation.

5. See Marzano's discussion in Laurent de Premierfait, *Livre de vieillesse*, 9–27; and Delsaux, "La philologie au risqué."

6. For the attribution to the Roman Texts Master, see Meiss, *French Painting*, 1:350–51 and 405; for discussion of the manuscript and its text, see Delahaye, *Paris 1400*, 236–37 and 241–43, no. 145.

7. See ch. 2 for the manuscripts of Sallust. For books transcribed by Monfaut belonging to Jean Courtecuisse—Valerius Maximus (BnF Ms. lat. 6147), Cicero (Bern, Burgerbibliothek Ms. 254)—see Ouy, "Jean Lebègue," in Croenen and Ainsworth, *Patrons, Authors and Workshops*, 143–71; Omont, "Inventaire des livres de Jean de Courtecuisse"; and Von Steiger, "Aus der Geschichte der Bongars-Handschriften," 89–90. For works by Nicolas de Clamanges, see Jeudy, "La bibliothèque cathédrale de Reims," in Ornato and Pons, *Pratiques de la culture écrite*, 75–91; and Ouy, "In Search of the Earliest Traces."

8. Bozzolo, "Laurent de Premierfait et Térence," 106.

9. See Meiss, *French Painting*, 1:350–51. Illuminations begin five of the six plays (fols. 5v, 36r, 68r, 98r, and 128v), several are included in the first portion of the play *The Brothers* (fols. 99r, 101v, 102v, 103v, 104r, 105r, 105v, 107v, and 109r), and there are underdrawings for six subsequent unpainted images in *The Brothers* (fols. 111v, 112v, 114r [2 drawings], 115v, and 118r).

10. Meiss, *French Painting*, 1:336–39 and 405.

11. Delahaye, *Paris* 1400, 241–43, no. 145.

12. See A. Turner, "Problems with the Terence Commentary Traditions," in Hill and Turner, *Terence between Late Antiquity and the Age of Printing*, 137–77.

13. Compare BnF Ms. lat. 8193, fol. 20r with BnF Ms. lat. 7907A, fol. 145r; BnF Ms. lat. 8193, fol. 28r with BnF Ms. lat. 7907A, fol. 145v; BnF Ms. lat. 8193, fol. 68r with BnF Ms. lat. 7907A, fol. 148v; BnF Ms. lat. 8193, fol. 72r with BnF Ms. lat. 7907A, fol. 149r; BnF Ms. lat. 8193, fol. 90r with BnF Ms. lat. 7907A, fol. 150r; and BnF Ms. lat. 8193, fol. 111v with BnF Ms. lat. 7907A, fol. 151v. The only notes that they do not share are the "actus quartus" BnF Ms. lat. 8193, fol. 84r, which has no counterpart on BnF Ms. lat. 7907A, fol. 152r; a note on BnF Ms. lat. 8193, fol. 111r, "de scena precedens/" [trimmed at margin]; and a note in BnF Ms. lat. 7907A, fol. 155r that comes at the end of the introduction to *Phormio*, an introduction that is unnecessary when the marginal note is adjacent to the play, as it is in BnF Ms. lat. 8193.

14. Meiss attributes Arsenal Ms-664 rés., fols. 1r–85v (quires 1–11) and 169r–204v (quires 22–26) to Luçon illuminators, fols. 90r–125r (quires 12–16) to *Cité des Dames* illuminators, the margin of fol. 1v (quire 1) and 128r–68r (end of quire 16 through quire 21) to Bedford Trend illuminators, and fols. 209v–35v (quires 27–30) to Orosius illuminators. Artists worked on independent quires, with the exception of the collaboration of the Bedford Trend artist on the margin of fol. 1v and of the Luçon and Orosius Master illuminators on a bifolium in quire 16. On this manuscript, see Meiss, *French Painting*, 1:41–50 and 336–39; and Delahaye, *Paris 1400*, 241–43, no. 145. Heather Tennison breaks down the artistic hands further and suggests that an Orosius Master illuminator, whom she calls Paris Associate 4 (OMPA4), painted images in *The Mother-in-Law* and worked in the artistic style but did not employ the compositional types visible in other Orosius Master illuminators' works. See Tennison, "Tradition, Innovation, and Agency," ch. 2. For reproduction of the two excised miniatures preserved in Nantes, see Charron, Gaultier, and Girault, *Trésors enluminés*, 190–91, no. 46.

15. For Laurent's collaborating scribes, see Delsaux, "Textual and Material Investigation."

16. Contrary to Bozzolo's statement, not all the manuscripts including Laurent's original commentary include the plays in this order: *The Woman of Andros, The Eunuch, The Self-Tormentor, The Brothers, Phormio,* and *The Mother-in-Law.* The iconographically related Terence belonging to John of Berry (BnF Ms. lat. 7907A), BnF Ms. lat. 8193, and the Terence in the library of Saint-Denis (BnF Ms. lat. 7899) reverse the last two plays, following this order: *Woman of Andros, The Eunuch, The Self-Tormentor, The Brothers, The Mother-in-Law,* and *Phormio.* See Bozzolo, "Laurent de Premierfait et Térence," 96.

17. Bozzolo studied Laurent's commentary and its expansion in BnF Ms. fr. 7907A, Arsenal Ms-664 rés., and BnF Ms. lat. 7907; see Bozzolo, "Laurent de Premierfait et Térence."

18. For this and the following see Bozzolo, "Laurent de Premierfait et Térence," 97–99 and 113.

19. See Delahaye, *Paris 1400*, 242.

20. For a list of all known illuminated copies of Terence's plays, see Keefe, "Illustrating the Manuscripts of Terence," in Hill and Turner, *Terence between Late Antiquity and the Age of Printing*, 36–66.

21. For discussion of the break between late antique and medieval theater, see Weigert, *French Visual Culture*.

22. Marzano, Bozzolo, and Brance report that there are at least eighty-six copies of the two versions of Laurent's translation of Boccaccio's *De casibus*, twenty-seven of his translation of Cicero's *De senectute*, fourteen copies of his translation of Cicero's *De amicitia*, and fifteen of the translation of Boccaccio's *Decameron.* See Marzano, " Laurent de Premierfait," 231; Bozzolo, *Manuscrits des traductions*; and Branca, *Opere d'arte d'origine francese.* Pons studied seven manuscripts in which Lebègue's translation of Leonardo Bruni appears with Pierre Bersuire's translation of Livy: Chantilly Mss. 759–761; Ass. nat. 1265; BnF Mss. fr. 33, 36, 15470; and BAV Reg. lat. 722. See Pons, "Leonardo Bruni, Jean Lebègue et la cour," 104. For the manuscript in the library of the Assemblée nationale, see also Tes-

nière, *L'histoire romaine de Tite-Live*. Pons also studied fourteen manuscripts of what she calls "copies isolées," in which Lebègue's translation of Bruni appears alone: Bordeaux, BM 731; Geneva, Com. Lat. Ms. 9; Pal. Arts 31; Arsenal Ms-5086 rés.; BnF Mss. fr. 722, 723, 724, 725, 1388, 1389, 17215, 23085, 23086; and Yale, Marston 274. Manuscripts in Brussels (KBR 10777) that belonged to Duke Philip the Good of Burgundy and from the collection of Samuel Ashton Thompson-Yates can be added to this list. See Bousmanne, Van Hemelryck, and Van Hoorebeeck, *La librarie,* 266–71; and Christies, London, *Yates, Thompson and Bright: A Family of Bibliophiles, sale Wednesday 16 July 2014,* lot 17. https://www.christie s.com/en/auction/yates-thompson-and-bright-a-family-of-bibliophiles-24799/.

23. For discussion of these texts, see ch. 4. The only textual emendation to the dukes' manuscripts that is not included in ÖNB Cod. Ser. n. 12766 is the paragraph about Dante that appears on Arsenal Ms-5193 rés., fols. 394v–95r, and Geneva Ms. fr. 190/2, fol. 181r.

24. For a complementary discussion, see Hedeman, *Translating the Past,* 135–43.

25. This manuscript (JPGM Ms. 63) was made around 1413 to 1415 for Girard Blanchet, who became a counselor to King Charles VII. His manuscript was painted by Boucicaut illuminators and includes a smaller cycle of illuminations, but it also was produced as part of the second wave of *De cas* manuscripts that escaped Laurent's control. Like the *Des cas* in Vienna, it was based on a series of written directions that may have been keyed to incipits. For further discussion of this manuscript in relation to the manuscript in Vienna, see Hedeman, *Translating the Past,* 129–54.

26. For a prior discussion of BnF Ms. fr. 131 that I expand here, see Hedeman, *Translating the Past.*

27. For much of this and what follows, see Autrand, *Charles VI;* Bozzolo, "L'humaniste Gontier Col et Boccace"; and Bozzolo and Loyau, *La Cour amoureuse,* 1:70–71, no. 59. For prior discussion of BnF Ms. fr. 131, see Branca, *Opere d'arte d'origine francese,* 83–86, no. 26; and Hedeman, *Translating the Past,* 154–64.

28. Bozzolo, "L'humaniste Gontier Col et Boccace," 18.

29. Surviving manuscripts from Col's collection include an unillustrated Latin copy of Boccaccio's *De casibus* (BML Med. Pal. 228); an illustrated copy of Laurent's *Des cas* (BnF Ms. fr. 131); an unillustrated Boccaccio's *Genealogia deorum* (Krakow, Biblioteka Jagiello ska, Kodeks J nr. 413); and three unillustrated manuscripts he copied himself: a *Trésor de Jean de Meun* (BnF Ms. NAF 6261), a *Tite-Live* (BnF Ms. lat. 14630), and a French translation of the letters of Abelard and Heloïse (BnF Ms. fr. 920). On these, see Bozzolo, "L'humaniste Gontier Col et la traduction." Col may have been associated with the production of a copy of the *Chronique universelle* (Morgan Ms. 516), possibly for his own collection or to give as a gift (private communication with Carla Bozzolo, June 2013).

30. The pamphlet has at its very end an inscription in Latin that Bamford suggests was also written by Gontier Col: "Remember the giver. / Kindly accept the gift and remember the giver / so that you may not give to the wind what he/she prays for you in his/her heart" [Memento dantis / Accipito datum placide dantis que memento / Sic quod non vento des quod tibi corde precatur]. On this manuscript, see Bamford, "Remember the giver(s)"; and Christine de Pizan, *Debate,* which contains extensive bibliography. Also see Christine de Pizan, *Le Livre des epistres du debat.*

31. For the Cour amoureuse, see Bozzolo and Loyau, *La Cour amoureuse.*

32. BnF Ms. fr. 131, fol. 116v, does not incorporate the change to book 4, ch. 8, that was seamlessly integrated in ÖNB Cod. Ser. n. 12766, fol. 126r, or the paragraph about Dante that ends book 9, ch. 23, in Arsenal Ms-5193 rés., fols. 394v–95r, and Geneva Ms. fr. 190/2, fol. 181r.

33. For prior discussion of the visual cycles of this manuscript, see Hedeman, *Translating the Past*, 154–64; and Hedeman, "Translating Prologues." For the textual analysis that follows, see Bozzolo, "L'humaniste Gontier Col et Boccace," 16–17 and 19.

34. On Laurent's Latin poem, see Ouy, "Poèmes retrouvés de Laurent de Premier-fait," in Bozzolo and Ornato, *Préludes à la Renaissance,* 228–29 and 240.

35. For Lebègue's annotation of his own manuscript of Sallust (Geneva, Ms. lat. 54) and of his notes on *Les histoires sur les deux livres de Salluste* (Bodl., D'Orville 141) with suggestions of changes to the visual cycle, see ch. 3.

36. We know very little about the man named Plesseboys who was the third scribe and signed the book, but he seems to have been from a family of scribes. A Plesseboys wrote "Nicolas Plesseboys. Troyes." on the back of a document of July 24, 1400 (Paris, Archives nationale, L 445, n° 28), and a "Meistre Nicole Plessebois" was one of the bourgeois of Paris who were listed as swearing an oath of allegiance to King Charles VI, John the Fearless, the city of Paris, and the men and servitors of the duke in August 1418, after the massacre of the Armagnacs that took place that May. Later, in 1450, a Jehan Placeboys is mentioned as one of two clerics who made three copies of the inventories after death at Vernon, Loches, and La Croisete of Charles VII's mistress, Agnes Sorel. For these, see Terroine and Fossier, *Chartes et documents,* 3:776–78; Fillon, "Liste des bourgeois de Paris"; Cavallier, "Compte des exécuteurs testamentaires," 112–13.

37. Bodl. 265 was illuminated by an artist close to the Master of the Royal Alexander, whom Meiss had collapsed together with the Harvard Hannibal Master. Catherine Reynolds argued for separating these two hands. For discussion of this style, see Meiss, *French Painting,* 1:390–92; Reynolds, "English Patrons and French Artists"; and Reynolds, "Master of the Harvard Hannibal"; and, for analysis of his eponymous manuscript, Pérez-Simon, "Royal MS. 20 B. XX." BL Royal 18 D. VII was illustrated by the Talbot Master and is discussed in McKendrick, Lowden, and Doyle, *Royal Manuscripts,* 246–47, no. 72. For the artist, see as well Reynolds, "The Shrewsbury Book"; and Avril and Reynaud, *Les manuscrits à peintures,* 168–72.

38. See Richard, *Notice sur l'ancienne bibliothèque des échevins,* 14–16, no. 3.

39. Col's marginal notes were not copied by the second of three scribes who transcribed quires 10–12 (fols. 73r–96v) in the manuscript. The other two scribes transcribed quires 1–9 and 13–41 and included hundreds of Col's notes, missing only a handful. They also inserted into the text many of the paragraph marks that Col had sketched in the margins and incorporated many of Col's textual corrections: see, for instance, Bodl. 265, fol. 36v, which incorporates into its text a correction written in the margin of BnF Ms. fr. 131, fol. 36r, or Bodl. 265, fol. 136v, which incorporates a marginal correction written in BnF Ms. fr. 131, fol. 129v, into its text.

40. For an abstract of the contents, see Saxl and Meier, *Catalogue of Astrological and Mythological Illuminated Manuscripts*, 3:292–94. For the diagrams themselves, see Bodl. 265, fols. 1r–1v, and Royal 18 D. VII, fol. 1r. Each contains a mnemonic row grouped in threes, a row grouped in fours, three rows grouped in sevens, a row grouped in tens, two rows grouped in twelves, and a final row that juxtaposes groups of twelve, of sixteen, and of twelve. Bozzolo also noted the presence of these texts. See Bozzolo, *Manuscrits des traductions*, 19–20, 140–41.

41. On these diagrams, see Sandler, *Psalter of Robert De Lisle*, 11–27; Carruthers, *Book of Memory*, 253–54; Saxl, "A Spiritual Encyclopedia"; and Ransom, "The *Speculum theologie* and Its Readership." Sandler identified thirty-two manuscripts containing these diagrams dating from the thirteenth to the fifteenth century and made in France, England, Germany, and Italy.

42. See Carruthers, *Book of Memory*, 253–54; and Carruthers, "*Ars oblivionalis*."

43. For the poem, which ends the section on physiology, see De Renzi, Henschel, and Daremberg, *Collectio Salernitana*, 1:52.

44. On the twelve winds, see Obrist, "Wind Diagrams."

45. See the discussion of the text within its original Irish context and within an English context in Meen, "Politics, Mirrors of Princes," especially 349–51; and Brown "Pride of Life."

46. Throop, *Vincent of Beauvais*, 115. The chart omits the concluding sentence of the prologue: "They are the twelve abuses of the world through which, if they exist in the world, the wheel of the world is deceived and is turned towards the darkness of hell through the righteous judgment of God, with no intervening approval of justice."

47. On mirrors of princes, a generic term applied to literary works that vacillate between poles, offering moral guidance, historical exempla, or political treatises, see Jónsson, "Les 'miroirs aux princes'"; and Lachaud and Scordia, *Le prince au miroir*.

48. It is noteworthy that Arsenal Ms-5193 rés., the *Des cas* made for John the Fearless described in ch. 4, contains 30 marginal notes written by the scribe that also appear among the 337 preserved in BnF Ms. fr. 131. Might this suggest that annotations such as these gradually accrued over time in copies of the text circulating among *libraires*?

49. Meiss attributes fols. 1r and 176r to the Master of the *Cité des Dames*. I would class fols. 40v, 107v, and 276v with them in an expanded *Cité des Dames* group, even though the style is distinctly different. See Meiss, *French Painting*, 1:381.

50. See Hedeman, *Translating the Past*, 154–64.

51. On the *Grandes chroniques*, see Hedeman, *Royal Image*; on the illustrations of Valerius Maximus, see Dubois, *Valère Maxime*.

52. The marginal notes from Laurent's first prologue in the two dukes' manuscripts are: Pour quoy choses mondaines sont subjects a fortune [Why earthly things are subject to fortune], appearing in Geneva Ms. fr.190/1, fol. 1r and Arsenal Ms-5193 rés., fol. 1r; Comment homme affranchit soy et ses choses de fortune [How man liberates himself and his things from fortune], appearing in Geneva Ms. fr. 190/1, fol. 2r and Arsenal Ms-5193 rés., fol. 2r; Le cas de l'eglise presente et des prestres [The case of the present church and of

priests], appearing in Geneva Ms. fr. 190/1, fol. 2v and Arsenal Ms-5193 rés., fol. 2v; Le cas de noblesse mondaine [The case of earthly nobility], appearing in Geneva Ms. fr. 190/1, fol. 3r and Arsenal Ms-5193 rés., fol. 3v; and Le cas des laboureurs champestres [The cases of laborers in the field], appearing in Geneva Ms. fr. 190/1, fol. 4r and Arsenal Ms-5193 rés., fol. 4v. These are incorporated as red rubrics within the text in Gontier Col's manuscript (BnF Ms. fr. 131) on fols. 1v, 2r, 2v, 3r, and 4r.

The discussion of the present church includes this phrase at its beginning: see Arsenal Ms-5193 rés., fol. 2v: "Quelz yeux tant soient secs se pourroient abstenir de larmes quant les hommes voient clerement et cognoiscent les cas ja advenuz de trois estats du monde, c'est assavoir des prestres, des nobles hommes, et aussi des laboureurs de cestui temps."

53. See BnF Ms. fr. 131, fol. 2v: "Quelz cuers tant soient durs pourroient soy abstenir de douleur. Quelz ieulx tant soient secs se pourroient soy abstenir de larmes quant les hommes voient clerement et congnoissent les cas ja advenus des troys estatz du monde, c'est assavoir des prestres, des nobles hommes et aussi des laboureurs de cestui temps."

54. Odile Blanc was the first to discuss the care with which costume delineates the three estates in these manuscripts. See Blanc, *Parades et parures,* 39–45.

55. See the catalogue of manuscripts in Hedeman, *Royal Image,* for fourteen manuscripts that represent her punishment.

56. For prior discussion of this manuscript, see König, *Boccaccio Decameron;* Schwall-Hoummady, *Bilderzählung im 15. Jahrhundert;* and Hedeman, "Illuminating Boccaccio."

57. For description of the illuminated manuscripts, see Branca, *Opere d'arte d'origine francese,* 205–45; and Hedeman, "Illuminating Boccaccio." For a detailed analysis of Arsenal Ms-5070 rés., see Muzerelle and Tesnière, *El Decameron de Bocaccio.*

58. For the identification of the artist of the first eight illuminations as the Guise Master and for the date ca. 1415–1420, see Clark, *Art in a Time of War,* 283–86.

59. Jews were represented with a variety of badges in late medieval France and Flanders, ranging from badges that looked like circular rings to yellow badges to bipartite yellow-and-red or red-and-white badges. See Sansy, "Marquer la différence"; and Wolfthal, "Complicating Medieval Anti-Semitism."

60. For discussion of the manuscript tradition and a sketch of how distinct the texts of the surviving copies are from each other, see Boccaccio, *Boccace Decameron,* xi–xxii. Di Stefano could not make a traditional stemma for the surviving manuscripts because of their notable differences; he discusses the texts' diffusion and the distinct characteristics of surviving manuscripts within the context of explaining which manuscripts he will use as the base of his edition, and why he selected the handful of manuscripts that appear in his apparatus, including the two (BnF Ms. fr. 129 and Bodl. Douce 213) that preserved the dedicatory prologue to John of Berry.

61. The other manuscript with a single frontispiece is now in two volumes: BL Royal 19 E I and 19 E J, made in Bruges ca. 1473–1483.

62. The textual placement of the surviving images is as follows: fol. 3v, picture before the introduction to day 1; fol. 47v, picture before the summary for the first tale of day 2; fol. 121v, picture before the summary for the first tale of day 3; fol. 172v, picture before the in-

troduction for day 4; fol. 256r, picture before the introduction to day 6; fol. 278v, picture before the introduction to day 7; fol. 360r, picture before the prologue to day 9. This manuscript would also have had illuminations for days 5, 8, and 10.

63. See Boccaccio, *Boccace Decameron*, 859: "Guilfroy, surnommé Proende emprunta grant somme de pecune d'un marchant milanois nommé Gaspariol, avec la femme du quel cestui Guilfroy accorda de gesir par ainsi que elle auroit deux cens florins, et Guilfroi lui donna; et après en la presence du mari Guilfroy lui dist, comme vray estoit, que a sa femme il avoit baillé la pecune a lui prestee, et elle confessa la chose estre vraie."

64. For the full tale, see Boccaccio, *Boccace Decameron*, 865–73.

65. On the Dunois Master, see Avril and Reynaud, *Les manuscrits à peintures*, 36–38; and Clark, *Art in a Time of War*, 270–78.

66. BnF Ms. fr. 239 lacks Laurent's prologue with its dedication to John of Berry, as most of the surviving copies do. It omits the summary for the fourth tale on day 3 and all the transitional material (continuation, song, statement) between the tenth tale of day 8 and the first tale of day 9.

67. Drawings are still visible in the margins on folios 106r, 112v, 120v, and 159r.

68. Most of the signatures are trimmed, and some are very strange (as when the twentieth quire has signatures with the letters *s, t, u,* and *k* or *h*), so it is difficult to deduce much beyond this possibility. All the quires have catchwords that correspond to the opening of the quire that follows.

69. In this manuscript, as in Laurent's full translation, there is a song at the end of every day but the eighth and one placed after the seventh tale of day 10. The images of song in BnF Ms. fr. 239 appear at the ends of days 3, 4, 5, 6, 7, and 9. See folios 109r, 140r, 168v, 184v, 211v, and 266r of BnF Ms. fr. 239, online at *Gallica* at ark:/12148/btv1b8458435h.

70. For instance, Étienne Chevalier's brother-in-law, Antoine Raguier, and his son-in-law Laurent Girard, like Étienne, seem to have commissioned books at least partly illustrated by Jean Fouquet. In addition to the famous Hours of Étienne Chevalier in Chantilly, Fouquet painted eight miniatures in a book of hours likely begun for Antoine (Morgan M. 834) and the famous frontispiece of the Trial of Jean d'Alencon for Laurent Girard's copy of the *De cas des nobles hommes et femmes* (Munich, Bayerische Staatsbibliothek Cod. Gall. 6). For the Hours of Étienne Chevalier, see Avril, *Jean Fouquet*, 193–217; and Reynaud, *Jean Fouquet*. For the *De cas* in Munich, see Avril, *Jean Fouquet*, 272–307, no. 32; and Morrison and Hedeman, *Imagining the Past*, 239–42, no. 43. For a fuller analysis of Étienne Chevalier's *Le livre des cent nouvelles*, see Hedeman, "Rereading Boccaccio."

71. For a fuller analysis of this visual cycle, see Hedeman, "Rereading Boccaccio."

72. See Ianziti, "Between Livy and Polybius."

73. For these dates, and for the analysis of the two versions of the texts, see Pons, "Leonardo Bruni, Jean Lebègue et la cour," 104–105. For the earlier version, see Tesnière, *L'histoire romaine de Tite-Live*.

74. I would like to thank Gregory Clark for consulting with me (correspondence of December 2, 2018) about the artists of this manuscript. For the style associated with the Johannes Gielemans Master who was active in Brussels, see Bousmanne and Delcourt, *Miniatures flamandes*, 202–3; and Alexander, Marrow, and Sandler, *Splendor of the Word*,

no. 96, 407–12. For the style labeled the Maître aux grisailles fleurdelisées, see Bousmanne and Delcourt, *Miniatures flamandes,* 372–77.

75. For these dates, and for the analysis of the two versions of the texts, see Pons, "Leonardo Bruni, Jean Lebègue et la cour," 104–5. There may have been a numbered list describing the illuminations, since a copy made before its first mention in the inventory in 1467 from the collection of Philip the Good (KBR Ms. 10777) has illuminations painted by two different artists that are numbered sequentially in their margins. See Bousmanne and Delcourt, *Miniatures flamandes,* 248–49, no. 47.

76. See BnF Ms. fr. 23086, fols. 6r and 10r. This same thing happens in the Thompson-Yates manuscript on folios 1r and 3r.

77. The directions have been rubbed and often are written in the gutter of the manuscript, so it is difficult to make them out.

78. The legates in Arsenal Ms-5086 rés. (fols. 44v, 77r, and 78v), the former Thompson-Yates manuscript (fols. 27r, 49v, and 50r), and BnF Ms. fr. 23086 (fols. 59v, 104r, and 106r) are all represented as secular figures. ATILF CNRS, *DMF,* offers a definition of *légat* as a secular figure based on its usage in translations by Pierre Bersuire, Simon de Hesdin, and Nicolas Oresme, and as a cardinal in several descriptions of a legate as a representative of the Holy See. See http://www.atilf.fr/dmf/definition/légat1.

79. See, for instance, the image of the battle of Trasimene from circa 1415 (Houghton, Ms. Richardson 32, vol. II, fol. 18v) in Bersuire's *Histoire romaine,* a translation of Livy, which shows Hannibal's forces crammed into castellated towers on the backs of elephants. Morrison and Hedeman, *Imagining the Past,* 230–32, no. 40.

80. See previous discussion of this letter above in the introduction. For the text of letter 157, see Jean de Montreuil, *Epistolario,* 224–25; for Ornato's French summary of it, see Jean de Montreuil, *Monsteroliana,* 237–39.

Alexander, Jonathan. *Medieval Illuminators and Their Methods of Work*. New Haven, CT: Yale University Press, 1992.

Alexander, Jonathan, James H. Marrow, and Lucy Freeman Sandler. *The Splendor of the Word: Medieval and Renaissance Illuminated Manuscripts at the New York Public Library*. New York: Harvey Miller, 2005.

Alirot, Anne-Hélène, Murielle Gaude-Ferragu, Gilles Lecuppre, Elodie Lequain, Lydwine Scordia, and Julien Véronèse. *Une histoire pour un royaume (XIIe–XVe siècle)*. Paris: Perrin, 2010.

Anderson, Harald. *The Manuscripts of Statius*. 3 vols. Arlington, VA: Anderson, 2009.

Andrews, Christine Geisler. "The Boucicaut Masters." *Gesta* 41(2002): 29–38.

———. "The Boucicaut Workshop and the Commercial Production of Books of Hours in Early Fifteenth-Century Paris." Ph.D. diss., Northwestern University, 2006.

ATILF CNRS—Nancy Université. *DMF: Dictionnaire du Moyen Français, version 2015*. ATILF—CNRS and Université de Lorraine. http://www.atilf.fr/dmf.

Autrand, Françoise. *Charles VI: La folie du roi*. Paris: Fayard, 1986.

Autrand, Françoise, Claude Gauvard, and Jean-Marie Moeglin, eds. *Saint-Denis et la royauté: Études offertes à Bernard Guenée*. Paris: Publications de la Sorbonne, 1999.

Avesani, Rino, Mirella Ferrari, Tino Foffano, Giuseppe Frasso, and Agostino Sottili, eds. *Vestigia: Studi in onore di Giuseppe Billanovich*. Rome: Edizioni di storia e letteratura, 1984.

Avril, François. *Jean Fouquet: Peintre et enlumineur du xve siècle*. Paris: Hazan, 2003.

———. "Un manuscrit d'auteurs classiques et ses illustrations." In *The Year 1200: A Symposium*, edited by Jeffrey Hoffeld, 261–71. New York: Metropolitan Museum of Art, 1975.

———. "Trois manuscrits Napolitains des collections de Charles V et de Jean de Berry." *Bibliothèque de l'École des chartes* 127 (1969): 291–328.

Avril, François, Marie-Thérèse Gousset, Jacques Monfrin, Jean Richard, Marie-Hélène Tesnière, and Thomas Reimer, eds. *Marco Polo, Le livre des merveilles: Manuscrit français 2810 de la Bibliothèque nationale de France*. Lucerne: Faksimile Verlag, 1996.

Avril, François, and Nicole Reynaud. *Les manuscrits à peintures en France, 1440–1520*. Paris: Flammarion: Bibliotheque Nationale, 1993.

Avril, François, Nicole Reynaud, and Dominique Cordellier. *Les Enluminures du Louvre: Moyen Age et Renaissance*. Paris: Hazan, 2011.

Bamford, Heather. "Remember the Giver(s): The Creation of the *Querelle* and Notions of Sender and Recipient in University of California, Berkeley, MS 109." *Atalaya* 11 (2009). http://journals.openedition.org/atalaya/460.

Barrois, Joseph. *Bibliothèque prototypographique, ou libraries des fils du roi Jean: Charles V, Jean de Berri, Philippe de Bourgogne, et les siens.* Paris: Treuttel et Würtz, 1830.

Battles, Dominique. *The Medieval Tradition of Thebes: History and Narrative in the OF* Roman de Thèbes, *Boccaccio, Chaucer, and Lydgate.* New York: Routledge, 2004.

Bauermeister, Ursula, and Marie-Pierre Laffitte. *Des livres et des rois: La bibliothèque royale de Blois.* Paris: Bibliothèque nationale, 1992.

Beck, Linda. "Laurent de Premierfait's *Les Cent Nouvelles*: An Emblem for Cultural Appropriation in Fifteenth-Century French Literature." Ph.D. diss., University of Washington, 2003.

Berenbeim, Jessica. "Livy in Paris." A.B. thesis, Harvard University, 2003.

Bibliothèque nationale de France. *Archives et manuscrits.* http://archivesetmanuscrits.bnf.fr/.

———. *Gallica.* http://gallica.bnf.fr.

Blanc, Odile. *Parades et parures: L'invention du corps de mode à la fin du Moyen Âge.* Paris: Gallimard et C., 1997.

Boccaccio, Giovanni. *Boccace Decameron traduction (1410–1414) de Laurent de Premierfait.* Edited by Giuseppe Di Stefano. Montreal: CERES, 1999.

———. *De casibus virorum illustrium.* Vol. 9 of *Tutte le opera di Giovanni Boccaccio.* Edited by Pier Giorgio Ricci and Vittorio Zaccaria. Venice: Arnoldo Mondadori Editore, 1983.

———. *Des cleres et nobles femmes: Ms. Bibl. Nat. 12420.* Edited by Jeanne Baroin and Josiane Haffen. 2 vols. Paris: Les Belles Lettres, 1993–1995.

———. *Genealogy of the Pagan Gods.* Edited and translated by Jon Solomon. The I Tatti Renaissance Library, 46. Cambridge MA: Harvard University Press: 2011.

Boislisle, M. A. de, and M. le duc de la Trémoïlle. "Inventaire des bijoux: vêtements, manuscrits et objets précieux: appurtenant à la Comtesse de Montpensier, 1474." *Annuaire-Bulletin de la Société de l'histoire de France* 17 (1880): 269–309.

Boudon-Machuel, Marion, Maurice Brock, and Pascale Charron, eds. *Aux limites de la couleur: Monochromie & polychromie dans les arts (1300–1600).* Turnhout: Brepols, 2011.

Bousmanne, Bernard, and Thierry Delcourt. *Miniatures flamandes 1404–1482.* Paris: Bibliothèque nationale de France, 2011.

Bousmanne, Bernard, Tania Van Hemelryck, and Céline Van Hoorebeeck. *La librarie des ducs de Bourgogne: Manuscrits conservés à la Bibliothèque royale de Belgique.* Vol. 4 of *Textes historiques.* Turnhout: Brepols, 2009.

Boutet, Dominique, and Jacques Verger, eds. *Penser le pouvoir au Moyen Age (VIIIe–XVe siècle): Études d'histoire et de littérature offertes à Françoise Autrand.* Paris: Rue d'Ulm, 2000.

Bozzolo, Carla. "Familles éclatées, amis dispersés: Échos des guerres civiles dans les écrits de Christine de Pizan et de ses contemporains." In *Contexts and Continuities: Proceedings of the Fourth International Colloquium on Christine de Pizan (Glasgow 21–27 July*

2000), edited by Angus J. Kennedy, Rosalind Brown-Grant, James C. Laidlaw, and Catherine M. Müller, 3 vols., 1:115–28. Glasgow: University Press, 2002.

———. "L'humaniste Gontier Col et Boccace." In *Boccaccio in Europe: Proceedings of the Boccaccio Conference, Louvain December 1975*, edited by Gilbert Tournoy, 15–22. Leuven: University Press, 1977.

———. "L'humaniste Gontier Col et la traduction française des *Lettres* d'Abélard et Héloïse." *Romania* 95 (1974): 199–215.

———. "L'intérêt pour l'histoire romaine à l'époque de Charles VI: l'exemple de Laurent de Premierfait." In *Saint Denis et la royauté: études offertes à Bernard Guenée*, edited by Françoise Autrand, Claude Gauvard, and Jean-Marie Moeglin, 109–24. Paris: Publications de la Sorbonne, 1999.

———. "Laurent de Premierfait et Térence." In *Vestigia: Studi in onore di Giuseppe Billanovich*, edited by Rino Avesani, Mirella Ferrari, Tino Foffano, Giuseppe Frasso, and Agostino Sottili, 93–129. Rome: Edizioni di storia e letteratura, 1984.

———. *Manuscrits des traductions françaises d'œuvres de Boccace, XV siècle.* Padua: Antenore, 1973

———, ed. *Un traducteur et un humaniste de l'époque de Charles VI: Laurent de Premierfait.* Paris: Publications de la Sorbonne, 2004.

Bozzolo, Carla, and Colette Jeudy. "Stace et Laurent de Premierfait." *Italia medioevale e umanistica* 22 (1979): 413–47.

Bozzolo, Carla, and Hélène Loyau. *La Cour amoureuse dite de Charles VI.* 3 vols. Paris: Le Léopard d'or, 1982–92.

Bozzolo, Carla, and Ezio Ornato, eds. *Préludes à la Renaissance: Aspects de la vie intellectuelle en France au XVe siècle.* Paris: Editions du CNRS, 1992.

Branca, Vittore, ed. *Opere d'arte d'origine francese, fiamminga, inglese, spagnola, tedesca.* Vol. 3 of *Boccaccio visualizzato: Narrare per parole e per immagini fra Medioevo e Rinascimento.* Torino: G. Einaudi, 1999.

Briquet Online. https://briquet-online.at.

British Library. Digitised Manuscripts. http://www.bl.uk/manuscripts.

———. *Electronic British Library Journal.* http://www.bl.uk/eblj/.

Brown, Carleton. "The 'Pride of Life' and the 'Twelve Abuses.'" *Archiv für das Studium der neueren Sprachen und Literaturen* 128 (1912): 72–78.

Buettner, Brigitte. *Boccaccio's* Des cleres et nobles femmes: *Systems of Signification in an Illuminated Manuscript.* Seattle: University of Washington Press, 1996.

———. "Past Presents: New Year's Gifts at the Valois Court circa 1400." *Art Bulletin* 83 (2001): 598–625.

Buonocore, Marco, ed. *Vedere i classici: L'illustrazione libraria dei testi antichi dall'età romana al tardo Medioevo.* Rome: Palombi Editori, 1996.

Bussi, Angela Dillon, and Giovanni M. Piazza. *Biblioteca Trivulziana, Milano.* Fiesole: Nardini, 1996.

Byrne, Donal. "An Early French Humanist and Sallust: Jean Lebègue and the Iconographical Programme for the *Catiline* and *Jugurtha*." *Journal of the Warburg and Courtauld Institutes* 49 (1986): 41–65.

Carruthers, Mary. "*Ars oblivionalis, ars inveniendi*: The Cherub Figure and the Arts of Memory." *Gesta* 48, no. 2 (2009): 99–117.

———. *The Book of Memory: A Study of Memory in Medieval Culture*. Cambridge: Cambridge University Press, 2008.

Cavailler, Paulette. "Le compte des exécuteurs testamentaires d'Agnès Sorel." *Bibliothèque de l'École des chartes* 114 (1956): 97–114.

Cayley, Emma. *Debate and Dialogue: Alain Chartier in His Cultural Context*. Oxford: Clarendon, 2006.

Cazelles, Raymond. *Société politique, noblesse, et couronne sous Jean le Bon et Charles V.* Mémoires et documents publiés par la Société de l'École des chartes, no. 28. Geneva: Librarie Droz, 1982.

Cecchetti, Dario, Lionello Sozzi, and Louis Terreaux, eds. *L'aube de la Renaissance*. Geneva: Slatkine, 1991.

Champion, Peter, ed. *La librarie de Charles d'Orléans*. Paris: Honoré Champion, 1910.

Charras, Caroline. "La traduction de Valère-Maxime par Nicolas de Gonesse." Ph.D. diss., McGill University, 1982.

Charron, Pascale, Marc-Edouard Gautier, and Pierre-Giles Girault. *Trésors enluminés des Musées de France—Pays de la Loire et Centre*. Angers: Musées d'Angers, 2013.

Châtelet, Albert. *L'âge d'or du manuscrit à peintures en France au temps de Charles VI*. Paris: Faton, 2000.

———. "Un traité de bonnes moeurs écrit et illustré dans une période tourmentée." *Art de l'enluminure* 1 (2002): 40–62.

Christine de Pizan. *The Book of the City of Ladies*. Translated by Earl Jeffrey Richards. New York: Persea Books, 1982.

———. *Debate of the* Romance of the Rose. Edited by David Hult. Chicago: University of Chicago Press, 2014.

———. *Le Livre des epistres du debat sus le* Rommant de la Rose. Edited by Andrea Valentini. Paris: Classiques Garnier, 2014.

———. *Le livre des fais et bonnes meurs du sage roy Charles V par Christine de Pisan*. Edited by Suzanne Solente. 2 vols. Paris: H. Champion, 1936–40.

Cicero, Marcus Tullius. *Cicero Orations Pro Milone. In Pisonem. Pro Scauro. Pro Fonteio. Pro Rabirio Postumo. Pro Marcello. Pro Ligario. Pro Rege Deiotaro*. Edited and translated by Nevile H. Watts. Cambridge, MA: Harvard University Press, 1979.

———. *On Old Age. On Friendship. On Divination*. Translated by William Armistead Falconer. Cambridge, MA: Harvard University Press, 1979.

Clark, Gregory. *Art in a Time of War: The Master of Morgan 453 and Manuscript Illumination in Paris during the English Occupation (1419–35)*. Text Image Context: Studies in Medieval Manuscript Illumination 3. Toronto: Pontifical Institute of Medieval Studies, 2016.

Clogan, Paul. "Literary Genres in a Medieval Textbook." *Medievalia et Humanistica* 11 (1982): 199–209.

———. *The Medieval Achilleid of Statius*. Leiden: E. J. Brill, 1968.

Coleman, Joyce. *Public Reading and the Reading Public in Late Medieval England and France*. Cambridge: Cambridge University Press, 1996.

Coleman, Joyce, Mark Cruse, and Kathryn Smith, eds. *The Social Life of Illumination: Manuscripts, Images, and Communities in the Late Middle Ages*. Medieval Texts and Cultures of Northern Europe 21. Turnhout: Brepols, 2013.

Contamine, Philippe, ed. *La noblesse au Moyen Âge, XIe–XVe siècles. Essais à la mémoire de Robert Boutruche*. Paris: Presses universitaires de France, 1976.

Croenen, Godfried, and Peter Ainsworth, eds. *Patrons, Authors, and Workshops: Books and Book Production in Paris around 1400*. Louvain: Peeters, 2006.

Cucchi, Paolo. "The First French *Decameron*: A Study of Laurent de Premierfait's Translation." Ph.D. diss., Princeton University, 1972.

Delahaye, Elisabeth, ed. *Paris 1400: Les arts sous Charles VI*. Paris: Fayard, 2004.

Delisle, Leopold. *Recherches sur la librairie de Charles V*. 2 vols. Paris: Honoré Champion, 1907.

Delsaux, Olivier. "Laurent de Premierfait, dernier poète courtois champenois ou premier poète français italianisant? La première traduction française des canzoni du Decameron de Giovanni Boccaccio." *Medioevo Romanzo* 40 (2016): 301–32.

———. *Manuscrits et pratiques autographes chez les écrivains français de la fin du Moyen Âge: L'exemple de Christine de Pizan*. Geneva: Droz, 2013.

———. "La ou les traduction(s) française(s) du *De casibus virorum illustrium* de Giovanni Boccaccio au XVe siècle? Mise au point sur l'histoire d'ʻun' texte. 1re partie." *Revue d'histoire des textes* 12 (2017): 321–52.

———. "La ou les traduction(s) française(s) du *De casibus virorum illustrium* de Giovanni Boccaccio au XVe siècle? Mise au point sur l'histoire d'ʻun' texte. II." *Revue d'histoire des textes* 13 (2018): 355–81.

———. "La philologie au risque des traditions mixtes. Le cas du *Livre de vieillesse* de Laurent de Premierfait." *Revue belge de philologie et d'histoire* 91 (2013) [2014]: 935–1009.

———. "Qu'est-ce qu'un escripvain au Moyen Âge? Étude d'un polysème." *Romania* (2014): 11–158.

———. "Textual and Material Investigation on the Autography of Laurent de Premierfait's Original Manuscripts," *Viator* 45, no. 3 (2014): 299–338.

Delsaux, Olivier, and Tania Van Hemelryck. *Les manuscrits autographes en français au Moyen Âge: Guide de recherche*. Turnhout, Brepols, 2014.

De Renzi, Salvatore, August Wilhelm, Eduard Theodor Henschel, and Charles Daremberg. *Collectio Salernitana: Ossia documenti inediti, e trattati di medicina appartenenti alla scuola medica Salernitana*. 5 vols. Naples: Dalla Tipographia del Filiatre-Sebezio, 1852–1859.

de Winter, Patrick M. *La bibliothèque de Philippe le Hardi, duc de Bourgogne (1364–1404): Étude sur les manuscrits à peintures d'une collection princière à l'époque du "style gothique international."* Paris: Éditions du Centre nationale de la recherches scientifiques, 1985.

Di Stefano, Giuseppe. "Il *Decameron* da Boccaccio a Laurent de Premierfait." *Studi sul Boccaccio* 29 (2001): 105–36.

———. "Tradurre il *Decameron* nel Quattrocento: Quale *Decameron*?" *La parola del testo* 1, no. 2 (1997): 272–78.

Dominik, William J., Carole Elisabeth Newlands, and Kyle Gervais, eds. *Brill's Companion to Statius*. Leiden: Brill, 2015.

Douët-d'Arcq, Louis, ed. *Inventaire de la bibliothèque du roi Charles VI fait au Louvre par ordre du régent duc de Bedford*. Paris: Société des bibliophiles, 1867.

Doutrepont, Georges. *Inventaire de la "librairie" de Philippe le Bon (1420)*. Brussels: Kiessling et cie, 1906.

Dubois, Anne. "Tradition et transmission: Un exemple de filiation dans les manuscrits enluminés de Valère Maxime." *Revue des archéologues et historiens d'art de Louvain* 27 (1994): 51–60.

———. *Valère Maxime en français à la fin du Moyen Âge. Images et tradition*. Manuscripta Illuminata 1. Turnhout: Brepols, 2016.

Du Fresne de Beaucourt, Gaston. *Histoire de Charles VII*. 6 vols. Paris: A. Picard, 1881–1891.

Eikelmann, Renate, and Christoph Kürzeder. *Bewegte Zeiten: Der Bildhauer Erasmus Grasser (um 1450–1518)*. Munich: Hirmer Verlag, 2018.

Enguerran de Monstrelet. *La cronique d'Enguerran de Monstrelet*. Edited by Louis Douët-D'Arcq. 6 vols. Paris: Renouard, 1857–61.

Fachechi, Grazia Maria. "Plauto illustrato fra medioevo e umanesimo." *Rendiconti. Accademia Nazionale dei Lincei, Classe di Scienze Morali*. Series 9, vol. 13 (2002): 177–242.

Falmagne, Thomas, and Baudouin Van den Abeele, eds. *Dukes of Burgundy*. Vol. 5 of *Corpus Catalogorum Belgii: The Medieval Booklists of the Southern Low Countries*. Leuven: Peeters, 2016.

Famiglietti, Richard. *Royal Intrigue: Crisis at the Court of Charles VI, 1392–1420*. AMS Studies in the Middle Ages 9. New York: AMS Press, 1986.

Fillon, Benjamin. "Liste des bourgeois de Paris qui prêtèrent serment à Jean sans Peur, duc de Bourgogne, le 28 aout 1418 et jours suivants." *Bulletin de la Société des antiquaires de l'Ouest* (1845): 193–215.

Fresco, Karen, ed. *Authority of Images/Images of Authority. Shaping Political and Cultural Identities in the Pre-Modern World*. Kalamazoo, MI: Medieval Institute Publications, 2016.

Galderisi, Claudio, ed. *Translations médiévales: Cinq siècles de traductions en français au Moyen Âge (XIe – XVe siècles), Étude et Répertoire*. Vol. 1, *De la* translatio studii *à l'étude de la* translatio. Turnhout: Brepols, 2011.

Galderisi, Claudio, and Cinzia Pignatelli. *La traduction vers le moyen français: Actes du IIe colloque de IAIEMF, Poitiers 29 avril 2006*. Turnhout: Brepols, 2007.

Galderisi, Claudio, and Jean-Jacques Vincensini, eds. *La fabrique de la traduction. Du topos du livre source à la traduction empêchée*. Bibliothèque de Transmédie 3. Turnhout: Brepols, 2016.

Gauvard, Claude. *"De grace especial": Crime état et société en France à la fin du Moyen Âge.* 2 vols. Paris: Publications de la Sorbonne, 1991.

———. "Pendre et dépendre à la fin du Moyen Âge: Les exigences d'un ritual judiciaire." *Histoire de la justice* 4 (1991): 2–24.

Gerson, Jean. *Jean de Gerson et l'éducation des dauphins de France: Édition critique suivi du texte de deux de ses opuscules et de documenets inédits sur Jean Majoris, preceptor de Louis IX.* Edited by Antoine Thomas. Paris: Librairie E. Droz, 1930.

———. *L' Œuvre épistolaire.* Vol. 2 of *Œuvres completes.* Edited by Palémon Glorieux. Paris: Desclée & Cie., 1960.

Gorochov, Natalie. *Le collège de Navarre de sa fondation (1305) au début du XVe siècle (1418): Histoire de l'institution, de sa vie intellectuelle et de son recrutement.* Paris: Honoré Champion-Slatkine, 1997.

Gualdo, Germano, ed. *Cancelleria e cultura nel Medio Evo.* Actes de la Commission Internationale de Diplomatique au Congrès International des Sciences Historiques (Stuttgart, août 1985). Vatican City: Archivio Segreto Vaticano, 1990.

Guenée, Bernard. *Un meutre, une société: L'assassinat du duc d'Orléans 23 novembre 1407.* Paris: Gallimard, 1992.

Guiffrey, Jules, ed. *Inventaires de Jean, duc de Berry (1401–16).* 2 vols. Paris: E. Leroux, 1894–1896.

Guineau, Bernard, Inès Villela-Petit, Robert Akrich, and Jean Vezin. "Painting Techniques in the Boucicaut Hours and in Jacques Coene's Colour Recipes as found in Jean Lebègue's *Libri Colorum.*" In *Painting Techniques: History, Materials, and Studio Practice,* edited by Ashok Roy and Perry Smith, 51–54. London: International Institute for Conservation of Historic and Artistic Works, 1998.

Hankins, James. *Virtue Politics: Soulcraft and Statecraft in Renaissance Italy.* Cambridge, MA: Belknap Press, 2019.

Harf-Lancner, Laurence. "L'élaboration d'un cycle romanesque antique au XIIe siècle et sa mise en images: *Le roman de Thèbes, Le roman de Troie* et le *Roman d'Énéas* dans le manuscrit BN français 60." In *Le monde du roman grec. Actes du colloque international tenu à l'École normale supérieure, Paris 17–19 décembre 1987,* edited by Marie-Françoise Baslez, Philippe Hoffmann, and Monique Trédé, 291–306. Études de littérature ancienne 4. Paris: Presses de l'École normale supérieure, 1992.

Hargreaves-Mawdsley, William Norman. *A History of Legal Dress in Europe until the End of the Eighteenth Century.* Oxford: Clarendon Press, 1963.

Hedeman, Anne D. "Advising France through the Example of England: Visual Narrative in the *Livre de la prinse et mort du roy Richart* (Harl. MS. 1319)." *Electronic British Library Journal* (2011). https://www.bl.uk/eblj/2011articles/article7.html.

———. "L'humanisme et les manuscrits enluminés: Jean Lebègue et le manuscrit de Salluste de Genève, Bibliothèque publique et universitaire, ms. 54." In *La création artistique en France autour de 1400, Rencontre de l'École du Louvre,* edited by Elisabeth Delahaye, 443–57. Paris: Publications du Louvre, 2006.

———. "Illuminating Boccaccio: Visual Translation in Early Fifteenth-Century France." *Mediaevalia* 34 (2013):111–53.

———. "Jean Lebègue et la traduction visuelle de Salluste et de Leonardo Bruni au XVᵉ siècle." In *Quand l'image relit le texte*, edited by Sandrine Hériché-Pradeau and Maud Pérez-Simon, 59–70. Paris: Presses Sorbonne Nouvelle, 2013.

———. "Laurent de Premierfait and the Visualization of Antiquity." In *Medieval Manuscripts, Their Makers and Users: A Special Issue of Viator in Honor of Richard and Mary Rouse*, edited by Christopher Basewell, 27–50. Turnhout: Brepols, 2011.

———. "Making the Past Present in Laurent de Premierfait's Translation of *De senectute* (BnF lat. 7789)." In *Excavating the Medieval Image: Manuscripts, Artists, Audiences—Essays in Honor of Sandra Hindman*, edited by Nina Rowe and David Areford, 59–80. London: Ashgate Press, 2004.

———. "Performing Documents and Documenting Performance in the *Procès de Robert d'Artois* (BnF MS fr. 18437) and Charles V's *Grandes chroniques de France* (BnF MS fr. 2813." In *The Social Life of Illumination: Manuscripts, Images, and Communities in the Late Middle Ages*, edited by Joyce Coleman, Mark Cruse, and Kathryn Smith, 339–69. Medieval Texts and Cultures of Northern Europe 21. Turnhout: Brepols, 2013.

———. Rereading Boccaccio in Etienne Chevalier's Decameron (Houghton Library MS Richardson 31)." in *Beyond Words: Illuminated Manuscripts in Boston Collections. Proceedings of the International Conference, Nov. 3–5, 2016*, edited by Lisa Fagin Davis, Anne-Marie Eze, Jeffrey F. Hamburger, Nancy Netzer, and William Stoneman, 77–98. Toronto: Pontifical Institute of Mediaeval Studies, 2021.

———. *The Royal Image: The Illustrations of the* Grandes Chroniques de France, *1274–1422*. California Studies in the History of Art 28. Berkeley: University of California Press, 1991.

———. "Translating Power for the Princes of the Blood: Laurent de Premierfait's Des cas des nobes homme et femmes." In *Textual and Visual Representations of Power and Justice in Medieval France: Manuscripts and Early Printed Books*, edited by Rosalind Brown-Grant, Anne D. Hedeman, and Bernard Ribémont, 15–41. Farnham: Ashgate, 2015.

———. "Translating Prologues and Prologue Illustration in French Historical Texts." In *Inscribing Knowledge in the Medieval Book: Power and the Paratext*, edited by Rosalind Brown-Grant, Patrizia Carmazzi, Gisela Drossbach, Anne D. Hedeman, Victoria Turner, and Iolanda Ventura, 197–223. Berlin: de Gruyter, 2019.

———. *Translating the Past: Laurent de Premierfait and Boccaccio's* De casibus. Los Angeles: Getty, 2008.

———. "Visual Translation in Laurent de Premierfait's French Versions of Boccaccio's *De casibus virorum illustrium*." In *Un traducteur et un humanist de l'époque de Charles VI: Laurent de Premierfait*, edited by Carla Bozzolo, 83–113. Paris: Publications de la Sorbonne, 2004.

Hériché-Pradeau, Sandrine, and Maud Pérez-Simon, eds. *Quand l'image relit le texte*. Paris: Presses Sorbonne Nouvelle, 2013.

Hill, Giulia Torello, and Andrew Turner, eds. *Terence between Late Antiquity and the Age of Printing: Illustration, Commentary and Performance*. Leiden: Brill, 2015.

Hindman, Sandra. *Christine de Pizan's Epistre Othéa: Painting and Politics at the Court of Charles VI.* Toronto: Pontifical Institute of Medieval Studies, 1986.

Hirschbiegel, Jan. *Étrennes: Untersuchungen zum höfischen Geschenkverkehr im spätmittel-alterlichen Frankreich der zeit König Karls VI (1380–1422).* Munich: R. Oldenbourg Verlag, 2003.

Hoffmann, Mara, and Caroline Zöhl, eds. *Quand la peinture était dans les livres: Mélanges en l'honneur de François Avril à l'occasion de la remise du titre de docteur honoris causa de la Freie Universität Berlin.* Turnhout: Brepols, 2007.

Hutchison, Emily. "Partisan Identity in the French Civil War, 1405–1418: Reconsidering the Evidence on Livery Badges." *Journal of Medieval History* 33 (2007): 250–74.

———. "*Pour le bien du roy et de son royaume*: Burgundian Propaganda under John the Fearless, Duke of Burgundy 1405–1419." Ph.D. diss., University of York, 2006.

Ianziti, Gary. "Between Livy and Polybius: Leonardo Bruni on the First Punic War." *Memoirs of the American Academy in Rome* 51/52 (2006/2007): 173–97.

Isidore of Seville. *The Etymologies of Isidore of Seville.* Translated by Stephen A. Barney, W. J. Lewis, J. A. Beach, and Oliver Berghof. Cambridge: Cambridge University Press, 2006.

Jean de Montreuil. *Epistolario.* Edited by Ezio Ornato. Vol. 1 of *Opera.* Turin: G. Giappichelli, 1963.

———. *Monsteroliana.* Edited by Ezio Ornato, Gilbert Ouy, and Nicole Grevy-Pons. Vol. 4 of *Opera.* Paris: Éditions CEMI, 1986.

Jeudy, Colette, and Yves-François Riou. "L'Achilléide de Stace au moyen age: abrégées et arguments." *Revue d'histoire des textes* 4 (1974): 143–80.

Jónsson, Einar Már. "Les 'miroirs aux princes' sont-ils un genre littéraire?" *Médiévales* 51 (2007): 1–11.

Jung, Marc-René. *La Légende de Troie en France au moyen age.* Basel: Francke Verlag, 1996.

Kallendorf, Craig W., ed. *A Companion to the Classical Tradition.* Blackwell Companions to the Ancient World 18. Chichester: Blackwell, 2010.

König, Eberhard. *Boccaccio Decameron: Alle 100 Miniaturen der ersten Bilderhandschrift.* Stuttgart: Belser Verlag, 1989.

Kristeller, Paul Oskar. "Humanism," In *The Cambridge History of Renaissance Philosophy*, edited by Charles Schmitt and Quentin Skinner, 113–37. Cambridge: Cambridge University Press, 1988.

Krynen, Jacques. *L'empire du roi.* Paris: Gallimard, 1993.

Kubiski, Joyce. "Orientalizing Costume in Early Fifteenth-Century French Manuscript Painting." *Gesta* 40, no. 2 (2001): 161–80.

Kumler, Aden. "'Faire translater, faire historier:' Charles V's *Bible historiale* and the Visual Rhetoric of Vernacular *Sapience*." *Studies in Iconography* 29 (2008): 90–135.

Labère, Nelly. "Du jardin à l'étude: lectures croisées du *Décaméron* de Boccace et de sa traduction française en 1414 par Laurent de Premierfait." *Rassegna europea di letteratura italiana* 20 (2002): 9–54.

Lachaud, Frédérique, and Lydwine Scordia, eds. *Le prince au miroir de la littérature politique de l'Antiquité aux Lumiéres*. Mont-Saint-Aignan: Publications des universités de Rouen et du Havre, 2007.

Laffitte, Marie-Pierre. "Les ducs de Bourbon et leurs livres d'après les inventaires." In *Le duché de Bourbon: Des origines au Connétable, suivi d'un extrait du "Désastre de Pavie," de Jean Giono. Actes du colloque des 5 et 6 octobre 2000, organisé par le Musée Anne-de-Beaujeu de Moulins*, 169–78. Saint-Pourçain-sur-Sioule: Bleu autour, 2001.

Lalande, Denis, ed. *Le "Livre des fais" du bon messier Jehan le Maingre, dit Bouciquaut, marechal de France et gouverneur de Jennes*. Paris: Droz, 1985.

Laurent de Premierfait. "Édition critique du *Des cas des nobles hommes et femmes* par Laurent de Premierfait (1400)," edited by Stefania Marzano. Ph.D. diss., University of Toronto, 2008.

———. *Laurent de Premierfait's "Des cas des nobles hommes et femmes" Book 1. Translated from Boccaccio. A Critical Edition Based on Six Manuscripts*. Edited by Patricia Gathercole. Chapel Hill: University of North Carolina Press, 1968.

———. *Laurent de Premierfait, Livre de vieillesse*. Edited by Stefania Marzano. Texte, Codex & Contexte 6. Turnhout: Brepols, 2009.

———. *Le livre de la vraye amistié*. Edited by Olivier Delsaux. Les classiques français du Moyen Age: Collection de textes français et provençaux antérieurs à 1500 177. Paris: H. Champion, 2016.

Lebègue, Jean. *Les histoires que l'on peut raisonnablement faire sur les livres de Salluste*. Edited by Jean Porcher. Paris: Pour la Société des Bibliophiles françois, Librairie Giraud-Badin, 1962.

Lendering, Jona. "Pontifex Maximus." *Livius: Cultuur, gescheidenis en literatuur* (March 14, 2019). http://www.livius.org/articles/concept/pontifex-maximus/.

Leroux de Lincy, Antoine. "Catalogue de la bibliothèque des ducs de Bourbon en 1524." In *Mélanges de la littérature et d'histoire recueillis et publiés par la Société des bibliophiles François*, 43–144. Paris: Impr. de Crapelet, 1850.

Liberman, Max. "Chronologie gersonienne, II." *Romania* 73 (1952): 480–96.

———. "Chronologie gersonienne, III." *Romania* 74 (1953): 289–337.

Maddocks, Hilary. "The Illuminated Manuscripts of the Légende Dorée: Jean de Vignay's Translation of Jacobus de Voragine's *Legenda aurea*." Ph.D. diss., University of Melbourne, 1990.

Mann, Nicholas, and Birger Munk Olsen. *Medieval and Renaissance Scholarship: Proceedings of the Second European Science Foundation Workshop on the Classical Tradition in the Middle Ages and the Renaissance (London, Warburg Institute, 27–28 November 1992)*. Mittellateinische Studien und Texte 21. Leiden: E. J. Brill, 1997.

Marshall, Mary M. "Theater in the Middle Ages: Evidence from Dictionaries and Glosses." *Symposium* 4 (1950): 1–39.

Marzano, Stefania. "Itinéraire français de Boccace: perspectives et enjeux d'un succès littéraire." *Le Moyen Français* 66 (2010): 61–68.

———. "Laurent de Premierfait: Entre le latin et le français." In *L'Ecrit et le manuscrit à la fin du Moyen Age*, edited by Tania Van Hemelryck, 229–38. Turnhout: Brepols, 2006.

————. "Le *Pro Marcello* de Cicéron en France au XVe siècle: le ms. La Haye, KB, 76 F 26." *Le Moyen Français* 62 (2008): 79–98.

————. "Traductions de Laurent de Premierfait: le texte après le texte." *Le Moyen Français* 63 (2008): 73–82.

Mattéoni, Olivier. "Portrait du prince idéal et idéologie nobiliaire dans 'La Chronique du bon duc Loys de Bourbon," *Studi Francesi* 39 (1995): 1–23.

McCormick, Thomas James. *A Partial Edition of "Les Fais des Rommains."* Ph.D. diss., Fordham University, 1981.

McKendrick, Scott, John Lowden, and Kathleen Doyle. *Royal Manuscripts: The Genius of Illumination.* London: British Library, 2011.

Meens, Rob. "Politics, Mirrors of Princes, and the Bible: Sins, Kings, and the Well-Being of the Realm." *Early Medieval Europe* 7 (1998): 345–57.

Meiss, Millard. *French Painting in the Time of Jean de Berry: The Limbourgs and Their Contemporaries.* 2 vols. New York: G. Braziller, 1974.

Meiss, Millard, with Sharon Off. "The Bookkeeping of Robinet d'Estampes and the Chronology of Jean de Berry's Manuscripts." *Art Bulletin* 53 (1971): 225–35.

Merrifield, Mary P., ed. *Original Treatises on the Arts of Painting.* 2 vols. London: n.p., 1849; repr. New York: Dover, 1999.

Mombello, Gianni. "I manoscritti delle opera di Dante, Petrarca, e Boccaccio nelle principale librerie francesi del secolo XV." In *Il Boccaccio nella cultura francese*, edited by Carlo Pellegrini, 81–209. Florence: Olschki, 1971.

Monfrin, Jacques. "La connaissance de l'antiquité et le problème de l'humanisme en langue vulgaire dans la France du XVe siècle." In *The Late Middle Ages and the Dawn of Humanism outside Italy*, edited by Gérard Verbeke and Jozef Ijsewijn, 131–70. Louvain: Leuven University Press, 1972.

————. "Humanisme et traduction au moyen age." *Journal des savants* (1963): 161–90.

————. "Les traducteurs et leur publique en France au moyen age." *Journal des savants* (1964): 5–20.

Morrison, Elizabeth. "Illuminations of the *Roman de Troie* and French royal dynastic ambition (1260–1340)." Ph.D. diss., Cornell University, 2002.

Morrison, Elizabeth, and Anne D. Hedeman. *Imagining the Past in France: History in Manuscript Painting 1250–1500.* Los Angeles: J. Paul Getty Museum, 2010.

Muzerelle, Danielle, and Marie-Hélène Tesnière. *El Decameron de Bocaccio [libro estudio del manoscrito conservado en la Bibliotheque de l'Arsenal, con signatura Ms. 5070 réserve].* Valencia: Scriptorium, 2009.

Nadolny, Jilleen, ed. *Medieval Painting in Northern Europe: Techniques, Analysis, Art History: Studies in Commemoration of the 70th Birthday of Unn Plahter.* London: Archetype, 2007.

Nebbiai-Dalla Guarda, Donatella. *La bibliothèque de l'abbaye de Saint-Denis en France du IXᵉ au XVIIᵉ siècle.* Paris: Edition du Centre nationale de la recherche scientifique, 1985.

Nordenfalk, Carl. "Hatred, Hunting and Love: Three Themes Relative to Some Manuscripts of Jean sans Peur." In *Studies in Late Medieval and Renaissance Painting in*

Honor of Millard Meiss, edited by Irving Lavin and John Plummer, 324–41 and figs. 112–16. New York: New York University Press, 1977.

Norton, Glyn P. "Laurent de Premierfait and the Fifteenth-Century French Assimilation of the *Decameron:* A Study in Tonal Transformation." *Comparative Literature Studies* 9, no. 4 (1972): 376–91.

Obrist, Barbara. "Wind Diagrams and Medieval Cosmology." *Speculum* 72, no. 1 (1997): 33–84.

Olsen, Birger Munk. *L'étude des auteurs classiques latins aux XIe et XIIe siècles.* 3 vols. Paris: Editions du CNRS, 1982–89.

Omont, Henri, ed. "Inventaire des livres de Jean Courtecuisse, évêque de Paris et de Genève (27 octobre 1423)." *Bibliothèque de l'École des chartes* 80 (1919): 109–20.

Ornato, Ezio. *Jean Muret et ses amis Nicolas de Clamanges et Jean de Montreuil: Contribution à l'étude des rapports entre les humanistes de Paris et ceux d'Avignon (1394–1420).* Geneva: Droz, 1969.

Ornato, Monique, and Nicole Pons, eds. *Pratiques de la culture écrite en France au XVe siècle.* Louvain-la-Neuve: Fédération internationale des instituts d'études médiévales, 1995.

Osmond, Patricia J., and Robert W. Ulery Jr. "Sallustius Crispus, Gaius." In vol. 8 of *Catalogus translationum et commentariorum: Mediaeval and Renaissance Latin Translations and Commentaries: Annotated Lists and Guides,* edited by Virginia Brown, 183–326. Washington, D.C.: Catholic University of America Press, 2003. http://catalogustranslationum.org/index.php/archives/volume-viii.

———. "Sallustius Crispus, Gaius. Addenda et Corrigenda." In vol. 10 of *Catalogus translationum et commentariorum: Mediaeval and Renaissance Latin Translations and Commentaries: Annotated Lists and Guides,* edited by Greti Dinkova-Bruun, 375–91. Toronto: Pontifical Institute of Medieval Studies, 2014.

Ouy, Gilbert. Dossier Lebègue. Fonds Gilbert Ouy, LaMOP Paris 1—Villejuif.

———. "Le collège de Navarre, berceau de l'humanisme français." In *Enseignement et vie intellectuelle, IXe–XVIe siècle (Actes du 95e Congrès National des Sociétés Savantes, Reims 1970),* 1: 276–99. Paris: Bibliothèque nationale, 1975.

———. "L'humanisme et propaganda politique en France au début du XVe siècle: Ambrogio Migli et les ambitions imperials de Louis d'Orléans." In *Culture et politique en France à l'époque de l'humanisme et de la Renaissance, atti del Convegno internazionale promosso dall'Accademia delle scienze di Torino in collaborazione con la Fondazione Giorgio Cini di Venezia, 29 marzo–3 aprile 1971,* edited by Franco Simone, 13–42. Turin: Accademia delle scienze, 1974.

———. "In Search of the Earliest Traces of French Humanism: The Evidence from Codicology." *Library Chronicle* 43, no. 1 (1978): 3–38.

———. *La librarie des frères captives: Les manuscrits de Charles d'Orléans et Jean d'Angoulême.* Turnhout: Brepols, 2007.

———. "Une maquette de manuscrit à peintures (Paris, B.N. lat. 14643, fols. 269r–83v, Honoré Bouvet, *Somnium prioris de Sallano super material scismatis,* 1394)." In *Mé-*

langes d'histoire du livre et des bibliothèques offerts à Monsieur Franz Calot: 35–41. Paris: Librarie d'Argences, 1960.

———. "Paris, l'un des principaux foyers de l'humanisme en Europe au début du quinzième siècle." *Bulletin de la Société historique de Paris et de l'Ile-de-France* (1967–1968): 71–98.

———. "Les premiers humanistes et leurs livres." In *Histoires des bibliothèques françaises.* Vol. 1, *Les bibliothèques médiévales du VI siècle à 1530,* edited by André Vernet, 267–83. Paris: Promodis-Editions du Cercle du librairie, 1989.

———. "Les recherches sur l'humanisme français des XIVe et XVe siècles." In *La filologia medievale e umanistica greca e latina nel secolo XX* (Atti del Congresso Internazionale delle Ricerche 11–15 dicembre 1989), 275–327. Testi e studi bizantino-neoellenici 7. Rome: Dipartimento di Filologia Greca e Latina, Sezione Bizantino-Neoellenica, Univ. di Roma, "La Sapienza," 1993.

———. "Le songe et les ambitions d'un jeune humaniste parisien vers 1395." In *Miscellanea di studi e ricerche sul Quattrocento francese,* edited by Franco Simone, 357–407. Turin: Giappichelli, 1966.

Ouy, Gilbert, Christine Reno, and Inès Villela-Petit. *Album Christine de Pizan.* Turnhout: Brepols, 2012.

Oxford University Press. *Oxford Music Online.* www.oxfordmusiconline.com.

Pade, Marianne. "Hvad er Teater? Terentskommentarer og leksikografi." *Renæssanceforum* 3 (2007): 1–30.

———. "Un nuovo tetimone dell'Illiade di Leonzio Pilato; il Diez. B. Sant. 4 della Staatsbibliothek, Stiftung Preussischer Kulturbesitz di Berlino." In *Posthomerica III,* edited by Franco Montaneri and Stefano Pittaluga, 87–102. Genoa: Dipartimento di Archeologia, Filologia Classica e loro Tradizioni, 2001.

Panayotova, Stella, ed. *Colour: The Art and Science of Illuminated Manuscripts.* Turnhout: Brepols, 2016.

Pellegrin, Elisabeth. "Note sur deux manuscrits enluminés contenant le *De senectute* de Cicéron avec la traduction de Laurent de Premierfait." *Scriptorium* 12 (1958): 276–80.

Pérez-Simon, Maud. "Royal MS. 20 B. XX: Alexander the Great and the Voice of the Master. Interpretation and Astrology in a Medieval Manuscript." *Electronic British Library Journal* (2014). http://www.bl.uk/eblj/2014articles/article8.html.

Pitti, Bonaccorso. *Bonaccorso Pitti marchand et aventurier Florentin.* Translated by Adelin Charles Fiorato, Hélène Giovannetti, and Corinne Lucas. Paris: Presses du CNRS, 1991.

Pons, Nicole. "Érudition et politique: La personnalité de Jean le Bègue d'après les notes marginales de ses manuscrits." In *Les serviteurs de l'État au Moyen Age. XXIXe congres de la S.H.M.E.S. (Pau, mai 1998)*: 281–97. Paris: Publications de la Sorbonne, 1999.

———. "Les humanistes et les nouvelles autorités." In *La méthode critique au Moyen Âge,* edited by Mireille Chazan and Gilbert Dahan, 289–303. Bibliothèque d'histoire culturelle du Moyen Âge 3. Turnhout: Brepols 2006.

———. "Leonardo Bruni, Jean Lebègue et la cour. Échec d'une tentative d'humanisme à l'italienne?" In *Humanisme et culture géographique à l'époque du concile de Constance. Autour de Guillaume Fillastre*, edited by Didier Marcotte, 95–125. Turnhout: Brepols, 2002.

Porcher, Jean. "Un amateur de peinture sous Charles VI: Jean Lebègue." In *Mélanges d'histoire du livre et des bibliothèques offerts à Monsieur Franz Calot*, 35–41. Paris: Librarie d'Argences, 1960.

Price, Merrall Llewelyn. *Consuming Passions: The Uses of Cannibalism in Late Medieval and Early Modern Europe*. New York: Routledge, 2003.

Purkis, G. S. "Laurent de Premierfait's Translation of the *Decameron*." *Medium Ævum* 24 (1955): 1–15.

Quilligan, Maureen. *The Allegory of Female Authority: Christine de Pizan's* Cité des Dames. Ithaca: Cornell University Press, 1991.

Rabel, Claudia. "Artiste et clientèle à la fin du Moyen Age: Les manuscrits profanes du Maître de l'échevinage de Rouen." *Revue de l'Art* 84 (1989): 48–60.

Ransom, Lynn. "The *Speculum theologie* and Its Readership: Considering the Manuscript Evidence." *Papers of the Bibliographical Society of America* 93, no. 4 (1999): 461–83.

Reno, Christine, and Inèz Villela-Petit. "Du *Jeu des échecs moralisés* à Christine de Pizan: Un recueil bien mystérieux (BnF, fr. 580)." In *Le recueil au Moyen Âge—La fin du Moyen Âge*, edited by Tania Van Hemelryck and Stefania Marzano, 263–76. Brepols: Turnhout, 2010.

Reynaud, Nicole. *Jean Fouquet: Les heures d'Étienne Chevalier*. Dijon: Éditions Faton, 2006.

Reynolds, Catherine. "English Patrons and French Artists in Fifteenth-Century Normandy." In *England and Normandy in the Middle Ages*, edited by David Bates and Anne Curry, 299–313. London: Hambledon Press, 1994.

———. "Master of the Harvard Hannibal." *Oxford Art Online*. https://doi.org/10.1093/gao/9781884446054.013.9002293109.

———. "The Shrewsbury Book, British Library Royal MS 15 E VI." In *Medieval Art, Architecture and Archaeology at Rouen*, British Archaeological Association Conference Transactions 12, edited by Jenny Stratford, 109–16. London: Routledge, 1993.

Reynolds, Leighton Durham. *Texts and Transmission: A Survey of the Latin Classics*. Oxford: Clarendon Press, 1983.

Reynolds, William Donald. "The *Ovidius Moralizatus* of Petrus Berchorius: An Introduction and Translation." Ph.D. diss., Urbana-Champaign, University of Illinois, 1971.

Richard, Charles Victor L. *Notice sur l'ancienne bibliothèque des échevins de la ville de Rouen*. Rouen: Imprimé Chez Alfred Péron, 1845.

Riou, Yves-François. "Les commentaires médiévaux de Terence." In *Medieval and Renaissance Scholarship: Proceedings of the Second European Science Foundation Workshop on the Classical Tradition in the Middle Ages and the Renaissance (London, Warburg Institute, 27–28 November 1992)*. Mittellateinische Studien und Texte 21, edited by Nicholas Mann and Birger Munk Olsen, 33–50. Leiden: E. J. Brill, 1997.

Roubilles, Maurice. "Martin Gouges des Charpaignes. Evêque de Clermont et Chancelier de France 1370–1444." University of Paris, Diplôme d'Études Spécialisées, 1961.

Rouse, Richard H., and Mary A. Rouse. *Manuscripts and Their Makers: Commercial Book Producers in Medieval Paris, 1200–1500.* 2 vols. Turnhout: Harvey Miller, 2000.

Rundle, David, ed. *Humanism in Fifteenth-Century Europe.* Oxford: Society for the Study of Medieval Languages and Literature, 2012.

Runnalls, Graham A. "*Mansion* and *lieu*: Two Technical Terms in Medieval French Staging?" *French Studies* 35 (1981): 387–93.

Sallust. *Works.* Edited by John Carew Rolfe. Cambridge, MA: Harvard University Press, 1931.

Sandler, Lucy Freeman. *The Psalter of Robert De Lisle in the British Library.* London: Harvey Miller, 1983.

Sansy, Danièle. "Marquer la différence: L'imposition de la rouelle aux XIIIe et XIVe siècles." *Médiévales, La rouelle et la croix. Destins des Juifs d'Occident* 41 (2001): 15–36.

Saxl, Fritz. "A Spiritual Encyclopedia of the Late Middle Ages." *Journal of the Warburg and Courtauld Institutes* 5 (1942): 82–134.

Saxl, Fritz, and Hans Meier. *Catalogue of Astrological and Mythological Illuminated Manuscripts of the Latin Middle Ages.* Vol. 3 of *Manuscripts in English Libraries,* edited by Harry Bober. London: Warburg Institute, 1953.

Schullian, D. M. "A Preliminary List of Manuscripts of Valerius Maximus." In *Classical, Mediaeval and Renaissance Studies in Honor of Berthold Louis Ullmann,* edited by Charles Henderson Jr., 81–95. Storia e letteratura 93–94. Rome: Edizioni di Storia e Letteratura 1964.

Schwall, Christine. "Erzählstrukturen im illustrierten Decamerone Vat. Pal. lat.1989." *Miscellanea Bibliothecae Apostolicae Vaticanae* 5 (1997): 295–327.

Schwall-Hoummady, Christine. *Bilderzählung im 15. Jahrhundert: Boccaccios Decamerone in Frankreich.* Frankfurt am Main: Peter Lang, 1999.

Scott, Catherine. "The French *Cité de Dieu* in the Philadelphia Museum of Art." M.A. thesis, University of Pennsylvania, 1967.

Scott, Margaret. *Fashion in the Middle Ages.* Los Angeles: J Paul Getty Museum, 2011.

Secousse, Denis-François, ed. *Contenant les ordonnances de Charles V données depuis le commencement de l'année 1374 jusques à la fin de son règne, et celles de Charles VI depuis le commencement de son règne jusques à la fin de l'année 1382.* Vol. 6 of *Ordonnances des roys de France de la troisième race, recueillies par ordre chronologique.* Paris: de l'Imprimerie royale, 1741.

Sherman, Claire. *Imaging Aristotle: Verbal and Visual Representations in Fourteenth-Century France.* Berkeley: University of California Press, 1995.

Silk, Michael, Ingo Gildenhard, and Rosemary Barrow. *The Classical Tradition: Art, Literature, Thought.* Malden, MA: Wiley-Blackwell, 2014.

Smalley, Beryl. "Sallust in the Middle Ages." In *Classical Influences on European Culture A.D. 500–1500,* edited by R. R. Bolgar, 165–75. Cambridge: Cambridge University Press, 1971.

Smith, Florence Alice. "Laurent de Premierfait's French Version of the *De casibus* and its Influence in France." *Revue de littérature comparée* 14 (1934): 512–16.

Smith, Kathryn. "The Destruction of Jerusalem Miniatures in the Neville of Hornby Hours and their Visual, Literary, and Devotional Contexts." *Journal of Jewish Art* 23/24 (1997–1998): 179–202.

Smith, Sharon Off Dunlap. "Illustrations of Raoul de Praelles' Translation of St. Augustine's *City of God* between 1375 and 1420." Ph.D. diss., New York University, 1974.

Spiegel, Gabrielle. *Romancing the Past: The Rise of Vernacular Prose Historiography in Thirteenth-Century France.* Berkeley: University of California Press, 1993.

Stahuljak, Zrinka. *Bloodless Genealogies of the French Middle Ages: Translation, Kinship, and Metaphor.* Gainesville: University Press of Florida, 2005.

Statius. *Thebaid, Books 1–7.* Edited by D. R. Shackleton Bailey. Cambridge, MA: Harvard University Press, 2003.

———. *Thebaid, Books 8–12, Achilleid.* Edited by D. R. Shackleton Bailey. Cambridge, MA: Harvard University Press, 2003.

———. *Thebais.* Edited by Alfred Klotz and Thomas C. Klinnert. Leipzig: BSB B. G. Teubner Verlagsgesellschaft, 1973.

Tanis, James, ed. *Leaves of Gold: Manuscript Illumination from Philadelphia Collections.* Philadelphia: Philadelphia Museum of Art, 2001.

Tennison, Heather. "Tradition, Innovation, and Agency in a *City of God*: The Philadelphia *Cité de Dieu* and Early Fifteenth-Century Parisian Manuscript Culture." Ph.D. diss., University of Kansas, 2021.

Terence [P. Terenti Afri]. *Comoediae.* Edited by Robert Kauer and Wallace M. Lindsay. Oxford: Oxford University Press, 1963.

———. *Phormio, The Mother-in-Law, The Brother.* Edited by John Barsby. Cambridge, MA: Harvard University Press, 2001.

———. *The Woman of Andros, The Self-Tormentor, The Eunuch.* Edited by John Barsby. Cambridge, MA: Harvard University Press, 2001.

Terroine, Anne, and Lucie Fossier. *Chartes et documents de l'Abbaye de Saint-Magloire: 1330–début du XVᵉ siècle.* Vol. 3, *1330–début du XVᵉ siècle.* Paris: CNRS, 1976.

Tesnière, Marie-Hélène. *L'histoire romaine de Tite-Live, Un miroir de sagesse antique pour le roi de France au XVᵉ siècle.* Paris: Assemblée nationale, 2000.

———. "À propos de la traduction du Tite-Live par Pierre Bersuire. Le manuscript Oxford, Bibliothèque Bodléienne, Rawlinson C 447." *Romania* 118 (2000): 449–98.

———. "Un remaniement du *Tite-Live* de Pierre Bersuire par Laurent de Premierfait." *Romania* 107, nos. 426–27 (1986): 231–81.

Thomas, Marcel. "Une prétendue signature de peintre dans un manuscrit du début du XVᵉ siècle." *Bulletin de la Société nationale des antiquaries de France* (1958): 114–15.

Throop, Priscilla, ed. *Vincent of Beauvais, The Moral Instruction of a Prince and Pseudo-Cyprian, The Twelve Abuses of the World: An English Translation of "De morali principis institutione" and "De duodecim abusivis saeculi."* Charlotte, VT: Medieval MS, 2011.

Turner, Nancy. "The Recipe Collection of Johannes Alcherius and the Painting Materials Used in France and Northern Italy c. 1380–1420." In *Painting Techniques: History, Ma-*

terials, and Studio Practice, edited by Ashok Roy and Perry Smith, 45–50. London: International Institute for Conservation of Historic and Artistic Works, 1998.

Van Buren, Anne. *Illuminating Fashion: Dress in the Art of Medieval France and the Netherlands, 1325–1515*. With Roger Wieck. New York: Morgan Library and Museum, 2011.

Villa, Claudia. "Laurencius." *Italia medioevale e umanistica* 24 (1981): 120–33.

Villela-Petit, Inès. *L'atelier de Christine de Pizan*. Paris: Bibliothèque nationale de France, 2020.

———. *Le bréviaire de Châteauroux*. Paris: Somogy, 2003.

———. "Palettes comparées: Quelques réflexions sur les pigments employés par les enlumineurs parisiens au début du XVe siècle." In *Quand la peinture était dans les livres: Mélanges en l'honneur de François Avril à l'occasion de la remise du titre de docteur honoris causa de la Freie Universität Berlin*, edited by Mara Hoffmann and Caroline Zöhl, 383–92. Turnhout: Brepols, 2007.

———. "La peinture médiévale vers 1400, autour d'un manuscrit de Jean Lebègue." Thesis, École nationale des chartes, 1995.

———. "La peinture médiévale vers 1400 autour d'un manuscrit de Jean Lebegue: Edition des *Libri colorum*." *Positions des theses de l'École des chartes* (1995): 275–78.

Von Steiger, Christoph. "Aus der Geschichte der Bongars-Handschriften der Burgerbibliothek Bern." *Librarium* 3, no. 2 (1960): 86–92.

Waugh, Christina Frieder. "Style-Consciousness in Fourteenth-Century Society and Visual Communication in the Moralized Bible of John the Good." Ph.D. diss., University of Michigan, 2000.

Weigert, Laura. *French Visual Culture and the Making of Medieval Theater*. Cambridge: Cambridge University Press, 2015.

Wilhelm, Raymund. "Alle soglie della narratività. Le rubriche del 'Decameron' nella traduzione francese di Laurent de Premierfait (1414)." *Romanische Forschungen* 113 (2001): 190–226.

Willard, Charity Cannon. "The Manuscripts of Jean Petit's Justification: Some Burgundian Propaganda Methods of the Early Fifteenth Century." *Studi Francesi* 13 (1969): 271–80.

Wolfthal, Diane. "Complicating Medieval Anti-Semitism: The Role of Class in Two Tales of Christian Violence Against Jews." *Gesta* 55 (2016): 105–27.

———. *Images of Rape: The "Heroic" Tradition and Its Alternatives*. Cambridge: Cambridge University Press, 1999.

Wright, David. "The Forgotten Early Romanesque Illustrations of Terence in Vat. Lat. 3305." *Zeitschrift für Kunstgeschichte* 56 (1993): 183–206.

———. "The Organization of the Lost Late Antique Illustrated Terence." In *Medieval Manuscripts of the Latin Classics: Production and Use*, edited by Claudine A. Chavannes-Mazel and Margaret M. Smith, 41–56. San Francisco: Anderson Lovelace, 1996.

INDEX

The names of historical figures who lived before 1500 are not inverted: for instance, Laurent de Premierfait or Jean Gerson. Page numbers in italics refer to illustrations.

ANNE D. HEDEMAN
is the Judith Harris Murphy Distinguished Professor
of Art History at the University of Kansas.
She is the author and co-editor of a number of books, including
Inscribing Knowledge in the Medieval Book:
The Power of Paratexts.

Printed in the USA
CPSIA information can be obtained
at www.ICGtesting.com
LVHW072345290923
759709LV00015B/940

9 780268 202279